JUSTICE LEAGUE

100

GREATEST MOMENTS

HIGHLIGHTS FROM THE HISTORY OF THE WORLD'S GREATEST SUPER HEROES

★ ★ ★ ★ ★

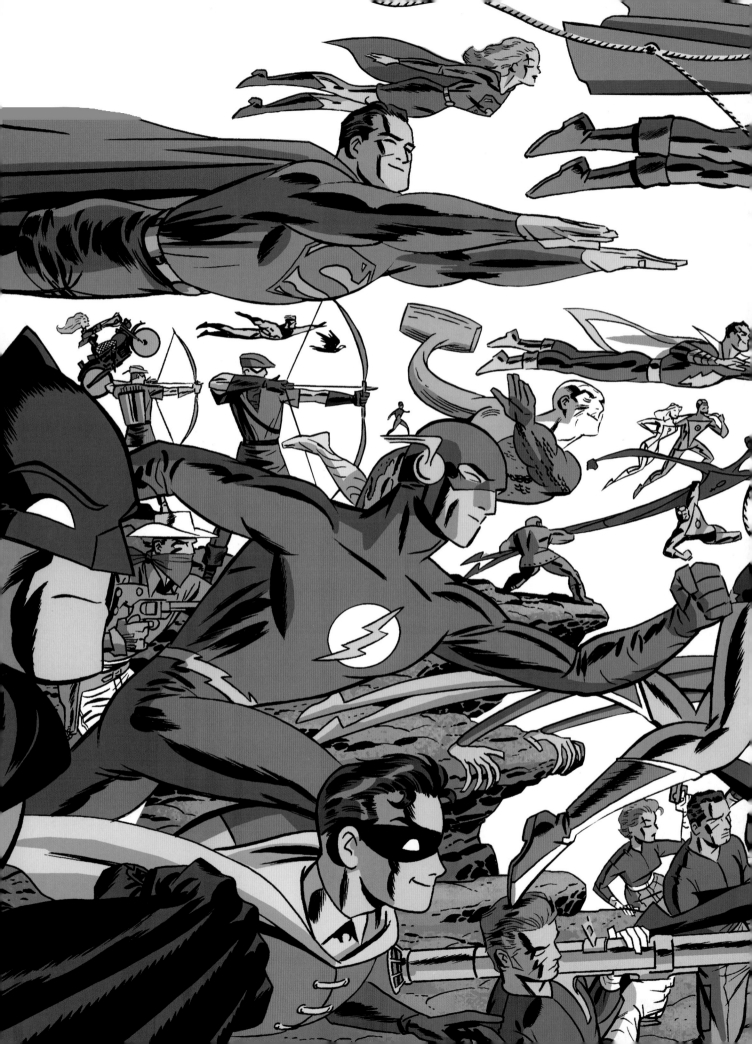

JUSTICE LEAGUE

100

GREATEST MOMENTS

HIGHLIGHTS FROM THE HISTORY OF THE WORLD'S GREATEST SUPER HEROES

Robert Greenberger

CHARTWELL
BOOKS

First published in 2018 by Chartwell Books, an imprint of The Quarto Group,
142 West 36th Street, 4th Floor, New York, NY 10018, USA
T (212) 779-4972 F (212) 779-6058 www.QuartoKnows.com

This edition published with permission of and by agreement with DC Entertainment
2900 W. Alameda Ave, Burbank CA 91505, USA

10 9 8 7 6 5 4 3 2

ISBN: 978-0-7858-3614-8

Editor: Michelle Faulkner
Editorial Project Manager: Leeann Moreau
Cover and Book Designer: Maria P. Cabardo
Team Rosters Chart Designer: Philip Buchanan
Design Assistant: Cheryl Smith
Project Editor: Su Wu

Printed in China

All identification of writers and artists in this book utilized information provided by the Online Grand Comics Database.

The author gratefully appreciates the time the following people gave him, brainstorming moments to consider for this book:
Kurt Busiek, Gerry Conway, Brian Cunningham, Michael Eury, J.M. DeMatteis, Mark Waid, and Marv Wolfman.

This is dedicated to John Wells, a fellow fan and historian, whose cheerful friendship and support has made this and countless other projects a joy to work on.

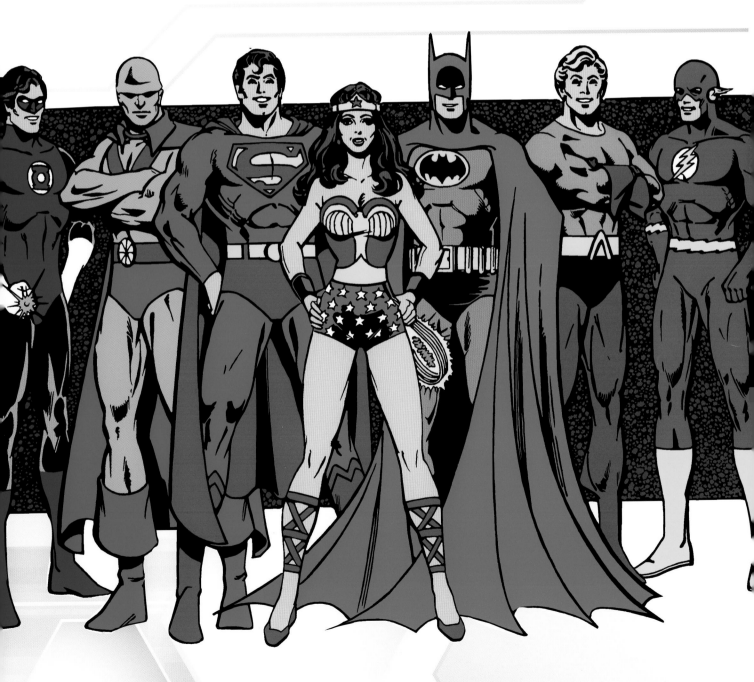

CONTENTS

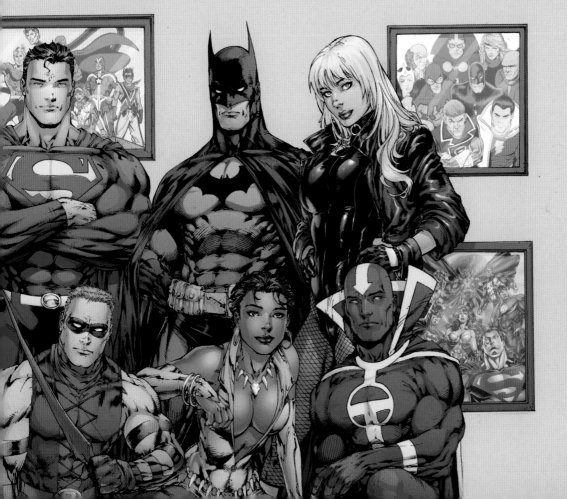

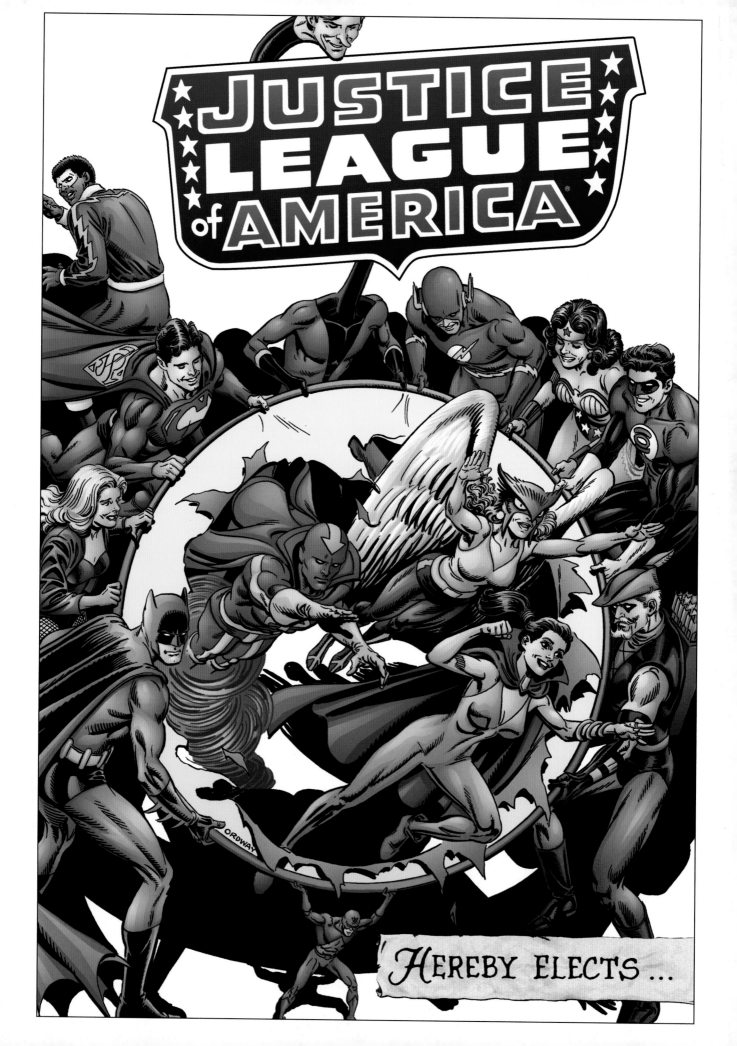

JUSTICE LEAGUE of AMERICA

HEREBY ELECTS ...

WHEN CONTINUING CHARACTERS BECAME
PREDOMINANT IN COMIC BOOKS, EACH
SERIES STOOD ON ITS OWN. THE IDEA OF
CHARACTERS FROM MULTIPLE SERIES
INTERACTING WASN'T ON ANYONE'S
MIND, LARGELY BECAUSE EACH CREATOR
CONTROLLED HIS OWN SERIES AND
THE NOTION OF A SHARED UNIVERSE
WAS AN ENTIRELY ALIEN ONE. THE RARE
CROSSOVERS THAT DID TAKE PLACE
IN COMIC BOOKS OF THE LATE 1930S
INVOLVED MINOR BACKUP CHARACTERS,
BEFORE MLJ, KNOWN TODAY AS ARCHIE
COMICS, STARTED HAVING ITS HEROES
INTERACT IN THE EARLY MONTHS OF 1940.

INTRODUCTION

Timely Comics upped the ante in mid-1940, proclaiming on the cover of *Marvel Mystery Comics* #8, "Something New! Human Torch Battles the Sub-Mariner." In the Sub-Mariner tale that opened the issue, Bill Everett had his avenging Atlantean attack New York City only to be opposed by the android Human Torch.

In that hero's story, by Carl Burgos, the events were retold from the android's point of view, and then they clashed. The battle didn't really get under way until the following issue, a rare continued story. The 22-page epic battle, the longest super-hero story yet, was produced by both men and sold very well, and the two characters fought each other again before teaming up to take on the Axis threat during World War II. Postwar, the duo joined other Timely heroes as the All-Winners Squad in two 1946 adventures.

Others paid attention, including Jack Liebowitz and M. C. Gaines, the men running All-American Publications. Gaines was one of the legendary figures in the creation

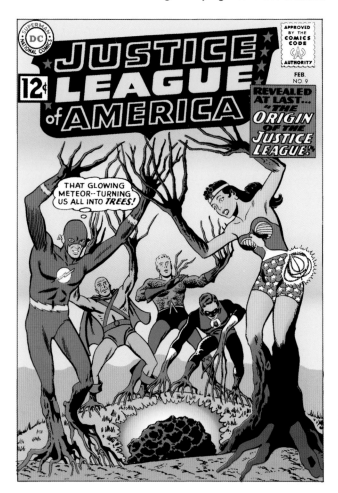

of the comic book and partnered with Liebowitz, who already ran Detective Comics, Inc. (also known as National Comics) with Harry Donenfeld (who helped fund the new firm), to create a new line of heroes starting with *Flash Comics* #1, which gave us both the Flash and Hawkman. As their line grew, they wanted to spotlight the various heroes in a new anthology, *All-Star Comics*. This 1940 quarterly also used heroes taken from Detective's line: Doctor Fate, Hour-Man (the spelling of the character's name at the time), the Spectre, and Sandman.

After two issues of individual stories, writer Gardner Fox took Timely's crossover idea one step further, by banding together the Atom, Sandman, Spectre, the Flash, Hawkman, Doctor Fate, Green Lantern, and Hour-Man as the Justice Society of America (JSA). For the next several years, the team would come together for a meeting, get a case, rush off to fight whoever the opponent was, and then come back together again for the final chapter. This way, each character could get a chapter produced by his regular creative team, except for the opening and closing installments.

This worked fine, and as members gained their eponymous titles, they would leave the team in favor of newer heroes in need of attention. In the title's eighth issue, the usual story was backed up with the introduction of All-American's latest character, Wonder Woman. She was then added to the team with issue #11, although as just the team secretary.

Over time, the series sold well enough to go from quarterly to bimonthly, and as page counts dropped, the individual chapters were changed into more team-ups, until the title's cancellation in 1951.

During comics' Golden Age, which spanned 1938–1950, imitation sometimes outstripped originality, so the Justice Society led to Timely's Young Allies (1941) and All-Winners Squad (1946), Fawcett's Marvel Family (1942), and National's own Seven Soldiers of Victory (1941).

Then the first super-hero era drew to a close. National was down to just a handful of heroes who didn't cross over, with the exception of Superman and Batman, who were forced to share *World's Finest Comics* as page

counts dropped and an editor suggested they partner in the lead story. Things were pretty sleepy for a time.

In 1956, though, National thought maybe it was time to try some super-powered people for a new audience. To test the waters, editor Julie Schwartz was asked to revive the Flash for the fourth issue of *Showcase* comics. Rather than just bring back Jay Garrick and his winged helmet, Schwartz wanted to keep the name and speed but reinvent everything else. Readers that year were introduced to Barry Allen, a police scientist who also read comics, including *Flash*. On a fateful night, a freak lightning bolt crashed into his lab, splashing him with charged chemicals that imbued him with super-speed. Honoring the hero of his youth, he donned a costume and called himself the Flash.

Taken aback by the comic book's strong sales reports, National tested the waters with three more trial issues. Satisfied that this was no fluke, the publisher returned *The Flash* to its regular schedule with late 1958's issue #105, keeping the original series' numbering. Within months, National followed with a revival of Green Lantern, which also found an audience. By 1960, super heroes were edging back onto the newsstands. When the company's *The Brave and the Bold* was converted into a companion try-out title, the second series sampled was something called *Justice League of America*. Schwartz, who never liked the term "society," feeling it suggested the upper class, preferred the more middle-class "league." Here, he gathered the company's heroes— Superman, Batman, Wonder Woman, Aquaman, Martian Manhunter, the Flash, and Green Lantern— to protect Earth from an invading super-powered alien that resembled a giant starfish aptly named Starro the Conqueror. (Green Arrow was an oversight, with multiple theories as to why he was omitted.)

The three issues sold well enough that the team was given their own title, which arrived with them confronting a new alien threat in the form of Despero. From those modest beginnings, the team also known as the World's Greatest Super Heroes have flowered and foundered, seen their ranks swell and shrink, and risen and fallen in sales popularity. However, it was this banding of heroes that became the gateway for readers to discover and sample heroes they may not have been reading. It was where cosmic concepts arrived and made the word "crisis" synonymous with the team and then the entire company, by then called DC Comics.

In the hands of dozens of writers and artists, the JLA have experienced moments that are intensely personal or of great cosmic importance. Their ability to shift in tone has kept the team always interesting, reflecting changing tastes among the readers and the times they existed in.

What you will see on the pages that follow are one hundred of these greatest moments, in no particular order of priority, each one a piece of the mosaic that is the Justice League. Although the team was also seen in the 1960s as part of the *Superman/Aquaman Hour of Adventure,* renamed *Super Friends* for the next decade-plus on ABC and then as *Justice League Unlimited* on Cartoon Network before finally reaching the big screen in 2017's *Justice League,* we have limited our selections to the comics that gave rise to these interpretations. The selections were not made in a vacuum but consist of nominations that came from various Facebook fan groups as well as former *JLA* scribes Mark Waid, Kurt Busiek, J. M. DeMatteis, Bob Rozakis, Gerry Conway, and Marv Wolfman; in addition to former DC editors Michael Eury and KC Carlson; and finally, ace researcher and comics historian John Wells. Brian Cunningham, who edited the *JLA* during the initial Rebirth era starting in 2011, also offered the most contemporary selections.

JUSTICE LEAGUE of AMERICA

Hereby Elects

* *

To membership for life, with all privileges and gratuities, including the wearing of the signal device and possession of the special key which permits entry into the sanctuary, its library and souvenir rooms. It is hereby further resolved and acted upon that:

* *

Shall receive this special commendation for expert assistance in the case we have entitled in our scrolls...

* *

★ ★ ★

Justice League of America.

THE HOUSE AD ANNOUNCING THE ARRIVAL OF A NEW
TEAM WAS ENTICING. "JUST IMAGINE! THE MIGHTIEST
HEROES OF OUR TIME... HAVE BANDED TOGETHER AS THE
JUSTICE LEAGUE OF AMERICA TO STAMP OUT THE FORCES
OF EVIL WHEREVER AND WHENEVER THEY APPEAR!"
WHO COULD RESIST?

CHAPTER 1
THE MEMBERSHIP

At first, membership in the League was pretty basic. Julie Schwartz's rule for writer Gardner Fox was to include all heroes who had their own series. In 1960, that meant Superman, Batman, Wonder Woman, Aquaman (then running in *Adventure Comics*), Green Arrow (*World's Finest*), Martian Manhunter (*Detective*), the Flash, and Green Lantern.

And yet, Green Arrow was missing from the League's debut appearance in *The Brave and the Bold* #28 (1960). No one is certain why: whether it was an oversight or creative determination that the Emerald Archer was too low-powered a hero to keep up with the others. Once

the team was awarded their own title, he became the first member to be inducted, in issue #4.

To illustrate such a packed comic, Schwartz turned to penciller Mike Sekowsky, who had not drawn any of these characters despite a prolific career dating back to the end of the Golden Age. He was a fast artist and didn't feel beholden to house styles for the individual heroes. As noted by Michael Eury in *The Justice League Companion*, "Another Sekowsky illustrative trait was his unorthodox anatomy. His characters were blocky and idiosyncratic, incompatible to the lithe, graceful figures drawn by so many other artists. Sekowsky's people,

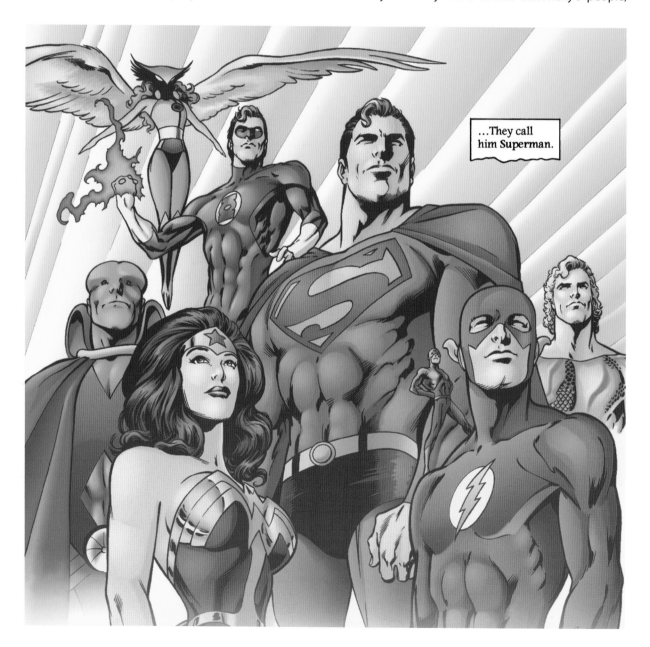

...They call him Superman.

however, looked true-to-life—not photorealistic, but with human characteristics, from personal traits like big noses to body language like thrashing bodies."

Bernard Sachs, one of the reliable inkers in Schwartz's stable, drew the assignment to add a slick finish to Sekowsky's unique pencils. Together, they would work on the series for the first forty-three issues, before other inkers—Frank Giacoia and then Sid Greene—stepped in.

Fox and Sekowsky would go on to produce the series for eight years, until first the artist and then the writer moved on in 1968. Their collective body of work remains a beloved part of comics' Silver Age, which was launched in 1956 with the introduction of Barry Allen, the second man to use the name Flash, and ended somewhere around 1970.

The team could certainly have used the Emerald Archer's help, since the Man of Steel and the Caped Crusader were largely absent from the early adventures. The reason behind this was twofold: first, their editors—Mort Weisinger and Jack Schiff, respectively—felt they might be overexposed by using them prominently in the new book; and second, this allowed the other, less popular heroes to be more obviously featured in the stories. When Schwartz met with publisher Jack Liebowitz to talk about improving the new book's sales, he mentioned the editorial interference. In his autobiography, Schwartz reported that Liebowitz snapped, "You go in and tell those sonuvabitches that Superman and Batman belong to DC Comics and *not* to Mort Weisinger and Jack Schiff!"

It wasn't until the team's ninth issue, in a story celebrating the team's first anniversary, that they recounted how the team came to exist. At the celebration, they took turns telling team mascot Snapper Carr, who aided them when Starro attacked the teen's hometown of Happy Harbor, how a cadre of competing aliens sought to be the first to conquer Earth. While Superman was incapacitated by a kryptonite meteor in the Arctic, the other heroes confronted these would-be rulers, and each one succumbed to their foe. Trapped on an island that was turning each into a tree, teamwork proved the difference. *Together* they helped one another gain

freedom and then made short work of the aliens, while Batman flew to the frozen wastes to rescue his friend. United in the aftermath, it was agreed they would form a league to protect Earth from future threats.

A decade later, a secret origin was revealed by writer Steve Englehart in *Justice League of America* #144 (1977). J'onn J'onzz was a green-skinned Martian who was exiled on Earth while his people were in a civil war with their white-skinned brethren. Shortly after his arrival, Martian Manhunter's mortal enemy, Commander Blanx, came hunting him and created a panic among the populace, resulting in the arrival of the Flash. Since the speedster was still a rookie at the time, he felt he was in over his head and summoned aid from Superman, Batman, and Robin the Boy Wonder.

While they battled Blanx, Roy Raymond, host of TV's *Impossible But True*, broadcast news of the fight, which caught the attention of several adventurers including the Blackhawks, the Challengers of the Unknown, Plastic Man, the Vigilante, Robotman, Congo Bill and Congorilla, Rex the Wonder Dog, Rip Hunter, Aquaman, Wonder Woman, Lois Lane, and Jimmy Olsen. Once again, Green Arrow is absent, but Englehart concocted an excuse, making this an overtly deliberate choice. Hal Jordan, Earth's Green Lantern, has his own close encounter while test-piloting a plane. Later, the core members of what would be the JLA agreed to form then, keeping the news a secret rather than inflame anti-alien hysteria. It took Green Arrow reading Snapper Carr's JLA Casebook to discover the inconsistencies and get his teammates to fess up.

In actuality, this was Englehart's nod to all the characters who were active during the 1950s, a fond look back at different kinds of heroes and the wide variety of types that populated the line (which during the decade came to include Quality Comics' Blackhawk and Plastic Man after the publisher ceased operation). Over time, the company's continuity changed, most notably after an event called Crisis on Infinite Earths that saw the multiverse collapse into a single positive-matter universe. Some of the more substantive changes to reality meant a later debut for Wonder Woman, so Black Canary was substituted when the events of *JLA* #9 were retold in 1988's *Secret Origins* #32. Based on this version,

writers Mark Waid and Brian Augustyn, along with artist Barry Kitson, expanded on what happened next in *JLA: Year One*, a 1998 maxiseries that explored the foundations in depth. They paid particular attention to how these newer heroes were learning to use their powers, work together, and trust one another despite huge differences in persona.

Several years later, it was revealed in *Justice League Task Force* #16 (1994) that a hero named Triumph was also present during the League's founding and was even serving as their first chairman when they were summoned into action. Triumph wound up saving the world, but that resulted in his being transported to another dimension, which also resulted in time being rewritten, so no one remembered him. Another cosmic event called Infinite Crisis resulted in the 2006 formation of what was briefly called New Earth. Once more, time was rewritten, removing Triumph and Black Canary from the League's creation and instead restoring Wonder Woman as a founding member. Soon after, Superman and Batman were also confirmed as inaugural members. So, going forward, the Big Seven—Superman, Batman, Wonder Woman, Green Lantern, the Flash, Aquaman, and Martian Manhunter—have remained intact as the initial founders of the Justice League.

In the wake of the next cosmic event, dubbed Flashpoint, reality was written afresh in 2011 with substantive alterations. It took an incursion of forces from the extradimensional world known as Apokolips to bring the heroes together, beginning with Batman and Green Lantern. It was not an auspicious start, as the Dark Knight and Emerald Crusader had very different ideas about their roles and each other. Once they put their differences aside, they journey to Metropolis to seek out Superman, meet the Flash, and are then joined by Aquaman and Wonder Woman just in time for a full-scale assault by an army of Parademons. They all encounter a Mother Box, which is a sentient machine capable of opening Boom Tubes, conduits between Earth and Apokolips, just as Darkseid, its ruler, steps through. The heroes are aided by a newcomer, Cyborg, and when they chase Darkseid from Earth, the public embraces them. While the Flash wants to call them the

Super Seven, an unnamed reporter at the scene calls them the Justice League, and the name sticks.

Regardless of its origins, the team roster remained a fluid one, with early-1960s adventures showing the team rotate chairing the meetings and actively discussing new additions (reflecting new series and characters arriving during the Silver Age). Green Arrow was quickly added in 1961's *Justice League of America* #4 and it took a year after to add the Atom, and almost another two years before Hawkman was invited into the clubhouse.

The first hero to refuse such a cherished offer was Metamorpho, who helped the team on a 1965 case but turned them down since he didn't see himself as a hero. Instead, he was an adventurer unluckily transformed into the Element Man, and all he wanted was his humanity back.

There was a fundamental shift in 1968 as the company was sold and there were changes from the top down. In the case of *Justice League of America*, it meant the departure of penciller Mike Sekowsky, who finally tired of the demanding assignment and moved to give fresh life to *Wonder Woman*. He was replaced by Dick Dillin, a veteran illustrator who had toiled on *Blackhawk* for the previous decade-plus. When the company canceled *Blackhawk*, Schwartz took him on, and a new era of longevity began with Dillin stepping in with issue #64 and lasting until his death, as he drew issue #184.

Schwartz replaced Fox with the far younger and fresher Denny O'Neil, just imported to DC Comics from Charlton Comics. While not entirely comfortable with an ensemble, especially one with such massive powers, O'Neil brought a different sensibility to the series, with more stories being inspired by current events, a precursor to his legendary collaboration with Neal Adams on *Green Lantern* two years later.

In 1969, the team began to change with the first member to resign. Diana Prince arrived at their HQ and revealed herself to be a powerless Wonder Woman. In Sekowksy's effort to freshen Wonder Woman's own title, she lost her Amazonian gifts and felt she no longer fit in. Two issues

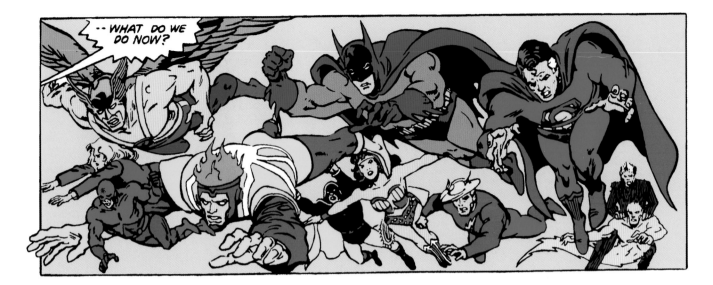

later, Martian Manhunter also left the group—and Earth. With his own series having ended a year earlier, in *House of Mystery*, it was deemed time for him to return home from his thirteen-year exile. It was in this story that readers were first told of the green-white civil war, and he felt his efforts were needed to help the survivors.

The seemingly depleted ranks were increased in issue #75 when Black Canary crossed the multiverse, leaving behind her sorrow over the loss of her husband on Earth-2 to start afresh on the JLA's Earth-1. Not long after, following a fleeting flirtation with Batman, she and Green Arrow ignited their long romance.

Members continued to join and others took leaves of absence, but the core Justice League remained largely intact. O'Neil lasted nearly twenty issues before moving on to other assignments, and letter-column hack turned professional writer Mike Friedrich inherited the series. Friedrich's first story, in #86, had a helping hand from O'Neil and Adams, but it also honored Fox's original structure, splitting the League into smaller teams to tackle an ecological dilemma. After that, his stories proved more cosmic than O'Neil's while retaining an emphasis on characterization.

Over time, the ranks grew more than shrank, so regardless of whoever was available, when a calamity called them to action, an able team was ready to respond. To celebrate their one-hundredth meeting, the entire League, including honorary members,

gathered in issue #100, which also welcomed aboard Len Wein, a fan who had recently begun writing for the company. Wein's run was a relatively brief one, but his focus on the interactions between Leaguers added new dimensions to the stories. He changed things up by having new member the Elongated Man suggest the team deal with one another's foes for one mission. The opposing ideologies between the law-and-order Hawkman and liberal Green Arrow also added some sustained tension in the title for the first time.

After Wein's run, Schwartz let his stable of writers, including Martin Pasko, Elliot S! Maggin, and Cary Bates, take turns writing adventures. As a result, the relatively unchanging roster took on a variety of cosmic threats and even had time to attend the wedding of Adam Strange to his beloved Alanna. Steve Englehart arrived to write the series for a year at the same time the comic briefly expanded in size from 32 to 48 pages, with 34-page stories, something that benefitted the team tremendously. During his tenure he used a variety of elements from the DC mythos to fuel stories, from the alien Manhunter robots to the previously mentioned "secret" origin of the team.

Then Gerry Conway arrived to begin the longest run of any writer on the title. He had broken into comics as a teenager, and by the time he took over *Justice League of America*, he had already made a name for himself at Marvel Comics as both writer and editor-in-chief and as a DC writer and editor. With the team under his control,

Conway also honored the title's legacy with a mix of cosmic, occult, and super-villain stories that kept things never less than entertaining. He gave us the *Homo magi*, the race that gave us Zatara and his daughter Zatanna, who finally joined the team. Things kept churning and the Conway/Dillin team kept readers engaged.

After Dillin's untimely death, superstar artist George Pérez stepped in to draw the book, infusing it with fresh vitality. In time, though, he was needed elsewhere, and the book fell to veteran artist Don Heck before ceding to newcomer Chuck Patton, who brought a more traditional storytelling approach, working well with Conway.

There came a time, however, when the team needed to be rebuilt from the ground up. In the wake of 1984's Earth-Mars War, it was clear not every member could be counted on during an event. After their orbiting satellite headquarters was crippled, Aquaman, a ruler of some experience, saw that times had changed and the League needed members who were committed to the team full time. Addressing the United Nations, he explained that the team had to be disbanded until a full-time complement could be found. Existing members Zatanna, Martian Manhunter, and the Elongated Man were up for the commitment. They were soon after joined by newer heroes Vixen, Steel, Vibe, and Gypsy. Steel invited them to a high-tech

Detroit compound that belonged to his grandfather, Commander Steel, and was maintained by Vietnam vet Dale Gunn. This became their new home, and the Justice League was reborn. Unfortunately, it was not to last, as the team was systematically taken down by enemies during an attack on Earth's legends that was initiated by Darkseid.

But Earth needed its defenders, and the Justice League was soon reformed under the auspices of billionaire industrialist Maxwell Lord. He bankrolled the new team and got them United Nations recognition, resulting in JLA Embassies being set up around the world, inviting a more worldwide representation among the membership. In time, there were two main teams, one based in America and another in Europe. There was briefly, sort of, maybe, a branch in Antarctica.

The silliness of that statement is emblematic of the team's late-1980s era. Editor Andrew Helfer recruited writer/artist Keith Giffen to step in and help relaunch the League. Giffen's thumbnail layouts were turned over to relative newcomer Kevin Maguire, who had an immense talent for body language and facial expressions. Coupled with J. M. DeMatteis's hilarious dialogue, *Justice League* was an antidote to the relentlessly grim super-hero comics of the time. It was also a critical and sales darling, resulting in the spinoffs. *Justice League Europe* was kicked off by Giffen, dialoguer Gerry Jones

(replacing DeMatteis with issue #14), and penciller Bart Sears, establishing a more muscular and wry tone. Jones would take over the full writing chores and later move on to the main *Justice League of America* title.

Martian Manhunter felt there were some missions that required more specific sets of skills beyond the JLA membership. Formed in 1993, his Task Force was a fluid assortment of heroes, as he continued to train Gypsy, who proved one of his most capable operatives. Meanwhile, Captain Atom took several members with him to form a more proactive team called Justice League West that dealt out more extreme justice.

By 1996, the sprawling sets of teams had proven unwieldy, and once more, the core founders returned to lead the JLA. They were on hand to repel Mageddon and other threats, while establishing a base on the moon, a watchtower to protect all of Earth from homegrown and intergalactic threats. Early on, they dealt with the invading White Martians, Lex Luthor's Injustice Gang, and Darkseid. They endured, fought, and prevailed until the powerful Superboy from the Prime Universe came and destroyed the Watchtower. Despite Green Arrow's best efforts, the team dissolved in 2006. Superboy-Prime continued his destructive path, ushering in the Infinite Crisis. In the wake of these cosmic events, the need for global protectors did not diminish, and a new Justice League rose from the ashes. Superman, Batman, and Wonder Woman sifted through the available champions of justice in 1996 and selected Green Lantern (Hal Jordan), Black Canary, Red Arrow (Green Arrow's former partner), Red Tornado, Vixen, Black Lightning, and Hawkgirl. With Black Canary as the new chair, the team set up two headquarters connected by teleporter: the Hall, in Washington, DC, and a rebuilt satellite in orbit. The roster proved more fluid than in the past, as events built toward what was nicknamed the Final Crisis (2006). In the wake of that event, it appeared that both Batman and Martian Manhunter were casualties, while Superman and Wonder Woman resigned to focus on personal crises.

Under Vixen's leadership, the team seemed to fracture in two, with Green Lantern and Green Arrow heading up the secondary team that took a more brutal approach to fighting villainy. They felt forced into this approach by their foe Prometheus, who wound up maiming Red Arrow and killing his daughter Lian—two of the most horrific events to occur to the team. Green Arrow would violate the law and his own moral code by tracking and killing Prometheus in 2010.

In the aftermath, a restructured League would emerge, featuring Batman (Dick Grayson), Green Lantern (Hal Jordan), Green Arrow, the Atom, Donna Troy, Mon-

El, Cyborg, Doctor Light, Starfire, Congorilla, and the Guardian. The unlikely team quickly morphed, with most leaving, and Jade and Jesse Quick joining the team until reality was rewritten by Flashpoint in 2011.

Referred to only as the Justice League, the latest incarnation of the team formed to confront Darkseid would come to include Superman, Batman, Wonder Woman, Green Lantern (Hal Jordan), Aquaman, the Flash (Barry Allen), Cyborg, the Atom (Rhonda Pineda), Firestorm (Ronnie Raymond), and Element Woman. Briefly, a new version of Justice League International operated with Batman, Booster Gold, Rocket Red #7 (Gavril Ivanovich), Vixen, Green Lantern (Guy Gardner), Fire, Ice, August General in Iron, and Godiva among the first members. It disbanded after several missions.

Seeing an opportunity, Amanda Waller, on behalf of the federal government, formed her own version called the Justice League of America, recruiting Steve Trevor as field leader, along with Martian Manhunter, Green Arrow, Hawkman, Catwoman, Green Lantern (Simon Baz), Stargirl, Katana, and Vibe. Waller had earlier embedded the Atom (Rhonda Pineda) as a member of the original Justice League to gain useful intelligence on their operations. Waller came to regret this when it was revealed that Rhonda was actually an interloper from Earth-3 and its Crime Syndicate. John Constantine, Shade, the Changing Man, Madame Xanadu, Deadman, Zatanna, and Mindwarp banded together as supernatural threats proved too great to ignore. They archly called themselves Justice League Dark but had no formal affiliation with the League proper, despite Peter Milligan, Jeff Lemire, and J. M. DeMatteis charting their adventures.

The Justice League, Justice League of America, and Justice League Dark did come to blows during what was known as the Trinity War storyline. The Atom's treachery was revealed, and Shazam joined the Justice League in the conflict that preceded the Crime Syndicate's assault on Earth. To thank Lex Luthor and Captain Cold for their heroic efforts during the Forever Evil crisis, the League welcomed both to its ranks. Jessica Cruz was an agoraphobic who found herself attached to the sentient Power Ring from Earth-3. In time, she would master these newfound powers, tame the malevolent spirit, and emerge as a Green Lantern and join the team. Additionally, a new team, Justice League United, formed in the wake of this war, with members including Animal Man, Martian Manhunter, Green Arrow, Hawkman, Stargirl, Supergirl, Adam Strange, his wife Alanna, and native Canadian sixteen-year-old hero Equinox.

A strange, unrevealed force tinkered with reality, stealing time and leaving memories of events somewhat fuzzy. Batman and the Flash were the first to recognize this, and the Dark Knight realized that the current roster of the Justice League—composed of himself, the Scarlet Speedster, Superman, Wonder Woman, Aquaman, Cyborg, and two Green Lanterns (Simon Baz and Jessica Cruz)—would be called upon in the conflict to come. They remained Earth's premier force to defend the planet from all major threats.

Privately recognizing the need for more resources, Batman assembled a secondary team, recruiting the Atom, Black Canary, Vixen, the Ray, Killer Frost, and intergalactic bounty hunter Lobo for his Justice League of America. The Dark Knight has always had an odd relationship with the League, at times an active, even eager participant. He has found himself philosophically opposed to the League's non-interventionist code and left the team at least once. The first time was to form the Outsiders to rescue his friend, Wayne Enterprises CEO Lucius Fox. Over the years, though, he recognized the world was growing more dangerous and saw his peers at various times overtaken by forces beyond their control.

As a result, he was always cautious and prepared files on how to neutralize each member of the team. But the contingency plans fell into Ra's al Ghul's hands, and the master terrorist used them to good effect. Another time, Batman arrived as the team had voted to alter

Doctor Light's memories and personality, punishment of a sort for brutally raping the Elongated Man's wife, Sue Dibny. Batman objected and Zatanna removed the incident from his memory—until circumstances saw those memories return. Horrified, Batman felt the need to monitor all super-powered beings on Earth, so he built and launched Brother Eye, a sophisticated artificial intelligence. Unfortunately, Brother Eye was hacked by former JL backer Maxwell Lord and its program altered, going from passive observer to outright threat. It put all of Earth's champions on the road to Infinite Crisis.

Regardless of events or personal issues, when Earth needs champions, a Justice League will respond. Their legend spans the stars and endures through time, so that even in the year 1,000,000 a number of teams call themselves the Justice League, with Justice Legion Alpha seeing descendants now guarding planets throughout the Sol system.

In the end, it doesn't matter who is on the team, as each member voluntarily serves to protect human life, willing to sacrifice their own in the cause of all that is good.

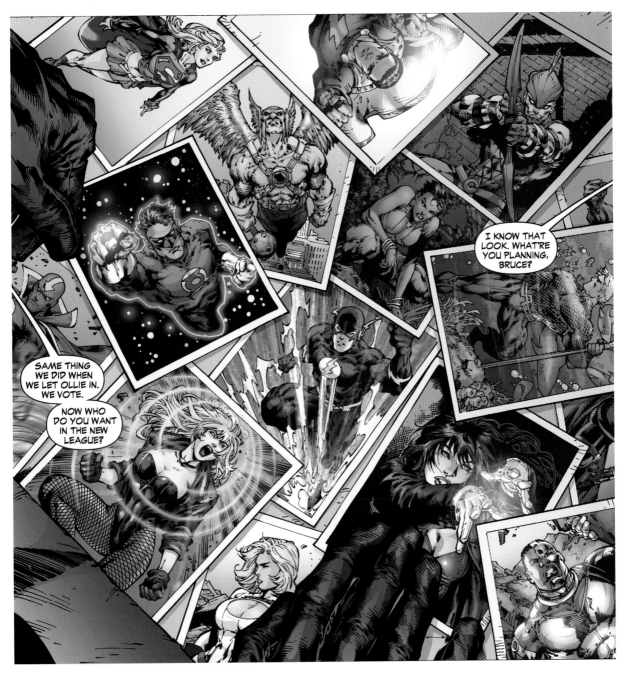

GREATEST MOMENTS

THERE'S ONLY ONE JUSTICE LEAGUE

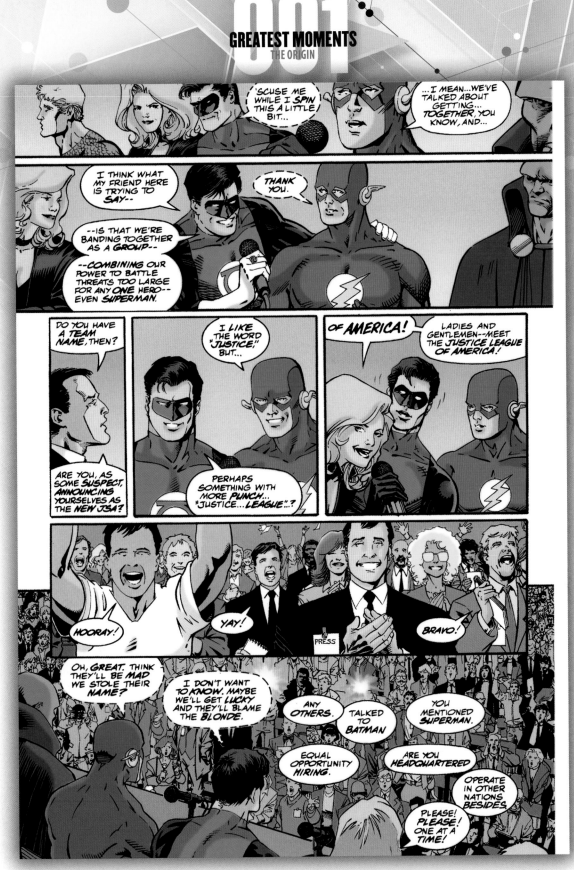

In a modern retelling of the JLA's origin, Mark Waid, Brian Augustyn, and Barry Kitson expanded on how the heroes first encountered one another and then addressed the public. *JLA: Year One* took the initial story and applied modern characterization, making each member distinct.

JLA: Year One #2, February 1998
Writers: Mark Waid & Brian Augustyn *Artist:* Barry Kitson

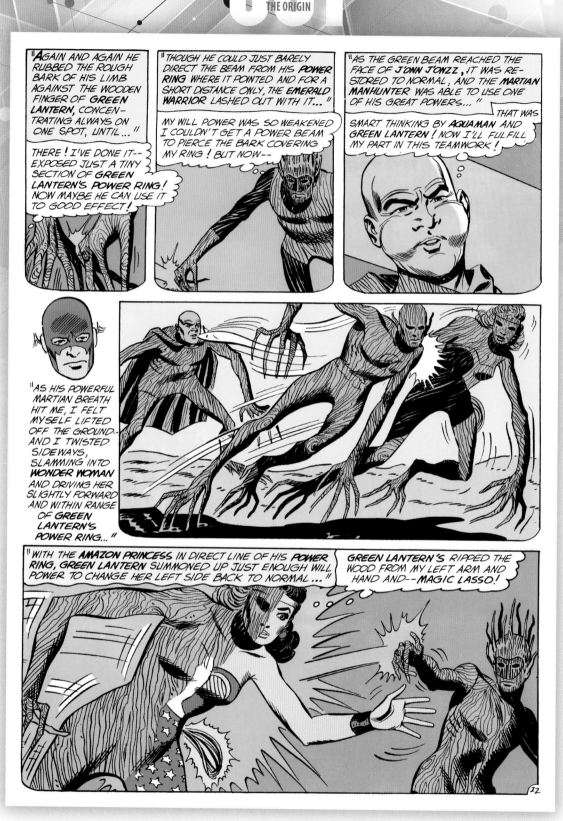

Competing Appellaxians arrived on Earth and one by one bested the great heroes, capturing them and leaving them on a small island where they were gradually being transformed from living flesh to wood. Only together could they find freedom and then success against their foes as told in *Justice League of America* #9.

Justice League of America #9, February 1962
Writer: Gardner Fox *Artists:* Mike Sekowsky & Bernard Sachs

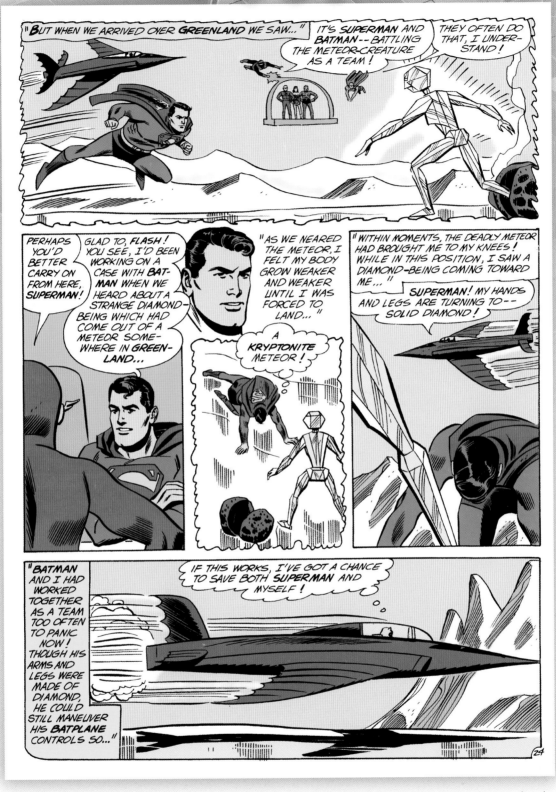

Superman had to be isolated from the others and at tale's end, they arrived in Greenland, only to discover that the Man of Steel's pal Batman successfully removed the kryptonite that incapacitated the hero. Despite missing the fun, the World's Finest heroes eagerly joined the new team.

Justice League of America #9, February 1962
Writer: Gardner Fox *Artists:* Mike Sekowsky & Bernard Sachs

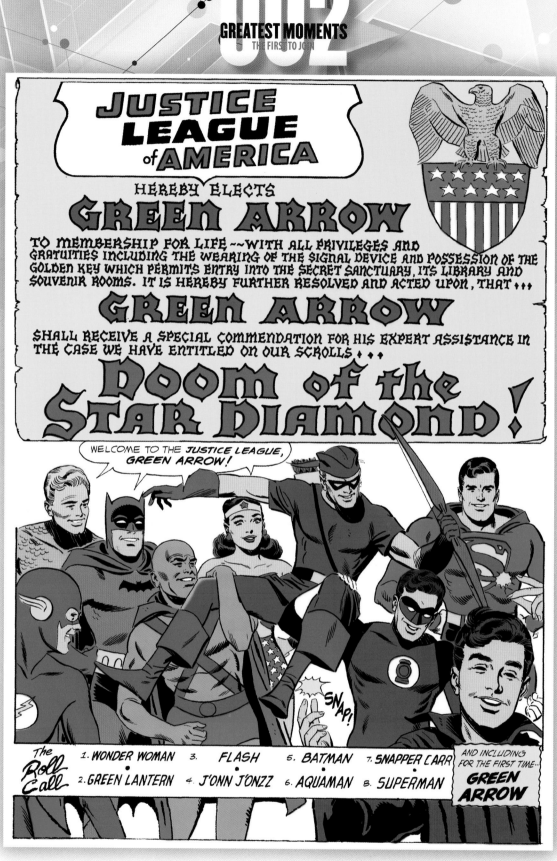

Correcting a probable editorial oversight, writer Gardner Fox saw to it that Green Arrow became the first new member added to the team. The splash page to *Justice League of America* #4 was the first time the election language appeared, but far from the last.

Justice League of America #4, April-May 1961
Writer: Gardner Fox *Artists:* Mike Sekowsky & Bernard Sachs

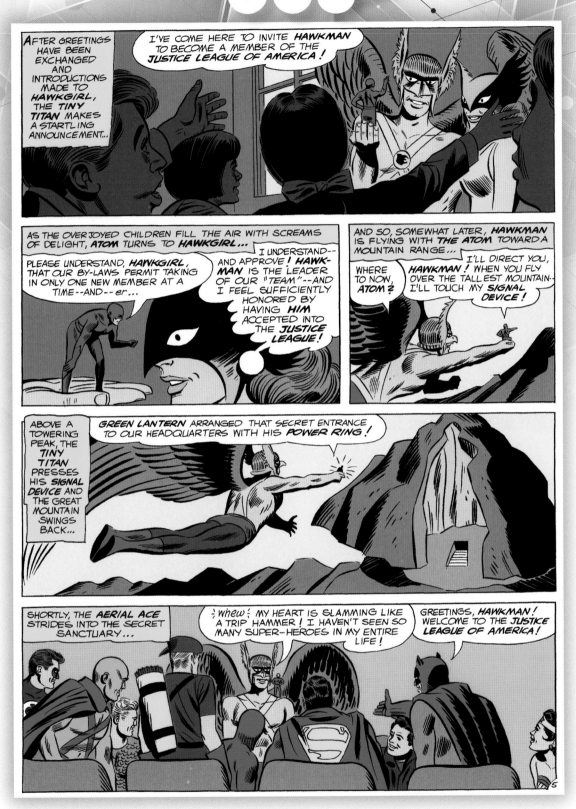

As new heroes arrived on the scene, the team periodically discussed which ones to invite onto the roster. The Atom joined in issue #14 and was followed by Hawkman as seen here in *Justice League of America* #33. Hawkgirl would have to wait over 100 issues before being welcomed. Note this rare look at an aerial entrance to the Secret Sanctuary.

Justice League of America #33, February 1965
Writer: Gardner Fox *Artists:* Mike Sekowsky & Bernard Sachs

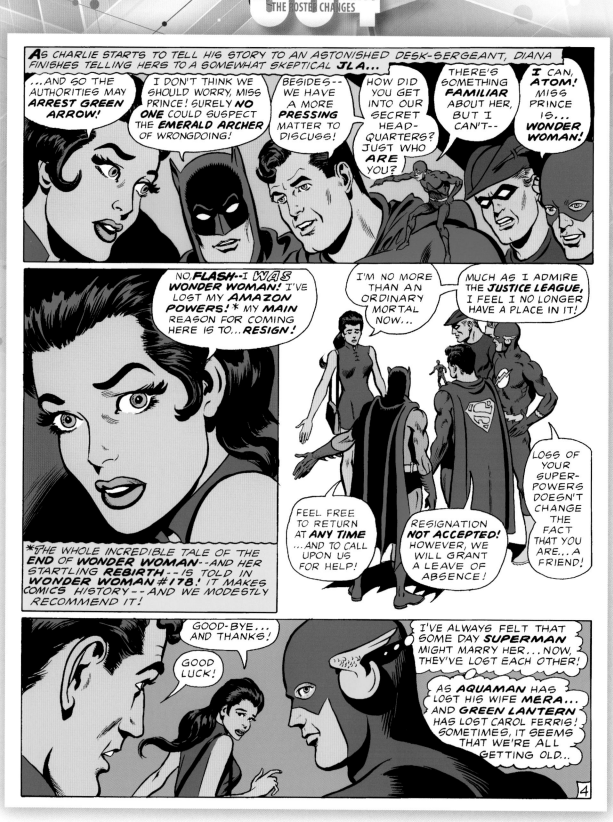

In 1968, Wonder Woman gave up her Amazonian powers to remain on Earth and felt she no longer belonged on the team. Writer Denny O'Neil was handling the JLA and her solo adventures, so the moving moment in *Justice League of America* #69 felt right.

Justice League of America #69, February 1969
Writer: Denny O'Neil *Artists:* Dick Dillin & Sid Greene

Surprisingly, two issues later saw O'Neil remove J'onn J'onzz from the team after increasingly infrequent appearances. He returned to the stars to find the last handful of Martians after a racial civil war, sowing seeds for future stories over the next five decades.

Justice League of America #71, May 1969
Writer: Denny O'Neil *Artists:* Dick Dillin & Sid Greene

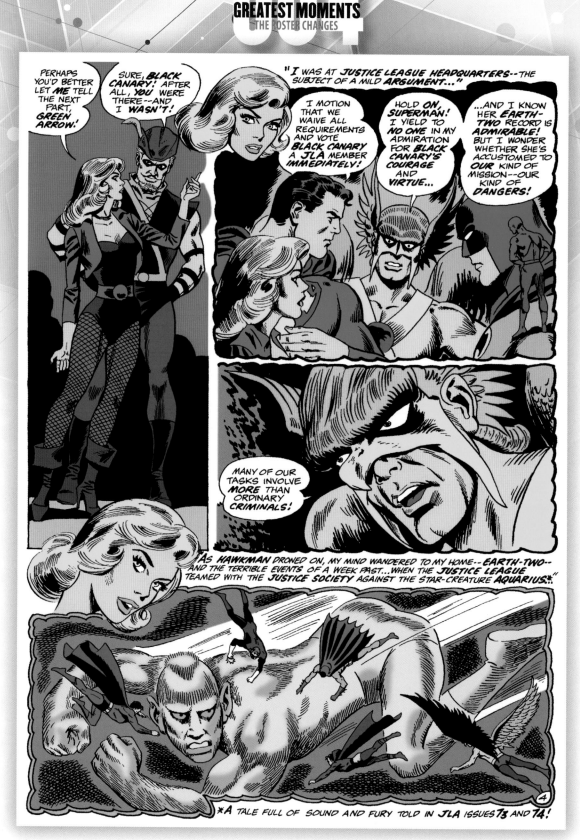

The roster may have felt thin to some and O'Neil interestingly transplanted Black Canary from Earth-2 to Earth-1 after the Justice League worked with her team, the Justice Society of America, to stop a cosmic entity dubbed Aquarius.

Justice League of America #75, November 1969
Writer: Denny O'Neil *Artists:* Dick Dillin & Joe Giella

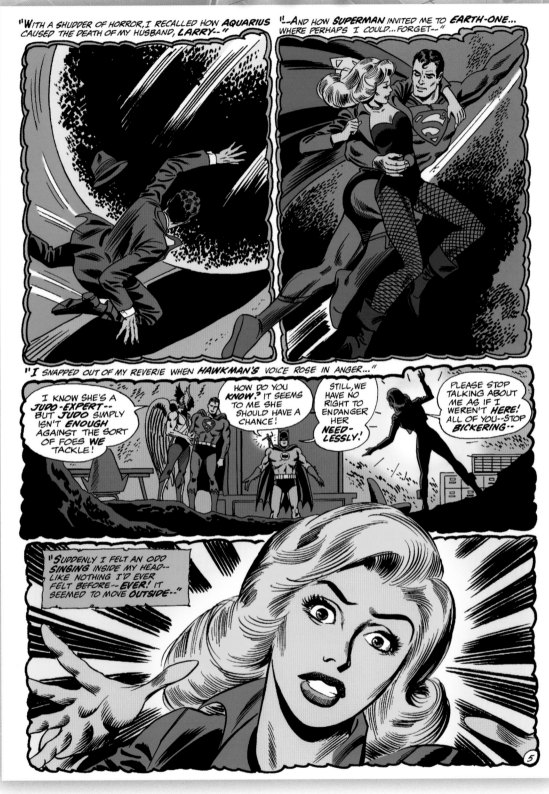

In these pages from *Justice League of America* #75, the Canary relived her husband Larry Lance's heroic sacrifice, prompting her to relocate worlds. As she's telling the story to Green Arrow, you can already get a sense of the romance to come.

Justice League of America #75, November 1969
Writer: Denny O'Neil *Artists:* Dick Dillin & Joe Giella

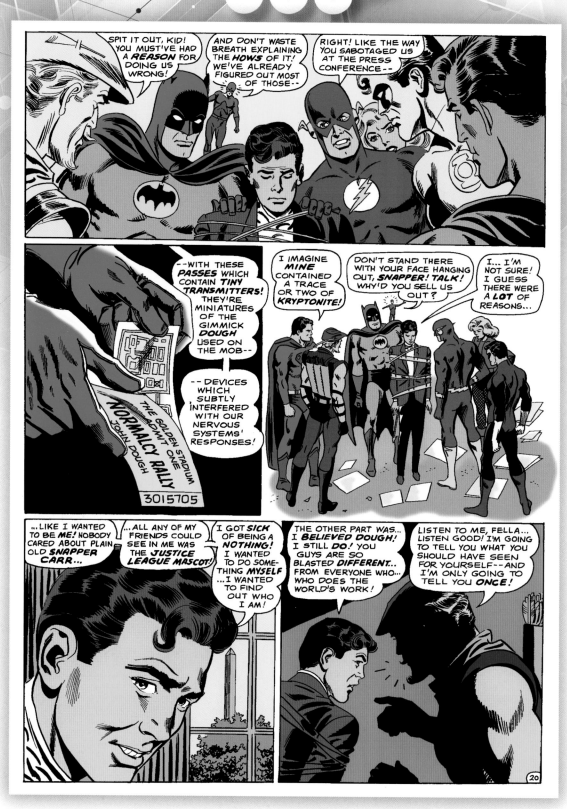

Teen mascot Snapper Carr became a young man and felt marginalized by the team, making him susceptible to John Dough's entreaties, resulting in him betraying the JLA in *Justice League of America* #77. Worse, Dough turned out to be the Joker in disguise. It compromised the Secret Sanctuary, prompting the team to relocate.

Justice League of America #77, December 1969
Writer: Denny O'Neil *Artists:* Dick Dillin & Joe Giella

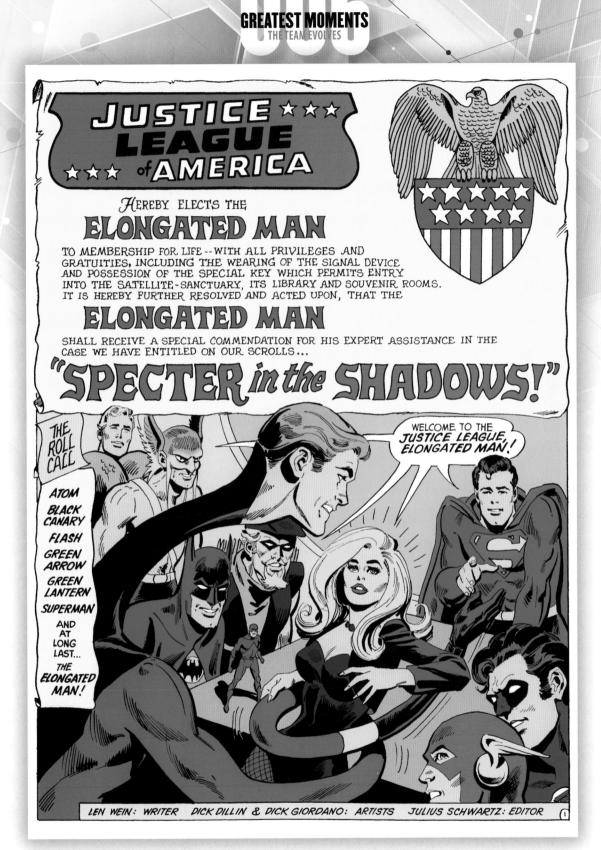

It was exactly thirty issues before another member was welcomed to the team, adding the stretchable sleuth, the Elongated Man in *Justice League of America* #105. He had repeatedly partnered with both Flash and Batman, who happily vouched for his admittance.

Justice League of America #105, April-May 1973
Writer: Len Wein *Artists:* Dick Dillin & Dick Giordano

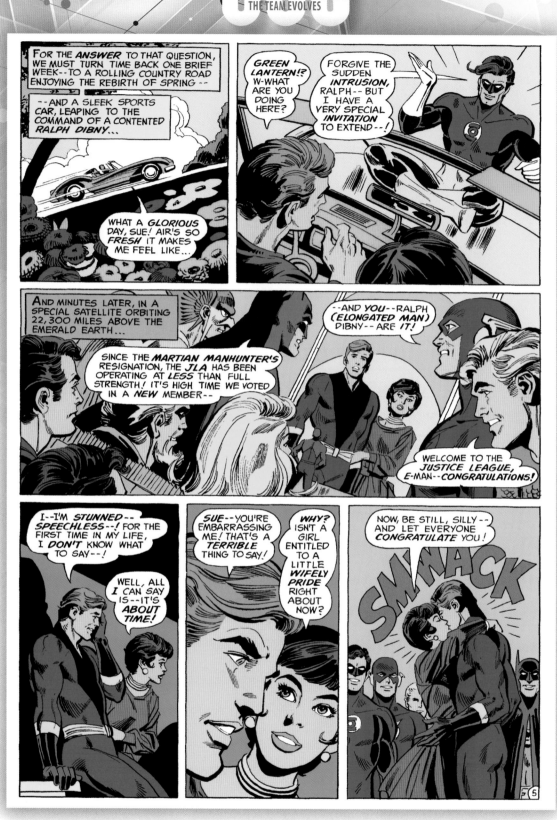

One of the most unique and charming aspects to the Elongated Man was that his wife, Sue Dibny, was a full partner to his cases so was fittingly present when he was inducted. Their romance was one of the great ones in comics, making her a beloved figure.

Justice League of America #105, April-May 1973
Writer: Len Wein *Artists:* Dick Dillin & Dick Giordano

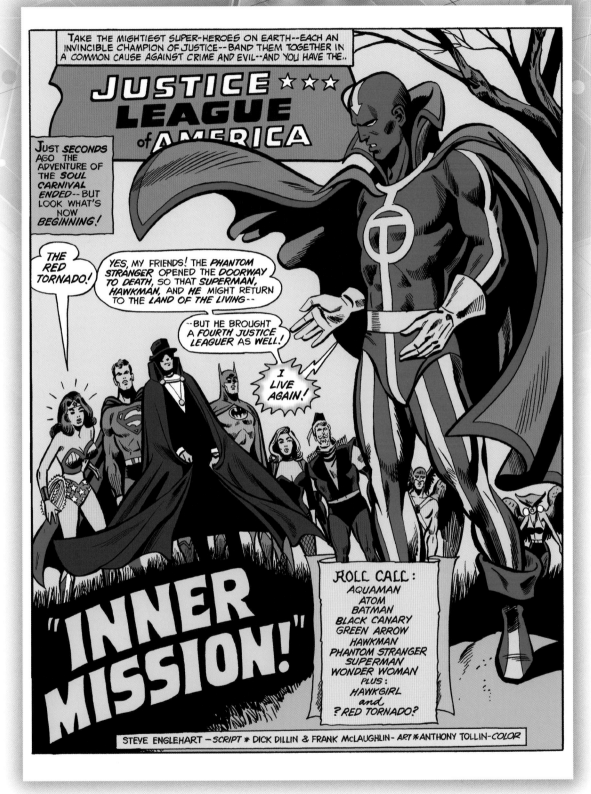

Created by T.O. Morrow to destroy the Justice League and Justice Society, the Red Tornado exceeded his programming and became a hero. He was welcomed to the team an issue after Elongated Man, adding heft to the ranks. He apparently had sacrificed himself in issue #129 before surprisingly reappearing in *Justice League of America* #146.

Justice League of America #146, September 1977
Writer: Steve Englehart *Artists:* Dick Dillin & Frank McLaughlin

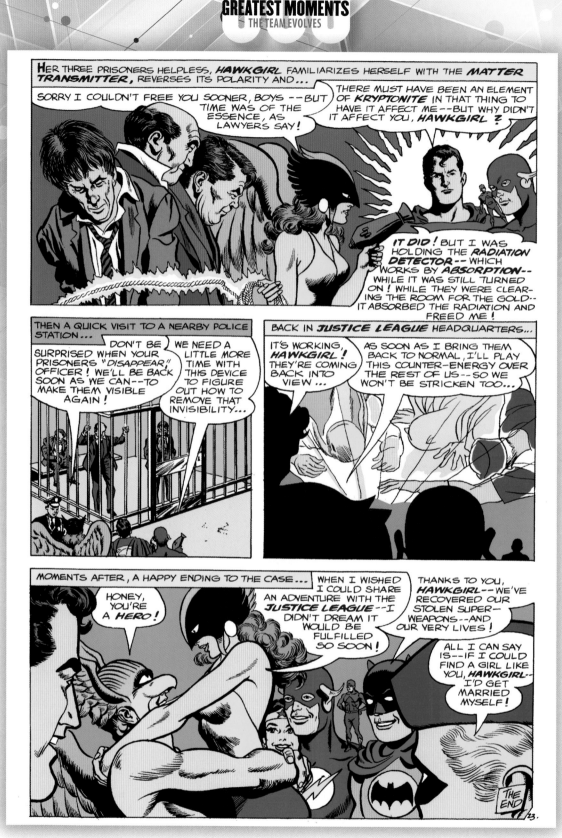

Hawkgirl was married to Hawkman and on occasion helped the JLA as seen in this moment from *Justice League of America* #53, but she wasn't allowed to join according to their bylaws, which wouldn't be adjusted until issue #146 the same issue that revived the Red Tornado.

Justice League of America #53, February 1966
Writer: Gardner Fox *Artists:* Mike Sekowsky & Sid Greene

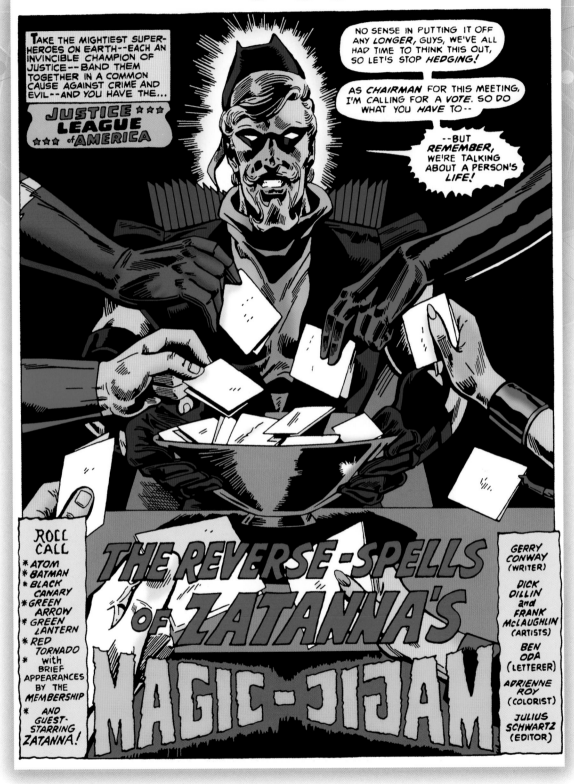

The discussion and voting for new members had become a hallmark of the series by *Justice League of America* #161 and frequent friend Zatanna, the maid of magic, was voted in unanimously. She first appeared in the title exactly 110 issues earlier as the team helped her locate her missing father, Zatara.

Justice League of America #161, December 1978
Writer: Gerry Conway *Artists:* Dick Dillin & Frank McLaughlin

The costumes may change, powers wax and wane, but whenever Earth is threatened, humanity knows they can count on the Justice League to be on hand. That was never truer than a return of the Appellaxians in the mammoth *Justice League of America* #200, a celebratory tale by Gerry Conway that managed to work in the past and present members.

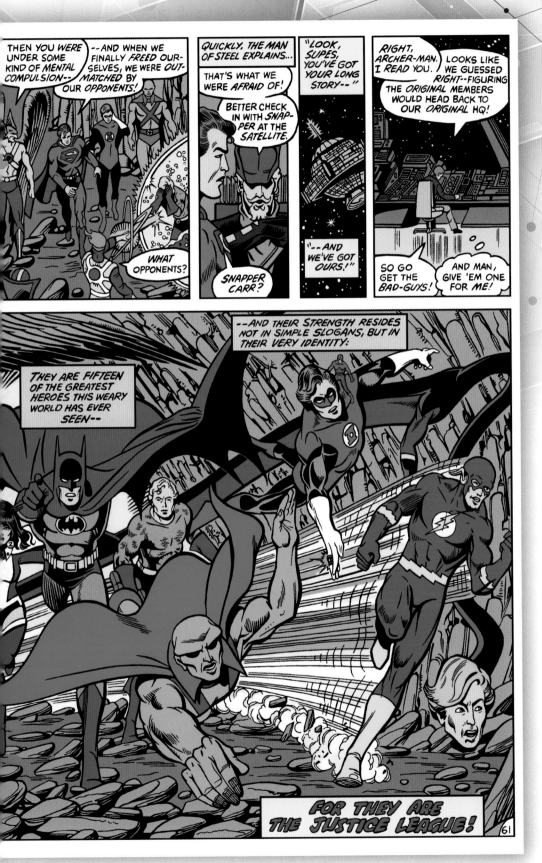

As you can see, by this point, Firestorm the Nuclear Man had also joined the roster while Wonder Woman had long regained her powers and the Martian Manhunter returned from helping rebuild society on Mars II to help his comrades. Never had the team been stronger or more cohesive.

Justice League of America #200,
March 1982
Writer: Gerry Conway
Artists: George Pérez & Brett Breeding

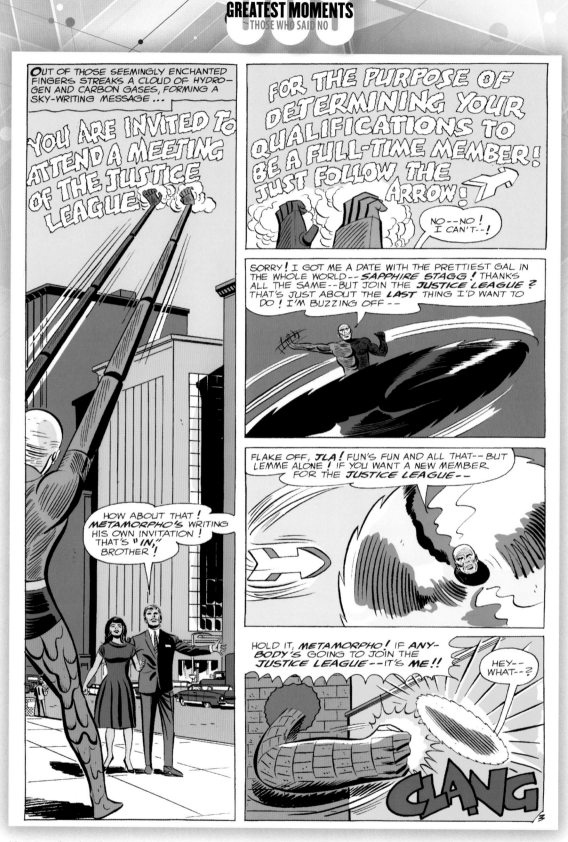

Metamorpho the Element Man was your atypical hero, especially since Rex Mason hated his newfound form and powers. Imagine the JLA's surprise when he was the first to spurn their invitation to join the team in *Justice League of America* #42. He would eventually come around and join but that was many decades away.

Justice League of America #42, February 1966
Writer: Gardner Fox *Artists:* Mike Sekowsky & Sid Greene

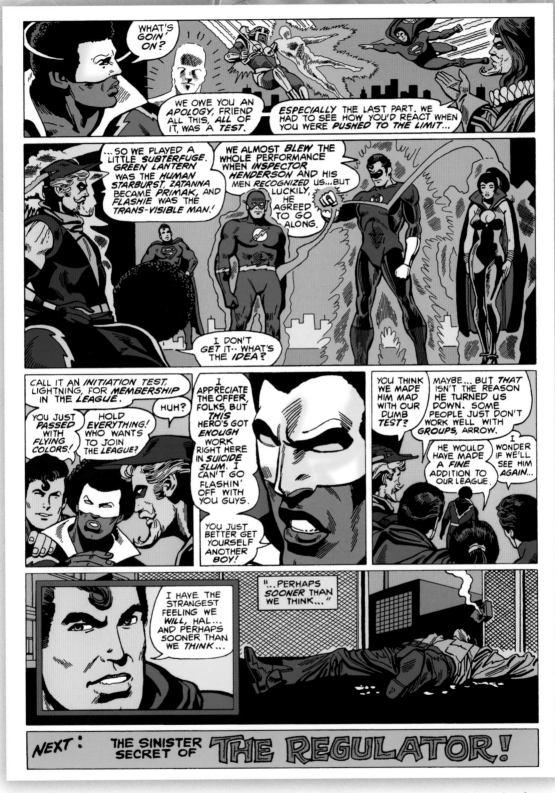

There were many who tried to join, from Mind-Grabber Kid to the Crusader, only to be turned down, but few rebuffed offers to join. The second to outright refuse was Black Lightning as seen in this moment from *Justice League of America* #174.

Justice League of America #174, January 1980
Writer: Gerry Conway *Artists:* Dick Dillin & Frank McLaughlin

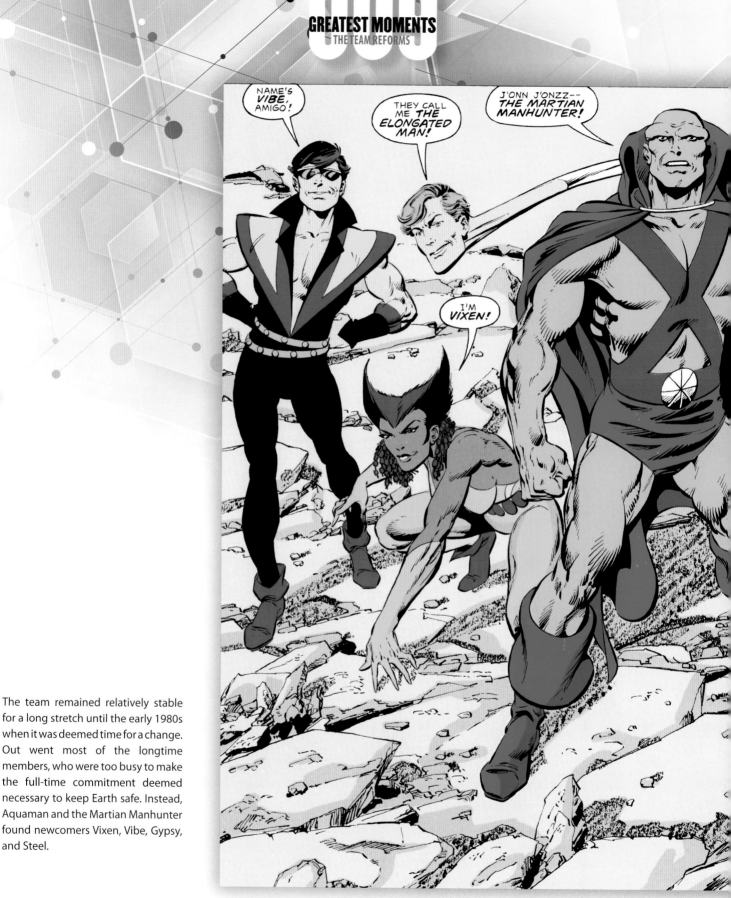

The team remained relatively stable for a long stretch until the early 1980s when it was deemed time for a change. Out went most of the longtime members, who were too busy to make the full-time commitment deemed necessary to keep Earth safe. Instead, Aquaman and the Martian Manhunter found newcomers Vixen, Vibe, Gypsy, and Steel.

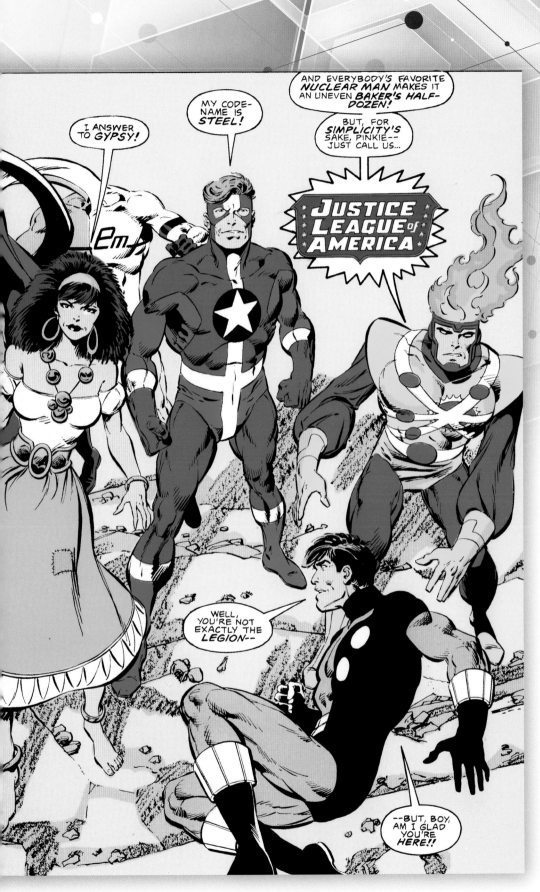

The team relocated to a bunker in Detroit and were joined by Elongated Man and others from time to time. They made their last stand in this incarnation just when Darkseid and the Phantom Stranger put humanity's faith in heroes to the test as seen in this moment in *Legends*.

Legends #1, November 1986
Writers: John Ostrander & Len Wein
Artists: John Byrne & Karl Kesel

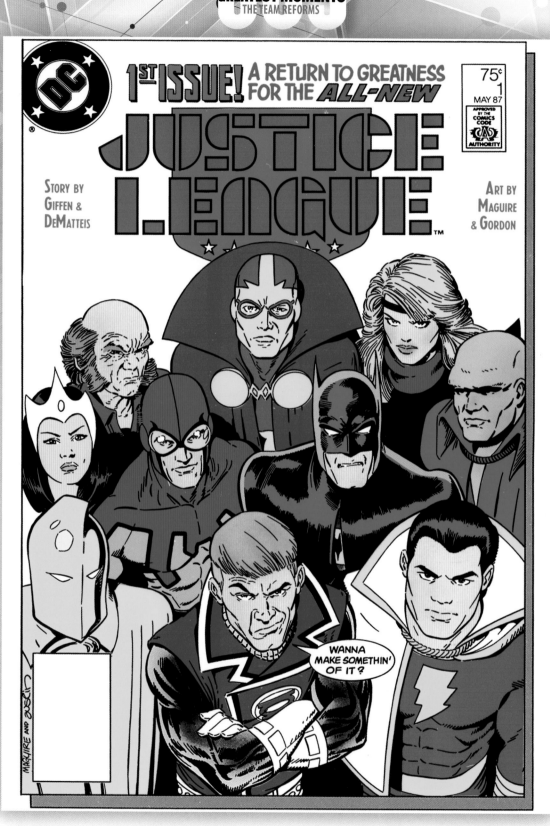

1ST ISSUE! A RETURN TO GREATNESS FOR THE ALL-NEW

JUSTICE LEAGUE™

STORY BY GIFFEN & DeMATTEIS

ART BY MAGUIRE & GORDON

75¢ 1 MAY 87

WANNA MAKE SOMETHIN' OF IT?

In the aftermath of the JLA's deconstruction, a new team arose from the ashes in a book with a new title, new creative team, and new attitude. Under writers Keith Giffen and J.M. DeMatteis, and penciller Kevin Maguire, fresh life was breathed into the grim and gritty heroes.

Justice League #1, May 1987
Artists: Kevin Maguire & Terry Austin

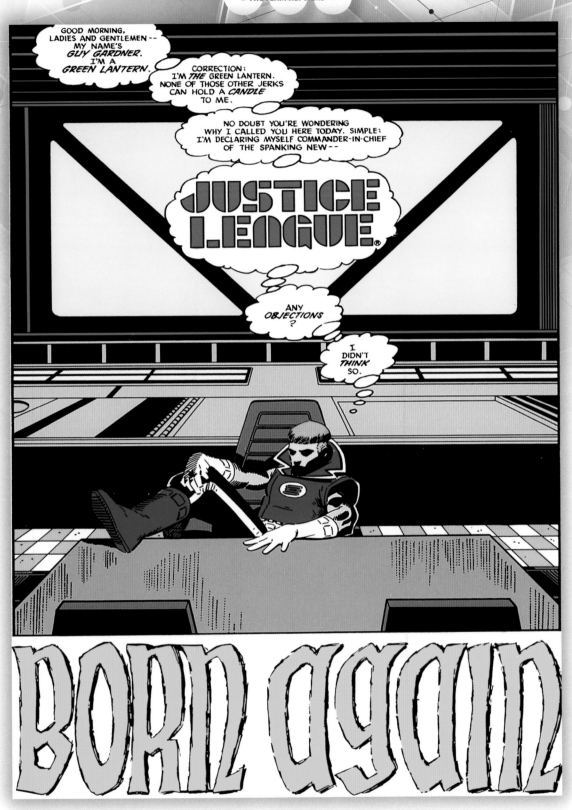

The arrogant Guy Gardner felt he was meant to run the new team and chafed under the presence of The Batman. They bickered, but in time, Guy became the heart of the team, his energy fueling them through tough times.

Justice League #1, May 1987

Writers: Keith Giffen & J.M. DeMatteis *Artists:* Kevin Maguire & Al Gordon

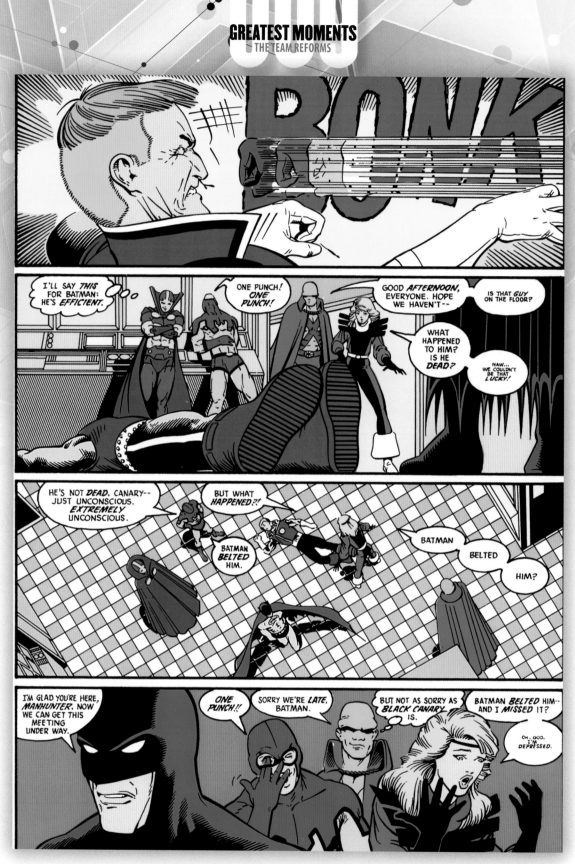

This may be the single best remembered moment of the Giffen/DeMatteis/Maguire era and "one punch" became a shorthand for comic book creators and readers ever since. Guy Gardner egged on Batman one time too many and in *Justice League* #5 the Dark Knight settled the bickering once and for all. Black Canary's reaction said it all.

Justice League #5, September 1987
Writers: Keith Giffen & J.M. DeMatteis *Artists:* Kevin Maguire & Al Gordon

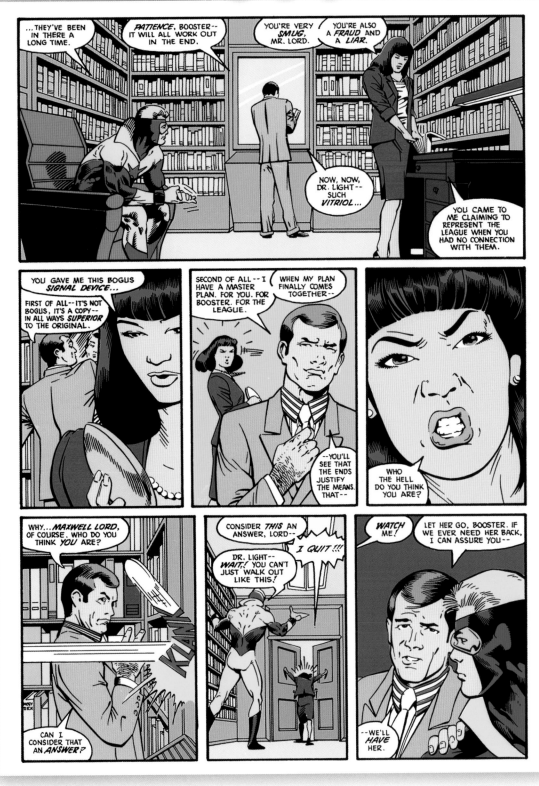

It wasn't all jokes as tensions among the team rose under the manipulations of their current sponsor Maxwell Lord. Here, in this moment from *Justice League* #4, the heroic Doctor Light and Booster Gold try and figure things out.

Justice League #4, August 1987
Writers: Keith Giffen & J.M. DeMatteis *Artists:* Kevin Maguire & Al Gordon

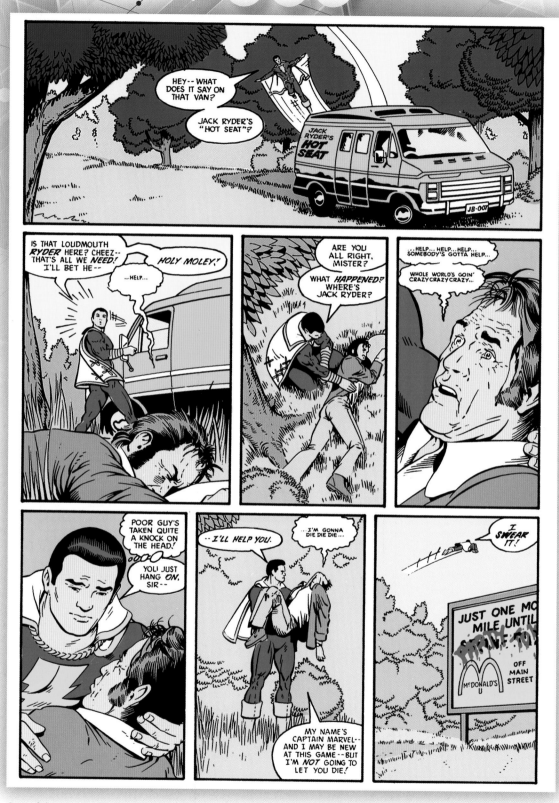

One of the more refreshing aspects of the new team's early days was the sunny disposition of Captain Marvel, who proved too innocent and trusting to truly fit in the team and left after a short stint.

Justice League #4, August 1987
Writers: Keith Giffen & J.M. DeMatteis *Artists:* Kevin Maguire & Al Gordon

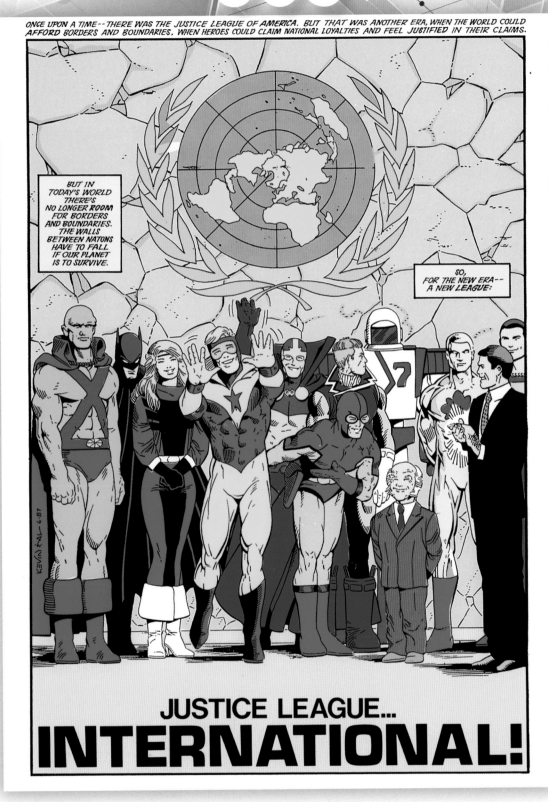

ONCE UPON A TIME—THERE WAS THE JUSTICE LEAGUE OF AMERICA. BUT THAT WAS ANOTHER ERA, WHEN THE WORLD COULD AFFORD BORDERS AND BOUNDARIES, WHEN HEROES COULD CLAIM NATIONAL LOYALTIES AND FEEL JUSTIFIED IN THEIR CLAIMS.

BUT IN TODAY'S WORLD THERE'S NO LONGER ROOM FOR BORDERS AND BOUNDARIES. THE WALLS BETWEEN NATIONS HAVE TO FALL IF OUR PLANET IS TO SURVIVE.

SO, FOR THE NEW ERA— A NEW LEAGUE:

JUSTICE LEAGUE...
INTERNATIONAL!

Maxwell Lord propped up the team and positioned them to win United Nations sanctioning, making them a global force. To reflect that, in *Justice League International* #7 one of Russia's Rocket Reds was added to the team and the military's Captain Atom was added as a counterbalance. Also joining by that time was Mister Miracle, hailing from the interdimensional New Genesis.

Justice League International #7, November 1987
Writers: Keith Giffen & J.M. DeMatteis
Artists: Kevin Maguire & Al Gordon

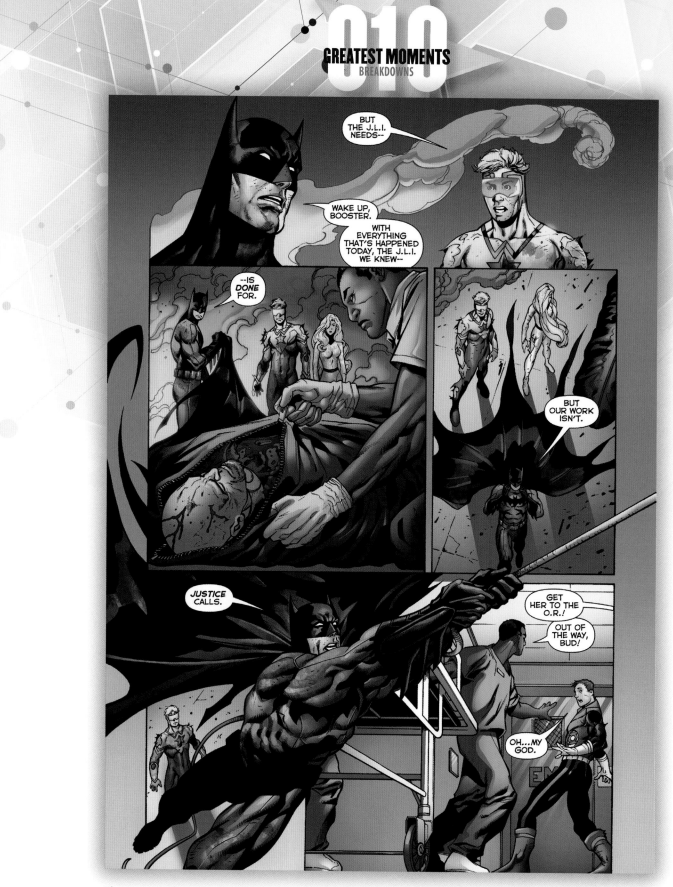

The concept of a Justice League would continue to endure as the world changed and as the heroes populating Earth changed. At one point, Booster Gold formed a new incarnation of the team, hoping to recapture the glory days, but as Batman notes in *Justice League International* #7 forces were beyond his control.

Justice League International #7, August 2012
Writer: Dan Jurgens *Artists:* Aaron Lopresti & Matt Ryan

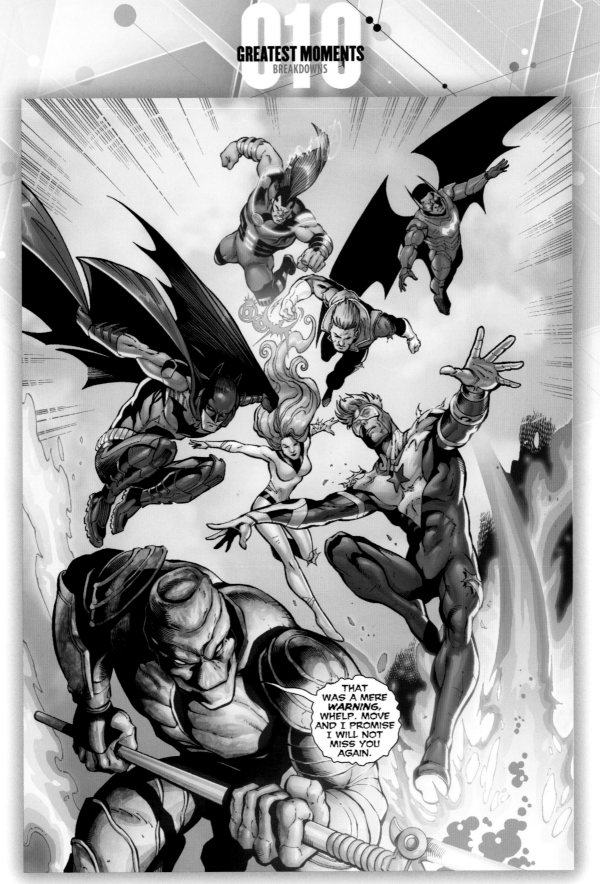

Of course, being the Justice League, they don't go down without a fight as seen in this moment from *The Fury of the Firestorm: The Nuclear Man* #9 as a new incarnation of Rocket Red, Booster Gold, Batman, Godiva, Guy Gardner, Batwing, and OMAC prove.

The Fury of Firestorm: The Nuclear Man #9, August 2012
Writers: Ethan Van Sciver & Joe Harris
Artists: Yildiray Cinar, Mario Alquiza, & Norm Rapmund

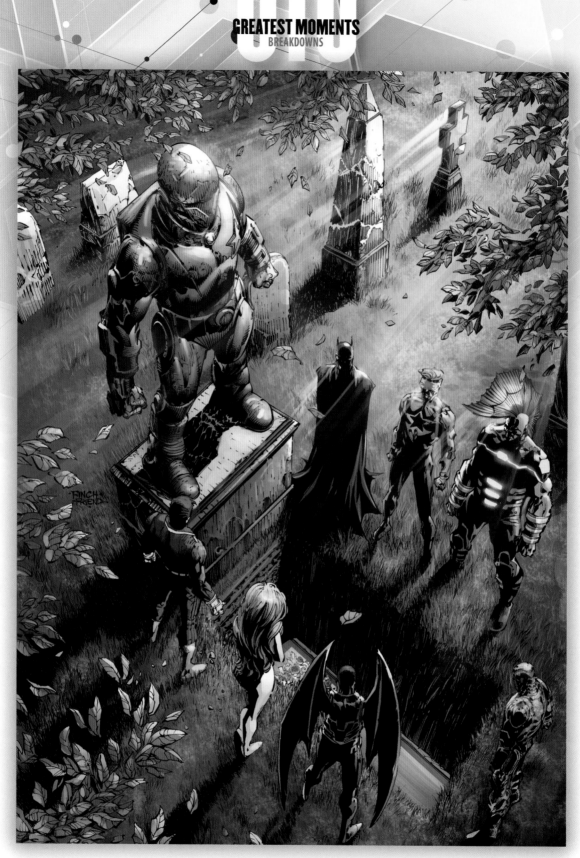

Self-sacrifice is nothing new to the team as many members have laid down their lives in the name of Good. Rocket Red made the ultimate sacrifice at the end of the Breakdown storyline in *Justice League International* #12.

Justice League International #12, October 2012
Artists: David Finch & Richard Friend

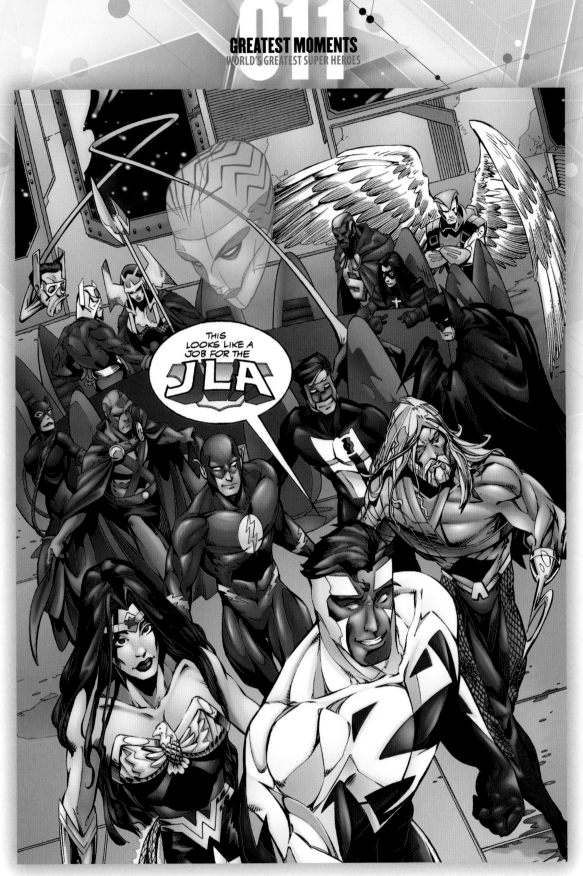

Under writer Grant Morrison, the JLA was comprised of analogues to the gods and goddesses of mythology. In some cases, they were literal gods with Orion and Big Barda on hand from New Genesis and Zauriel from the Host of Heaven. This powerful configuration, as seen in *JLA* #17, didn't last long but was just what Earth needed when Mageddon came calling.

JLA #17, April 1998
Writer: Grant Morrison *Artists:* Arnie Jorgensen,
David Meikis, & Mark Pennington

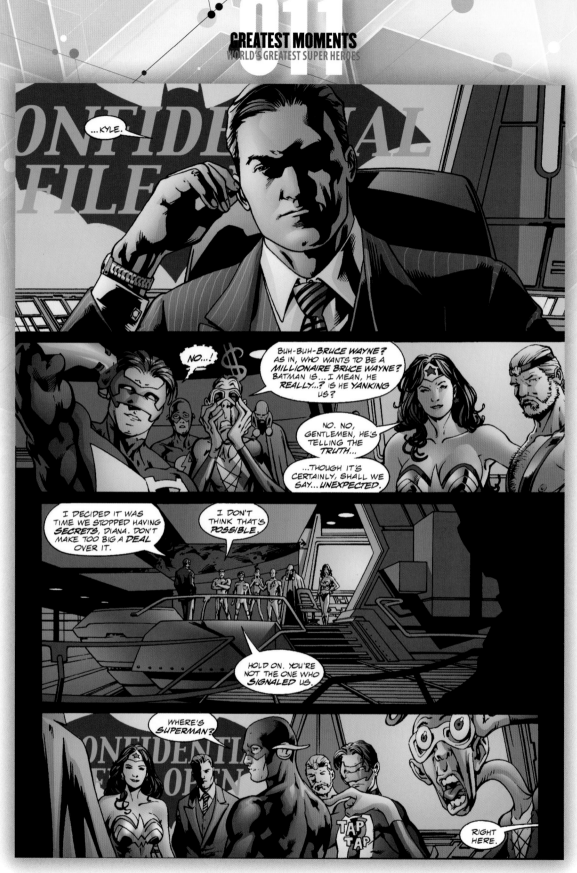

Another threat from Doctor Destiny in *JLA* #50 reminds the heroes they remain stronger together than apart and out of the ashes arose a new Justice League, this one featuring the World's Greatest Super Heroes. The freshly assembled team recognized they needed to trust one another and that meant sharing their secrets.

JLA #50, February 2001
Writer: Mark Waid *Artists:* Bryan Hitch & Paul Neary

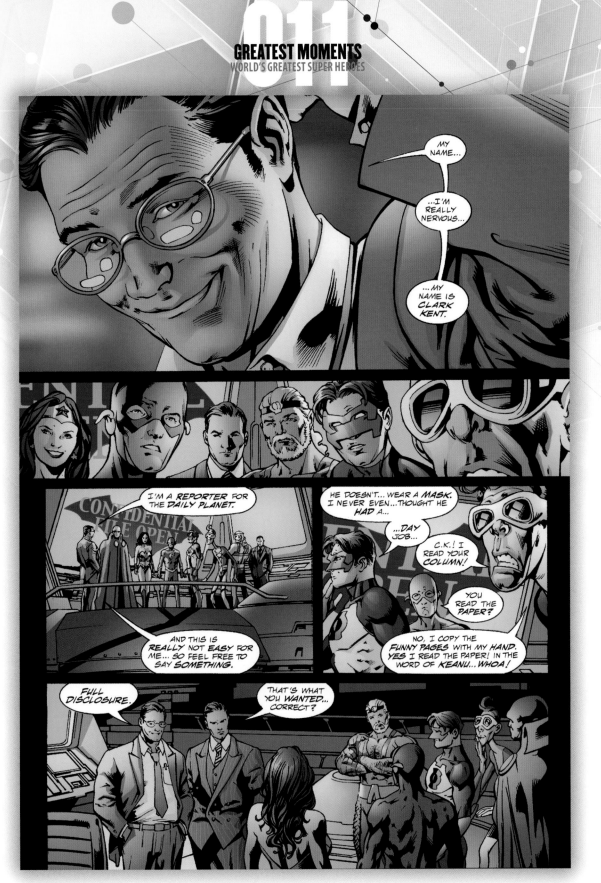

It used to be, protecting secret identities triumphed over friendship but in modern times, it made more sense that the members grew to know one another in and out of costume. As seen here in *JLA* #50, the level of trust had to be complete.

JLA #50, February 2001
Writer: Mark Waid *Artists:* Bryan Hitch & Paul Neary

Batman was perhaps the most prepared hero to ever walk the Earth. He had maintained computerized contingency plans and once, when the Justice League was trapped in the past, one such plan was activated in *JLA* #69, summoning a new team, under Nightwing's command. In issue #71, he reflects on the gravity of the situation.

JLA #71, February 2001
Writer: Joe Kelly *Artists:* Doug Mahnke & Mark Propst

While some, like Firestorm, Green Arrow, and the Atom had served in the past, to others like Major Disaster, Faith, and Jason Blood, it was a singular distinction. Its impact, as seen here in *JLA* #71, was not lost on them.

JLA #71, February 2001
Writer: Joe Kelly *Artists:* Doug Mahnke & Mark Propst

It was clear in short order that Batman left the Justice League legacy in capable hands as his first partner led the new team, balancing raw power with stealth, skill, and a hefty dose of magic, ready to take on all comers as seen in this moment from *JLA* #69.

JLA #69, November 2000
Writer: Joe Kelly *Artists:* Yvel Guichet & Mark Propst

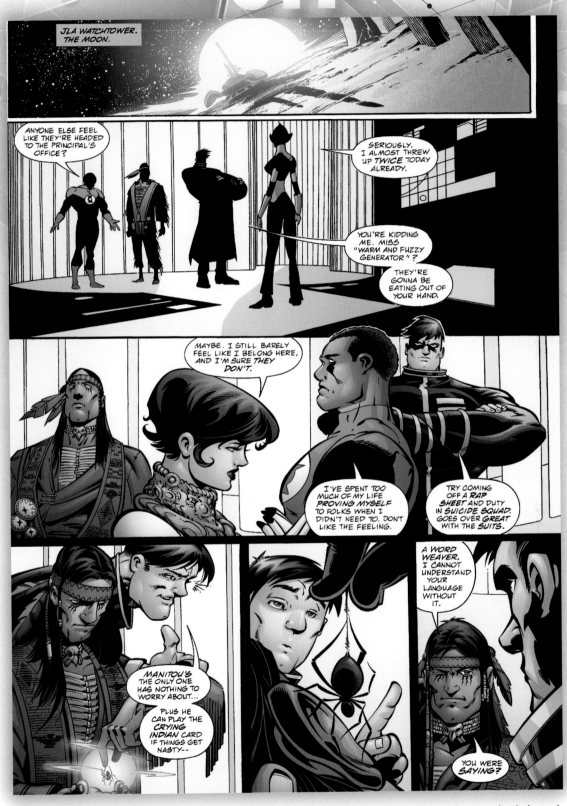

JLA WATCHTOWER. THE MOON.

ANYONE ELSE FEEL LIKE THEY'RE HEADED TO THE PRINCIPAL'S OFFICE?

SERIOUSLY. I ALMOST THREW UP *TWICE* TODAY ALREADY.

YOU'RE KIDDING ME. MISS "WARM AND FUZZY GENERATOR"?

THEY'RE GONNA BE EATING OUT OF YOUR HAND.

MAYBE. I STILL BARELY FEEL LIKE I BELONG HERE, AND I'M SURE *THEY* DON'T.

I'VE SPENT TOO MUCH OF MY LIFE *PROVING MYSELF* TO FOLKS WHEN I DIDN'T NEED TO. DON'T LIKE THE FEELING.

TRY COMING OFF A *RAP SHEET* AND DUTY IN *SUICIDE SQUAD*. GOES OVER *GREAT* WITH THE *SUITS*.

MANITOU'S THE ONLY ONE HAS NOTHING TO WORRY ABOUT...

PLUS HE CAN PLAY THE *CRYING INDIAN CARD* IF THINGS GET NASTY--

A WORD WEAVER. I CANNOT UNDERSTAND YOUR LANGUAGE WITHOUT IT.

YOU WERE *SAYING*?

While trapped in the past, the team met other powerful people, including Manitou Raven, who came back through time to work with the team for a period of time.

JLA #69, November 2000
Writer: Joe Kelly *Artists:* Yvel Guichet & Mark Propst

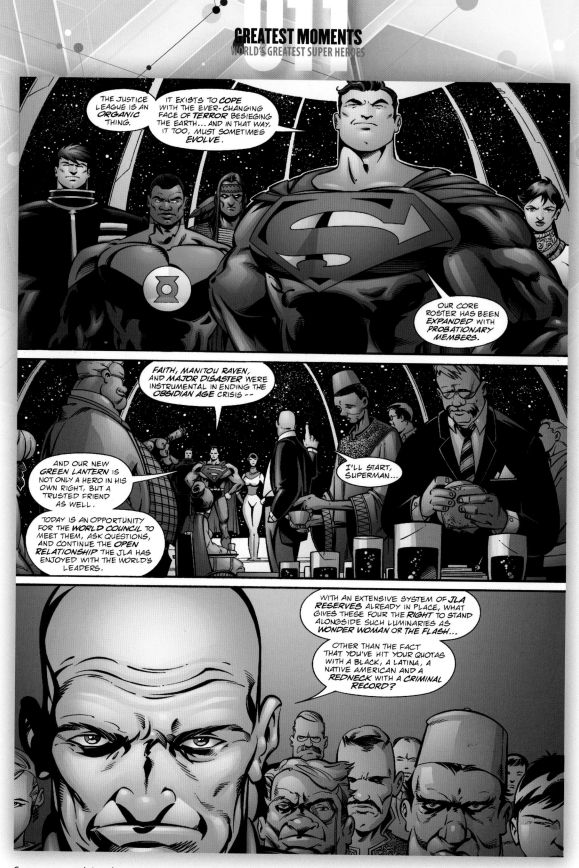

THE JUSTICE LEAGUE IS AN *ORGANIC* THING.

IT EXISTS TO *COPE* WITH THE EVER-CHANGING FACE OF *TERROR* BESIEGING THE EARTH... AND IN THAT WAY, IT TOO, MUST SOMETIMES *EVOLVE.*

OUR CORE ROSTER HAS BEEN *EXPANDED* WITH *PROBATIONARY* MEMBERS.

FAITH, MANITOU RAVEN, AND *MAJOR DISASTER* WERE INSTRUMENTAL IN ENDING THE *OBSIDIAN AGE* CRISIS --

AND OUR NEW *GREEN LANTERN* IS NOT ONLY A HERO IN HIS OWN RIGHT, BUT A TRUSTED FRIEND AS WELL.

TODAY IS AN OPPORTUNITY FOR THE *WORLD COUNCIL* TO MEET THEM, ASK QUESTIONS, AND CONTINUE THE *OPEN RELATIONSHIP* THE JLA HAS ENJOYED WITH THE WORLD'S LEADERS.

I'LL START, SUPERMAN...

WITH AN EXTENSIVE SYSTEM OF *JLA RESERVES* ALREADY IN PLACE, WHAT GIVES THESE FOUR THE *RIGHT* TO STAND ALONGSIDE SUCH LUMINARIES AS *WONDER WOMAN* OR *THE FLASH*...

OTHER THAN THE FACT THAT YOU'VE HIT YOUR QUOTAS WITH A BLACK, A LATINA, A NATIVE AMERICAN AND A *REDNECK* WITH A *CRIMINAL RECORD?*

Superman explains the team's purpose in this moment from *JLA* #80. By this time, Major Disaster, Faith, and Manitou Raven had proven their worth but a waiting world was more than skeptical.

JLA #80, February 2001
Writer: Joe Kelly *Artists:* Duncan Rouleau & Aaron Sowd

Novelist Brad Meltzer helped usher in a brand new incarnation of the team as they returned to their Justice League of America name. Superman, Batman, and Wonder Woman handpicked the new lineup, adding former Teen Titan Arsenal, now Red Arrow, Hawkgirl, Black Lightning (who finally accepted), and other familiar heroes.

Justice League of America #12, October 2007
Writer: Brad Meltzer *Artists:* Ed Benes & Sandra Hope

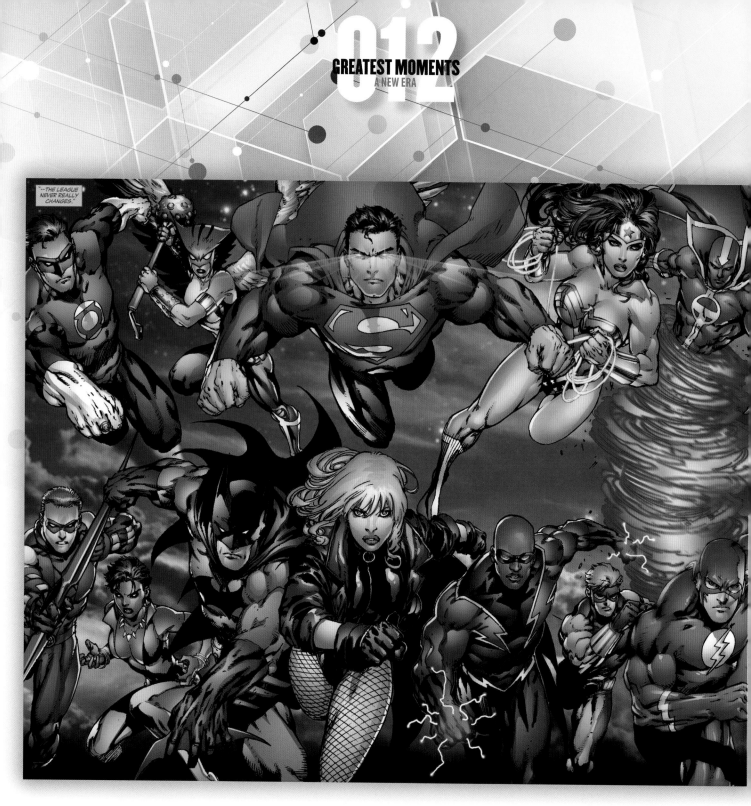

"--THE LEAGUE NEVER REALLY CHANGES."

They asked Black Canary to lead the new incarnation and she took charge of this powerful roster that included newcomers Vixen and Geo-Force.

Justice League of America #12, November 2006
Writer: Brad Meltzer *Artists:* Ed Benes & Sandra Hope

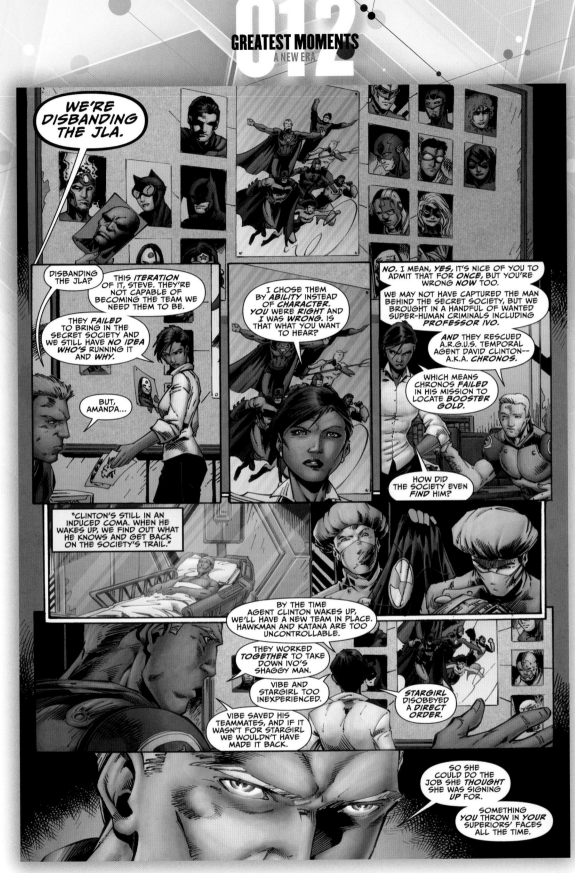

Steve Trevor has seen a lot, given his relationship with Wonder Woman, so in *Justice League of America* #4 he felt perfectly justified to ask Amanda Waller to explain her goals and rationale.

Justice League of America #4, July 2013
Writer: Geoff Johns *Artist:* Brett Booth

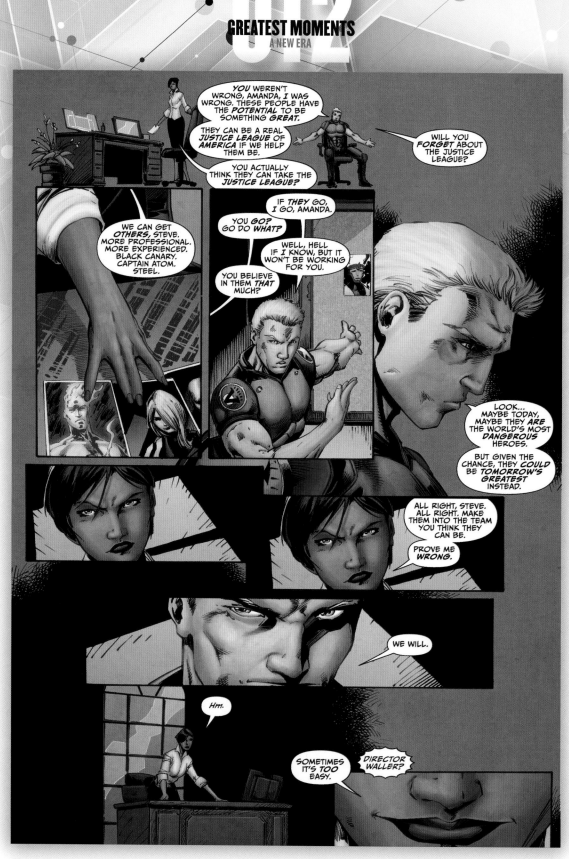

Change occurred with the New 52 and a new reality that saw a svelte Amanda Waller lead a plan to remake the JLA into the US government's image as seen in *Justice League of America* #4. She recruited Col. Steve Trevor, working with the A.R.G.U.S. operation to become the field leader of a team intended to do their work.

Justice League of America #4, July 2013
Writer: Geoff Johns *Artist:* Brett Booth

Novelist Brad Meltzer concluded his run in *Justice League of America* #12, a story that fondly looked back to simpler, sometimes happier days, while sowing seeds for his successors. The whole issue was a treat of action, memories, and even surprising romance.

Justice League of America #12, October 2007
Writer: Brad Meltzer *Artists:* Eric Wright & Sandra Hope

Regardless of the lineup, it was pretty clear that Superman, Batman, and Wonder Woman formed the trinity that guided the team and gave it a purpose. However, there came times when they disappointed one another as seen in this moment from *Justice League of America* #0.

Justice League of America #0, September 2006
Writer: Brad Meltzer *Artist:* Adam Kubert

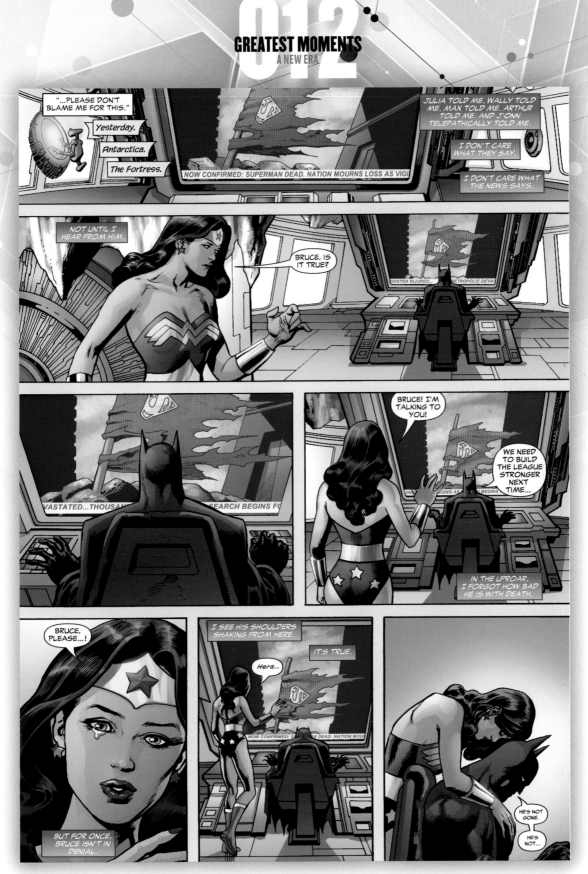

Superman's death took the world's breath away but its impact on Batman and Wonder Woman may have been even greater as seen in this moment from *Justice League of America* #0.

Justice League of America #0, September 2006
Writer: Brad Meltzer *Artist:* Kevin Nowlan

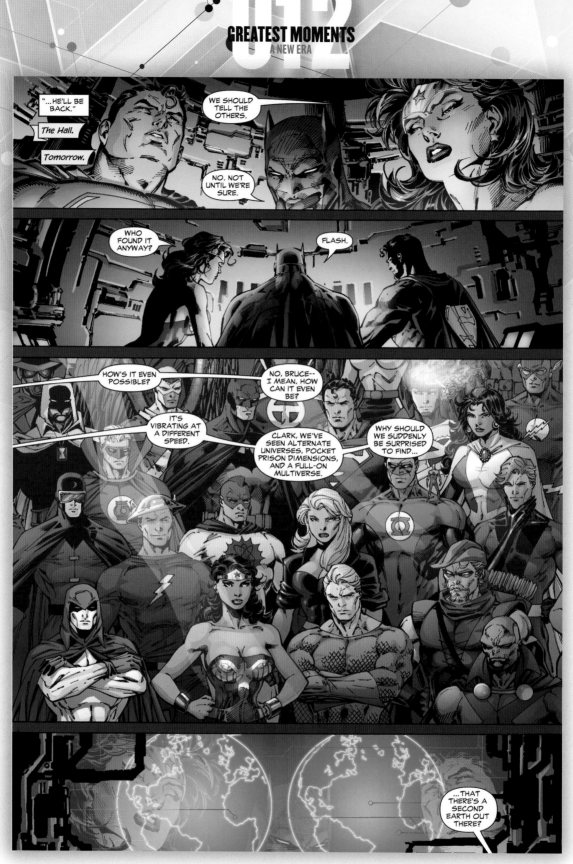

Foreshadowing the events that informed the DC Comics' New 52 and Rebirth eras, *Justice League of America* #0 had the trinity explore a parallel world that readers would recognize as the post-Crisis Earth, blending heroes from multiple eras.

Justice League of America #0, September 2006
Writer: Brad Meltzer *Artists:* Jim Lee

Under James Robinson, a far more diverse membership fueled a new direction for stories. As seen in *Justice League of America* #53, an alien Starman, Supergirl, Jade, Congorilla, Jesse Quick, Donna Troy, and the steady influence of Batman made for some of the more dramatic stories of the 1990s.

Justice League of America #53, March 2011
Writer: Gerard Jones *Artists:* Mark Bagley, Norm Rapmund, & Don Ho

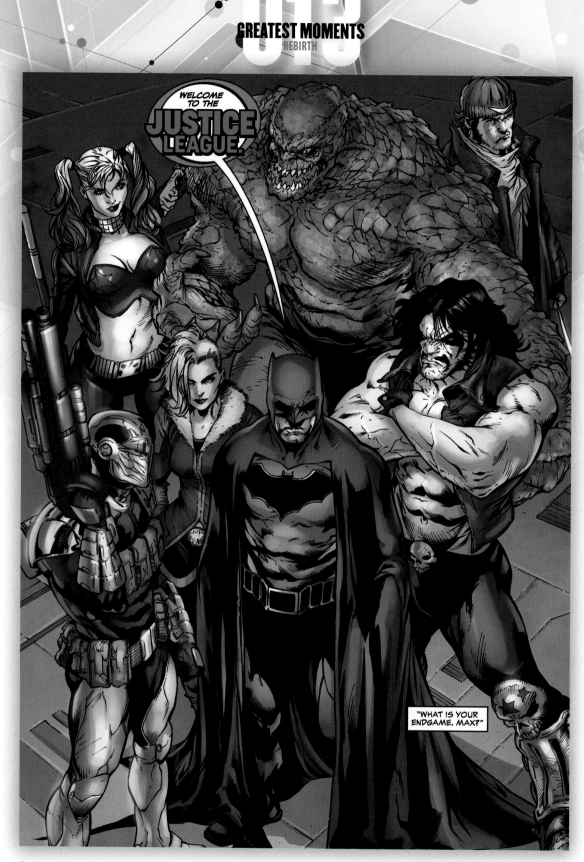

Desperate times call for desperate measures and when a greater threat than the Suicide Squad reared its ugly head, Batman did what needed to be done and welcomed his archnemesis Deadshot, the unpredictable Harley Quinn, the deadly Killer Frost, dangerous Killer Croc, immoral Captain Boomerang, and all-around bastich Lobo to the Justice League. It didn't last.

Justice League vs. Suicide Squad #5, March 2017
Writer: Joshua Williamson *Artists:* Robson Rocha, Jay Leisten,
Daniel Henriques, Sandu Florea, & Oclair Albert

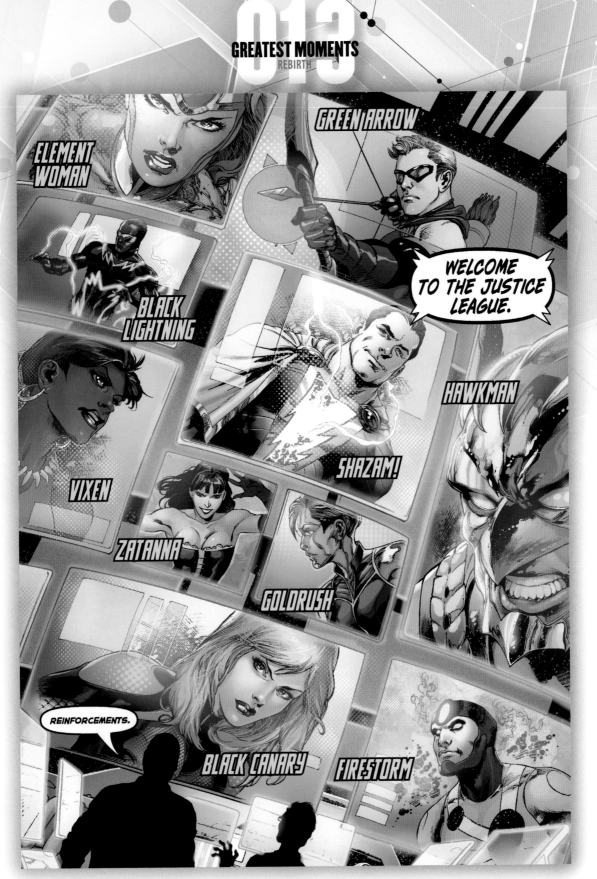

When circumstances found Atlantis goaded into declaring war against the surface world, the Justice League was stretched so thin that Cyborg took it upon himself to summon assistance as seen in this moment from *Justice League* #16.

Justice League #16, March 2013

Writer: Geoff Johns *Artists:* Ivan Reis & Joe Prado

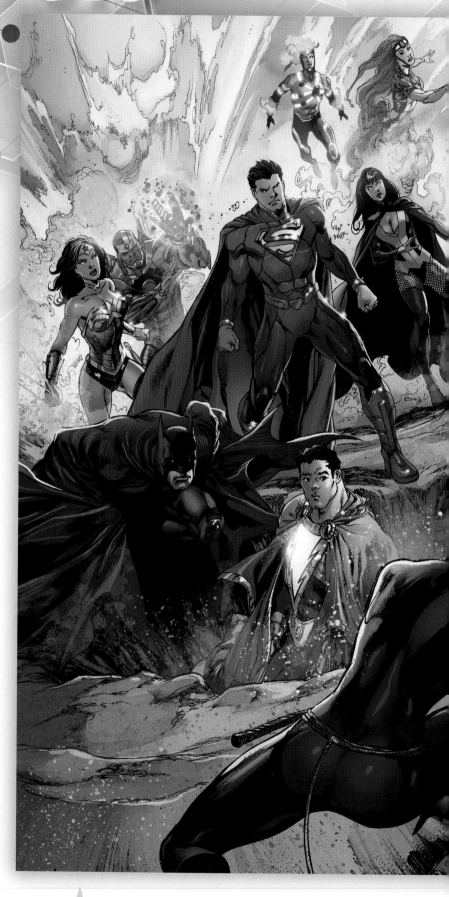

Justice League #22 was the opening chapter in the Trinity War, which pitted members of Amanda Waller's government-sponsored Justice League against the real Justice League against the supernatural group dubbed Justice League Dark in an 11-part tale orchestrated by Geoff Johns.

Justice League #22, September 2013
Writer: Geoff Johns *Artists:* Ivan Reis & Joe Prado

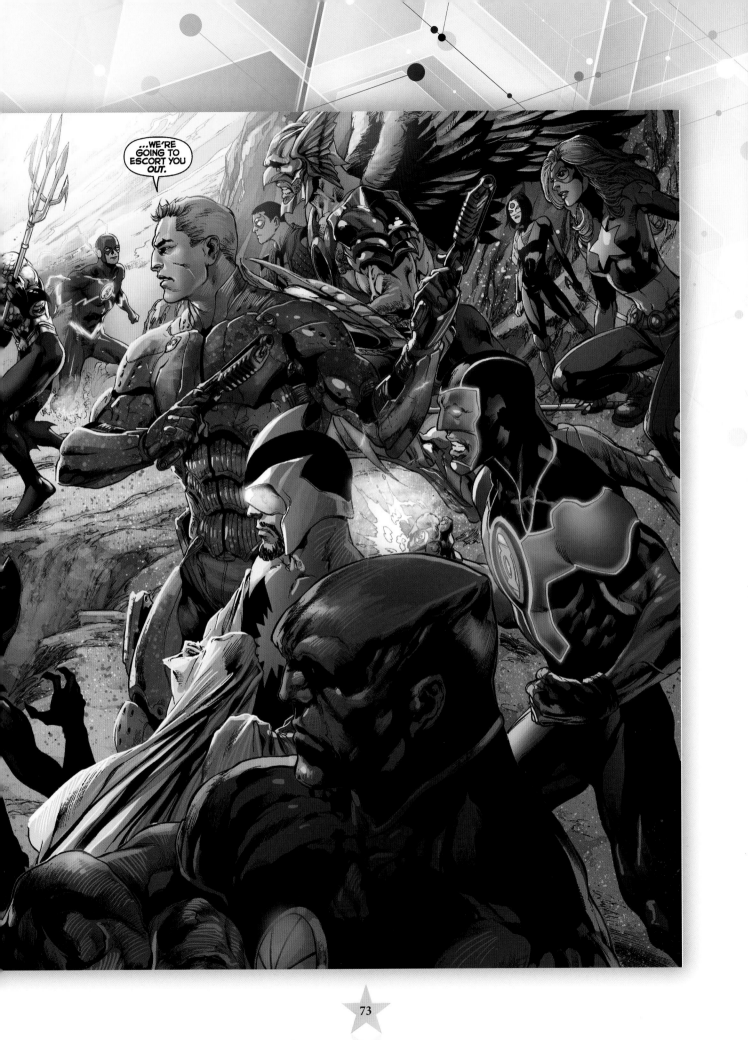

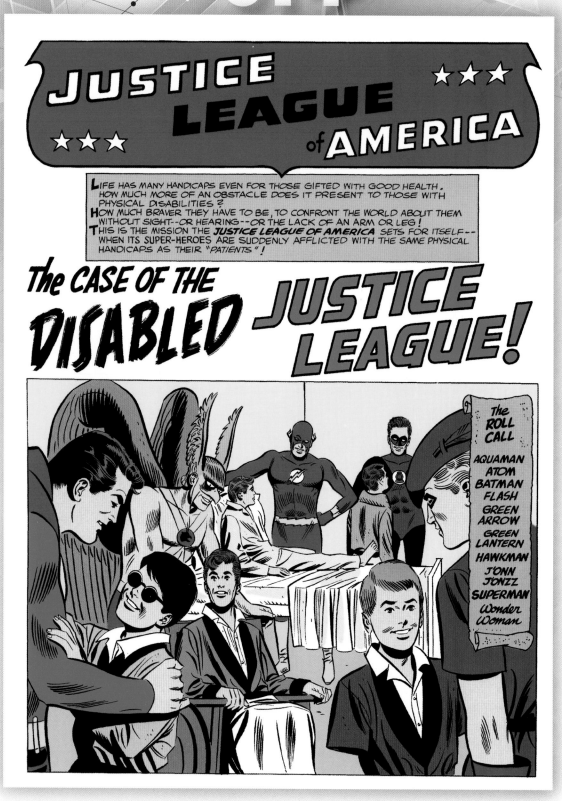

JUSTICE LEAGUE of AMERICA

★★★ ★★★

Life has many handicaps even for those gifted with good health. How much more of an obstacle does it present to those with physical disabilities?
How much braver they have to be, to confront the world about them without sight--or hearing--or the lack of an arm or leg!
This is the mission the *JUSTICE LEAGUE OF AMERICA* sets for itself-- when its super-heroes are suddenly afflicted with the same physical handicaps as their "*PATIENTS*"!

The CASE OF THE DISABLED JUSTICE LEAGUE!

The ROLL CALL

AQUAMAN
ATOM
BATMAN
FLASH
GREEN ARROW
GREEN LANTERN
HAWKMAN
J'ONN JONZZ
SUPERMAN
Wonder Woman

Writer Gardner Fox always had a soft spot for humanizing his heroes and took advantage of presenting these heart-warming moments as seen here in *Justice League of America* #36. The children with handicaps proved inspirational as the story progressed.

Justice League of America #36, June 1965
Writer: Gardner Fox *Artists:* Mike Sekowsky & Bernard Sachs

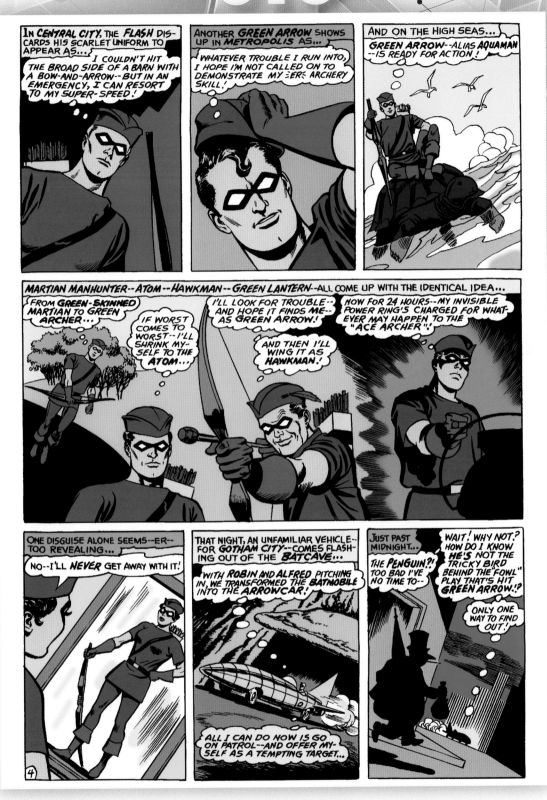

When a member was in trouble, the rest of the team rallied to lend their support. In one memorable case from *Justice League of America* #61, Green Arrow was the one in trouble so each member of the team donned his costume. As you can see in the final panel, trouble arrived in many shapes.

Justice League of America #61, March 1968
Writer: Gardner Fox *Artists:* Mike Sekowsky & Sid Greene

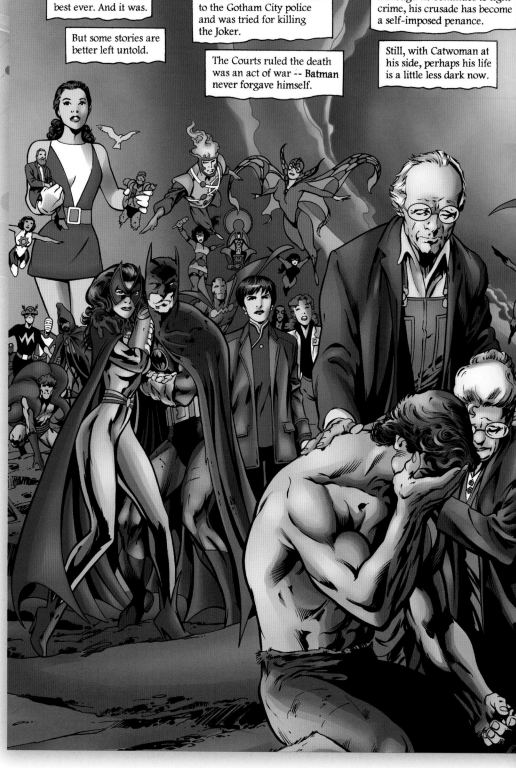

Jimmy had promised me an exclusive. The best ever. And it was.

But some stories are better left untold.

Batman surrendered himself to the Gotham City police and was tried for killing the Joker.

The Courts ruled the death was an act of war -- **Batman** never forgave himself.

He resigned from the JLA and although he continues to fight crime, his crusade has become a self-imposed penance.

Still, with Catwoman at his side, perhaps his life is a little less dark now.

In *JLA: The Nail*, writer/penciller Alan Davis told a story of a world where a nail flattened Jonathan and Martha Kent's truck, preventing them from rescuing baby Kal-El when his rocket landed from Krypton. A world of heroes and villains arose despite the absence of a Superman. There came a JLA, but one that lacked a certain spark, so tragedy occurred. In the end, the world needed a Man of Steel

The Kents, with their big hearts and easy acceptance of the bizarre, made an immediate connection with Kal El.

They helped him come to terms with what had happened, what he was and what he could become.

They insisted on maintaining their anonymity so the world has never discovered what it owes the Kents...

...Though dozens of meta-humans continue to secretly honor them, and Lana Lang, as their saviors.

Jimmy had been the JLA's most powerful opponent, and they had all been changed by the encounter...

... But there was a greater battle still -- to win back the public's trust.

New villains, new crises, gave the League ample opportunity to prove themselves...

... And, in time, they resumed their position of trust and respect.

Thanks in part to their newest member...

and the heroes banded together to be on hand for that moment. As you can see, not only were the familiar super heroes on hand, but so were the mystics of the day including the Spectre and Deadman. Even the extra-dimensional Shade the Changing Man was present.

JLA: The Nail #3, November 1998
Writer/Penciller: Alan Davis
Inker: Paul Neary

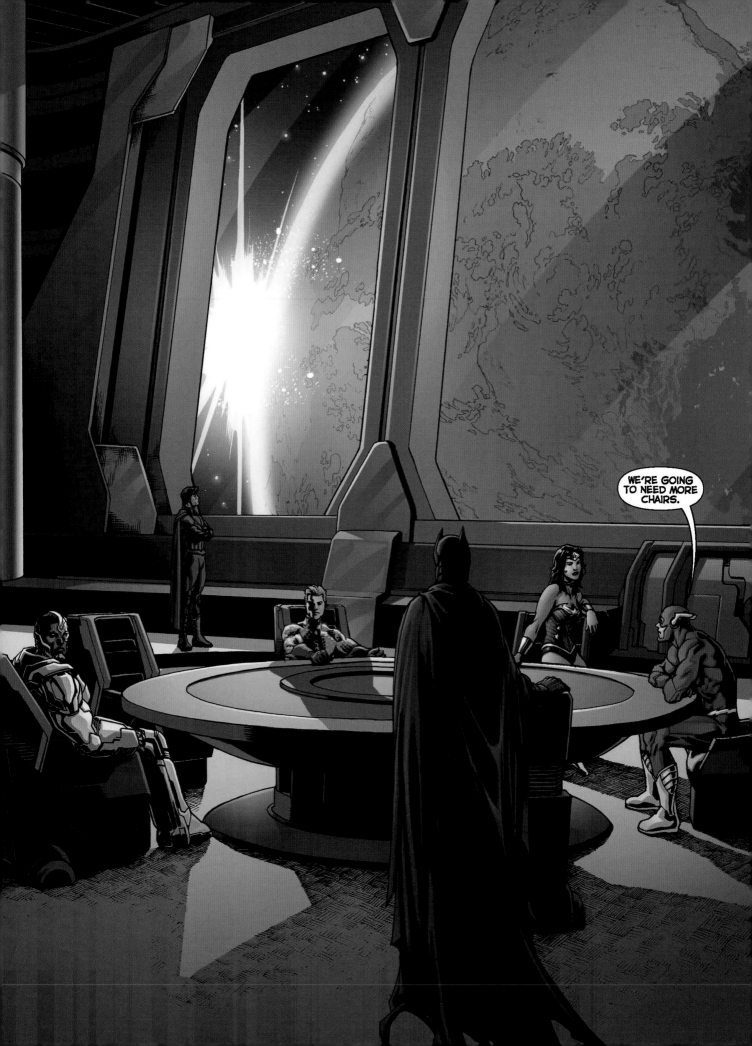

THE TEAM FORMED, AND THEN THEY NEEDED SOMEWHERE
TO MEET. IT WAS NEVER EXPLAINED HOW THEY SETTLED ON
THE MOUNTAIN OUTSIDE HAPPY HARBOR. THE RHODE ISLAND
DETAIL WAS ADDED IN A 1977 STORY. *AMAZING WORLD OF DC
COMICS* #14 AND THE COMICS AFTER THAT WERE INCONSISTENT,
SOMETIMES PLACING THE HQ OUTSIDE METROPOLIS. DUBBED
THE SECRET SANCTUARY, THE HEADQUARTERS INITIALLY HAD
A FAIRLY SPARE LAYOUT, BUT OVER TIME THEY BUILT IT UP TO
BE A FULLY FUNCTIONAL PLACE OF BUSINESS.

CHAPTER 2
THE
HEADQUARTERS

It wasn't until *Secret Origins* #46 (1989) that the origin of their first home was revealed. An alien encounter led the young JLA to a cavernous mountain where extraterrestrials had died millennia in the past. Moved as the beings' descendants paid their respects, the Flash proposed using the site as the team's base. Secretly, billionaire Oliver Queen funded the outfitting of the mountain, turning it into an operational meeting space. He did this surreptitiously through financier Simon Carr, Snapper's father. Snapper served as mechanic and handyman, getting to hang out with the heroes. This way, Queen ensured that the League would not feel beholden to induct Green Arrow until he earned his way onto the roster.

Atop the headquarters was a hangar setup large enough to accommodate both Batman's Batplane and Wonder Woman's Invisible Jet (parking the two would certainly be a challenge). It wasn't until March 1977 that DC's in-house fanzine, *The Amazing World of DC Comics*, ran a detailed floor plan, ironic since the team had long ago abandoned their first home for their satellite.

The rectangular meeting room, the focus of most stories set there, had a floating chair for the Atom and a water-equipped chair for Aquaman's need to hydrate at least hourly. On the fourth level, the team maintained its souvenir room, which at various times contained artifacts from early cases such as the dormant body of Starro the Conqueror, the deactivated Amazo, and Professor Amos Fortune's Stimu-Luck machine.

Almost from the beginning, their headquarters was breached by numerous threats, starting with their second appearance in *The Brave and the Bold* #29 and then repeatedly invaded for a total of seven recorded instances. After Xotar the Weapons Master from the year 11,960 invaded, he was followed by the alien despot Despero (#1), self-proclaimed dictator Kanjar Ro (#3), a gaggle of foes (#35), Doctor Light, for the first time (#12), two-bit hoodlum Joe Parry (#31), and the Key (#41). That final instance saw a disguised Joker corrupt Snapper Carr, their loyal mascot, who let him access the headquarters. This act of personal betrayal led to Snapper leaving the team and the League recognizing that it was time to relocate.

Although they took to the stars, the headquarters remained intact and served as not only an emergency JLA meeting spot but temporarily as home to the Doom Patrol, the time-displaced Legion of Super-Heroes, and finally

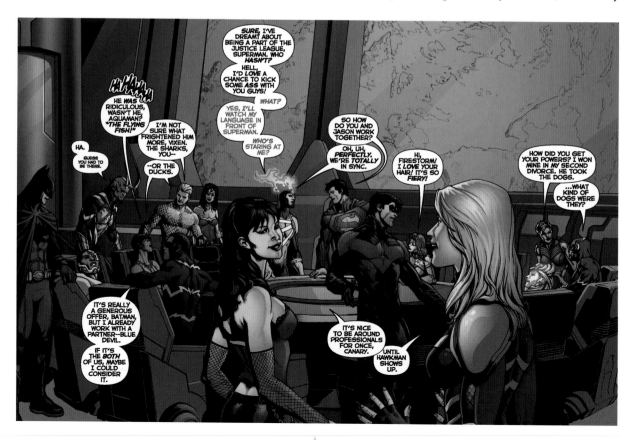

Young Justice. Once, the evil Injustice Gang invaded and took over the space, although that was mercifully brief.

In the wake of the Joker's discovery of the Secret Sanctuary, the team relocated in *Justice League of America* #78 (February 1970). It was never explained who designed and built or outfitted the satellite, which was in geosynchronous orbit 22,300 miles above the world. It was accessed by teleporters, using technology from Thanagarian member Hawkman's homeworld. Given its location, members worked out a schedule so someone was always aboard on monitor duty. Each member had their own apartment as well as guest quarters set aside for visitors.

Given the teleporters around the world, the satellite was not as secure as the team believed. One of their oldest foes, Doctor Light, accessed the satellite, found Sue Dibny alone, and raped her, as depicted in the harrowing *Identity Crisis* #1 (2004). When he was found, members of the League responded to the villain's threats against other loved ones by wiping his memory of the incident. Batman arrived as this vote was taken and was determined to go through with it, and Zatanna used her magical abilities to make him forget as well. The story, which proved controversial to readers, was from novelist Brad Meltzer, who drew inspiration from a three-part *Justice League of America* story from Gerry Conway and Dick Dillin. Illustrated with energy and pathos by Rags Morales, the miniseries was a fresh examination of what it meant to be a hero and the value of family.

While the satellite endured numerous attacks over the years, it took their android member, Red Tornado, who had been reprogrammed to self-destruct, to impact the orbiting fortress beyond repair, in *Justice League of America Annual* #3 (1985). Despero, an alien invader, saw to it that the satellite was completely obliterated in *Justice League of America* #251 (1986).

It should be noted that the allure of being able to oversee the world they were sworn to protect proved great, and they repeatedly built new facilities. They also temporarily used their foe the Overmaster's space station, called the Refuge, from 1994 to 1996.

In the wake of the satellite being damaged during the Earth-Mars War, Aquaman disbanded the League until he could find a team that could make a complete commitment to their mission. As the League was reassembled, new recruit Steel offered up his grandfather's Detroit factory/fortress as a base, nicknamed the Bunker. In *Justice League of America Annual* #2 (1983), the heroes moved in.

The work had been overseen by Vietnam vet and ace engineer Dale Gunn, who maintained the facility as an honorary member of the new team. Eventually, Steel and his grandfather, the first Steel, had a falling-out, and they had to vacate the Bunker, with the team disbanding soon after. This may be the one headquarters that was never breached by enemies of the JLA.

A world without a Justice League didn't seem right and the wealthy Maxwell Lord helped bring about a brand new team. Without a home to call their own, the team began operating out of the Secret Sanctuary, although they knew it would be temporary at best. Sure enough, once they received United Nations sanctioning, they began opening up embassies around the world, as seen in *Justice League International* #8 (1987).

The American embassy was a two-story brownstone located near the UN's headquarters in Manhattan. In addition to meeting spaces and the official offices for Lord, the building had apartments for active members, and in the basement were transporters that created a link with the other embassies, which included Japan, Paris, Brazil, Russia, Saudi Arabia, London, and Australia. The branch of the team known as Justice League Europe operated out of the Paris branch, with Catherine Cobert as the Paris embassy chief. That did not stop a hacker from accessing their mainframe, or prevent England's Beefeater from accidentally destroying the building, forcing the team to move to the London branch.

Soon after, Cobert learned that the European branch was planning to go against the UN's plan when the world was threatened by the Overmaster. She informed Lord, who sent a different squad of heroes to stop the international team, resulting in the dissolution of the League once more, but not before Ice died during the fight.

With the Overmaster defeated, Wonder Woman took possession of his space station's escape pod and used it as their refuge in *Justice League America* #0 (1994). The self-repairing facility seemed perfect, until Lord Havok led a successful "full purge" of the Refuge (*Justice League America* #111, 1996). The abandoned Refuge was jettisoned into space, and the remnants of the team used Captain Atom's Mount Thunder headquarters for a short time.

As the original founders reunited to reform the team, they knew that a more stable facility was needed. In this reimagined version of the team by writer Grant Morrison and artist Howard Porter, the team took on more mythic proportions and needed a headquarters that could rival Mount Olympus. Space remained a lure, but experience showed that Earth orbit made them an easy target. Instead, they built the Watchtower on

the moon, constructing it with promethium and using highly advanced Martian, Thanagarian, Kryptonian, and Terran technology (*JLA* #4, 1997). This time, the team used teleporters, developed by S.T.A.R. Labs, for transit using warped-space technology. After Orion and Big Barda joined the team, they brought with them additional technology from their home on New Genesis.

Even this far from Earth's super-villains and with the transporters securely placed in government buildings, the headquarters was attacked. Disguised as the hero Retro, the dangerous Prometheus invaded the Watchtower and nearly destroyed it in *JLA* #16 (1998). Later, Triumph, rescued from a dimensional trap, also accessed the structure and kidnapped Gypsy and Ray (*JLA* #29, 1999). The Injustice Gang breached the Watchtower in *JLA* #36 (1999), and soon after, a bomb nearly destroyed the entire structure, killing Triumph and the angel Zauriel.

During the rebuilding, the Oblivion Meme infiltrated the HQ's interstellar communications system before being stopped by Steel and Aquaman (*JLA Showcase 80-Page Giant* #1, 2000). Soon after, the daughter of the Demon, Talia, broke into the Watchtower and retrieved Batman's files on his teammates, allowing her father, Ra's al Ghul, to take the team apart.

Not long after, Superboy-Prime destroyed the moon base (2006), igniting the Infinite Crisis.

In the aftermath, it was decided by writer Brad Meltzer that the League needed greater flexibility and a backup facility. Thus was born the second Watchtower, an orbiting satellite with a dedicated transporter linking it to the Hall of Justice in Washington, DC (*Justice League of America* #7, 2007), both largely designed by artist Ed Benes.

The latter structure has a curious history, as it was based on Cincinnati's Union Terminal by Hanna-Barbera background supervisor Al Gmuer, when he was designing an HQ for ABC's Saturday-morning series *Super Friends*. A generation of fans would be mesmerized by the building and honored it when, as adults, they began writing and producing television series based on the comics. As a result, the now-familiar edifice was found in series including CW's *The Flash*, which revealed that S.T.A.R.

Labs had a warehouse with a familiar look. On *Lois & Clark: The New Adventures of Superman*, Metropolis's courthouse was named the Hall of Justice.

In comics, it was just a matter of time before the JLA itself would call it home. Designed by Wonder Woman and Green Lantern John Stewart, who was an architect, the central meeting room features a round table, similar to Camelot, with a dozen chairs for the members. The new structure was constructed solely by the Man of Steel and financed by the Caped Crusader. An underground chamber was built with special security apparatus so the remains of fallen comrades and dangerous foes could reside undisturbed, and behind was a garden with statues of the courageous dead warriors.

Meanwhile, the central hub of the new satellite was the Womb (aka the Crow's Nest), where members resumed monitor duty, although Martian Manhunter tended

to take more shifts than most. It was in the satellite Watchtower where a fresh collection of memorabilia was maintained, including Green Arrow's trick arrows, Booster Gold's armor, Kanjar Ro's Gamma Gong, and galleries of past League rosters. There was also the Kitchen, a computerized training room.

The Hall of Justice was destroyed during the New 52 incarnation of *Justice League International* and in winter 2018, the JLA's orbiting Watchtower was sabotaged by The Fan, someone who helped build it, and it came crashing to Earth, disturbing tribes in Africa. As the team is reconfigured under writer Scott Snyder, they return to a new Hall of Justice, which will be shared with the Titans.

While headquarters may come and go, the League would always have a place to call home, from which they could continue to serve and protect Earth's citizenry.

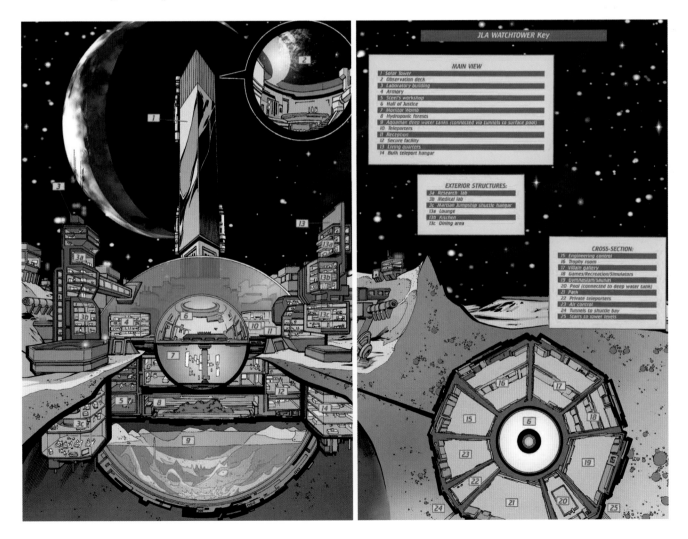

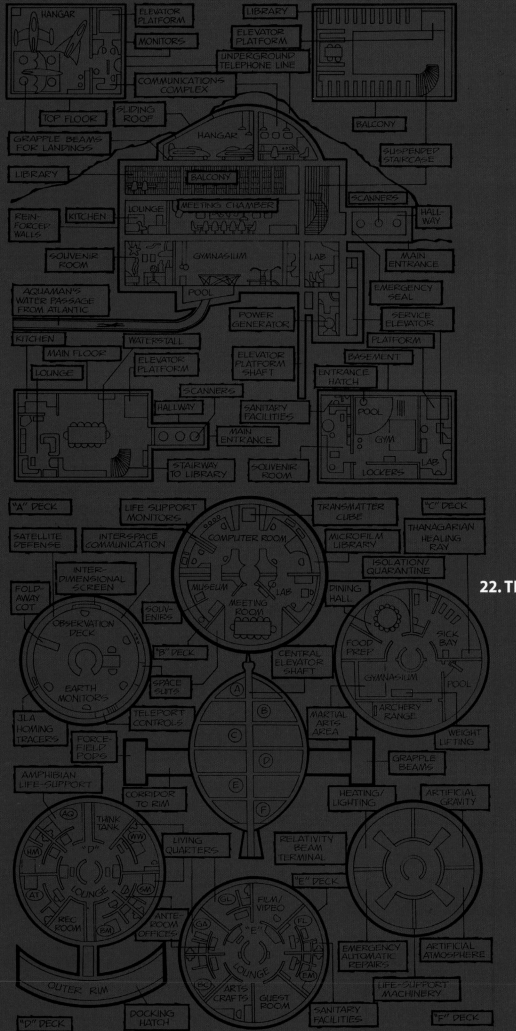

GREATEST MOMENTS

HEADQUARTERS

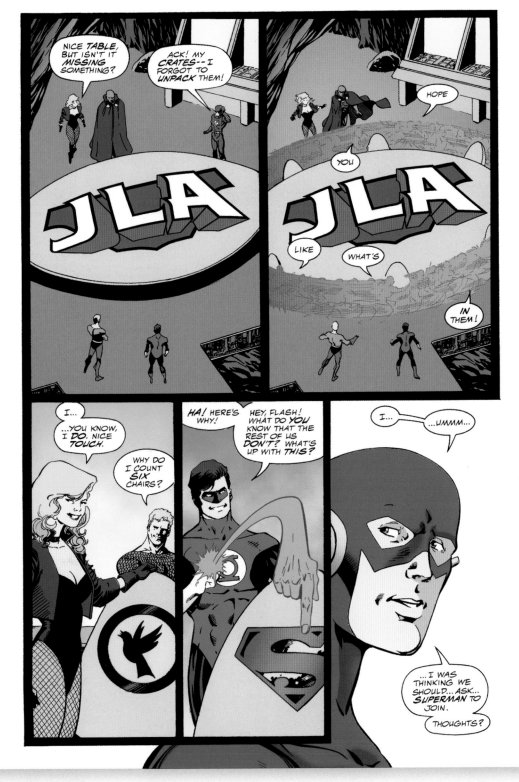

One of the major changes in *JLA: Year One* was the membership table, which had originally been a traditional rectangular shape. This one was circular à la King Arthur's fabled Round Table. Additionally, each member had an insignia added to identify seating with a team logo in the center.

JLA: Year One #3, March 1998
Writers: Mark Waid & Brian Augustyn *Artist:* Barry Kitson

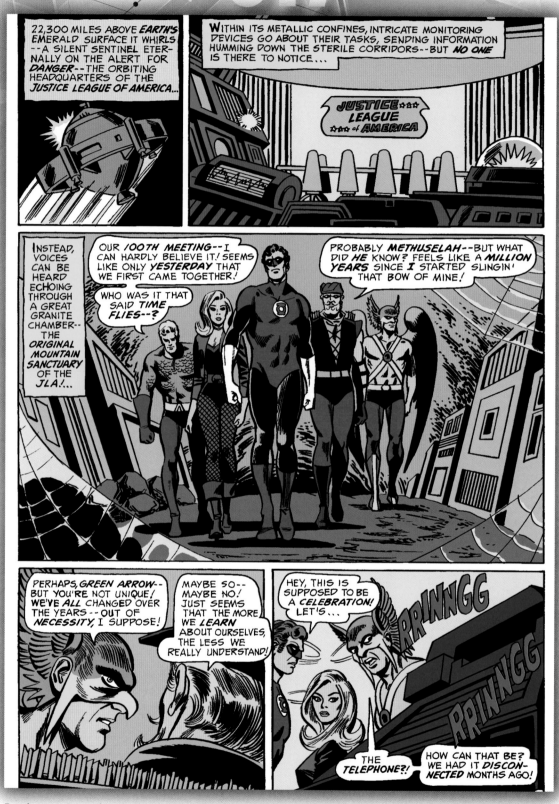

For the team's one-hundredth meeting, they returned to the Secret Sanctuary, pausing to recall earlier, perhaps happier times. Later on, they would loan the mountain HQ out to other groups, but clearly, it had gone unused as seen here in *Justice League of America* #100.

Justice League of America #100, August 1972
Writer: Len Wein *Artists:* Dick Dillin & Joe Giella

THE FIRST TO ARRIVE FOR A REGULARLY SCHEDULED MEETING OF THE *JUSTICE LEAGUE OF AMERICA* IS HONORARY MEMBER *SNAPPER CARR,* WHO AMUSES HIMSELF FOR A WHILE IN THE *HALL OF SOUVENIRS* ...

MAN, LIKE THIS IS SOME COLLECTION! *AMAZO*-- WHO STOLE THE *JLA'S* SUPER-POWERS! THE COSMIC BOAT OF *KANJAR RO!* I GET A BRAIN PAIN THINKING OF THEM!

AMAZO

STARRO

KANJAR RO'S COSMIC BOAT

TURNING TO MORE SERIOUS MATTERS, HE SORTS OUT THE MAIL FOR HIS FELLOW MEMBERS-- WHEN *WONDER WOMAN* AND *GREEN ARROW* ARRIVE ...

ANY INTERESTING LETTERS THIS TIME, *SNAPPER?*

THERE'S ONE FROM SOME CAT NAMED *RAY PALMER*--ABOUT A CANNON THAT FIRES ITSELF!

WHEN THE OTHER MEMBERS GATHER--WITH THE EXCEPTION OF *ATOM, BATMAN* AND *AQUAMAN* WHO CANNOT ATTEND BECAUSE THEY ARE DEEPLY INVOLVED IN CASES OF THEIR OWN-- *J'ONN J'ONZZ* ASSUMES THE ROTATING ROLE OF CHAIRMAN ...

NOW THAT WE'VE DISPOSED OF THE REGULAR BUSINESS, LET'S CONSULT OUR MAIL DE-PARTMENT. ANYTHING THAT CATCHES YOUR INTEREST, *SNAPPER?*

BESIDES THAT INK LINK FROM *RAY PALMER,* THERE'S ALSO A LETTER FROM *BRUCE WAYNE* OF *GOTHAM CITY.*

ONLY THE STERN CONTROL OF HIS FACIAL MUSCLES PREVENTS *SUPERMAN* FROM SHOWING HIS STUNNED SURPRISE ...

BRUCE WAYNE? BUT HE'S *BATMAN!* ONLY I KNOW THE SECRET OF HIS DOUBLE IDENTITY, OF COURSE--BUT WHY IS HE WRITING TO THE *JUSTICE LEAGUE?* AND WHY ISN'T HE AT OUR MEETING?

IT'S BEEN A LONG TIME SINCE WE WENT OUT ON MAIL CALLS*. MAYBE WE OUGHT TO TACKLE A FEW CASES, SINCE THERE'S NO EMER-GENCY DEMANDING OUR ATTENTION.

BRUCE WAYNE WRITES ABOUT AN "INVISIBLE" ROBBER--AND A CERTAIN *C. KING* TELLS US ABOUT A DISAPPEARING ISLAND...

CAN ANY OF THOSE OTHER NAMES HIDE THE IDENTITY OF OTHER *JLA* MEMBERS? I'D SURE LIKE TO BE SENT OUT TO ANSWER *BRUCE WAYNE'S* LETTER-- BUT I CAN'T MAKE AN ISSUE OF IT!

*Editor's Note: NOT SINCE *"The WHEEL OF MISFORTUNE"*--JLA #6.

WHAT CAN BE THE MEANING OF THE MYSTERIOUS LETTER FROM BRUCE (*BATMAN*) WAYNE? AND THE ONE FROM RAY (*ATOM*) PALMER? AND-- WHO IS THE MAN WHO SIGNS HIMSELF *C. KING?*

2

Much as Batman and Superman maintained trophies in their personal headquarters, the JLA also maintained me-mentos from their cases. Visually, it was nice to see earlier foes represented as in this moment at the beginning of *Justice League of America* #27.

Justice League of America #27, May 1964
Writer: Gardner Fox *Artists:* Mike Sekowsky & Bernard Sachs

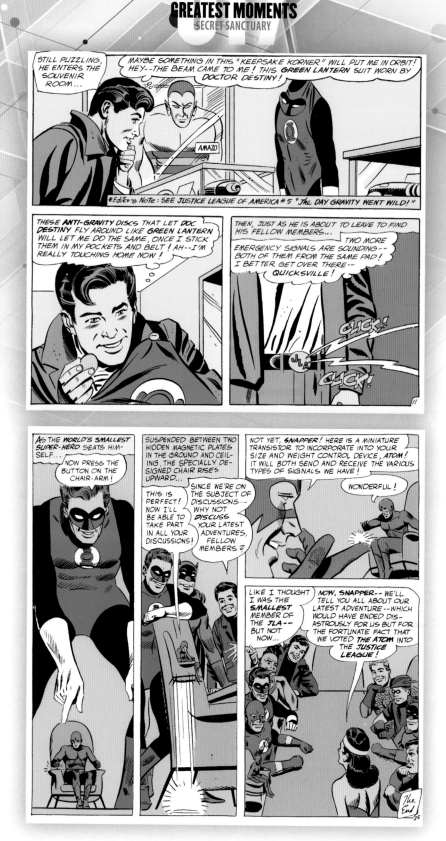

It would be rare to see the team's mascot, Snapper Carr, summon the team but since he did so judiciously, they heeded his summons in *Justice League of America* #8. Again, note the variety of mementos, including in this case a Green Lantern uniform used by their enemy Doctor Destiny just three issues earlier.

Justice League of America #8, Dec. 1961 / *Justice League of America* #14, Jan. 1962
Writer: Gardner Fox *Artists:* Mike Sekowsky & Bernard Sachs

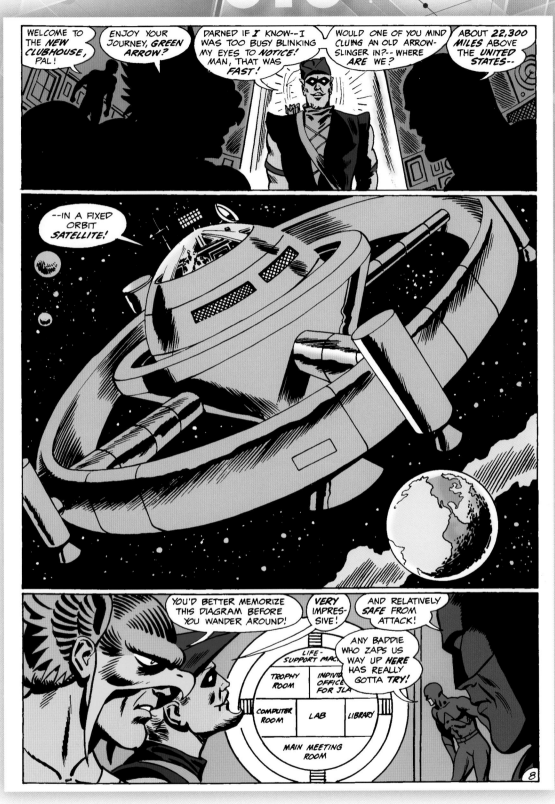

After the Joker discovered the Secret Sanctuary's location, the team immediately moved to the orbiting satellite, using Thanagarian teleporters to access it. Here, Green Arrow is given his first look at the team's new home in *Justice League of America* #78. Who received the construction contract was never revealed.

Justice League of America #78, February 1970
Writer: Denny O'Neil *Artists:* Dick Dillin & Joe Giella

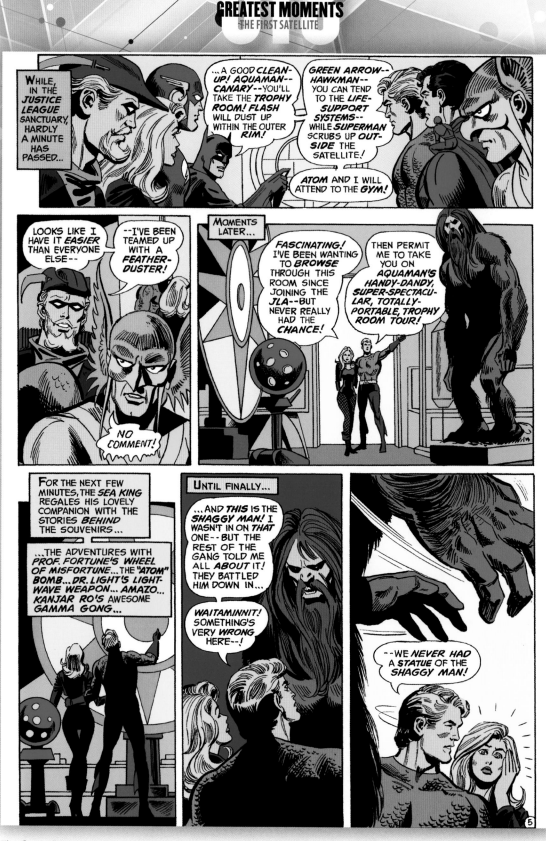

The first orbiting satellite headquarters was rarely the setting for stories so we never got to explore it thoroughly. However, writer Len Wein set the story in *Justice League of America* #104 exactly there and it was a rare chance to see the second incarnation of their trophy room, especially with Aquaman narrating about their earliest missions.

Justice League of America #104, February 1973
Writer: Len Wein *Artists:* Dick Dillin & Dick Giordano

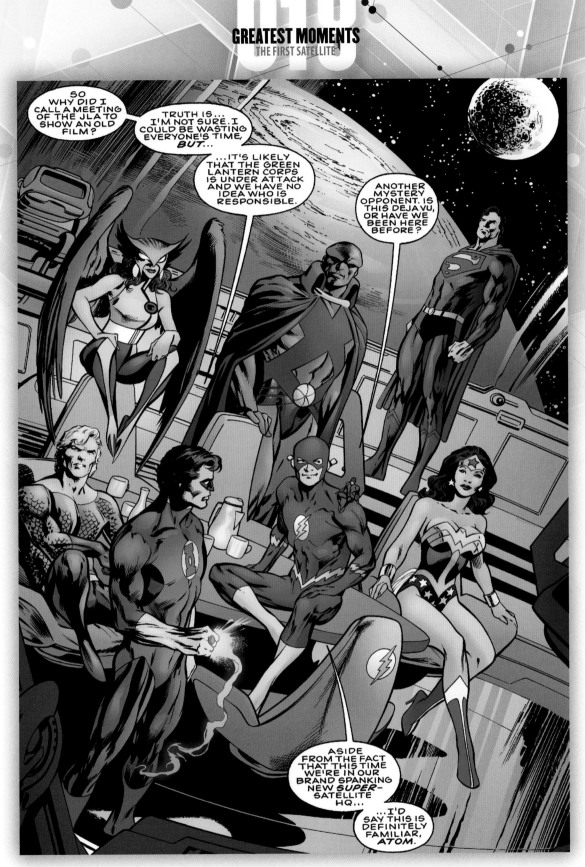

Although this image comes from the Elseworlds story *JLA: The Nail* #2 it's an excellent view of their high-tech meeting room with a nice view of the Earth from 22,200 miles as they circled in a geosynchronous orbit.

JLA: The Nail #2, October 1998
Writer/Penciller: Alan Davis *Inker:* Paul Neary

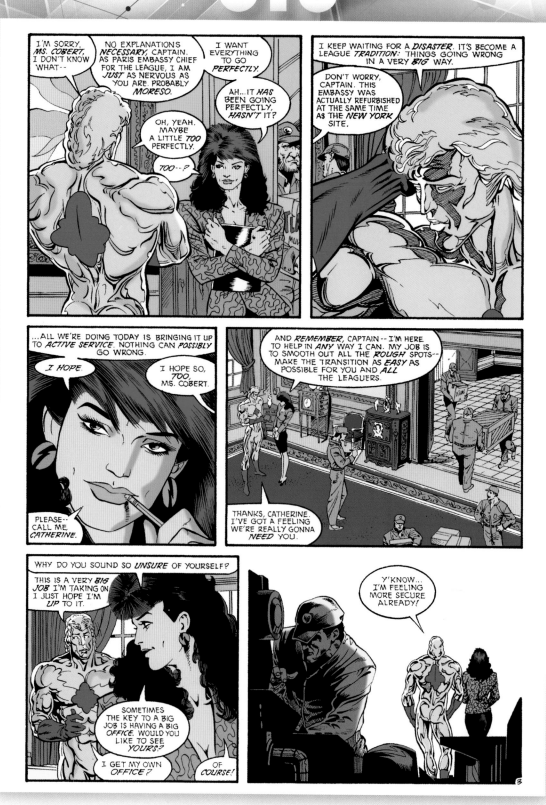

After receiving UN sanctioning, the Justice League opened embassies around the world, eventually placing an entire team at the European base, first in Paris. Catherine Cobert ran the operation with Captain Atom as one of the field leaders. In this moment from *Justice League Europe* #1, Cobert tries to reassure a concerned hero that everything is under control.

Justice League Europe #1, April 1989
Writers: Keith Giffen & J.M. DeMatteis
Artists: Bart Sears & Pablo Marcos

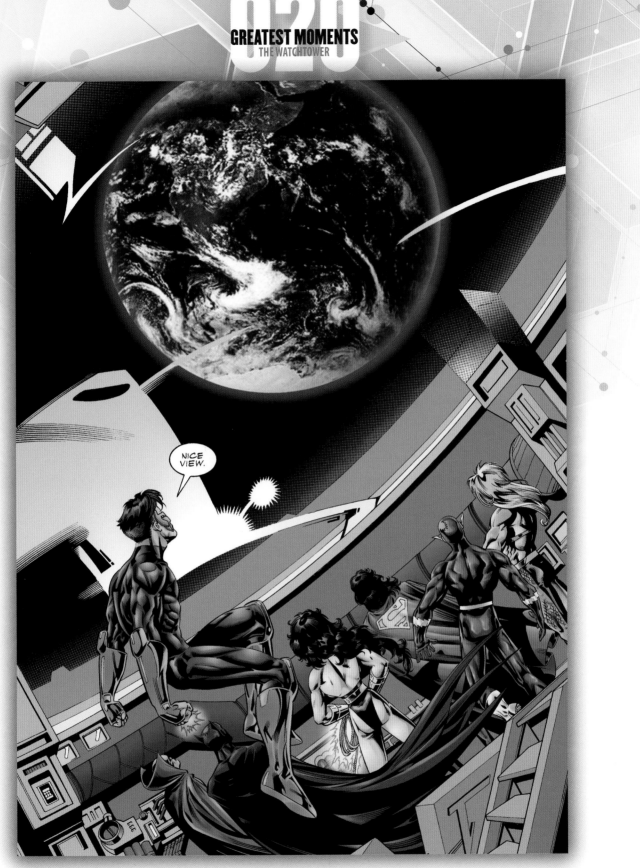

When the team re-formed with their charter members once more, it was deemed more appropriate to keep watch on their world from a secure base of operations. The Watchtower was located on the moon and offered them a visual reminder of their mission as seen in this moment from *JLA* #4, in which Green Lantern gets his first glimpse from the new headquarters.

JLA #4, April 1997
Writer: Grant Morrison
Artists: Howard Porter & John Dell

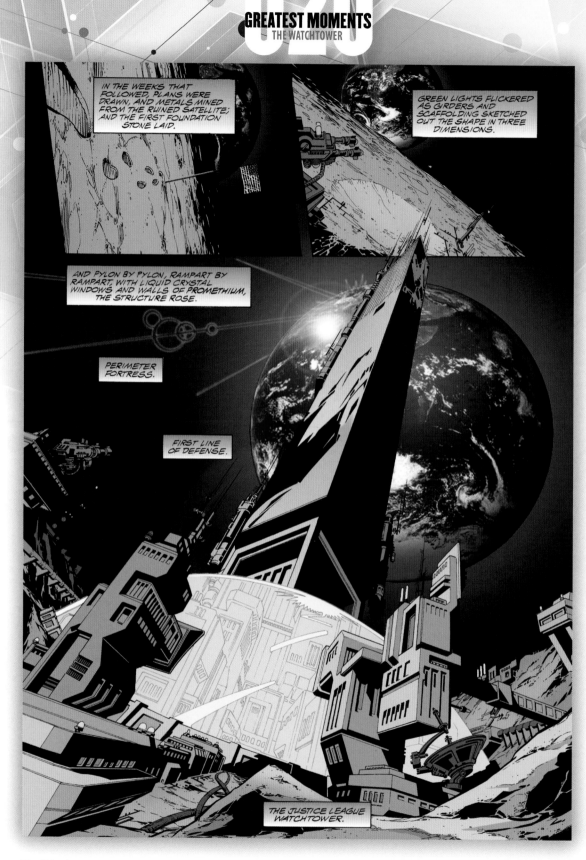

The Watchtower was constructed using a mélange of Earth, Thanagarian, and Martian technology, later bolstered with additional pieces from New Genesis. Seemingly impregnable and indestructible it stood as Earth's first line of defense against cosmic threats. This is the readers' first glimpse from *JLA* #4.

JLA #4, April 1997
Writer: Grant Morrison *Artists:* Howard Porter & John Dell

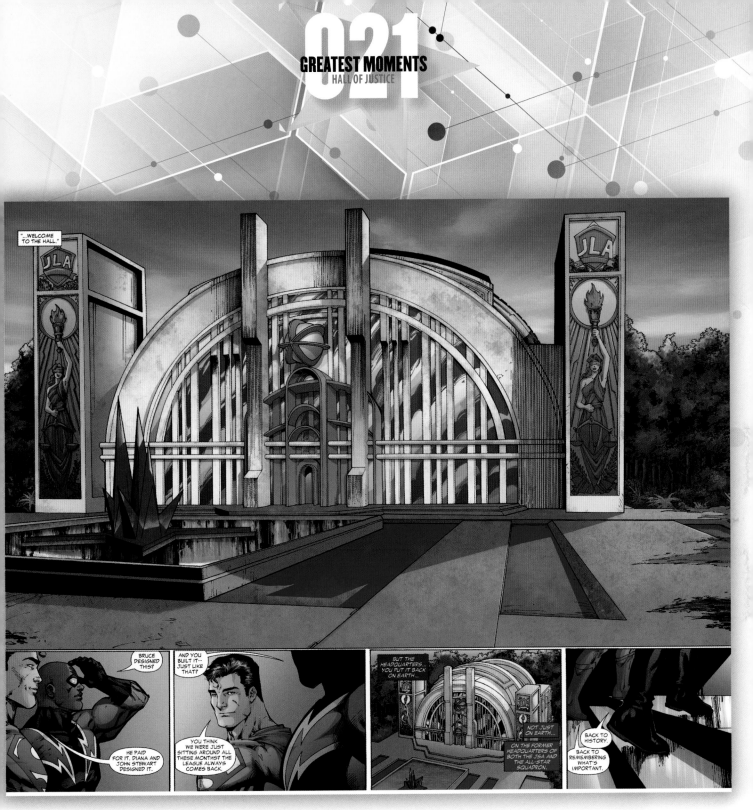

To the generation that first encountered the Justice League on ABC's *Super Friends* cartoon, this structure is instantly recognizable and shares the name: Hall of Justice. Connected by teleporter to the satellite HQ, it offers the team an Earth base, located in Washington, DC. This is the first look at it from *Justice League of America* #7.

Justice League of America #7, May 2007
Writer: Brad Meltzer *Artists:* Ed Benes & Sandra Hope

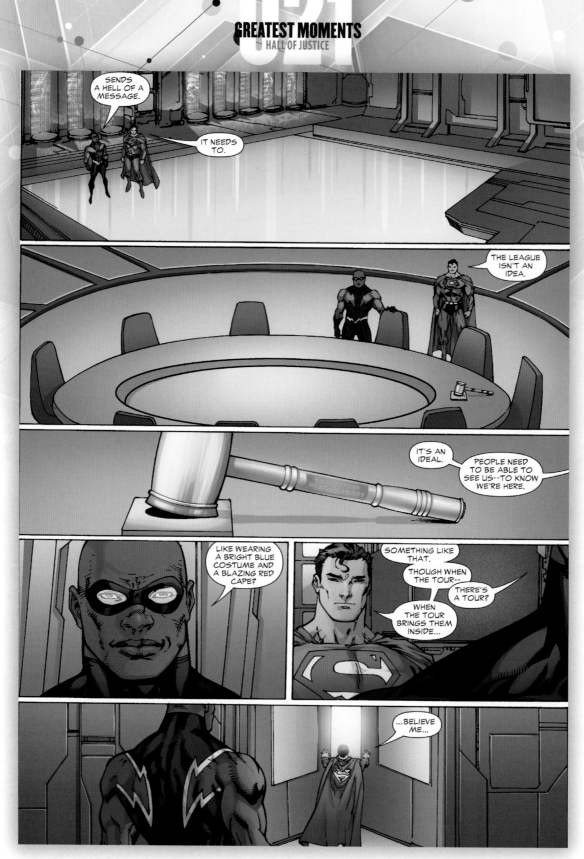

In *Justice League of America* #7, Superman shows new recruit Black Lightning the meeting room and even the veteran hero is given pause at actually seeing the table he has been offered a place at.

Justice League of America #7, May 2007
Writer: Brad Meltzer *Artists*: Ed Benes & Sandra Hope

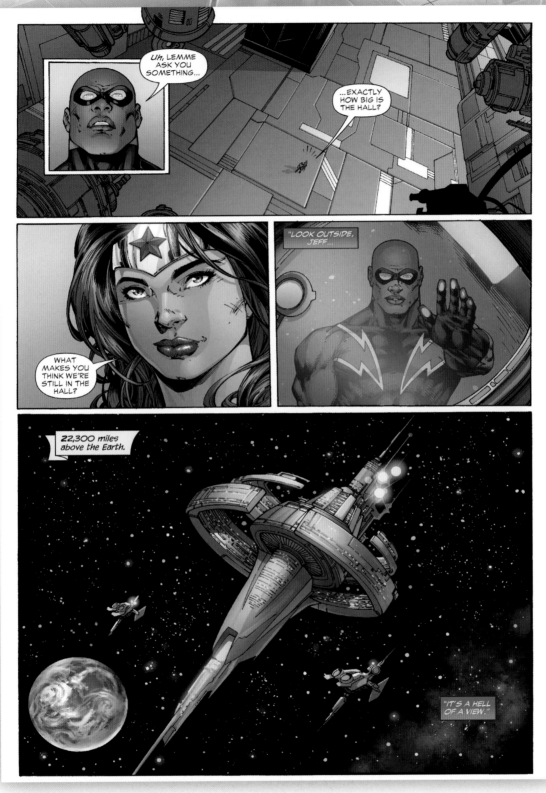

After touring the Hall of Justice, Black Lightning is taken into space, and is greeted by Wonder Woman, who gives him his first view from the new Watchtower in this moment from *Justice League of America* #7.

Justice League of America #7, May 2007
Writer: Brad Meltzer *Artists:* Ed Benes & Sandra Hope

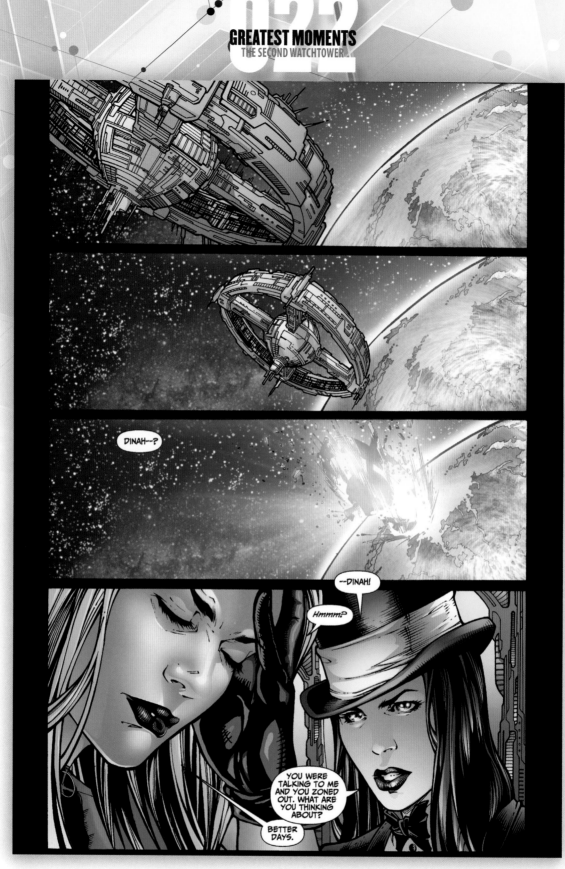

With time, the team lost their first satellite and eventually built a second, far more technologically sophisticated replacement. This one also boasted a teleportation link to the Hall of Justice on Earth and a secret meeting space within folded space. In this moment between Black Canary and Zatanna from *Justice League of America* #31, you have a sense of the HQ's size.

Justice League of America #31, May 2009
Writer: Dwayne McDuffie
Artists: Shane Davis & Sandra Hope

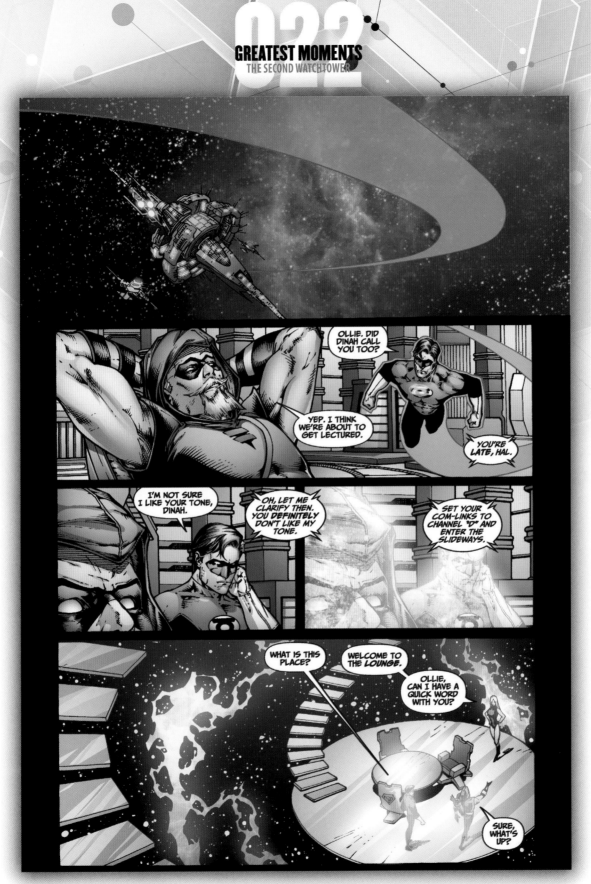

At first, the Lounge was used just by Superman, Batman, and Wonder Woman, but in time, team chair Black Canary discovered it and coopted it for personal conversations. In *Justice League of America* #31, she summoned her two closest comrades, Green Arrow and Green Lantern, for a conversation.

Justice League of America #31, May 2009
Writer: Dwayne McDuffie
Artists: Shane Davis & Sandra Hope

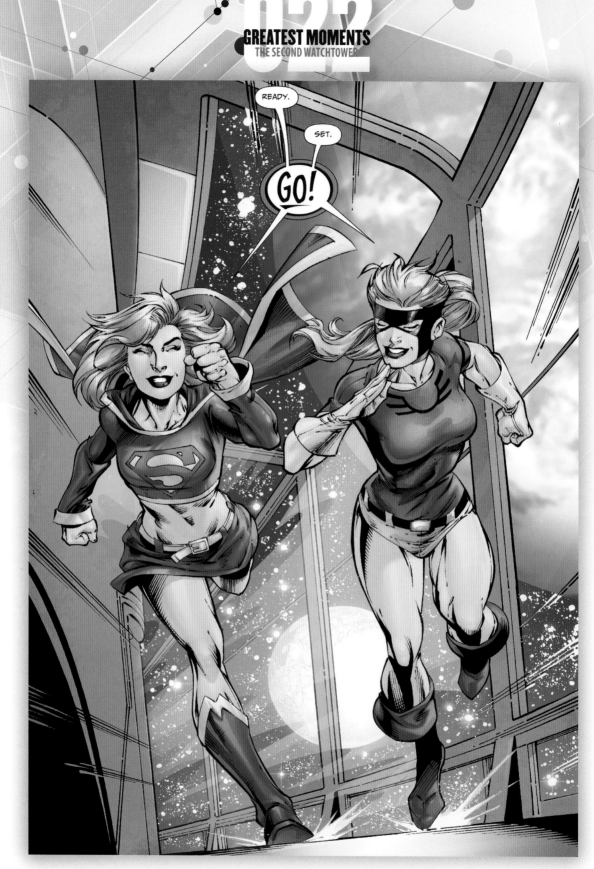

The second satellite took the name Watchtower from their previous moon-based home, and it was a spacious head-quarters with, apparently, enough room for new recruit and speedster Jesse Quick to race fellow newcomer Super-girl in this light-hearted moment from *Justice League of America* #50.

Justice League of America #50, May 2009
Writer: James Robinson *Artists:* Mark Bagley,
Rob Hunter, & Norm Rapmund

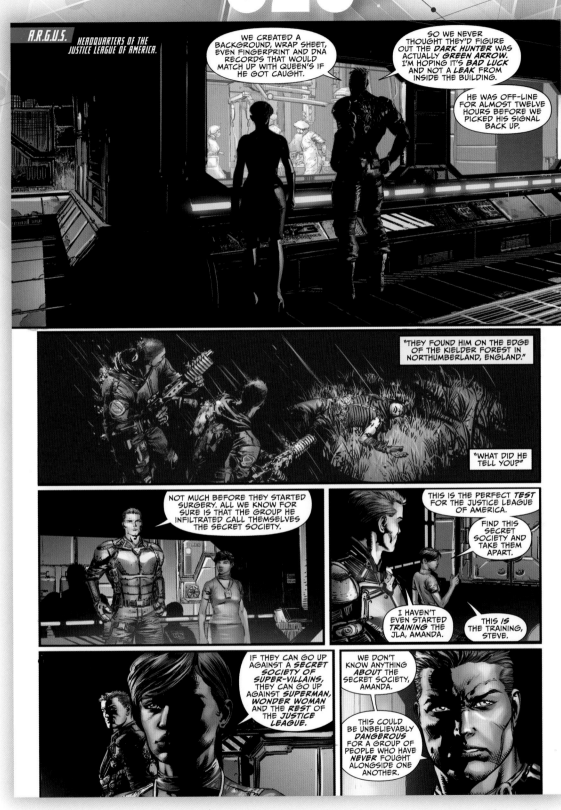

When Amanda Waller placed Steve Trevor and A.R.G.U.S. in control of a Justice League, they operated from a relatively nondescript base of operations, clearly designed and constructed under government contract, with little in the way of frills such as a fancy table or trophy room as seen here in *Justice League of America* #2.

Justice League of America #2, April 2003
Writer: Geoff Johns *Artist:* David Finch

THERE ARE COUNTLESS CIVILIZED WORLDS ACROSS THE UNIVERSE. ON A MACRO LEVEL, THEY ARE POLICED AND PROTECTED BY THE GREEN LANTERN CORPS'S 3,600 MEMBERS. STILL, EVEN THEY CANNOT BE EVERYWHERE, AND AT TIMES THE COSMOS NEEDS CHAMPIONS TO ANSWER ITS CALL.

CHAPTER 3
THE ALIENS

Considering that not every civilized world is a benevolent one, there has risen many predator races and powerful figures who would rule numerous solar systems.

To many, Earth, located in the Sol system, is a backwater on the fringes of the Milky Way, too insignificant to notice.

Others, though, see Earth as a breeding ground for trouble . . . or heroes. It all depends on your point of view.

Ever since Kal-El of Krypton was sent to Earth, the last survivor of his people, the world has been known for a unique set of heroes, whose tenacity and prowess has made them a legend across the stars. Most respect Superman for his service to the galaxies, and the Justice League's efforts continue to earn them praise—and enmity.

Little wonder, then, that aliens have found their way to the planet. When Superman was an adult, J'onn J'onzz was exiled from nearby Mars during its civil war. And then came Katar and Shayera Hol, police officers from Thanagar, 25 trillion light-years away. They were pursuing a criminal and, after apprehending him, came to stay, studying Earth's police techniques and fighting crime as Hawkman and Hawkgirl. They all wound up members of the Justice League.

But there were also the Appellaxians, who sent seven of their mightiest to Earth, letting them try and conquer the world. After all, Gardner Fox needed something large enough to engage the original members. His model at the time remained the old JSA stories, where a common threat had many parts so each member could go off and contribute to the greater good. With a mere 26 pages at the time, Fox needed things to happen quickly, which is one reason he began pairing the members rather than offering up solo escapades. Once Superman was incapacitated, each easily handled other heroes, until the other five heroes were trapped at Cape Hatteras, North Carolina, slowly being transmuted into trees. With teamwork, they freed themselves and defeated the conquerors.

Soon after the heroes banded together as the Justice League, a steady stream of alien threats arrived. There

was Starro, known also as the Star Conqueror, who could replicate his form countless times and, with its collective consciousness, take over world after world. It came to Earth and attempted to defeat its champions, succumbing only after the quick thinking of Happy Harbor's Snapper Carr. It was not easily defeated and returned to challenge the JLA on numerous occasions, always coming close but unable to add the planet to its control.

Others would come to try and rule the world, starting with Despero, whose third eye was a physical manifestation of his tremendous mental prowess. He challenged the League, and thanks to the Flash's strategies during a bizarre chess game, Despero was handed defeat. Undaunted, he would return time and again, more powerful with each visit, and yet could never beat the JLA.

With their reputation growing across the worlds, the JLA found themselves pressed into the service of Kanjar

Ro, dictator of the planet Dhor. Besieged by three rival worlds, he brought the team with him to act as his army and beat his foes. They turned the tables on him, earning his enmity. When he attempted to take over the planet Rann, the JLA made their first voluntary trip across space to stop him, aided by fellow human and Rann's champion, Adam Strange. In altered timelines, Kanjar Ro would plague Hawkman as a corrupt administrator on Thanagar. He even has a sister, Kanjar Ru, who has similar ambitions. Time and again, reality after reality, he would never extend his rule beyond his homeworld.

Adam Strange would work with the League on numerous occasions, never formally joining until more recent times, but he felt comfortable summoning them when a threat was beyond his singular effort. Such was the case when the energy vampire known as Starbreaker attempted to conquer and rule Rann. Superman, the Flash, Green Lantern, and Hawkman worked with Adam Strange to defeat the alien invader.

Seeking vengeance, though, Starbreaker targeted Earth, requiring the full might of the JLA to protect the planet. He was imprisoned by the Guardians of the Universe for a time before returning to Earth in search of vengeance. Different incarnations of the team proved up for the task, and he was soundly defeated in every battle.

Closer to home, Mars's white-skinned residents allowed their civil war with J'onn J'onzz's people to spill over to Earth, embroiling the JLA. After their defeat during the Earth-Mars War, the team was nearly destroyed when several masqueraded as the super-humans known as the Hyperclan.

And across space, Korll was a hiveworld ruled by its queen, Zazzala. Like Starro, they spread across space, advance Bee-Troopers subjugating each world's inhabitants before Zazzala came to finish the job. On her first visit to Earth, the Queen Bee was stopped by the JLA, but on a subsequent visit, she was co-opted

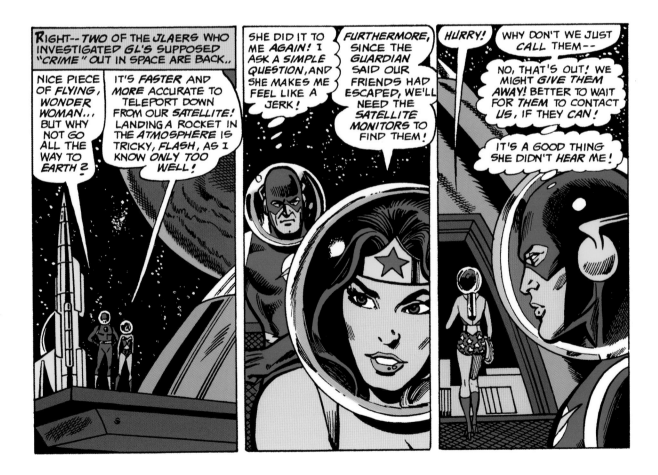

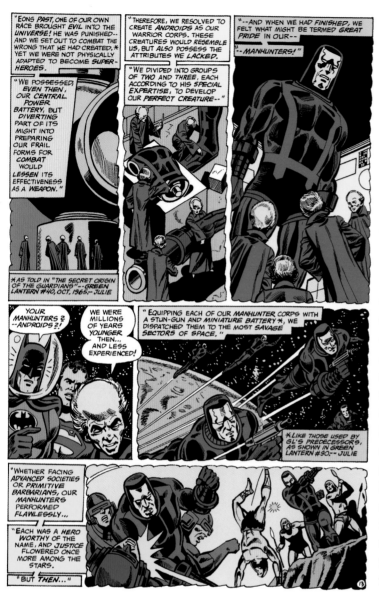

When he returned, he brought with him a Cadre of the Immortal but still could not obtain his goal. In the wake of his defeat, the JLA took over his escape pod as their temporary headquarters.

Not every alien threatening Earth has come with malevolent intent. The JLA once had to save Earth from the Quantum Mechanics, misguided aliens who took countless worlds from their natural orbits and used them to form a ladder to reach Heaven. They seemed oblivious to the consequences of their actions until zealots from within upset their plans, and the JLA restored their planet while helping them find a higher plane of existence.

On the opposite end was an entity that enjoyed different terrible names. Every civilization in every galaxy had a name for it. The Anti-Sun. The Primordial Annihilator. And to the Old Gods of Urgrund, it was called Mageddon. The gods of the Third World sacrificed themselves in a final conflict as the Third World came to an end and the Fourth World arose. Here, writer Grant Morrison took his cues from Jack Kirby, who never drew the JLA but contributed some of the company's greatest cosmic concepts. For the last 15 billion years, Mageddon, who survived the conflagration, was chained in a gravity sink in the outer curve of space-time. Over the eons, Mageddon slipped its bonds and was free. Takion, then leader of the New Gods, sensed the impending disaster and sent Orion and Big Barda to the JLA to bolster their ranks. This battle to save the universe is among the team's greatest.

by Lex Luthor to join his Injustice Gang, a canny way of saving his homeworld, while offering her a percentage of humanity as a spoil of war. The JLA made certain that was never to happen.

For 580 million years, an alien has been traversing the stars, collecting samples of sentient species and then obliterating their worlds, which is not to be confused with Brainiac's salvaging an entire city from a world before destroying it. The Overmaster intended on making Earth his latest acquisition. He assembled super-villains known as the Cadre to take out the JLA so he could do his work, but they were all beaten.

Perhaps the most dangerous foe faced by the JLA was Kirby's creation Darkseid, hailing from the extradimensional world of Apokolips. In search of the Anti-Life Equation, which would allow him to enslave all sentient beings, Darkseid would destroy any world, maim any being, commit whatever heinous act was required to find and obtain this formula. While normally opposed by the New Gods, led by his son Orion, Darkseid would frequently come to Earth, convinced his goal was somewhere on the planet, and find himself opposed by the Justice League. Their battles have become legendary ones.

GREATEST MOMENTS

The Anti-Matter Man was a force of the cosmos as opposed to your typical would-be conqueror. That did not prevent him from collapsing the interdimensional wall keeping Earth-1 and Earth-2 apart. When he arrived and threatened the two worlds, both worlds' greatest champions came to save all life as seen in this moment from *Justice League of America* #47.

Justice League of America #47, September 1966
Writer: Gardner Fox *Artists*: Mike Sekowsky & Sid Greene

It wasn't until the 1980s before anyone saw Anti-Matter Man again, when Mike W. Barr resurrected him for his issue of the round-robin *DC Challenge*. And he hasn't been seen since.

Justice League of America #47, September 1966
Writer: Gardner Fox *Artists:* Mike Sekowsky & Sid Greene

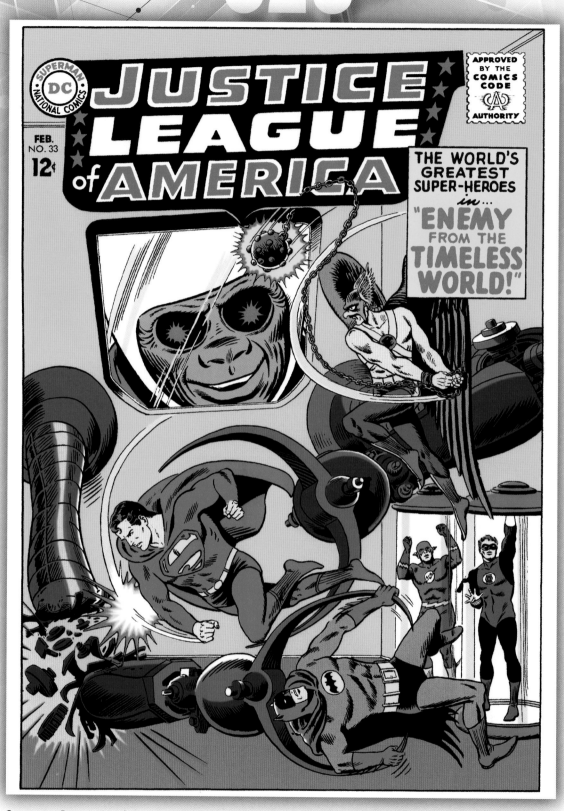

Superman, Batman, Hawkman, Green Lantern, and Flash were carried forward in time where in the year 25,673 they had to stop a time device from bringing the bizarre Alien-Ator to their world. Before they could defeat him, the team accidentally brought him to 1965, turning all humankind into aliens. They had all of *Justice League of America* #33 to stop him.

Justice League of America #33, February 1965
Artists: Mike Sekowsky & Murphy Anderson

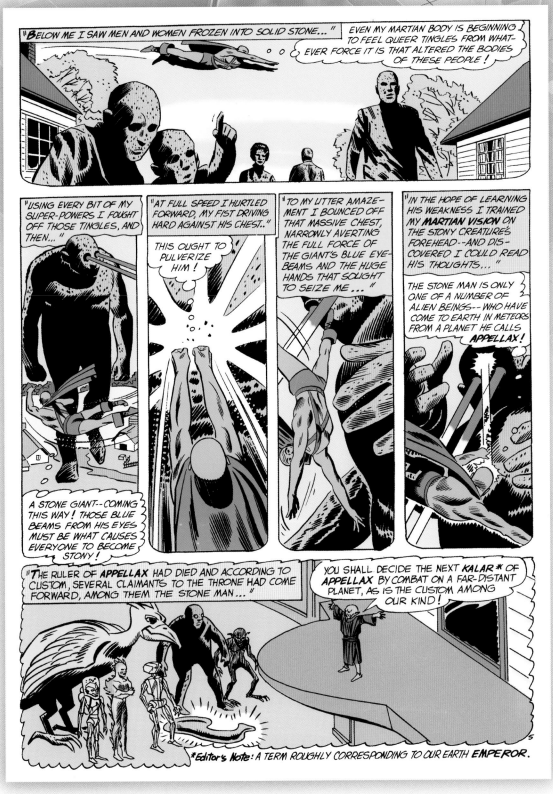

The Appellaxians chose Earth as their battlefield to determine who would next rule their world. Arriving in meteors, they immediately began to attack across the world, causing Superman, Batman, Wonder Woman, Aquaman, Martian Manhunter, Flash, and Green Lantern to swing into action and as a result, form the Justice League of America, as revealed in *Justice League of America* #9.

Justice League of America #9, February 1962
Writer: Gardner Fox *Artists:* Mike Sekowsky & Bernard Sachs

Byth Rok was once a Thanagarian Wingman before becoming a shape-changing menace to multiple worlds, including, on many occasions, Earth. It took an international squad of Justice Leaguers, and one mighty punch from

Supergirl, to keep his scheme from becoming a reality in *Justice League United* #6.

Justice League United #6, January 2015
Writer: Jeff Lemire *Artists:* Neil Edwards & Jay Leisten

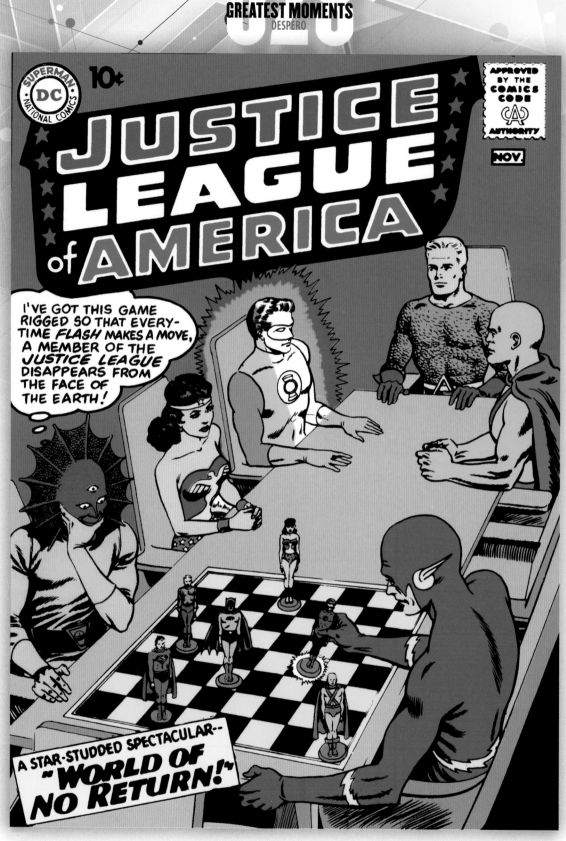

Despero arrived in time for *Justice League of America* #1, challenging the Flash to a deadly game of chess that could spell doom for the newfound team and then the inhabitants of Earth. His telepathic third eye proved a challenge to defeat each time he returned, always seeking vengeance.

Justice League of America #1, Oct.-Nov. 1960
Artist: Murphy Anderson

Over time, the alien Despero evolved, growing in size and ferocity, his fin switching direction but maintaining his thirst for destroying the JLA and making Earth his home. His telepathic duel with the team's telepaths, Aquaman and the Martian Manhunter, was a highlight in *JLA* #118.

JLA #118, Early November 2005
Writers: Geoff Johns & Allan Heinberg
Artists: Chris Batista & Mark Farmer

With the help of former foe Scorch, J'onn J'onzz worked to overcome his fear of fire but accidentally unlocked genetic memories, releasing Fernus the Burning. The fiery creature hated the Green Lantern Corps and the immortal Vandal Savage. It took a newly recruited and telepathically resistant Plastic Man to stop him physically while J'onn won on the psychic plane in *JLA* #89.

JLA #89, Late December 2003
Writer: Joe Kelly *Artists*: Doug Mahnke & Tom Nguyen

Kanjar Ro wanted to rule the cosmos and entrapped the JLA to do his bidding until they freed themselves from his thrall. Undeterred, Kanjar Ro tried to conquer the distant world of Rann but the JLA arrived there to aid fellow human Adam Strange in defending his adopted world as seen in *Mystery in Space* #75.

Mystery in Space #75, May 1962
Writer: Gardner Fox
Artists: Carmine Infantino & Murphy Anderson

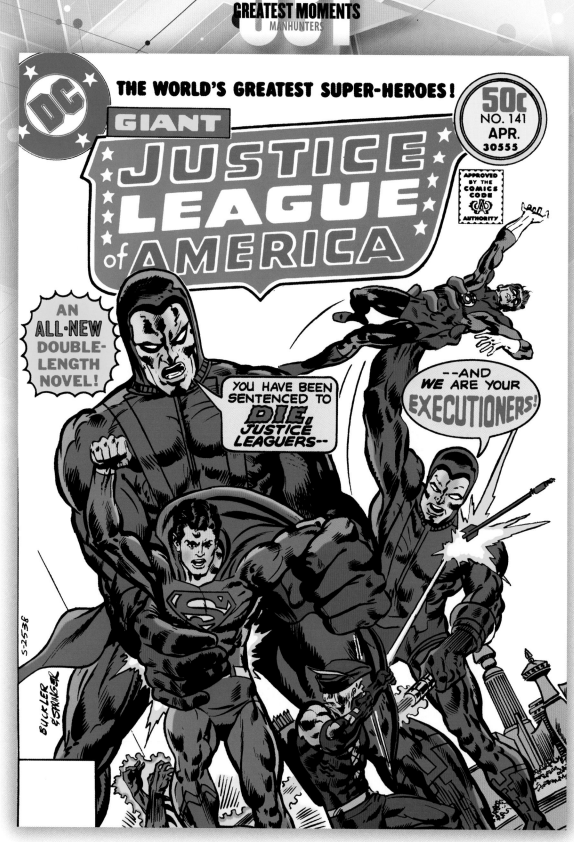

Created by the Guardians of the Universe, the android Manhunters were a precursor to the Green Lantern Corps until they deviated from their programming and became a threat. Thought long gone, they had been biding their time in secret and returned to threaten Oa and Earth beginning in *Justice League of America* #141.

Justice League of America #141, March 1977
Artists: Rich Buckler & Frank Springer

The Quantum Mechanics were among the earliest entities to develop after the Big Bang, traveling the universe in search of divine enlightenment, seeking the perfect afterlife. They captured Earth among other worlds in order to build a path to their version of nirvana until the JLA helped them achieve their goal while freeing Earth as seen in *JLA: Heaven's Ladder*.

JLA: Heaven's Ladder, October 2000
Writer: Mark Waid *Artists:* Bryan Hitch & Paul Neary

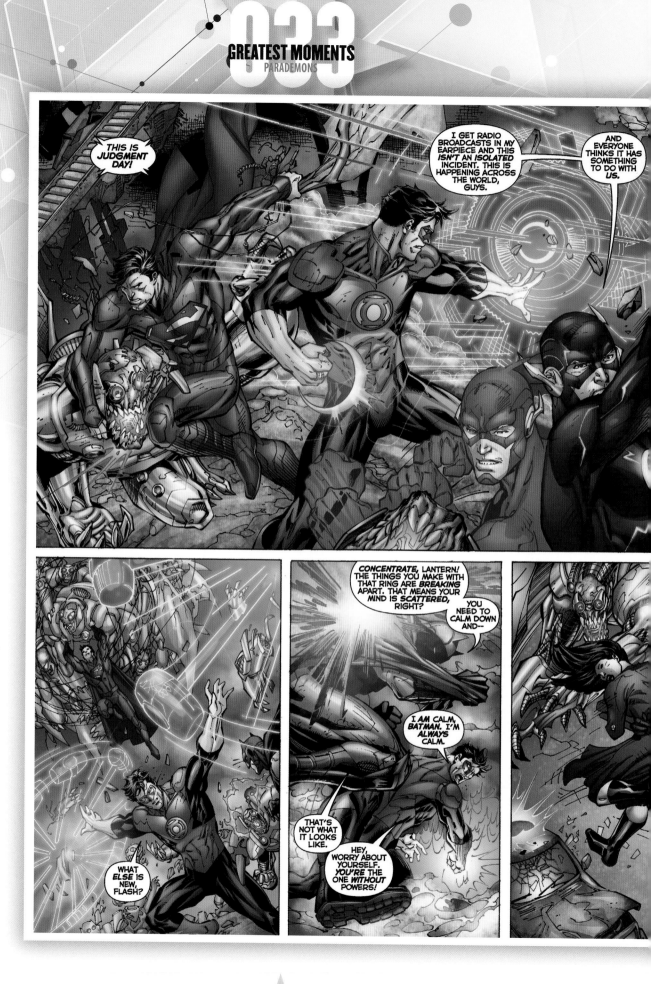

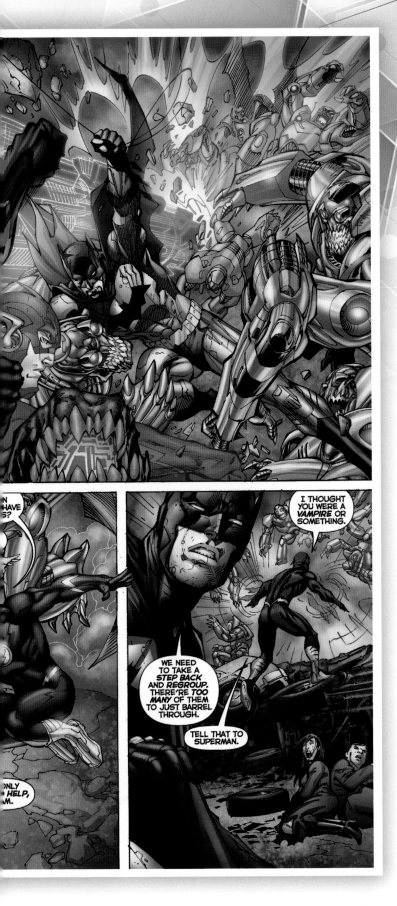

Superman, Green Lantern, Flash, and Batman had their hands full protecting civilians from the cosmic threat while still getting to know—and trust—one another. They had to do so in a hurry to be ready for the Parademons' master. Darkseid's arrival begins in *Justice League* #3.

Justice League #3, January 2012
Writer: Geoff Johns *Artists:* Jim Lee & Scott Williams

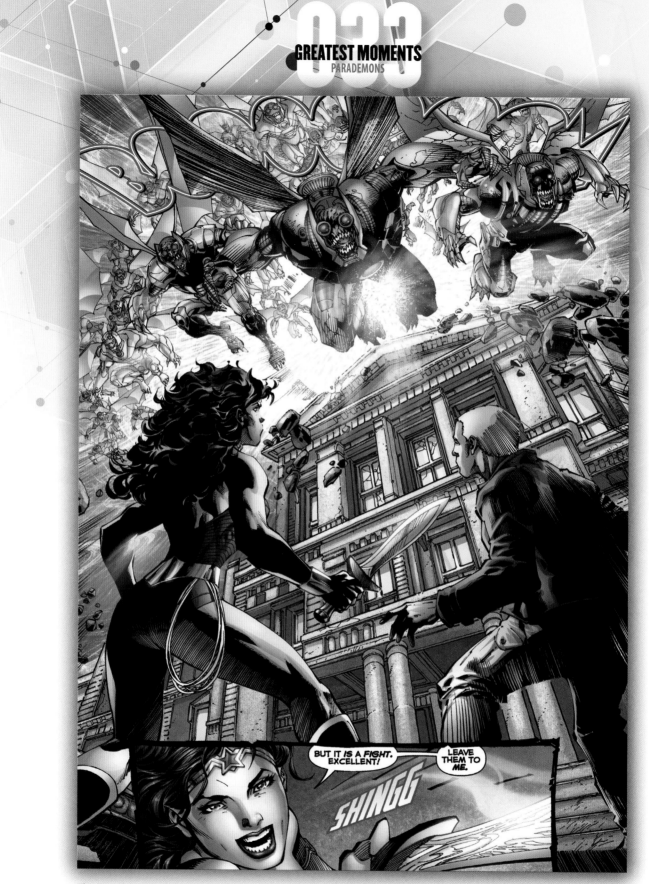

The Parademons were Darkseid's shock troops, creatures bred on Apokolips to do his bidding. Wearing supplemental armor to bolster their combative edge, they traveled by Boom Tube on missions for their master. Their arrival in *Justice League* #3 heralded the coming of Darkseid and the need for heroes to form a team to protect Earth.

Justice League #3, January 2012
Writer: Geoff Johns *Artists:* Jim Lee & Scott Williams

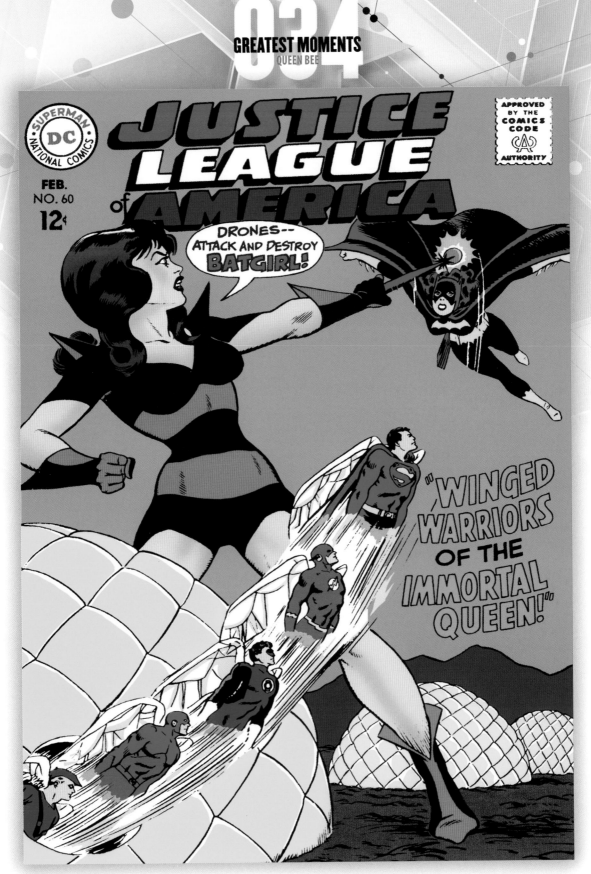

Zazzala was an alien bent on conquering the Earth only to be defeated time and again by the Justice League. In one case from *Justice League of America* #60, she thought she finally had the team under her control until the unexpected arrival of Batgirl.

Justice League of America #60, February 1968
Artists: Mike Sekowsky & Murphy Anderson

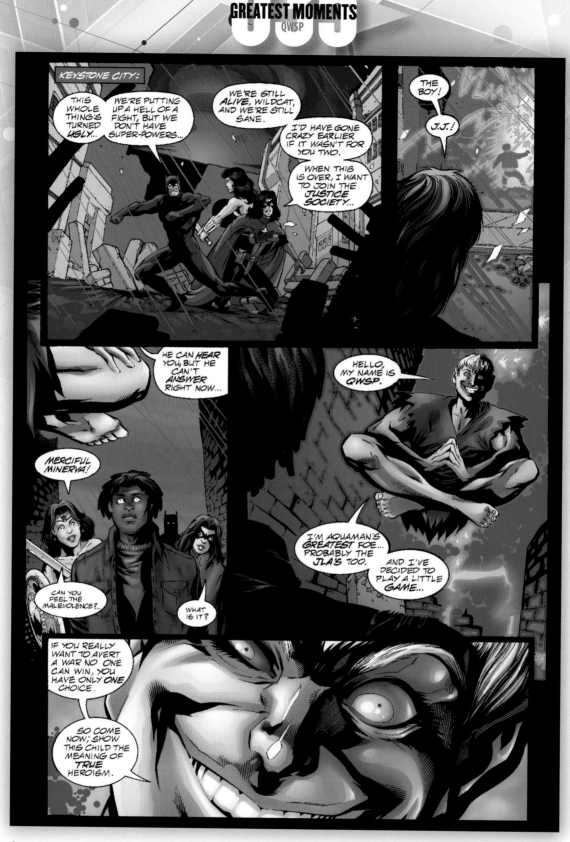

Once seen as Aquaman's magical companion, Qwsp proved to be anything but friendly as he brought magic and chaos from the Fifth Dimension to Earth, igniting a magical war with Johnny Thunder's Thunderbolt as seen in *JLA* #30.

JLA #30, July 1999
Writer: Grant Morrison *Artists:* Howard Porter & John Dell

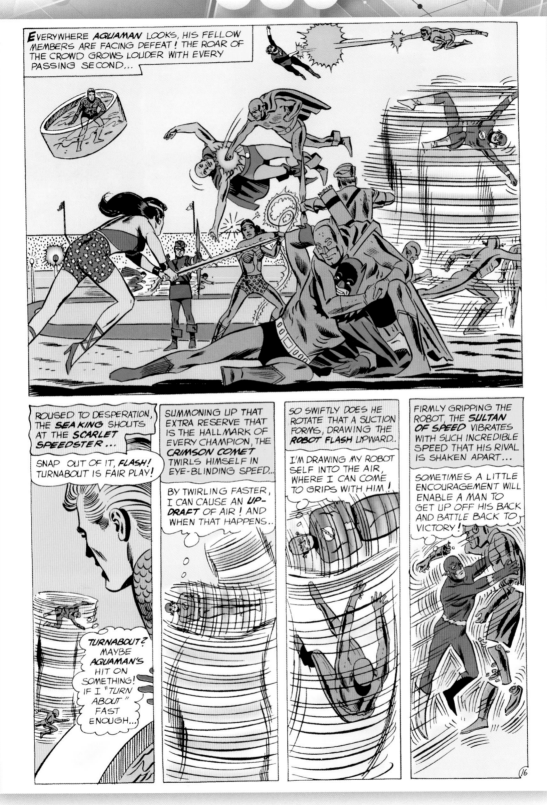

Sforll wasn't really a bad man, but a desperate alien in need of the JLA to stop Zedd Brann from draining all life from the universe in *Justice League of America* #13. Before stopping Brann, they found themselves in an arena fighting robot versions of the JLA, except for Aquaman, whose encouraging words proved the deciding factor.

Justice League of America #13, August 1962
Writer: Gardner Fox *Artists:* Mike Sekowsky & Bernard Sachs

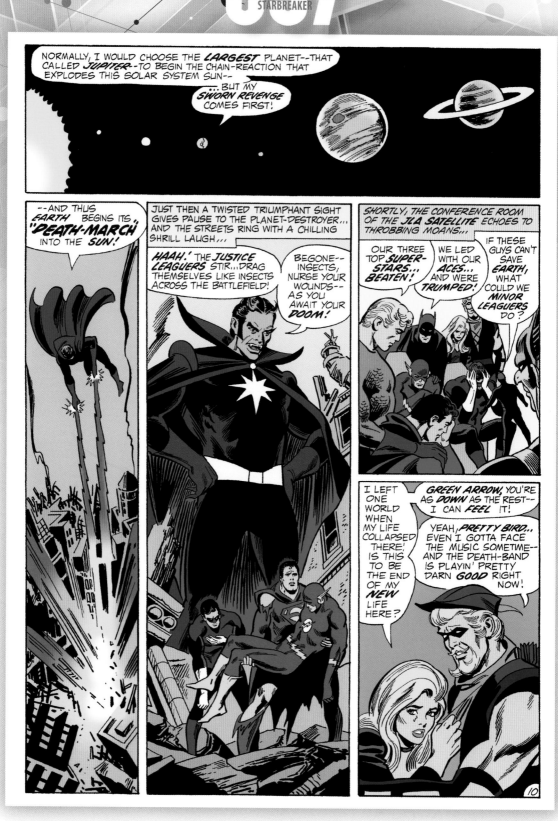

Mike Friedrich was a fan letter writer who was among the first of the second generation of comic book creators. He took over the JLA's writing reins in the late 1960s and charted their course for some time, concluding with a strong three-parter bringing the threat of Starbreaker to Earth starting with *Justice League of America* #96.

Justice League of America #96, February 1972
Writer: Mike Friedrich *Artists:* Dick Dillin & Joe Giella

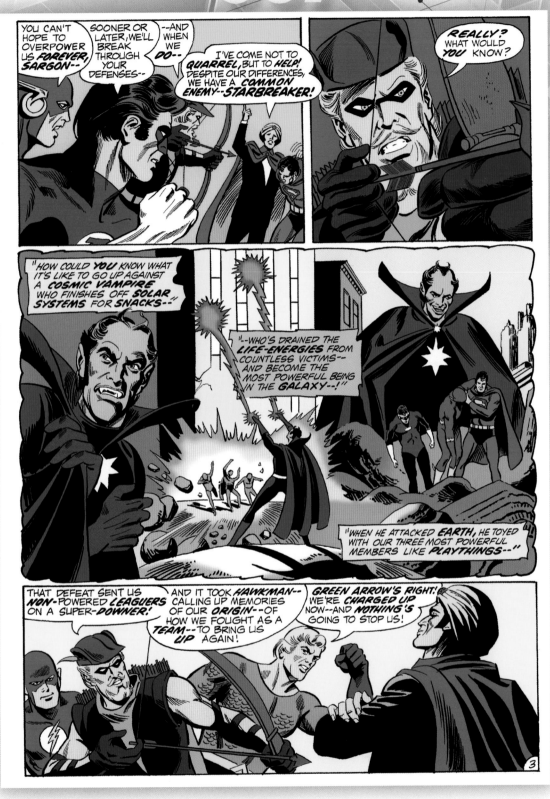

Starbreaker was a rare combination of magic and science, which seemed to be more than the JLA could handle (not yet having a magician on the team). They turned to the mystic Sargon the Sorcerer for help in *Justice League of America* #98.

Justice League of America #98, April 1972
Writer: Mike Friedrich *Artists:* Dick Dillin & Joe Giella

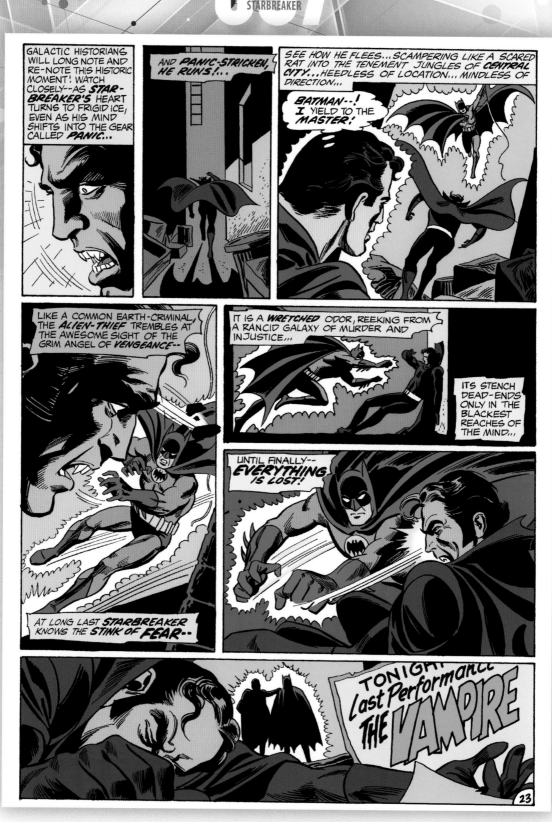

Friedrich had the team break into squads to obtain the Ruby of Life which Green Lantern's ring helped reform. However, all cosmic power and supernatural powers aside, Starbreaker was taken down in *Justice League of America* #98 by the non-powered Batman in one of Friedrich's best moments.

Justice League of America #98, April 1972
Writer: Mike Friedrich *Artists:* Dick Dillin & Joe Giella

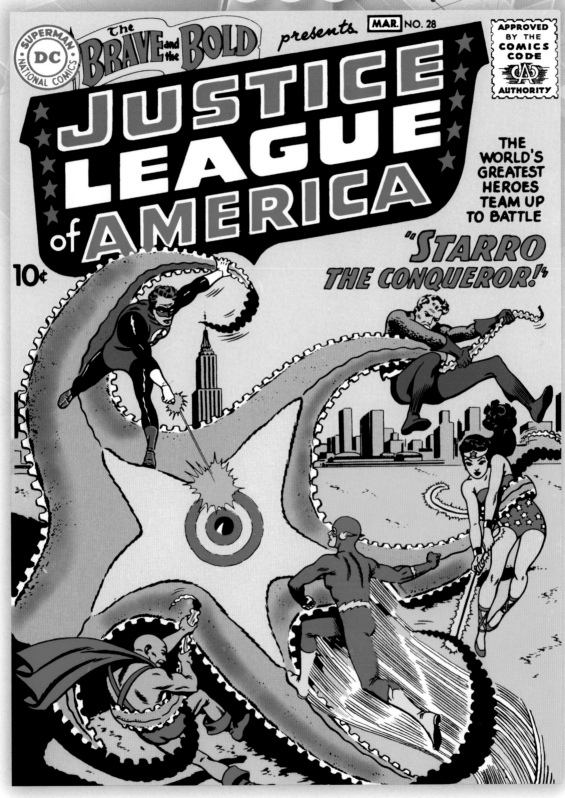

Starro the Conqueror could survive the vacuum of space, had powerful telepathy, and arrived on Earth intending on adding the world to his holdings. He did not count on the combined might of the World's Greatest Super Heroes along with the ingenuity of Snapper Carr to defeat him in the team's first appearance in *The Brave and the Bold* #28.

The Brave and the Bold #28, March 1960
Artists: Mike Sekowsky & Murphy Anderson

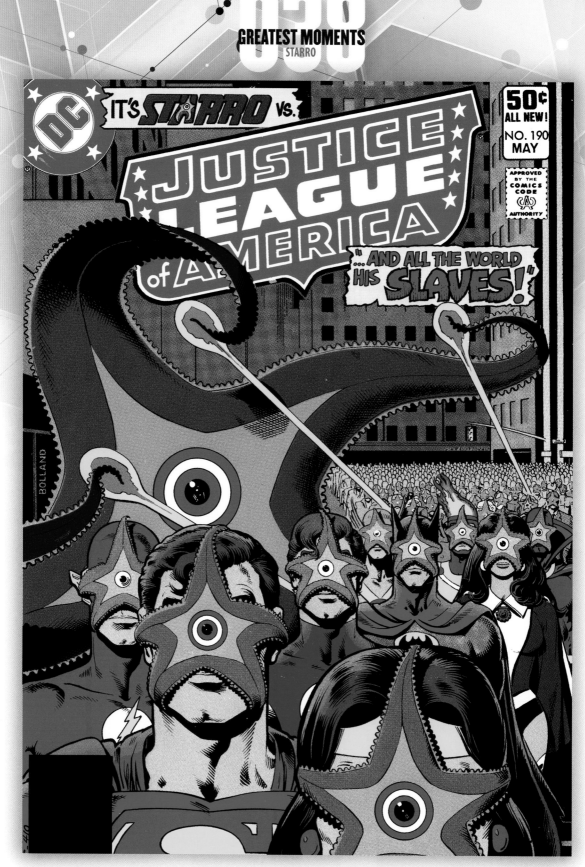

Starro had been gone from comics for quite some time, but when he returned in *Justice League of America* #190, he proved a far greater menace than previously imagined. After this appearance, readers could count on his reappearance every few years with new wrinkles to his plans for galactic conquest.

Justice League of America #190, May 1981
Artist: Brian Bolland

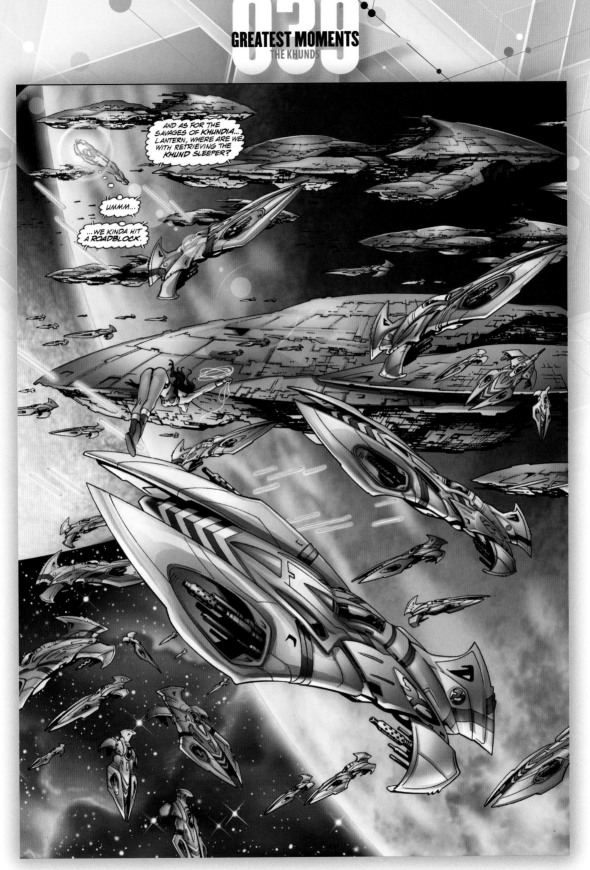

Although the Khunds are more of a menace to Earth in the 30th century, they are among the more aggressive races in the 21st century. On several occasions, they have attacked Earth, on their own or as part of an alien invasion. Each time, the JLA is on hand to repel them as seen here in *JLA: Heaven's Ladder.*

JLA: Heaven's Ladder, October 2000
Writer: Mark Waid *Artists:* Bryan Hitch & Paul Neary

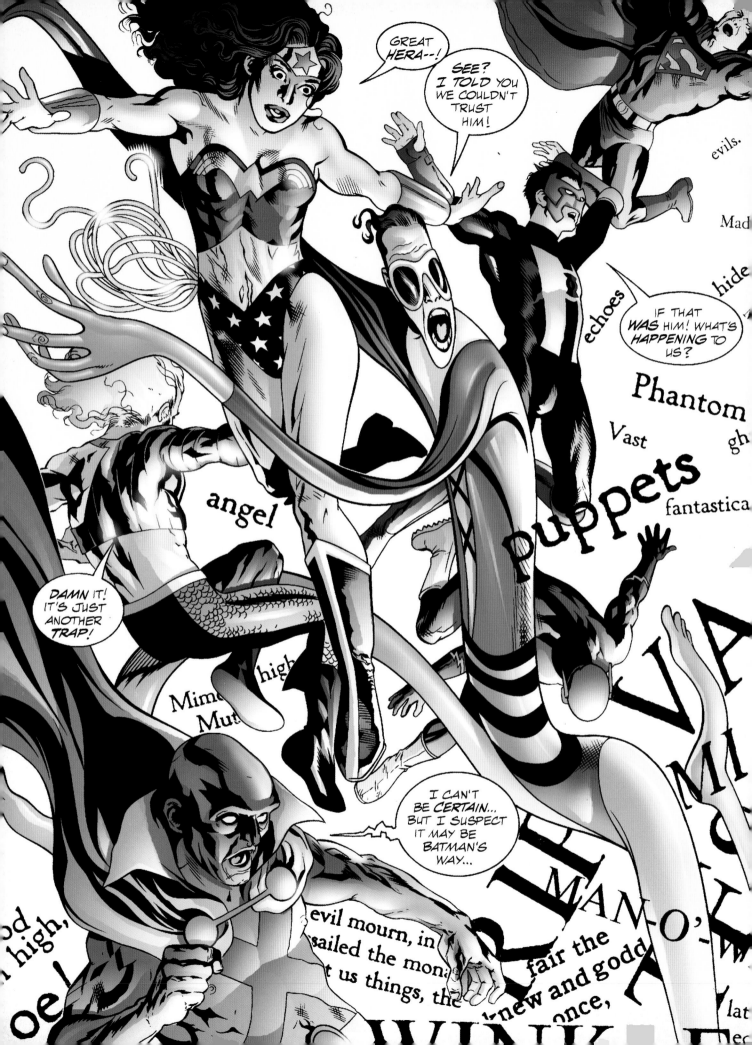

NOT EVERY THREAT THE TEAM FACED CAME FROM BEYOND THE STARS. THERE WERE DANGERS BETWEEN THE DIMENSIONS AND BETWEEN PLANES OF EXISTENCE, AS THE TEAM WAS QUICK TO LEARN. TO THE LEAGUE, MERLIN WAS A FIGURE FROM LEGEND, NOT A REAL SORCERER. HOWEVER, WHEN A TRIO OF MAGICIANS TRANSPORTED EARTH TO A DIMENSION DUBBED MAGIC-LAND, THE TEAM FOUND THEY NEEDED THE MAGE'S WISDOM AND IMMENSE POWER TO STOP THE MAGICIANS AND RETURN EARTH TO ITS PROPER PLACE.

CHAPTER 4
THE OCCULT

From then on, the heroes mixed with alien and occult threats with astonishing regularity. Despite Wonder Woman's existence from the Greek gods' benevolence and Aquaman's legendary Atlantean history, other members of the League were downright suspicious of magic. After all, other than kryptonite, it was one surefire way to attack Superman. Scientists, such as the Flash, and Batman thought themselves too rational to accept magic and the supernatural as real. Their tenure in the League would alter those beliefs.

Magic existed with the birth of the universe 15 billion years ago. It was also the basis of life in dimensions adjacent to the Justice League's, and was prevalent in many of the parallel universes. In time, there came a great Crisis, and the multiverse was collapsed to just one positive-matter universe and one negative-matter universe, and yet magic remained. And when the multiverse was reborn and revised in more recent times, magic continued to flow across time and space.

As Earth developed sentient life, there came the Red and the Green, watching over its flora and fauna. In time, the Green's avatars lived and died, their spirits forming the Parliament of Trees. It saw to it that a human would die a fiery death and be reborn as an elemental to watch over the planet, most recently including Swamp Thing, a member of the loose-knit Justice League Dark. The Red was less overt, although recent circumstances led to Buddy Baker being imbued with their power to channel animal life, and he protected the world's dwindling species from man's rapacious appetite, working for a time as the Justice Leaguer known as Animal Man.

When the Maltusians thought magic interfered with more rational scientific thought, they collected the energy and compressed it into a green-glowing chunk of matter and sent it hurtling through space. In the JLA's first reality, that rock became known as the Starheart and traveled to the adjacent parallel world known as Earth-2, and its energies led to the first Green Lantern and, later, his daughter Jade. In more recent times, the Starheart remained in the JLA's universe, and its powers manifested in a variety of ways.

Still, magic did not evenly appear on many worlds, so places such as Krypton, Thanagar, and Rann, for example, had far less experience with the occult than Earth did. This may explain Superman's vulnerability to the supernatural forces.

The evolution of magic in the DC Universe, and how it played a role with the JLA's membership and the team itself, is an amalgam of ideas, concepts, and throwaway lines of dialogue that a host of writers and artists mined, shaped, and added to the growing cosmology. Magic may be the one aspect of the continuity to receive the greatest number of contributions over the years.

Harnessing magic was difficult and beyond most mortals. Those who could wield magic usually did so using tools such as wands and rings. An entire magic-wielding species, *Homo magi*, came to prominence, before vacating Earth in favor of a dimension of their own. As with all things, magic on Earth waxed and waned, reaching its first crescendo some 45,000 years ago in Atlantis.

Shortly after the team celebrated their first anniversary, they were attacked by Felix Faust, a necromancer, who took control of the team and then unleashed the Demons Three—Abnegazar, Rath, and Ghast—trapped deep beneath Earth's surface millennia before human life existed on the still-cooling world. Faust and the Demons would prove incredibly challenging opponents during the League's existence. In fact, the Demons wound up working with the greatest magical threat from the 30th Century, Mordru the Magician, when he came back in time to attack Earth. He was pursued by the Legion of Super-Heroes, who worked with the JLA and Justice Society of America to preserve life across the centuries.

Other sorcerers and mages would challenge the JLA over the years, which makes it odd that they waited until long after they formed before adding a mystic member. After the enigmatic Phantom Stranger helped the team, he was offered membership but never formally accepted. Yet, he would repeatedly turn up when they needed him most. Finally, they welcomed Zatanna to their ranks, and her expertise proved the difference on multiple occasions. She first met the team while searching for her missing father, Zatara, who was trapped in a paranormal land called Kharma. When Earth was threatened by the alien Starbreaker, Zatara's old colleague Sargon the Sorcerer came to the JLA's aid.

Later, Zauriel, one of Heaven's Eagle Host, would serve with the team before being slain by Mageddon.

For a brief time, Aquaman had been visited by an interdimensional imp known as Quisp, who turned out to actually be a powerful being called Qwsp, hailing from the Fifth Dimension, where magic ruled. The Fifth Dimension was where Superman's nemesis Mr. Mxyzptlk hailed from, and in time, Batman gained Bat-Mite as a counterpart, while Aquaman had Quisp. It fell to Grant Morrison's imagination to link them all together and take things to a far grander level, so mischievousness became malevolence. After years away, Qwsp returned to spark a magic war between fellow beings Lkz and Yz, the latter known to the League as Thunderbolt, a companion to the Justice Society's Johnny Thunder. It took the combined efforts of the JLA and their companions the Justice

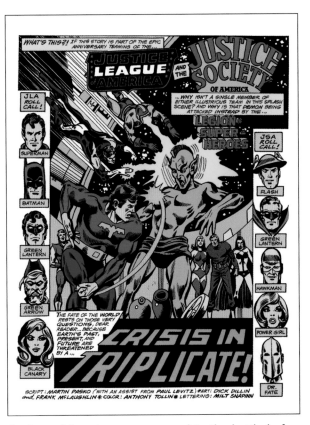

Society of America to put an end to the battle before Earth was damaged. Thankfully, Qwsp was remanded to his homeworld of Zrff for judgment.

Then there was the beautiful but deadly being known as the Queen of Fables, exiled from her home dimension. Wandering Europe centuries earlier, she helped inspire most of the world's best-known fairy tales. She was seen as a threat, and the wily Snow White imprisoned her in an enchanted storybook, turning the Queen into an immortal being. As a result, when she gained her freedom in the 21st Century, the Queen was ready to resume her work. Writer Mark Waid and artist Bryan Hitch (who would go on to write and draw the team's tales in the 21st Century) gave a brand-new take to an age-old concept. At first, the Queen mistook Wonder Woman for Snow White and, when thwarted, transformed Manhattan into a dark, magical forest filled with grim beings. It took Batman's deductive reasoning to learn the truth and lead the League into the storybook to confront and end the Queen's plan to rule the modern world.

And from perhaps the darkest realm of all came Neron, also known to mankind as Satan, Beelzebub, or Old

Scratch. He sought souls and used every trick at his disposal to gain them, going so far as to task Abnegazar and Ghast to rip the moon from its orbit to cause tidal woes for the world. There was little doubt this would be the Justice League's most dire fight, with all of humanity at risk. In the end, it took the childlike innocence of Billy Batson, the human host for Shazam (Captain Marvel), to thwart the immortal being.

Beyond the dimensions existed the Lords of Order and Chaos, who repeatedly interfered with mankind for their own purposes and reasons. They were first introduced by writer Martin Pasko, but it was Keith Giffen who did the most work exploring what they meant to Earth's inhabitants. One member of Order, though, went rogue and settled on Earth, taking the persona of the Gray Man, who tangled with Justice League International on several occasions.

Ruling over it all was the Voice, the Word, the entity worshipped on Earth as God. He sent his angels, such as Zauriel, to Earth and sent his Spirit of Vengeance to mete out justice. Initially taking the wrathful form known as Eclipso, the Spirit was later placed in the body of murdered cop Jim Corrigan, who rose as the Spectre. The ghostly guardian proved the difference on several occasions, keeping Earth-1 and Earth-2 from crashing into each other, for example. At one point, the Spirit was transferred to the recently dead Hal Jordan, who sacrificed himself to save the solar system. Rather than being the Spirit of Vengeance, Jordan's Spectre was, for a time, the Spirit of Redemption. When he won his life back, the Spectre returned to Corrigan's reanimated body, resuming his heavenly duties.

Despite initial misgivings early in their careers, the various members of the Justice League could no longer deny the existence of magic, having encountered friends and foes who manipulate the mystic arts. For every foe, such as the Wizard, the League has countered with powerful allies and members, including Ice, an actual goddess.

GREATEST
MOMENTS

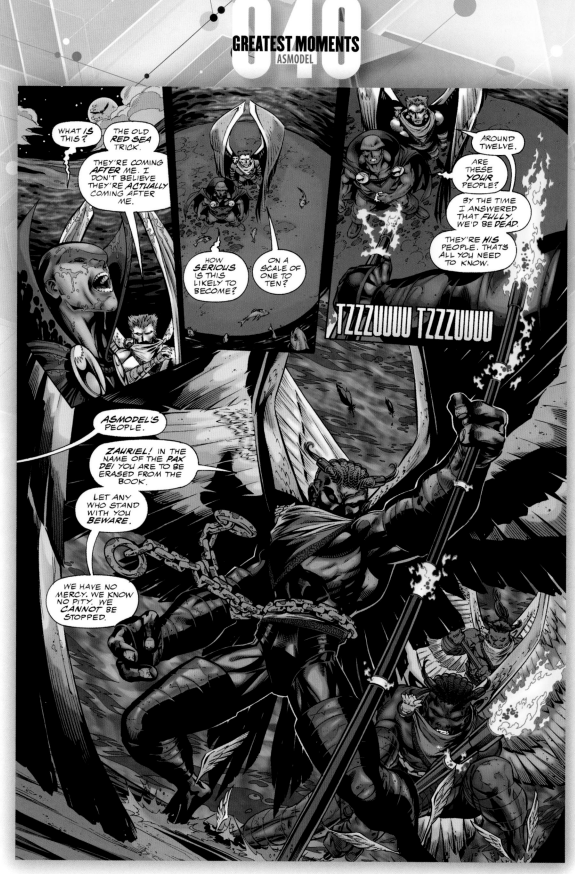

Grant Morrison didn't shy away from dreaming big and early in his tenure, pitting the Justice League against Asmodel, King-Angel of the Bull-Host of the Pax Dei, the Army of Heaven. When he attempted to succeed where Satan failed, to conquer Heaven, Zauriel led the team to oppose him, starting in *JLA* #6.

JLA #6, June 1997

Writer: Grant Morrison *Artists:* Howard Porter & John Dell

Mordru the Merciless was such a feared sorcerer that he was trapped within an asteroid until he regained his freedom, threatening all life in the 30th Century only to be stopped by the Legion of Super-Heroes. When he attempted to destroy the 20th Century Earth in *Justice League of America* #147, it took the JLA, Legion, and Justice Society of America to stop him.

Justice League of America #147, October 1977
Writers: Martin Pasko & Paul Levitz
Artists: Dick Dillin & Frank McLaughlin

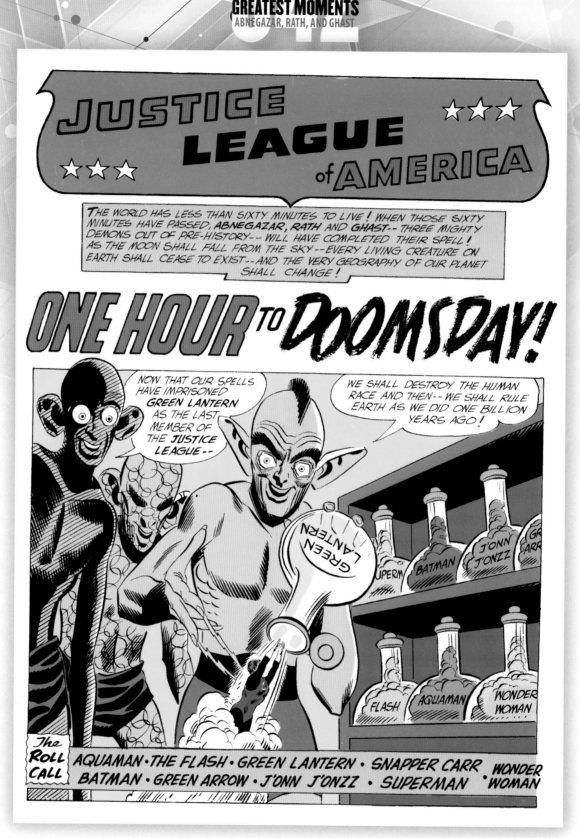

Before man walked the world, early life was the plaything of the Demons Three—Abnegazar, Rath, and Ghast. In time, they were trapped inside the Earth only to be freed by Felix Faust and they made quick work of the JLA in their first outing as seen here in *Justice League of America* #10.

Justice League of America #10, March 1962
Writer: Gardner Fox *Artists:* Mike Sekowsky & Bernard Sachs

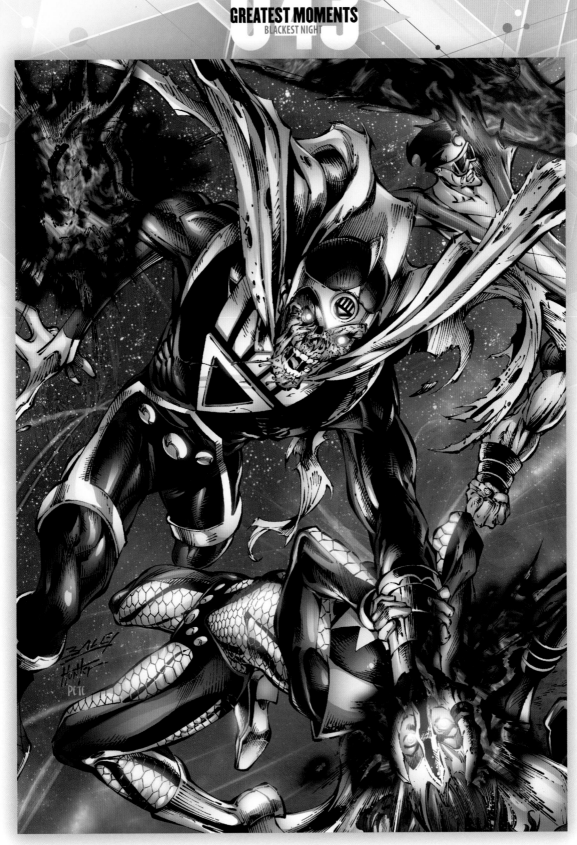

It was Earth's Blackest Night as the demonic Nekron returned and restored heroes who had died back to life, including the deranged Doctor Light, who battled his heroic namesake in *Justice League of America* #40.

Justice League of America #40, February 2010
Writer: James Robinson *Artists:* Mark Bagley, Scott Hanna, & Marlo Alquiza

141

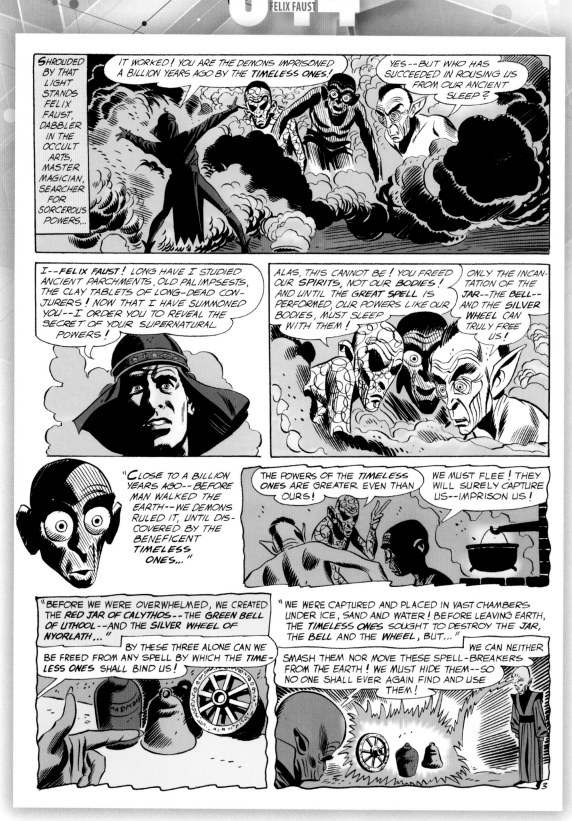

Felix Faust, searching for objects of power, freed the Demons Three to learn the secrets of the power contained with the Red Jar of Calythos, the Green Bell of Uthool, and the Silver Wheel of Nyorlath in *Justice League of America* #10.

Justice League of America #10, March 1962
Writer: Gardner Fox *Artists:* Mike Sekowsky & Bernard Sachs

Felix Faust was a practiced warlock who continued to try and tame the world to his will but was frequently opposed by the JLA. When he collaborated with the Secret Society of Super-Villains, he thought he would finally triumph only to be taken down by Catwoman in *JLA* #118.

JLA #118, Early November 2005
Writers: Geoff Johns & Allan Heinberg *Artists:* Chris Batista & Mark Farmer

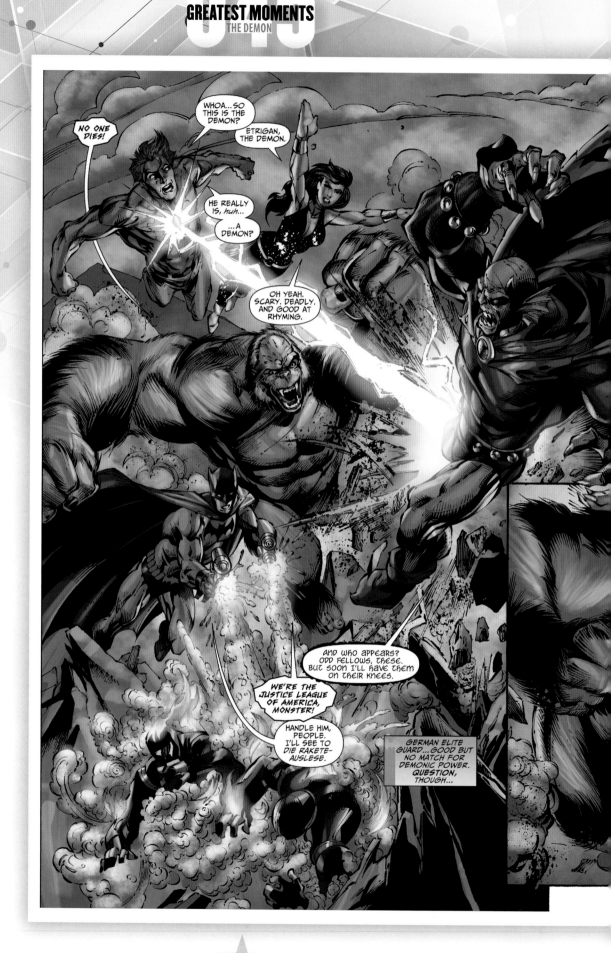

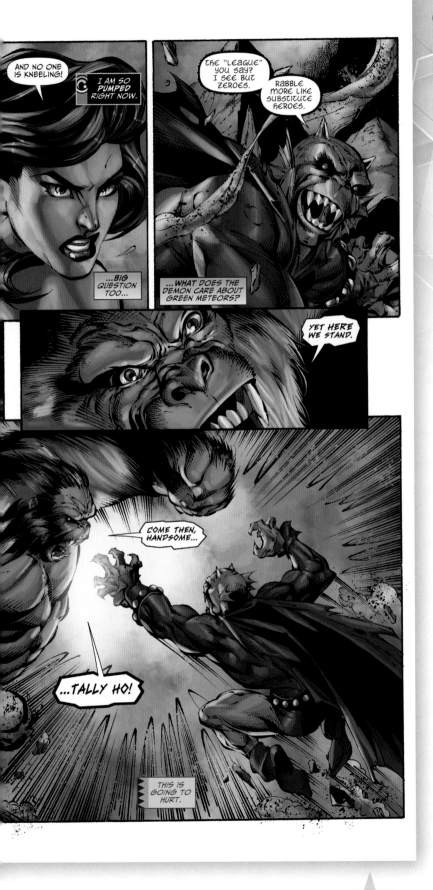

Etrigan, the Demon, was summoned by Merlin to help save Camelot, only to find himself bonded to Jason Blood for eternity. Throughout time, he fought for and against the side of the angels, even serving on a replacement JLA roster. Here, though, he fought the JLA in this moment from *Justice League of America* #44.

Justice League of America #44, June 2010
Writer: James Robinson *Artists:* Mark Bagley,
Rob Hunter, & Norm Rapmund

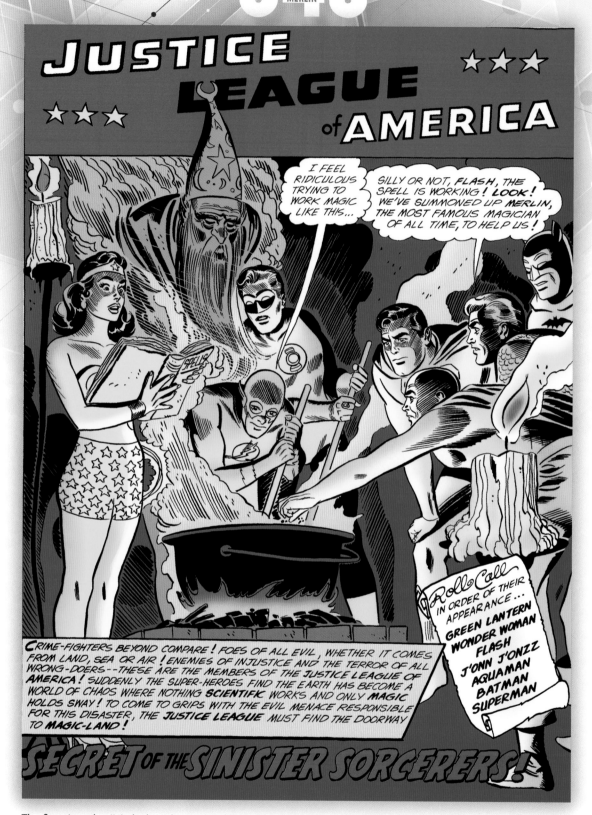

The first time the JLA dealt with magic, it happened to be with perhaps the greatest magician of all time: Merlin. They sought his guidance to help them deal with an interdimensional creature and since Superman was vulnerable to magic, it required the entire team in *Justice League of America* #2 to win the day.

Justice League of America #2, Dec. 1961/Jan. 1962
Writer: Gardner Fox
Artists: Mike Sekowsky & Bernard Sachs

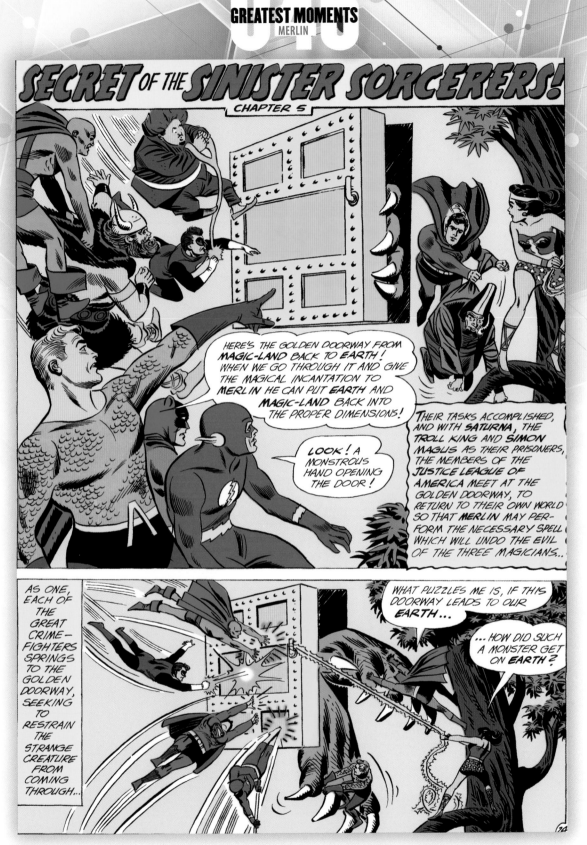

As it turns out, even Merlin appeared stumped at first but then the real culprit was found—Simon Magus who used a spell to reverse the properties of Magic Land and Earth. The JLA located three parchments containing the spell required to undo the magic in *Justice League of America* #2.

Justice League of America #2, Dec. 1961/Jan. 1962
Writer: Gardner Fox
Artists: Mike Sekowsky & Bernard Sachs

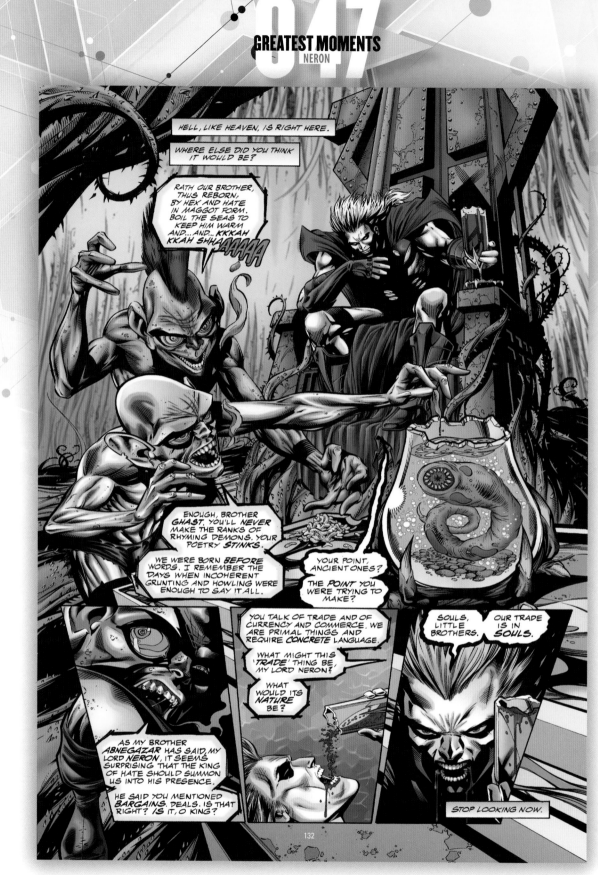

Neron was another fallen angel residing in Hell out to win the souls of humankind and once relied on the help from Rath and Ghast to obtain his goals. As it happened the first time, the combined efforts of the World's Greatest Super Heroes defeated him in the pages of *JLA* #6.

JLA #6, June 1997
Writer: Grant Morrison *Artists:* Howard Porter & John Dell

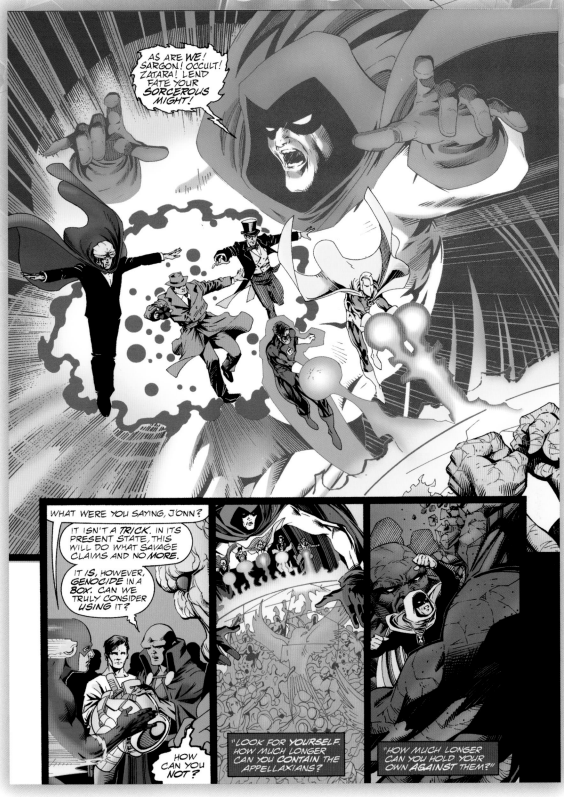

On several occasions, a threat was such that heroic might was not enough and it would take the combined efforts of Earth's mystic champions to save the day. In this moment from *JLA: Year One* #12, Sargon the Sorcerer, Dr. Occult, Zatara, Doctor Fate, and the Spectre lend their powers to Green Lantern's indomitable will to prevail.

JLA: Year One #12, December 1998
Writers: Mark Waid & Brian Augustyn
Artists: Barry Kitson & Michael Bair

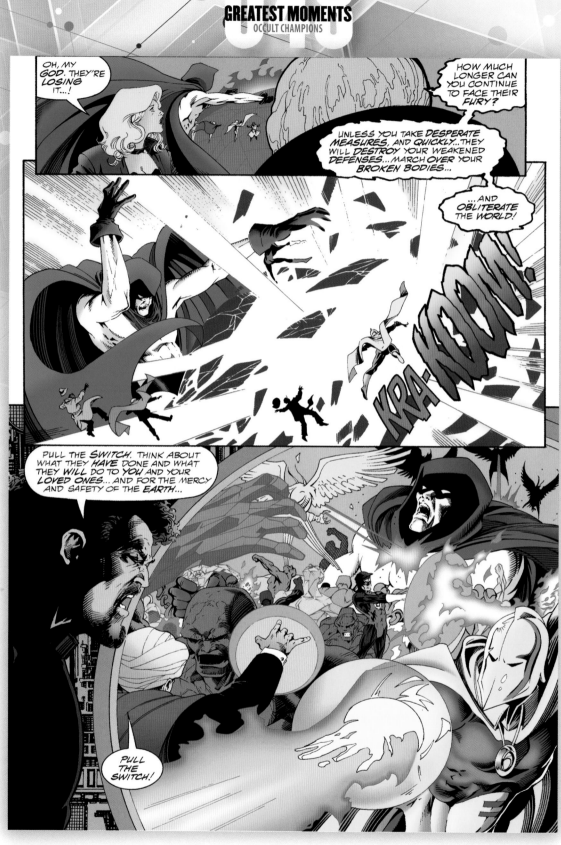

The immortal villain Vandal Savage had orchestrated events, culminating in *JLA: Year One* #12 to derail the gathering of Earth's heroes, leaving the planet's population vulnerable to his machinations. He did not account for their strength of will and commitment to fight for humanity.

JLA: Year One #12, December 1998

Writers: Mark Waid & Brian Augustyn *Artists:* Barry Kitson & Michael Bair

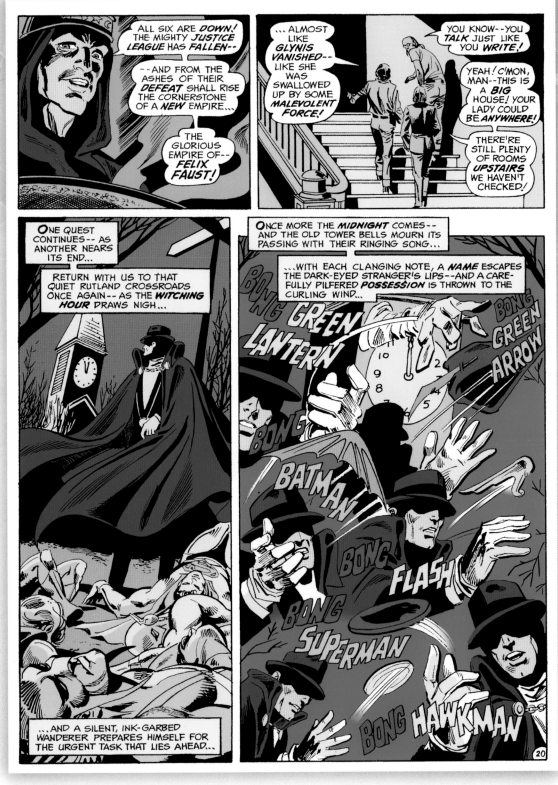

The enigmatic Phantom Stranger turned up to aid the JLA on several occasions beginning with *Justice League of America* #103, where he was offered admission to their ranks after assisting them against Felix Faust. He never said no or yes, but was always there when most needed.

Justice League of America #103, December 1972
Writer: Len Wein *Artists:* Dick Dillin & Dick Giordano

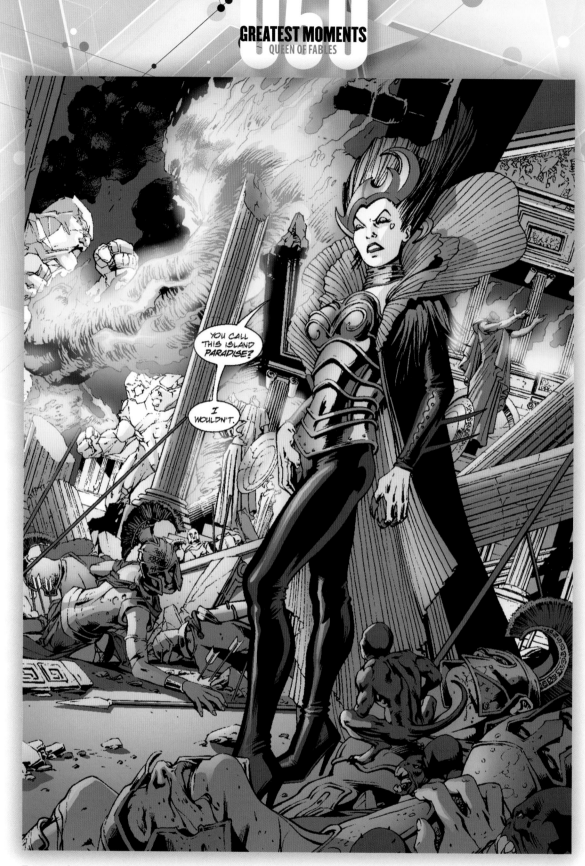

Tsaritsa, the Queen of Fables, hailed from another dimension but was exiled to Earth. She reigned until princess Snow White trapped her in the Book of Fables. After generations she gained freedom and sought to remake the modern world, beginning with disabling the Justice League.

JLA #48, November 2000
Writer: Mark Waid *Artists:* Bryan Hitch & Paul Neary

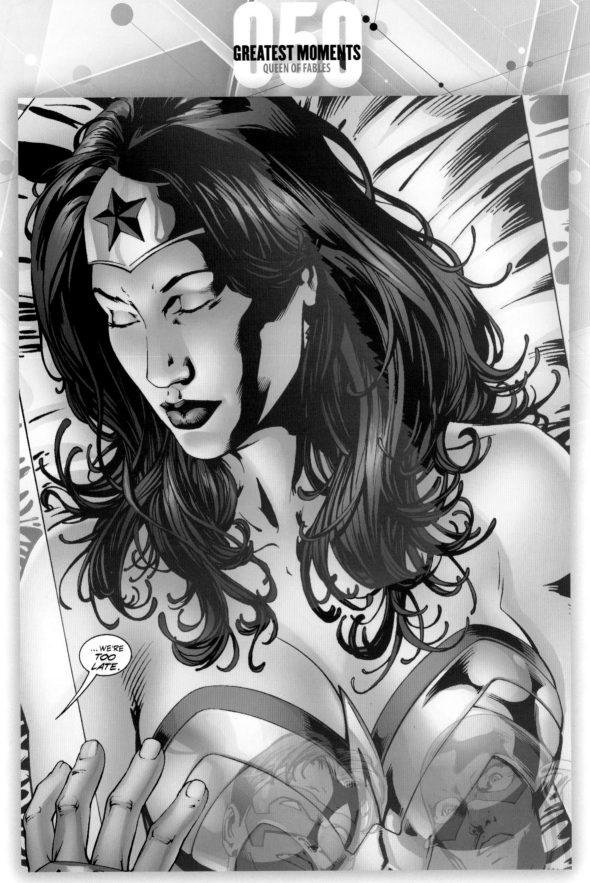

...WE'RE TOO LATE.

Fittingly, a different princess—Wonder Woman—wound up in enchanted sleep, distracting her teammates while she went on to conquer Diana's homeland of Themyscira in *JLA* #47. An issue later, the team finally stopped her, entrapping her once more in the Book of Fables.

JLA #47, December 2000
Writer: Mark Waid *Artists:* Bryan Hitch & Paul Neary

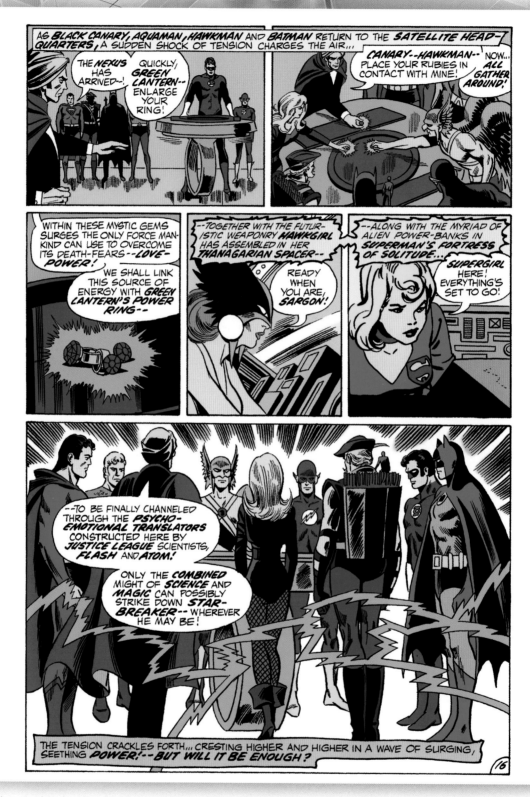

When Starbreaker attacked Earth, he possessed a unique blend of science-based and magical powers, proving a nearly unstoppable threat to all life. A demoralized Justice League turned to Sargon the Sorcerer for help despite his villainous ways. His work here, from *Justice League of America* #97, put him back on the righteous path.

Justice League of America #97, May 1972
Writer: Mike Friedrich *Artists:* Dick Dillin & Joe Giella

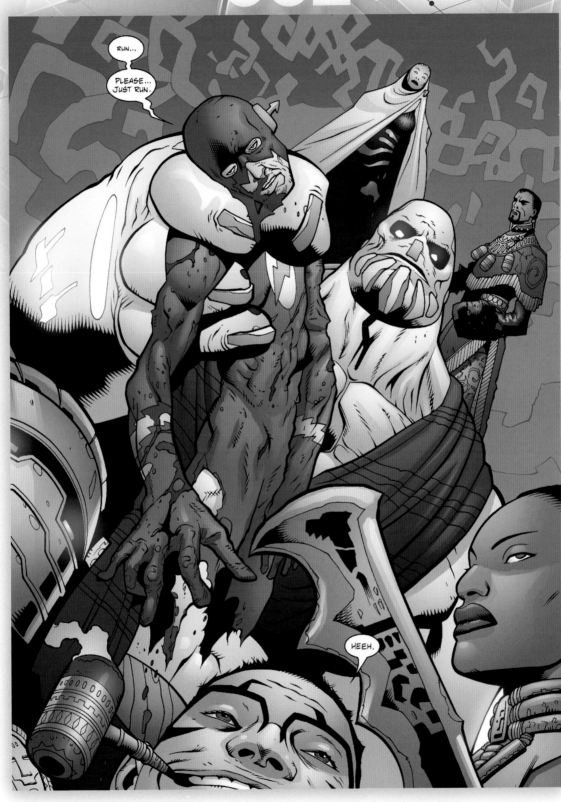

Joe Kelly's ambitious Obsidian Age storyline saw Atlantis missing and the JLA going back in time to rescue the city and its king, Aquaman. They encounter a group called the League of Ancients including Tezumak, Whaler, Sela, Rama Khan of Jarhanpur, Gamemnae, and Manitou Raven. The mission, as seen in this moment from *JLA* #73, was a challenging one.

JLA #73, Late December 2002
Writer: Joe Kelly *Artists:* Doug Mahnke & Tom Nguyen

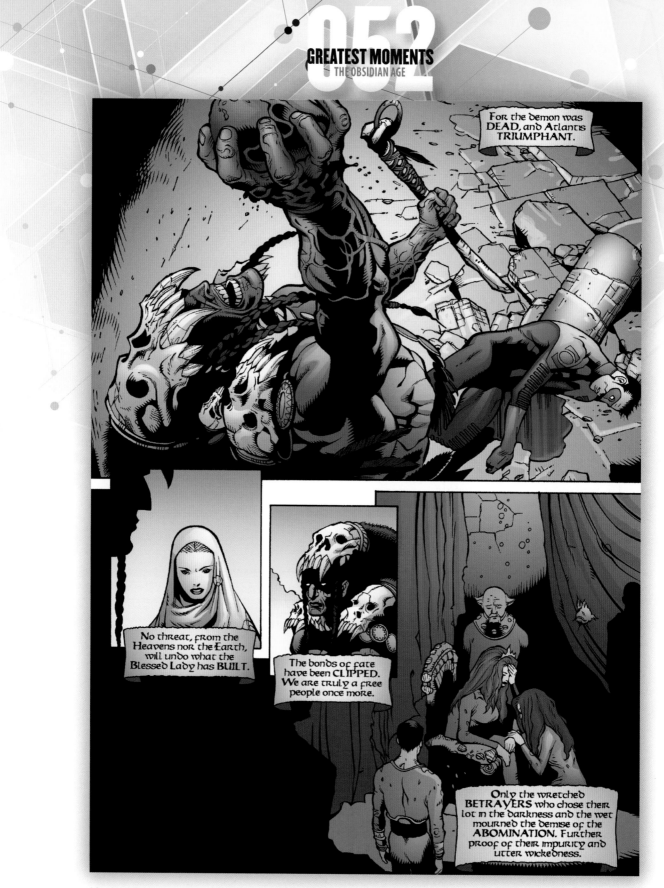

Manitou Raven seemingly killed Green Lantern Kyle Rayner in *JLA* #74, but thankfully, it was not to be. Still, things were looking bleak for the team as the League of Ancients' fervor made them nigh unstoppable.

JLA #74, Early January 2003
Writer: Joe Kelly *Artists:* Doug Mahnke & Tom Nguyen

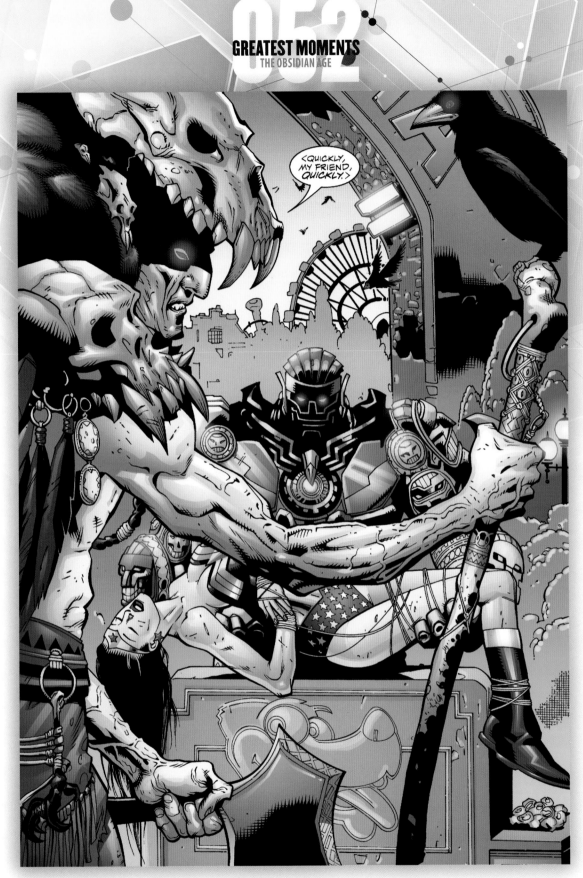

A murder of crows overwhelmed a slightly disoriented JLA soon after arriving in the past, making them susceptible to the League of Ancients. Wonder Woman was nearly sacrificed by Tezumak had Batman not interfered in *JLA* #67.

JLA #67, August 2002
Writer: Joe Kelly *Artists:* Doug Mahnke & Tom Nguyen

EVEN A TEAM AS POWERFUL AS THE JUSTICE LEAGUE OF
AMERICA CAN DO WITH A HELPING HAND EVERY NOW AND
THEN. THE VERY FIRST HERO TO AID THEM WAS GREEN ARROW,
WHO WAS ALSO THE FIRST HERO ADDED TO THEIR RANKS.

CHAPTER 5
THE ALLIES

Since then, the team could count on other costumed champions from around the world to lend a hand as circumstances demanded it. For example, when Zatanna recruited Batman, Hawkman, and the Atom to help her find her father, they brought along non-member the Elongated Man (who wound up a member later on). Not long after, Batgirl was in the right place at the right time when Queen Bee made her second attempt to rule Earth.

Gardner Fox was understandably reluctant to add even more heroes to the JLA's cases, but he made exceptions. The first sidekick to join in on a JLA case was, appropriately enough, Robin the Boy Wonder, working with them to oppose the Lord of Time in the team's fiftieth issue (1966).

Just as the JLA relocated to their first satellite, an ecological threat prompted Greg Sanders to give up retirement and return to action as the Vigilante.

The JLA also found themselves working with other teams, or occasionally opposing them, as events unfolded. They clashed, for example, with the Teen Titans shortly after they re-formed under Robin's guidance. It was a misunderstanding, but the new team earned their elders' respect.

But perhaps their greatest allies came from another realm, the parallel world known as Earth-2. While Marvel may have been first to use their Golden Age heroes in contemporary stories, DC did them one better by borrowing the concept of parallel universes from science fiction and had the Golden Age Flash meet his Silver Age counterpart in *Flash* #123 in 1961, a story that slowly kicked off a trend we're still seeing used (or overused, if you ask some) today. After all, if Barry Allen was a fan of the comics, the story ideas had to come from somewhere, and later it was revealed that writers like Gardner Fox and John Broome got them from strange dreams.

Fans of the original comics, who were now celebrating the past with fanzines dedicated solely to comics, were thrilled. They had been inundating DC with letters asking for one Golden Age hero after another to be revived in the wake of the successful reboots of the Flash and Green Lantern.

The first Flash story made these fans ecstatic, and sales merited repeat performances in *Flash* #129 and 137. In the latter, the twin speedsters came to rescue captured members of Earth-2's premier heroic team, the Justice Society of America.

Editor Julie Schwartz rolled the dice and had the legendary JSA meet their modern-day counterparts in Crisis on Earth-1 and Crisis on Earth-2, seen in *Justice League of America* #21 and 22. The two-part story sold very well and became an annual summer event until the 1980s, each story using the title "Crisis." In *Justice League of America* #21, the team reached across the vibrational barriers via a séance and met their older,

more experienced counterparts, the Justice Society of America. After having been freed by the Flashes not long before, they decided to return to active duty, just when their world needed them.

Once two Earths were established, and the Flashes, Green Lanterns, and the Atoms partnered up in their respective titles, a third Earth became inevitable. Here, editor Schwartz and writer Fox turned things upside down by having a world of super evildoers, funhouse mirror images of the JLA—the Crime Syndicate of America (CSA). Every now and then, other teams were brought in to spice things up such as the Legion of Super-Heroes and New Gods, but the focus remained on the JLA and JSA.

The summer team-ups continued unabated, but to celebrate the JLA's one-hundredth issue, incoming writer Len Wein went bigger—a three-part story that reintroduced readers to the Seven Soldiers of Victory— Green Arrow, Speedy, Crimson Avenger, Shining Knight, Vigilante, Star-Spangled Kid, and Stripesy—who had been displaced across time.

Given the positive response this earned the creative team, the following year, Wein brought back Quality Comics' heroes, acquired by DC in the 1950s but largely forgotten. Their world, Earth-X, saw the Allied forces fall to the Axis powers. The Freedom Fighters, led by Uncle Sam, included the Black Condor, Doll Man, the Ray, the Human Bomb, and Phantom Lady (Plastic Man and the Blackhawks also made cameos).

After the events of the Crisis on Infinite Earths in 1985 collapsed the multiverse to just the one Earth, the JSA became World War II–era heroes, most of whom aged very slowly and gracefully, allowing them to occasionally partner with their successors.

New champions would arise over time, and many found themselves working with the JLA during world or galactic crises. When Darkseid and the Phantom Stranger played a game, humanity's faith in their heroes was challenged, and for a brief time, the world lacked a Justice League to confront the threat. The story, from new-to-DC writer John Ostrander, Len Wein, and

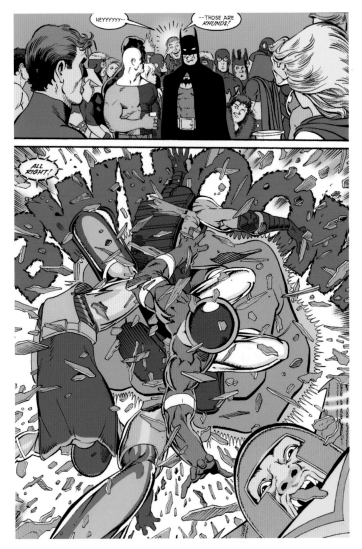

artist John Byrne, explored the notion of what made a legend. When humanity needed them, the heroes rose to the clarion call of justice, as Batman, Captain Marvel, Green Lantern (Guy Gardner), Martian Manhunter, Black Canary, and Doctor Fate banded together to thwart Glorious Godfrey's efforts to undermine faith in heroes. Wonder Woman, new to Man's World in this reality, also made her appearance here, as did Superman, but they did not join the reformed League until later.

The Maltusians, who displaced magic from the universe, eventually became the Guardians of the Universe and built androids called Manhunters to police the stars, as established by Steve Englehart during his run on the JLA. When they rebelled against their programming, the Manhunters were collected and banished—all save a handful that went underground for millennia before

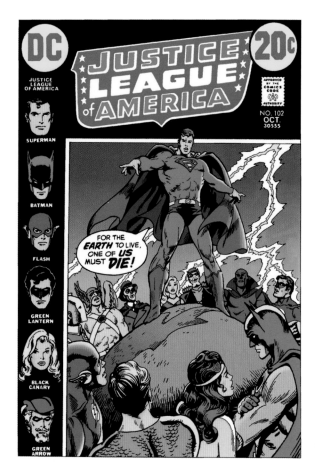

The JLA also led heroes off Earth to confront the impending arrival of the cosmic conqueror called Imperiex, perhaps second to Mageddon in terms of true danger to all of humanity. With his Warworld approaching Earth, the armored entity appeared on the cusp of winning, but it took Superman diving into the sun to absorb unmatched power to lead the vanguard in the final confrontation. With Martian Manhunter's telepathic link, Superman received unexpected aid from Darkseid, Lex Luthor, Steel, and Wonder Woman. Each contributed a piece to their final stand, allowing them to prevail by using modified Boom Tube technology to send Imperiex Prime back in time, to die at the moment of the Big Bang and the start of the Fourth World.

While there are many entities and races across the universe who consider the League their enemy, there are others who can always be counted to stand by their side. The Guardians, after the failure of the Manhunters, developed the ability to channel willpower through certain elements, and they crafted power rings and batteries to recharge them. From this development, they chose natives from across the stars, divided into one-degree arcs, giving birth to the 3,600-strong Green Lantern Corps. Earth is unique in the number of active human beings to concurrently wield the ring—Hal Jordan, Guy Gardner, John Stewart, Kyle Rayner, Simon Baz, and Jessica Cruz—but the JLA has received aid from the Corps on occasion, most recently when Darkseid struck at Earth.

surreptitiously replacing people close to Earth's heroes in an effort to stop the Guardians from creating the next evolutionary step for mankind. Englehart returned to DC for 1988's *Millennium,* working in tandem with artists Joe Staton and Ian Gibson, and he picked up those threads and wove a new cosmic epic. It took the combined efforts of the JLA, the recently formed Suicide Squad, Infinity, Inc., the Outsiders, the Spectre, the Teen Titans, and even Swamp Thing to warrant that man's destiny was preserved.

All of Earth's heroes, led by the JLA, went to war when nine alien races banded together to ensure that Earth and its meddlesome heroes left galactic politics alone. The invasion of Earth, led by the Dominators (a race that had ties to the Guardians of the Universe eons earlier), gave rise to new heroes, thwarting their plans. Similarly, alien parasites came to Earth, and their venomous bites activated various humans' metagenes, giving rise to another cadre of heroes, most of whom needed mentoring by members of the League. And when the chips were down, the new bloodline of heroes responded to the call.

The time-traveling Waverider came to the JLA and asked for their help in preventing the rise of Monarch, who, fifty years hence, would turn Earth into a bleak dystopia. As they rose to the challenge, they were collectively stunned to learn that the former Teen Titan known as Hawk was destined to become Monarch. Although they managed to stop him, there remains an alternative future where he won, a stark reminder that not every battle ends in total victory.

When the multiverse was reborn into at least fifty-two parallel worlds, the JLA visited many of them and even clashed with their counterparts in an event known as Convergence (2015).

GREATEST MOMENTS

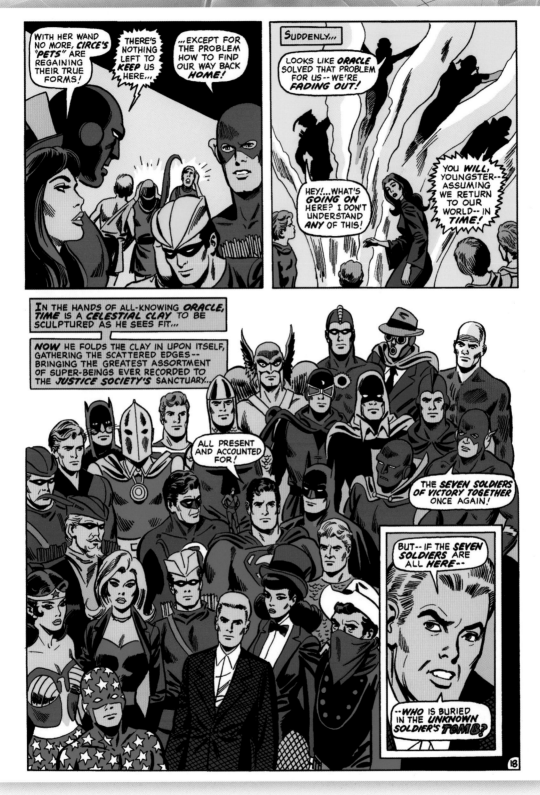

When the JLA met for their hundredth meeting, no one could suspect it would mean teaming with their friends in the Justice Society of America to travel through time and rescue the Seven Soldiers of Victory, who had been trapped by their deadly foe the Hand. The combined team, seen here in *Justice League of America* #102, are finally united.

Justice League of America #102, October 1972
Writer: Len Wein *Artists:* Dick Dillin & Joe Giella

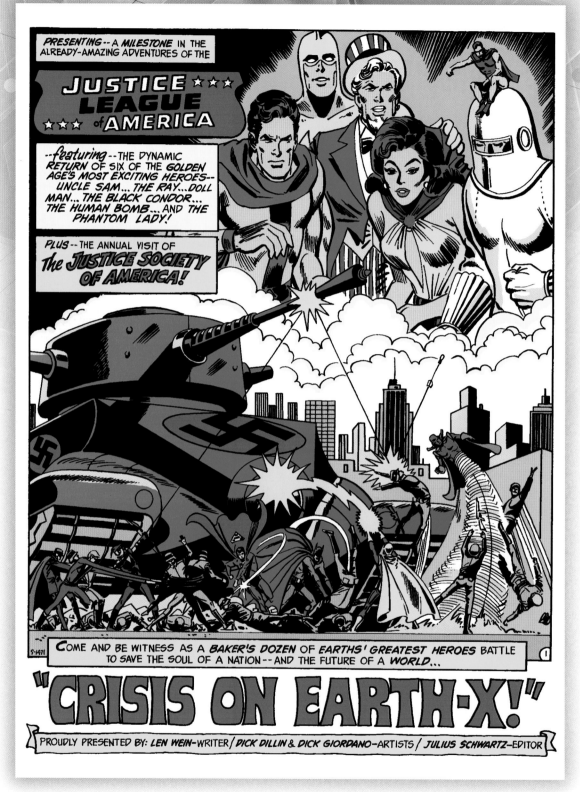

A year later, the JLA and JSA discovered Earth-X, where the Nazis won World War II and Earth's surviving heroes were left to become the Freedom Fighters, trying to restore peace. The arriving influx of the extra power helped the Freedom Fighters prevail beginning in *Justice League of America* #107.

Justice League of America #107, Sept./Oct. 1973
Writer: Len Wein *Artists:* Dick Dillin & Dick Giordano

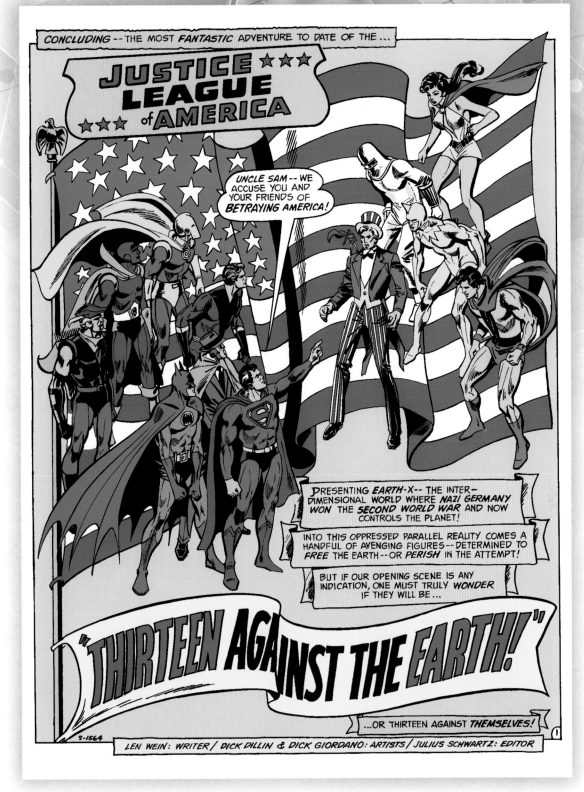

The story, which concluded in *Justice League of America* #108, proved so memorable that other worlds and teams were discovered in this manner but this story was inspirational to readers, some of whom went on to adapt it for the 2017 crossover of the CW series *Supergirl*, *The Flash*, *Legends of Tomorrow*, and *Arrow*.

Justice League of America #108, Nov./Dec. 1973
Writer: Len Wein *Artists:* Dick Dillin & Dick Giordano

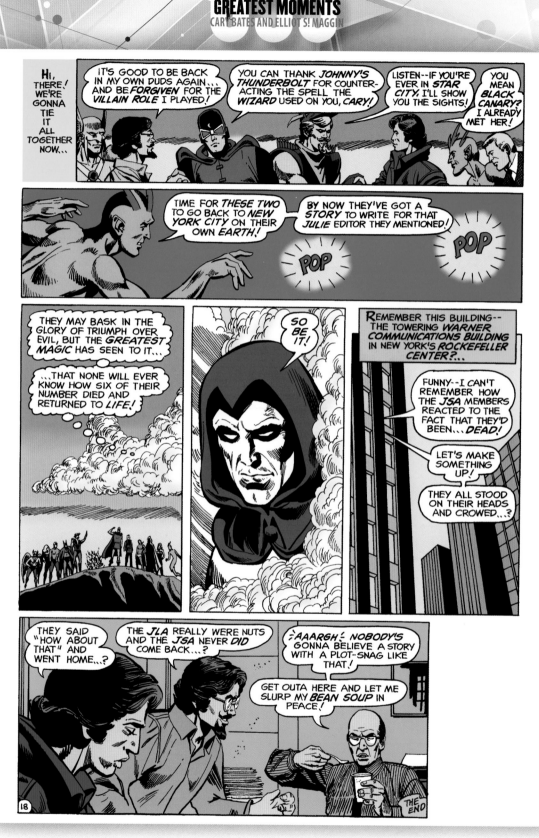

Readers learned that their world was known as Earth-Prime and the heroes from Earth-1 made their way to his world now and then. Comic writers Cary Bates and Elliot S! Maggin somehow found their way to Earth-1 and Earth-2, requiring the JLA and JSA to stop their influence, which they did in *Justice League of America* #124.

Justice League of America #124, November 1975
Writers: Cary Bates & Elliot S! Maggin
Artists: Dick Dillin & Frank McLaughlin

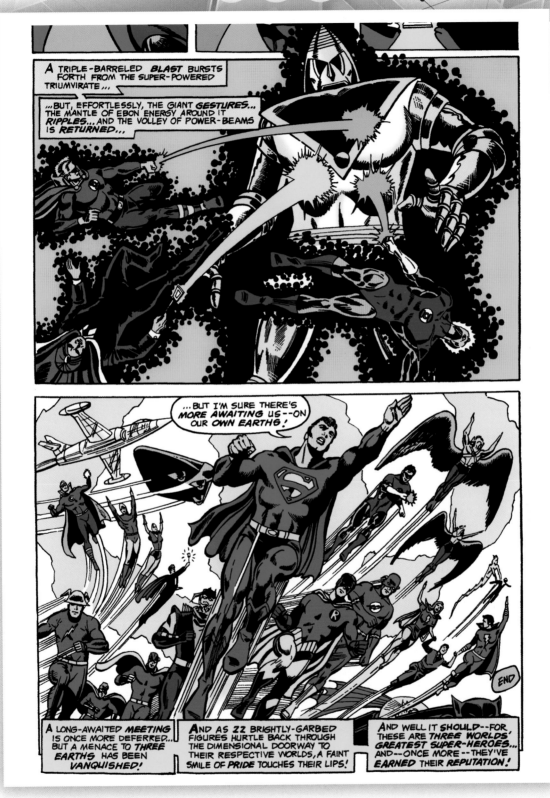

Earth-S was the home to the wizard Shazam and his champions Captain Marvel, Captain Marvel Jr., and Mary Marvel among others. When a threat was large enough, the JLA and JSA came to their aid as seen in these moments from *Justice League of America* #137.

Justice League of America #137, December 1976
Writers: E. Nelson Bridwell & Martin Pasko
Artists: Dick Dillin & Frank McLaughlin

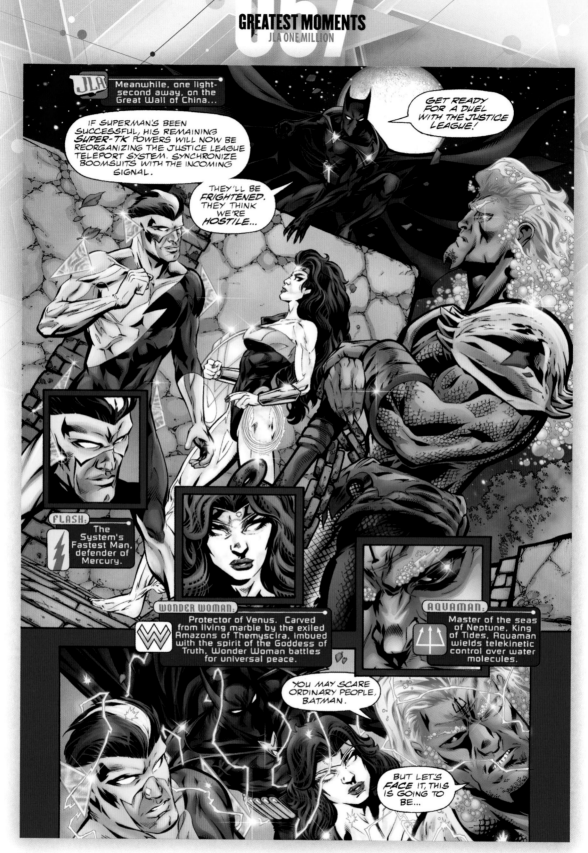

There's something comforting in knowing humankind makes it to the 853rd Century, but even there, the universe's mightiest heroes have to band together to stop all manner of threats. Leading the charge is the Justice Legion A, descendants of the original JLA, each guarding a world in the solar system, as seen in *JLA: One Million*.

JLA: One Million, November 1998
Writer: Grant Morrison *Artists:* Howard Porter & John Dell

The Justice League of America and the Justice Society of America fight for truth, justice, and the American Way. Every now and then, though, the teams enjoy rare down time together, which in this instance from *JSA* #54 means a Thanksgiving feast.

JSA #54, January 2004
Artists: Carlos Pacheco & Jesus Marino

Not long after the Flashes of Earths 1 and 2 discovered one another, it was inevitable that they would meet. Unfortunately, it came about as a result of needing to stop a combination of super-foes from both worlds. This cover to *Justice League of America* #21 is one of the most memorable of the Silver Age.

Justice League of America #21, August 1963
Artists: Mike Sekowsky & Murphy Anderson

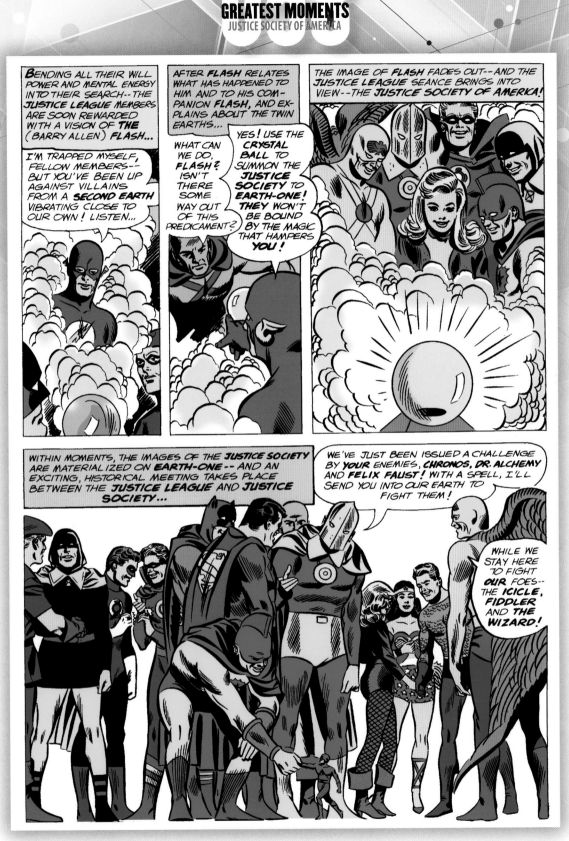

Despite being science-based heroes, for the most part, it's interesting to note the team used an old-fashioned séance of sorts to breach the dimension barrier. The historic meeting between teams is captured in this moment from *Justice League of America* #21.

Justice League of America #21, August 1963
Writer: Gardner Fox *Artists:* Mike Sekowsky & Bernard Sachs

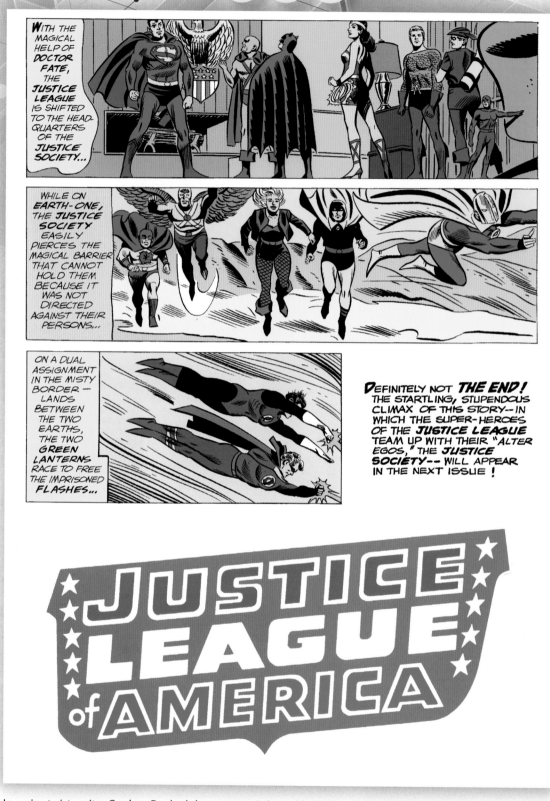

In a nice twist, writer Gardner Fox had the teams switch worlds to pursue their quarry, making you wait a month before seeing how successful they would be as seen in this final page from *Justice League of America* #21.

Justice League of America #21, August 1963
Artists: Mike Sekowsky & Murphy Anderson

There came a time when there was one world and the JLA and JSA operated independently until circumstances demanded it. One such instance involved the 31st Century's Legion of Super-Heroes. In *Justice League of America* #10, Black Canary and Mister Terrific try to unravel the Legion's secret.

Justice League of America #10, August 2007
Writer: Brad Meltzer *Artists:* Ed Benes & Sandra Hope

As it turns out, the various Legionnaires came back through time for not just one but several reasons, seeding plot lines that wouldn't be complete for several years. It was a treat for Legion fans who missed seeing them with regularity. This moment from *Justice League of America* #10 finds clues but not the reason.

Justice League of America #10, August 2007
Writer: Brad Meltzer *Artists:* Ed Benes & Sandra Hope

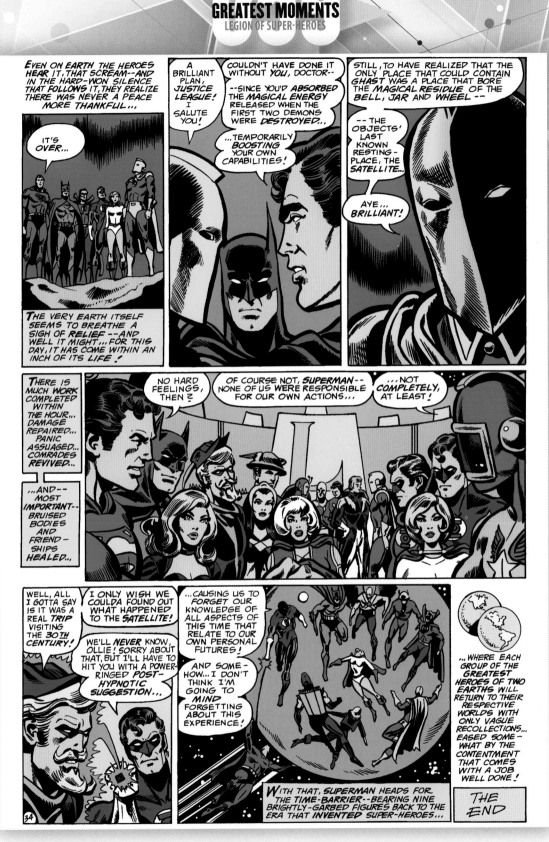

When Mordru the Merciless traveled to the 20th Century to use the Demons Three in his plan, it required the combined efforts of the JLA, JSA, and Legion of Super-Heroes to thwart the mad plan. They certainly knew how to fill a meeting space as seen in this moment from *Justice League of America* #148.

Justice League of America #148, November 1977
Writers: Paul Levitz & Martin Pasko
Artists: Dick Dillin & Frank McLaughlin

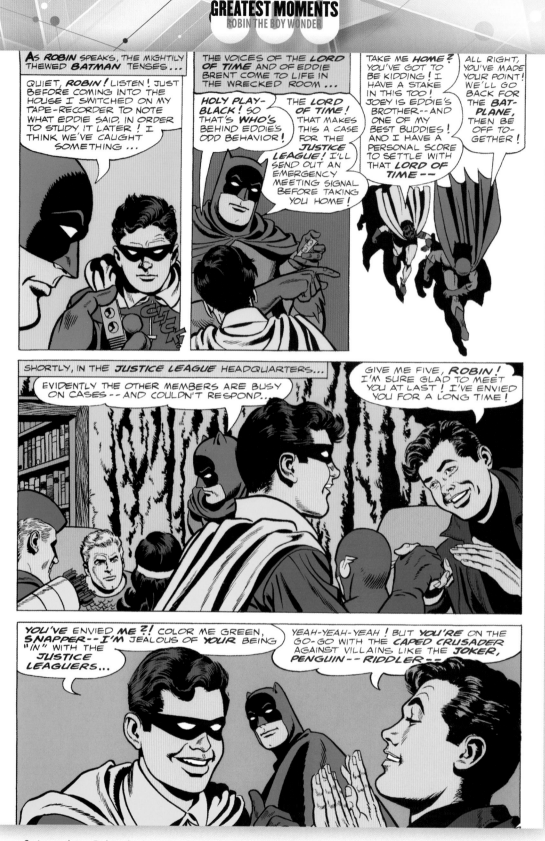

It was fitting to have Robin the Boy Wonder be the first sidekick to work with the JLA on a case since he was the first teen to join an adult in fighting crime. Here, from *Justice League of America* #50, he meets his peer, Snapper Carr.

Justice League of America #50, December 1966
Writer: Gardner Fox *Artists:* Mike Sekowsky & Sid Greene

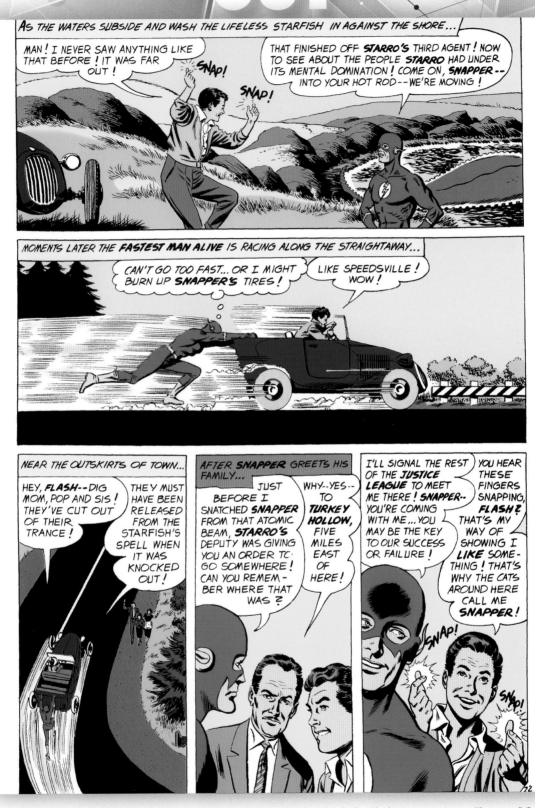

When Starro threatened the inhabitants of Happy Harbor, Rhode Island, the Flash met teen Lucas "Snapper" Carr. It was Snapper who helped figure out that lime would weaken the would-be conqueror and was invited to be an honorary member of the JLA as seen in *The Brave and the Bold* #28.

The Brave and the Bold #28, March 1960
Writer: Gardner Fox *Artists:* Mike Sekowsky & Murphy Anderson

Several times, the writers and artists found ways to honor DC Comics' publishing history by crafting stories that brought the heroes together from different times and eras. In *JLA: Year One*, writers Mark Waid and Brian Augustyn brought the modern generation of heroes together to form the team, but their predecessors, the Justice Society of America were still on semiactive duty along with the Doom Patrol, Seven Soldiers of Victory, and even the first Blue Beetle. In this classic moment from *JLA: Year One* #11, the heroes had been through many challenges but united, would stop Vandal Savage's threat for the last time.

JLA: Year One #11, November 1998
Writers: Mark Waid & Brian Augustyn
Artists: Barry Kitson & Michael Bair

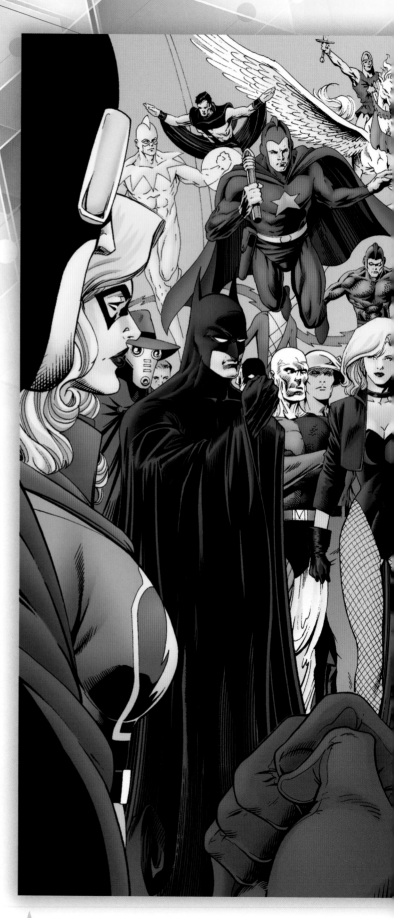

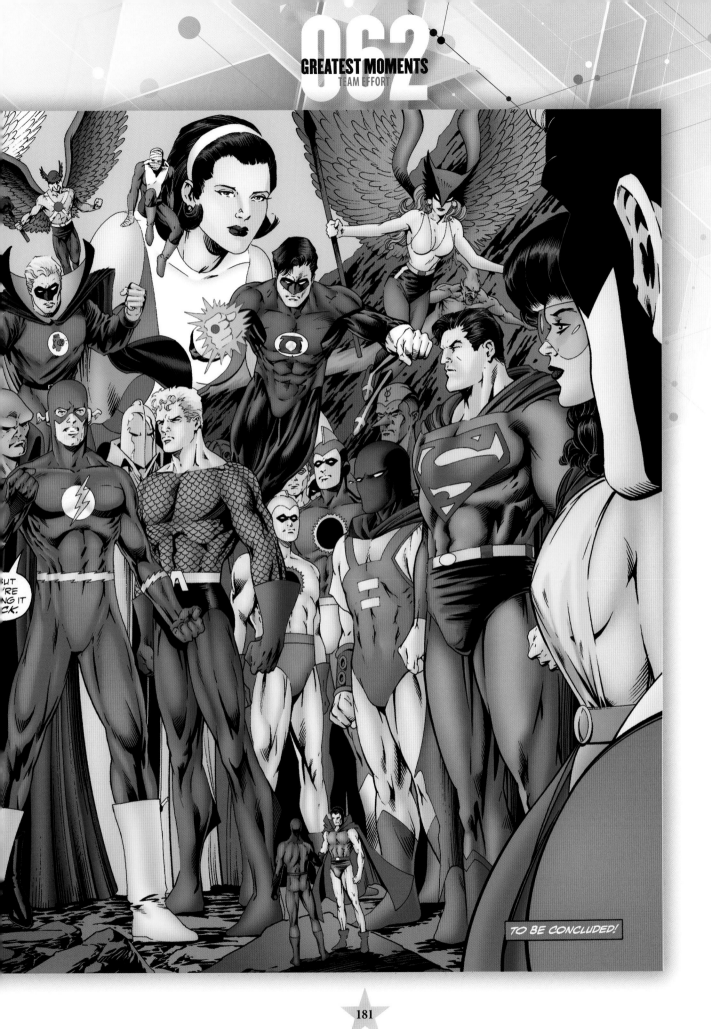

TO BE CONCLUDED!

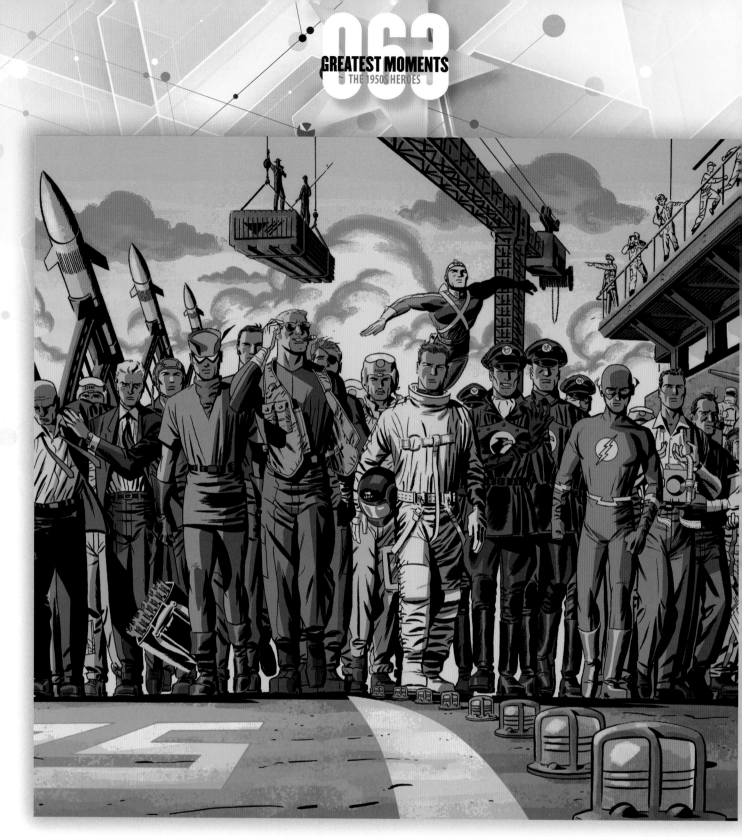

Creator Darwyn Cooke honored the 1950s era of DC Comics in *New Frontier*, a time of change as the Silver Age of heroes dawned, inspired by adventurers of all stripes, including World War II heroes the Blackhawks and more modern explorers such as Adam Strange and the Challengers of the Unknown.

New Frontier #6, November 2004
Writer/Artist: Darwyn Cooke

In this cover to *New Frontier* Volume One, Darwyn Cooke shows the coming Silver Age of the Justice League in his fanciful retelling of the classic science-tinged adventures of the high-flying 1950s.

New Frontier Volume One, 2005
Writer/Artist: Darwyn Cooke

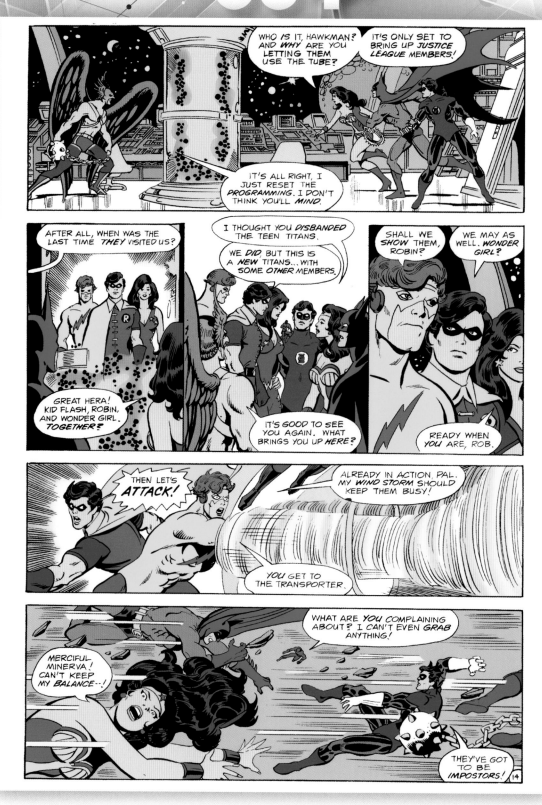

In classic misunderstanding style, Raven has convinced the newly reformed Teen Titans that their mentors, the JLA, must be stopped from defeating three sorcerers. It means the teens arrive on the JLA satellite and begin a fight in *New Teen Titans* #4.

New Teen Titans #4, February 1981

Writer: Marv Wolfman *Artists:* George Pérez & Romeo Tanghal

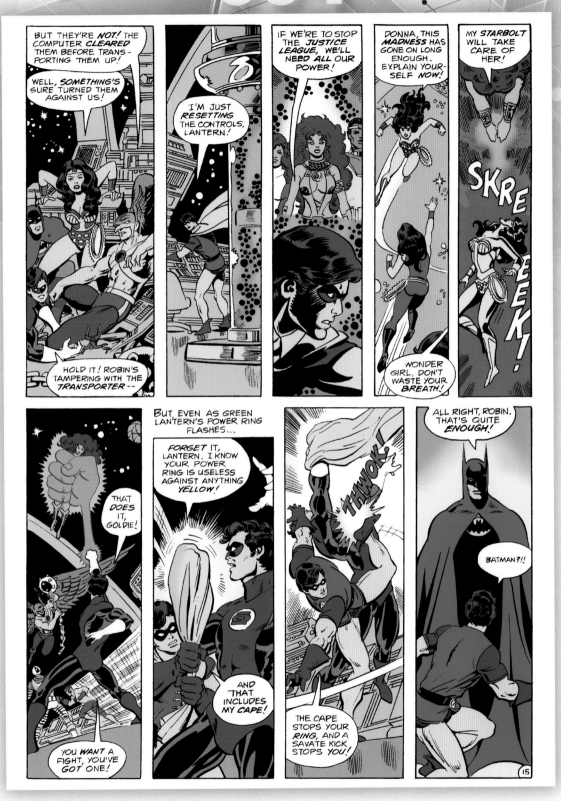

The teens versus adults concept was not new at the time, but with Marv Wolfman's finely honed characterizations, never before had the differences been so well etched as seen here in *New Teen Titans* #4.

New Teen Titans #4, February 1981
Writer: Marv Wolfman *Artists:* George Pérez & Romeo Tanghal

CONSIDERING THAT EACH HERO OPERATES IN HIS OWN
ENVIRONMENT, IT MAKES PERFECT SENSE THAT HE WOULD
HAVE A UNIQUE COLLECTION OF OPPONENTS. SO IF YOU
VISIT METROPOLIS, YOU COULD WELL OBSERVE THE MAN
OF STEEL STOPPING A RAMPAGING TITANO OR PRANKSTER
FROM DISRUPTING YOUR VACATION. A TRIP TO GOTHAM
CITY, OF COURSE, IS ADVISED ONLY IF YOU HAVE A STOMACH
FOR BIZARRELY ATTIRED CRIMINALS WHO LEAVE DEADLY
RIDDLES OR CARRY A DANGEROUS UMBRELLA.

CHAPTER 6
THE ENEMIES

When it came time for the World's Greatest Super Heroes to band together and form a team, it also made sense that the level of threat be something greater than any one member could handle. The first such threats came from the stars, with the JLA's first published adventure pitting the seven against Starro the Conqueror. Later, when their origin was retold for Snapper Carr's benefit, it featured the seven Appellaxian conquerors. Aliens would definitely present many of the mightiest challenges to confront any configuration of the League. Writer Gardner Fox had no illusions that the team could only fight threats from the stars and deftly introduced threats from other realms, dimensions, eras, and, of course, Earth.

Many homegrown threats proved as challenging as their alien counterparts. The first was from Earth, but Earth in the year 11,960. Xotar the Weapons Master arrived in the JLA's time period to elude the Intersolar Police. As a result, the first contemporary human foe was the fiendish genius Professor Ivo. He built an android that was able to absorb and replicate the abilities of each Leaguer (complete with imitation lasso of truth and power ring), making him a one-being powerhouse.

Over the years, Amazo would be defeated, rebuilt, and continue to adapt, proving to be one of the most persistent foes of the JLA. In time, Ivo would create other threats for the team, but none as devious as Kid Amazo, a cybernetic organism whose mind was more advanced than the first Amazo. He was embedded in human society and guided by Ivo's lab assistant and daughter Sara Shapiro, teaching him how to negotiate among conflicting human types. When he began absorbing the JLA's powers, Kid Amazo also absorbed their psyches, and that's where the trouble began. His digital mind could not parse and manage the diverse points of view that comprised the team. When he learned Sara was not his girlfriend but merely there to observe him, it proved one data input too many, and he self-destructed.

Their next human foe continued to grow and change over time, increasingly proving a worldwide threat. Initially a man known only as Doctor Destiny, he was a criminal who built sophisticated weapons to commit crimes. When he first encountered the team, he helped organize a collection of their existing foes—Getaway

Mastermind, Electric Man, Clock King, Professor Menace, Captain Cold, and the Puppet Master—the first time such a gathering of rogues would band together to try and take down the heroes (*Justice League of America* #5, 1960).

When the team next confronted Destiny, he had developed the Materioptikon, capable of creating illusions that were so realistic, people came to believe the world was suddenly run by a fascist League. In time, the device was able to turn Destiny's dreams into reality, each one becoming more richly detailed and darker, posing a true danger to all life on Earth. The JLA devised a way to stop Destiny from dreaming, but the resulting psychic trauma transformed him into a skull-headed monster. After reality was changed during the Crisis on Infinite Earths, the Materioptikon was now a Dreamstone, one of a dozen created by Dream of the Endless. When Dream wound up imprisoned, the gem eventually found its way to a man known as John Dee, who managed to reshape it into the Materioptikon, and a new Doctor Destiny was born, preying on mortals and super heroes alike.

Amos Fortune developed his own device, called the Stimoluck, able to bend reality, creating events of either "good luck" or "bad luck." He committed crimes with it and nearly prevented the team from capturing him, but he was finally stopped, although Fortune would find ways to come back time and again. And while the first foe they battled twice was the alien Kanjar Ro, Professor Fortune was the first human villain to strike more than once, although the second time he masqueraded as Mister Memory. He had recruited another collection of the JLA's foes—Hector Hammond, Pied Piper, Sea-Thief, Angle Man, and Doctor Davis—to help him defeat the League after he gave them amnesia. Thankfully, newly recruited member the Atom was able to help turn the tables against them.

When Fortune next surfaced, it was a surprise to the League and readers alike. He had disguised himself and recruited his fellow childhood juvenile delinquents, forming the Royal Flush Gang. With Fortune disguised as the Ace of Clubs, he outfitted each member—King of Clubs, Queen of Clubs, Jack of Clubs, and Ten of Clubs—with high-tech devices to help them commit crimes and stymie the League. After they were stopped and

Fortune revealed, the Royal Flush Gang was shuffled repeatedly, its membership in constant flux, long outliving Fortune's influence. Their second iteration may have been the deadliest, led by Green Lantern's brilliant opponent Hector Hammond.

Fortune himself created a new, short-lived gang called the Luck League, outfitting his members with tech that could imitate the JLA members' powers. It didn't work out, and they never re-formed.

Much later, he was present when the House of Secrets was blown up by a Parademon from Apokolips. Left blind in one eye and partially disfigured, Fortune took to wearing a mask and worked with a new iteration of the Secret Society of Super-Villains.

In the post-Flashpoint reality, Fortune never formed the Royal Flush Gang, which was a separate entity. He's been skulking in the shadows, awaiting the right chance to strike at the League.

By the title's third year, writer Gardner Fox was regularly bringing the popular villains back for encores, giving them deep roots in the DC mythos. He would continue to mix in occult and alien threats during his sixty-five-issue run, giving the DC mythos two more long-lasting characters, one facing the collective League in his final JLA-JSA team-up. Futurist Thomas Oscar Morrow tried to develop a time machine but managed only to create a time viewer. That proved to be enough, as he gained a fortune introducing devices ahead of their time, including one called the Duplicator. He used it to generate multiple versions of Green Lantern, requiring the hero's close friend the Flash to track them down and put an end to it. After that first meeting in *The Flash* #143 (1964), Morrow would continue to cause problems for the heroes.

When one device to predict the future told him to create an android to destroy Earth-2's Justice Society of America, he created the Red Tornado. What the machine failed to anticipate was the android exceeding its programming and gaining both artificial intelligence and free will. Morrow wound up in jail, and over time, the Red Tornado sought his own destiny, and the cosmos lent him a helping hand. Early on, the League also confronted the

Tornado Tyrant, a foe Adam Strange first encountered on Rann. The entity remade himself into the Tornado Champion and eventually took possession of the android Red Tornado, infusing the circuits with life and giving him feelings way beyond T.O. Morrow's programming.

Regardless of the reality, Morrow and the Tornado's destinies were inextricably connected, much as Morrow continued to prove a clear and present danger to the JLA.

Interestingly, the first villain from any hero's rogue's gallery to take on the team directly was the Joker. In his guise as John Dough, also known to the media as Mr. Average, he manipulated Snapper Carr into betraying the team.

While Fox and other writers cherry-picked various configurations of familiar foes to fight the team, it wasn't until Len Wein's run that they got organized. In 1974, the mysterious new foe called Libra created the Injustice Gang of the World, consisting of Chronos, Mirror Master, Poison Ivy, Scarecrow, Shadow-Thief, and Tattooed Man. Notably, only Batman had two

opponents on the team. It turned out that Libra had developed a device to absorb half a Leaguer's powers and equipped the Gang with their own gadgets to absorb the other half in hopes of destroying the team. Once it proved effective, Libra tried to absorb the universe's cosmic energies but became one with the cosmos instead. The Gang, though, remained active several more times, first under the command of the Construct and then the Flash's future foe Abra Kadabra.

A similarly named group, the Injustice League, preceded them in a retroactively revealed tale from 2000 wherein an interstellar conqueror named Agamemno targeted Earth. He brought with him Kanjar Ro and consulted with Lex Luthor on how best to destroy the JLA. He used his alien technology to switch the heroes' minds with their villainous counterparts—Black Manta, Chronos, Catwoman, Doctor Light, Felix Faust, Mister Element, the Penguin, and Sinestro—intending to ruin their stellar reputations. A coalition of non-JLA heroes rose up to challenge them, until Agamemno's gambit was revealed.

During the comedic era, Major Disaster, Big Sir, Clock King, Multi-Man, Cluemaster, and the Mighty Bruce formed a new version of the Injustice League, winding up with their one-time posting to Antarctica with hapless Green Lantern G'Nort.

The first example of individual foes of a super hero uniting as a group took place in *America's Greatest Comics* #1 (March 1941), when six of Mister Scarlet's old enemies teamed up with a seventh newcomer as the Death Battalion.

Earlier, the JLA's Earth-2 counterparts, the JSA, had to deal with an organization of villains known as the Injustice Society. One configuration, consisting of the Wizard,

Icicle, Sportsmaster, Huntress, Shade, and the Gambler, dared to take on both teams with predictable results.

In the Silver Age, Julie Schwartz and Gardner Fox gathered foes of the JLA members into periodic one-shot teams, mostly unnamed (including *Justice League of America* #5, 14, 28, 35, and 61), save for the Crime Champions (#21 and 22). Barry Allen's foes were first declared "Flash's Rogues' Gallery" in 1964's *80-Page Giant* #4 but didn't join forces in a story proper until 1965's *The Flash* #155.

"Well, it was DC (specifically, Julie Schwartz) that introduced the concept of a super-villain 'Rogues' Gallery,'" Gerry Conway explained. "Obviously this was lifted from *Dick Tracy*, but having costumed villains with a shared goal—even if it was simply the destruction of their common enemy—seems to be something that was unique to DC. Marvel's villains rarely teamed up in groups larger than two (at least, back in the sixties and early seventies), but DC seemed to do a number of stories where groups of villains—usually Batman villains— ganged up to plot their revenge. This may or may not have been true, but it was an impression I had at the time, and creating a team of super-villains that existed as a kind of 'evil' Justice League struck me as a fun idea."

As a result, when Conway was an editor, one of the books he conceived was the *Secret Society of Super-Villains*. The series lasted only a few years and its roster changed with alarming regularity as it tried to find a purpose and direction that made sense. However, it did latch on to readers' imaginations, resulting in various revivals through the years. The villainous group's impact, though, took an unexpected direction.

Imagine, if you will, the mighty Justice League of America, trapped by a band of their most dangerous foes and

forced to endure a personality swap (yes, Agamemno did this first, but those were simpler times). What could have happened during those hours when the villains inhabited the bodies of the World's Greatest Super Heroes? That's exactly what happened when the JLA fought the Secret Society of Super-Villains in three titanic issues of *Justice League of America* #166–168 (1979). While the heroes triumphed, it sparked the imagination of readers, who imagined what happened between panels. One such fan became obsessed with the concept, picturing the villains unmasking the heroes and posing for photos, the ultimate blackmail material. Such a moment became a pivotal revelation in 2004's *Identity Crisis*, written by comics fan turned best-selling novelist Brad Meltzer.

As Meltzer once said, "I'm so sad, I've been carrying that idea around since nearly the first moment I read it as a kid. Just made no sense to me. As for the title, it was the evil Justice League. How could that not be appealing?" Luthor later banded villains together, reusing the Injustice Gang moniker in concert with the Joker. While their joint goal was to destroy the Justice League in order to allow themselves free reign, their individual agendas would put them in opposition. Reuniting under the name of Injustice League Unlimited, Luthor and the Joker established a new core membership that included Cheetah, Doctor Light, Fatality, Gorilla Grodd, the first Killer Frost, Parasite, Poison Ivy, and Shadow-Thief. More than two dozen other villains also served with this gang. With such overwhelming numbers, the JLA were subdued until freed by Firestorm and, reinvigorated, they took down their enemies.

Combining familiar foes into new configurations has continued to plague the JLA, with perhaps the deadliest

alliance being the Injustice Gang formed by Lex Luthor. He recruited Circe, Ocean Master, the Joker, Mirror Master, and J'emm, a hero from Saturn under Luthor's mental control. The Worlogog—a piece of Fourth World technology that had passed from hand to hand until LexCorp acquired it and Luthor, with his keen intellect, discerned that it was something more than a paperweight—contained a map of the universe in four dimensions, and permitted its user a certain degree of control over time and space. With his Injustice Gang behind him, Luthor took on the JLA and nearly defeated them. But the heroes prevailed and the Worlogog was given to the android Hourman of the Justice Legion A in the 853rd Century.

On his own, Luthor was a deadly opponent to Superman or any other champion of justice who stood in his way. In the reality post-Flashpoint, Luthor was one of the world's most successful businessmen when he became embroiled in an invasion of super-powered conquerors from Earth-3. Determined to keep the world safe, he activated Subject B-0, an incomplete Superman clone. He then convinced Batman, Catwoman, Sinestro, and Deathstroke to actually work together as his Injustice League to take down the Crime Syndicate. After helping saving the world, Luthor was the most popular man worldwide, but the JLA were reluctant to grant his request for membership. That changed after he deduced Batman's secret identity, and the group reluctantly added him to their ranks.

Borrowing a notion from Professor Ivo, he developed EXP-052, nicknamed the Amazo Virus. Whereas the Amazo android was comprised of power absorbing cells, in the Amazo Virus Luthor turned those cells into a synthetic plague, allowing a possessor of the virus

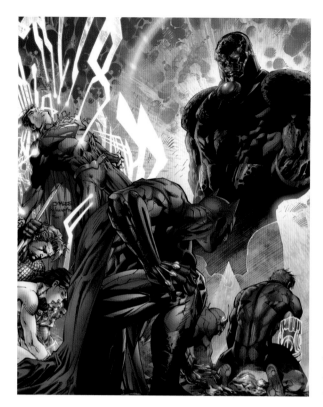

to mimic metahuman abilities. He tried to convince the White House that the virus actually suppressed metahuman abilities, but, as it was untested, they refused to sanction it. The villain Neutron had been hired to assassinate Luthor, but he missed, accidentally unleashing the virus.

Airborne, it found Dr. Armen Ikarus, making him Patient Zero, where it mutated, using the poor man as an incubator for the enhanced virus, which absorbed powers, transferring them to the new host. The virus also generated a hive mind among the infected, making them a larger threat. Heroes fell into comas, and it was determined the virus had three stages, the final one resulting in death. Within twenty-four hours, the disease had traveled to nearby Gotham City and Central City in the Midwest.

As various members of the League were infected, Luthor placed them into comas as well in order to keep them from becoming part of the hive mind as he worked on a cure. With Superman immune given his alien biology, he partnered with Captain Cold to freeze Patient Zero, rendering the infected people unconscious. Once the vaccine was completed, the government agency

A.R.G.U.S. and the Justice League distributed the cure. Based on their efforts, both Luthor and Captain Cold were welcomed into the JLA (*Justice League* #35, 2015). In two instances, a cadre of cold-powered villains teamed up, hoping they could put the JLA on ice.

The first version consisted of Captain Cold, Icicle, and Minister Blizzard (*Justice League of America* #139, 1977), while the second, more powerful outfit took the name Cold Warriors. With Mister Freeze, Captain Cold, Killer Frost, Minister Blizzard, Icicle, Snowman, Cryonic Man, and Polar Lord (General Eklu from the planet Tharr), one would think they might have had a chance to chill the League. Instead, the heroes turned up the heat and prevailed (*Justice League Adventures* #12, 2002).

Not every collection of criminals was comprised of familiar names. The Royal Flush Gang was just the first in a series of teams that dared tackle the heroes. When the Overmaster came to Earth, he assembled his Cadre, comprised of Black Mass, Crowbar, Fastball, Nightfall, Shatterfist, and Shrike. After several battles, the team eventually disbanded. But the Overmaster wasn't finished with trying to control or destroy the planet. He later returned with his Cadre of the Immortal, a collection of metahumans who thought they were working for the legendary explorer Prester John. This iteration of the team was defeated, but the Overmaster folded several of its members into an expanded Cadre that included brainwashed League member Ice.

Then there were the Extremists, powerful terrorists who hailed from a nearby dimension known as Angor. At first they were trying to change the world, but when they accidentally detonated a stolen megabomb, the quintet survived and mutated into super-beings. The members—Lord Havok, Doctor Diehard, Gorgon, Tracer, and Dreamslayer—wreaked destruction across Angor, prompting their heroes, the Assemblers, to recruit Justice League Europe for help. While the human Extremists ultimately died, robotic doppelgangers were created by Mitch Wacky's Wackyworld theme park on Angor. In time, that version of the Extremists made their way to the JLA's world.

Time and again, the Extremists would return to combat the League. In recent times, the latest splinter team formed by Batman—Black Canary, Vixen, the Atom, the Ray, Killer Frost, and Lobo—went into action when Lord Havok brought the Extremists back to Earth, intending to save the world by destroying mankind's free will. To Havok, freedom was the problem, and if they submitted to his will, all would be safe.

Even mystical forces put aside rivalries and various goals to tackle the protectors of mortal man. One such group, the League of Ancients, was created by an Atlantean sorceress named Gamemnae. She was inspired by one iteration of the JLA, sent back in time during the Imperiex War, and sought to destroy the time-displaced heroes in a preemptive strike. She left her Ancients—Rama Khan, Manitou Raven, the Anointed One, the Whaler, Tezumak, and Sela—to fight the heroes, thinking they were protecting Atlantis, while she journeyed to their time to strike at a world depleted of its champions.

What Gamemnae did not anticipate was a makeshift League assembled by Batman to defeat her. All of her Ancients, save Manitou Raven, were absorbed by her

quagmire spell. For a time, Raven served with the JLA, never getting comfortable with the modern era.

Nor has every team the League has battled been comprised of bad guys. After leaving the team, Booster Gold thought to form his own corporate-sponsored group, the Conglomerate. Although the members—Reverb (brother to Vibe), Praxis, Maxi-Man, Gypsy, Vapor, and Echo—meant well, they never gelled and came into conflict with the League. It did not help that their first sponsor was Claire Montgomery, the vengeful ex-wife of the JLI's then-sponsor, Maxwell Lord. Things improved when Despero attacked Earth once more and Booster insisted the Conglomerate come to their aid.

At one point, the team was made up of Norman the Doorman, Deadeye, Elasti-Man, Fiero, Frostbite, Scarab, and Slipstream—all of whom turned out to be impostors drawn from the anti-matter universe of Qward.

After three iterations, the team ultimately disbanded.

The Hyperclan—Protex, A-Mortal, Züm, Fluxus, Primaid, Tronix, Armek, and Zenturion—also appeared to be a heroic team, before Batman deduced they were actually White Martians intent on world domination.

The JLA even found themselves fighting representatives of the US government. The first such occasion was the Ultramarine Corps, comprised of United States Marine Corps recruits. Each was given an unstable artificial metagene to form a powerful squad that could be controlled by General Wade Eiling, who distrusted the super heroes. In time, the four members of the team—4-D, Flux, Pulse-8, and Warmaker One—left the service and went out on their own, taking the name Ultramarines, working from Superbia, a floating city over the ruins of Montevideo. They were not terribly successful as an independent entity and sought redemption after damaging the Congo capital Kinshasa. During Darkseid's assault in the Final Crisis, the team was last seen defending Superbia against the New God. Eiling went on to obtain one of the artificial Shaggy Man bodies and had his brain placed into it, turning him into a behemoth to tackle the JLA under the name of, of course, the General.

The government's Task Force X, also dubbed the Suicide Squad, once tangled with the JLI, but more recently truly went to war with the JLA. In the Rebirth continuity, Batman only recently discovered the existence of the Squad and informed his teammates about this persistent threat. The heroes arrived in time to actually save the Squad during their assault on the short-lived Brimstone Brotherhood's hideaway on the island of Badhnisia. As the two sides bickered, Maxwell Lord assembled his own force—Doctor Polaris, Emerald Empress, Johnny Sorrow, Lobo, and Rustam—and targeted Amanda Waller's squad for destruction. His true target was Eclipso's Heart of Darkness gem, giving him control over human life. Just as the JLA and the Squad were coming to understand one another, they now had to fight Lord's team and then stop Lord himself.

Only once did the world, through the United Nations, try and take on the JLA. When the UN insisted that the JLA not intervene in the Overmaster's latest visit to Earth, the team not-so-respectfully declined. Dubbed the League Busters, a collection of mostly criminals—Peacemaker, Ultraa, Mirror Master, Chromax, and Spellbinder—were put together with authorization to fight the League. Given their rookie status, the Busters had no experience and were easily handled by a squad led by Captain Atom.

While the various teams and groups tested the JLA's fortitude, two individuals might top a reader's list of the most dangerous foes the team ever faced.

Outside of space and time, in a realm known as the Ghost Zone, there was once a crooked house. Living within it was Prometheus, a non-powered individual—created by writer Grant Morrison—who had trained himself to become one of the world's smartest people. He was not only highly intelligent, he was also incredibly crafty, a master gamesman, able to think a dozen moves ahead of any opponent. As a child, he watched his criminal parents be shot and killed by policemen. Where Bruce Wayne swore a war on crime, the man who would grow up to be Prometheus swore vengeance on all forms of justice. Finding his parents' hidden caches of cash, he used it to finance his training. His education culminated in studying under monks who worshiped evil. Their leader showed him that they actually were living atop a

crashed spacecraft and that the monks were truly alien beings stranded on Earth. Taking possession of the craft and its access to the Ghost Zone, he began exacting revenge, killing every policeman who was involved in his parents' deaths.

When Prometheus learned of the Justice League, he switched his focus to bringing them down. After replacing a would-be hero named Retro, who won a tour of the Watchtower on the moon, the prepared stalker took down the team, one member at a time. With just Superman left, he threatened the lives of the civilians aboard the station but would spare them if the Man of Steel committed suicide. Before that could happen, an X factor presented itself in the form of Catwoman, who'd snuck aboard the Watchtower in order to steal shiny objects. She helped bring about Prometheus's downfall, although he escaped to the Ghost Zone, eluding capture.

Enraged, Prometheus bided his time until he allied himself with Luthor's Injustice Gang and nearly managed to kill Oracle before Batman intervened. The Caped Crusader had retained the villain's helmet and realized Prometheus had used its alien technology to replicate the world's greatest fighters' skills. Batman reprogrammed the helmet to match the physical skills of Dr. Stephen Hawking, making Prometheus easy to defeat. Martian Manhunter placed his mind into a psychic loop, reliving memories to keep the villain at bay. In time, though, he still managed to free himself, thirsting for vengeance.

He cut a bloody swath through members of the Global Guardians, killing Freedom Beast, Gloss, Tasmanian Devil, and Sandstorm merely to serve as a distraction so he could reprogram various JLA transporters designed to envelop the cities in pockets of time, both past and future. When the JLA arrived to stop him, he maimed Green Arrow's former sidekick Roy Harper, killed his daughter Lian, and nearly took down the team before he was stopped once and for all by Donna Troy. As the archer cried for vengeance of his own, Green Arrow shot and killed Prometheus.

Thanks to changes in reality post-Flashpoint, Prometheus remains active, most recently fighting non-League hero Midnighter.

Finally, there may be nothing more sinister than a friend who turns out to be working against the cause of justice. Such was the case with Maxwell Lord, who arrived out of nowhere to resurrect and bankroll the Justice League, obtaining United Nations sanctioning and overseeing their expansion to embassies around the world. Despite a long line of ex-lovers and wives, he was dapper and charming and seemed to be every member's friend. What no one realized until much later was that he was possessed by a powerful computer, originally built by the New God Metron but overtaken by the nefarious sentient program called Kilg%re. It forced Lord to create the international peacekeeping force as a piece of an overall plan to control the world. Lord later gained telepathic powers as a result of the Dominators detonating gene bombs, activating many humans' metagenes.

Heavily influenced by his mother, Lord tried to use his powers sparingly and for the good of others. He never wanted to be a super hero and never felt a part of their world. When Dreamslayer and the Extremists attacked Earth, they super-charged Lord's abilities, using him to help ruin the Justice League, costing them their UN sanction and breaking down the various teams.

A short time later, the conqueror Mongul came to Earth, and during the battle in a world without a Superman, Coast City was destroyed, killing Lord's mother. This altered his thinking, turning him against the very heroes he initially admired.

Lord was then given control over Batman's orbiting satellite, dubbed Brother Eye by Alexander Luthor Jr., who came from a parallel world and sought to control all reality. The angry Lord had gathered more than enough information to use against his former allies, but before he could execute his plan, he was discovered by Blue Beetle. When the hero refused an offer to join Lord's cause, he was shot and killed, setting the world on the road to Infinite Crisis. In time, Lord was tracked down and confronted by Wonder Woman, who snapped his neck to break his mental control over Superman, in accordance with her sense of Amazonian justice. His body was entombed beneath the JLA's Hall of Justice, until it was resurrected during the events known as Blackest Night and eventually restored to life during Brightest Day. He then assumed a role as the Black Knight in the revamped global peacekeeping operation Checkmate.

When reality was shuffled after Flashpoint, Lord remained with Checkmate but was always working against the heroes, assembling what he claimed to be the first Suicide Squad—Doctor Polaris, Emerald Empress, Johnny Sorrow, Rustam of Prime Earth, and Lobo—in an attempt to kill Amanda Waller. This led to him possessing the Heart of Darkness, briefly controlling America before being stopped by the JLA in one of their greatest battles.

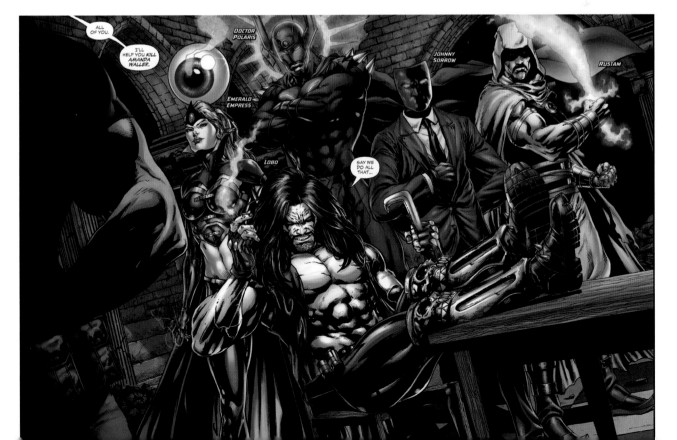

YOUR OFFERING IS ACCEPTED. **STARBREAKER** LIVES AGAIN.

GREATEST MOMENTS

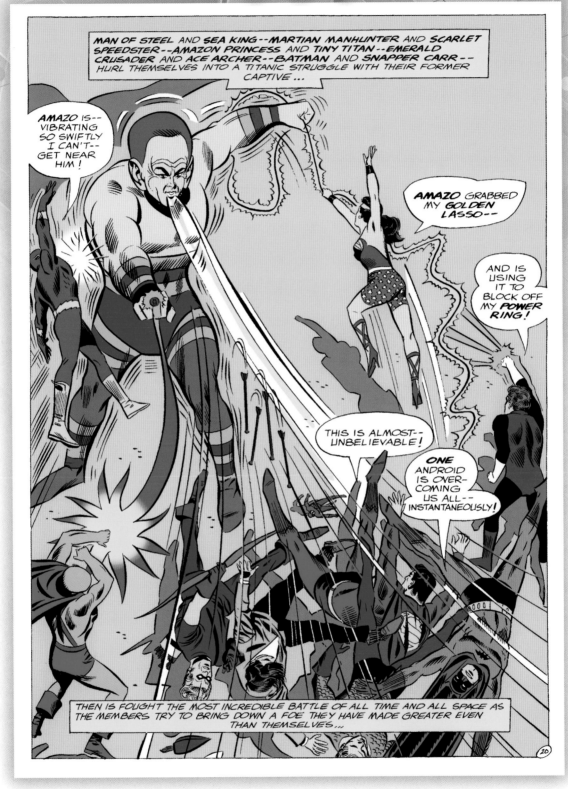

Amazo was like fighting yourself. Professor Ivo's android managed to replicate the powers of the JLA and as seen in this moment from *The Brave and the Bold* #30, he provided quite the challenge for the young team.

The Brave and the Bold #30, June/July 1960
Writer: Gardner Fox *Artists:* Mike Sekowsky & Bernard Sachs

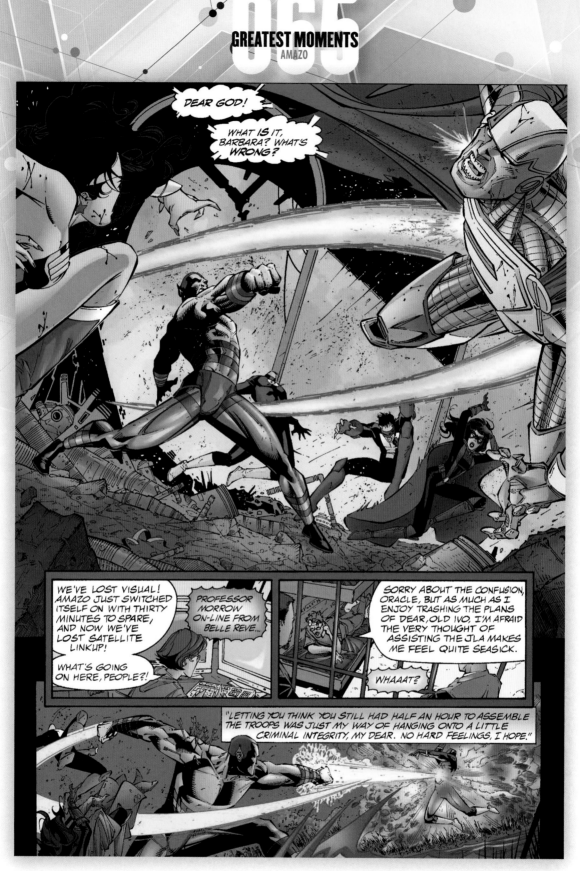

Repeatedly, Amazo would be rebuilt or reenergized and he seemed to develop an independent hatred of the JLA, seeking revenge more than anything else. He has proven to be one of the League's most tenacious adversaries as noted in this moment from *JLA #27*.

JLA #27, March 1999
Writer: Mark Millar *Artists*: Mark Pajarillo, Walden Wong, & Marlo Alquiza

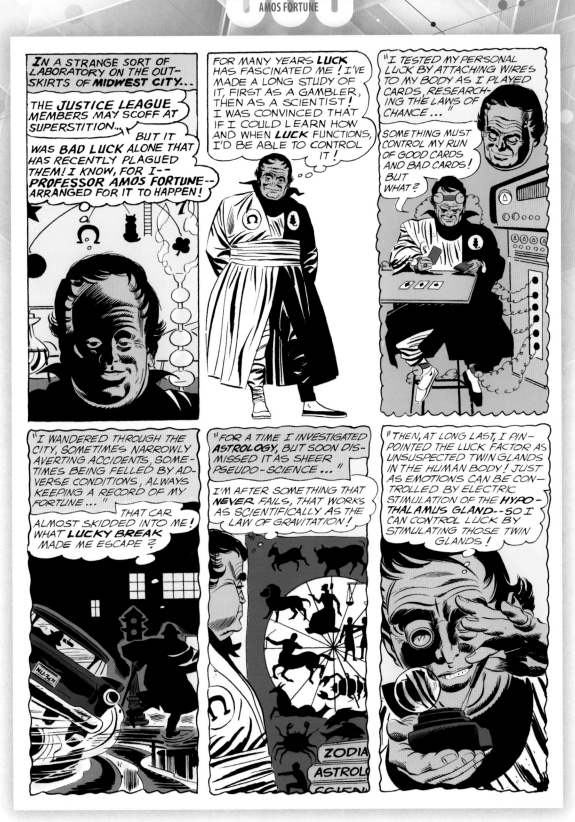

Fortune was intelligent, determining that humankind possessed "luck glands" which he could manipulate with the Stimu-Luck machine, of his own making. He could have grown rich just on that patent, but preferred his delinquent ways only to be beaten in *Justice League of America* #6.

Justice League of America #6, Aug./Sept. 1961
Writer: Gardner Fox *Artists:* Mike Sekowsky & Bernard Sachs

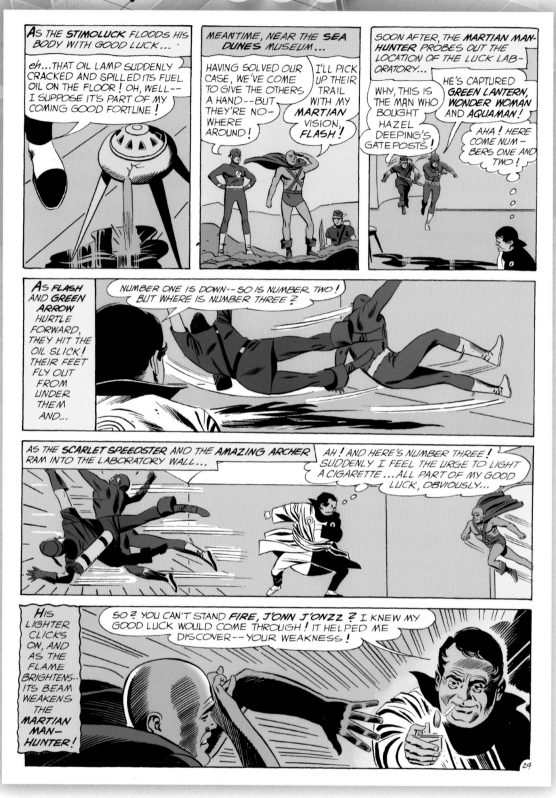

The JLA tried to beat the house with their frontal assault of Fortune, never realizing his Stimu-Luck machine would see to it they would never get within reach as seen in this first encounter from *Justice League of America* #6.

Justice League of America #6, Aug./Sept. 1961
Writer: Gardner Fox *Artists:* Mike Sekowsky & Bernard Sachs

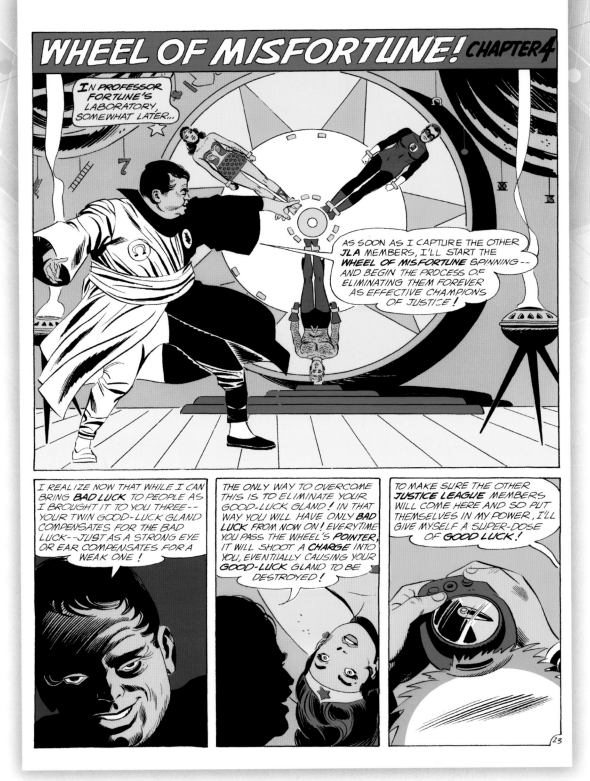

Amos Fortune didn't have much of a childhood, blaming it on bad luck so he studied the odds and found ways to channel that into energy, which he used for crime. When the JLA first encountered him in *Justice League of America* #6, Fortune proved surprisingly resourceful—just not very lucky.

Justice League of America #6, Aug./Sept. 1961

Writer: Gardner Fox *Artists:* Mike Sekowsky & Bernard Sachs

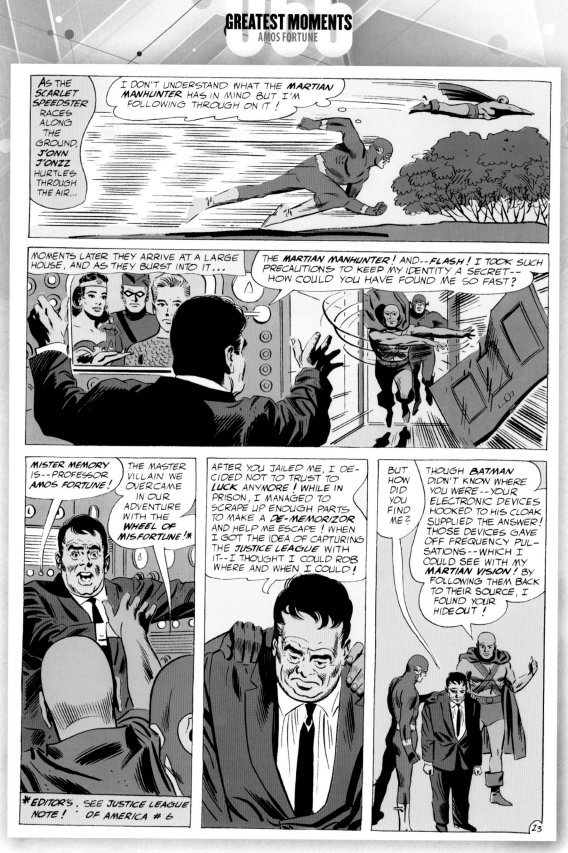

Amos Fortune continued to try and make the odds come out in his favor but found himself continuing to cross paths with the team and here, from *Justice League of America* #14, he was easily apprehended.

Justice League of America #14, September 1962
Writer: Gardner Fox *Artists:* Mike Sekowsky & Bernard Sachs

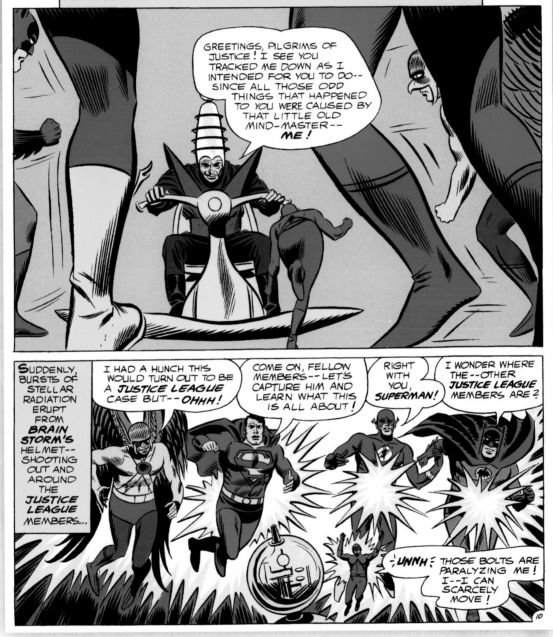

ATTACK OF THE STAR-BOLT WARRIOR! PART TWO

WITHIN MOMENTS, FIVE DOORS IN THE HILLTOP LABORATORY OF *BRAIN STORM* CRASH OPEN AND FIVE *JUSTICE LEAGUE* HEROES STAND FRAMED IN THEIR JAMBS. WHILE *SUPERMAN* HAS TRACKED HIS WAY HERE WITH HIS SUPER-VISION, *FLASH* HAS USED THE POLICE LABORATORY AS BARRY ALLEN, SCIENTIST, JUST AS *HAWKMAN* IN HIS *THANAGARIAN* SPACESHIP LABORATORY, *BATMAN* IN THE *BATCAVE* LABORATORY, AND THE *ATOM* (AS RAY PALMER, SCIENTIST) HAVE USED THEIR OWN SCIENTIFIC GENIUS TO TRAIL THE CURIOUS RADIATIONS IN THEIR UNIFORMS TO THEIR SOURCE ...

GREETINGS, PILGRIMS OF JUSTICE ! I SEE YOU TRACKED ME DOWN AS I INTENDED FOR YOU TO DO-- SINCE ALL THOSE ODD THINGS THAT HAPPENED TO YOU WERE CAUSED BY THAT LITTLE OLD MIND-MASTER-- ME !

SUDDENLY, BURSTS OF STELLAR RADIATION ERUPT FROM *BRAIN STORM'S* HELMET-- SHOOTING OUT AND AROUND THE *JUSTICE LEAGUE* MEMBERS...

I HAD A HUNCH THIS WOULD TURN OUT TO BE A *JUSTICE LEAGUE* CASE BUT-- OHHH !

COME ON, FELLOW MEMBERS--LET'S CAPTURE HIM AND LEARN WHAT THIS IS ALL ABOUT !

RIGHT WITH YOU, SUPERMAN !

I WONDER WHERE THE --OTHER *JUSTICE LEAGUE* MEMBERS ARE ?

--UNNH ! THOSE BOLTS ARE PARALYZING ME ! I--I CAN SCARCELY MOVE !

10

Axel Storm was a scientist who invented a helmet that absorbed stellar energy, turning his imagination into reality. The technology warped his mind, though, and when his brother was killed, he captured the JLA, in *Justice League of America* #32, forcing them to watch him deliver justice. Their powers had been transferred by the helmet to others so it was these newcomers who prevailed that day.

Justice League of America #32, December 1964
Writer: Gardner Fox *Artists:* Mike Sekowsky & Bernard Sachs

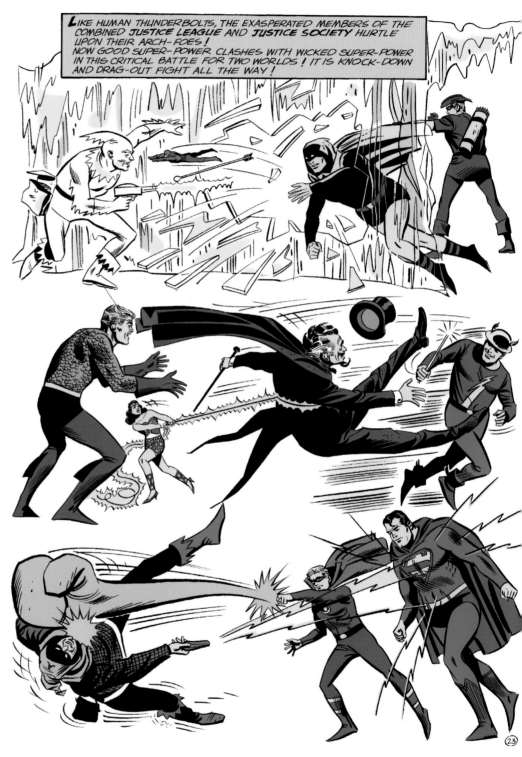

The Earth-2 villain the Fiddler was the first to discover the vibrational frequency allowing people to cross over to Earth-1. He subsequently teamed with his world's Icicle and Wizard along with Earth-1's Doctor Alchemy, Felix Faust, and Chronos to form the Crime Champions, the first interdimensional villain team. As a result, it took the combined efforts of the JLA and their newfound allies, the

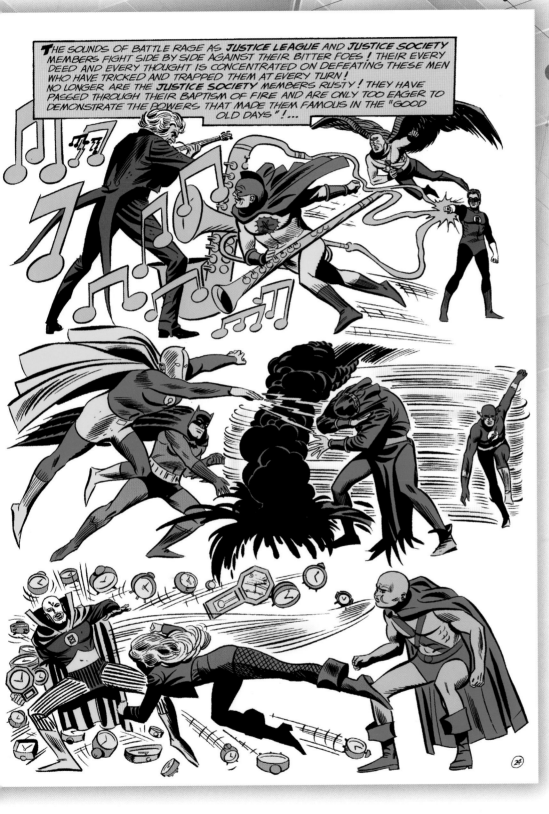

Justice Society of America, to protect both worlds. The story, Crisis on Earth-2, concluding in *Justice League of America* #22, was an instant classic and remains beloved by readers through the years.

Justice League of America #22,
September 1963
Writer: Gardner Fox
Artists: Mike Sekowsky
& Bernard Sachs

When Doctor Light's memory returned and he learned of how the JLA erased his memories, he was crueler than ever. The team tracked him down, believing Light was responsible for the death of Sue Dibny. Seeking protection, he hired Deathstroke to protect him, setting up this confrontation in *Identity Crisis* #3.

Identity Crisis #3, October 2004
Writer: Brad Meltzer *Artists*: Rags Morales & Michael Bair

Deathstroke was a soldier, trained to be one of the deadliest hand-to-hand combatants on Earth. When he was enhanced through chemical means, he became the world's most dangerous mercenary. Always prepared, he knew exactly which members of the JLA would seek him in *Identity Crisis* #3 and how to incapacitate them.

Identity Crisis #3, October 2004
Writer: Brad Meltzer *Artists:* Rags Morales & Michael Bair

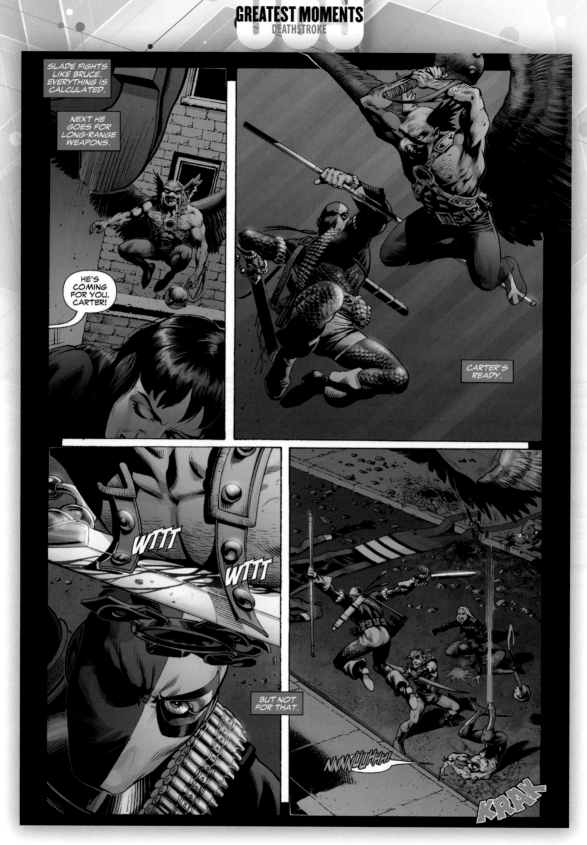

In a stunning sequence from *Identity Crisis* #3, Deathstroke took on the Flash, Black Canary, Green Arrow, Zatanna, Green Lantern, Elongated Man, and Hawkman, managing to keep each member at bay.

Identity Crisis #3, October 2004
Writer: Brad Meltzer *Artists:* Rags Morales & Michael Bair

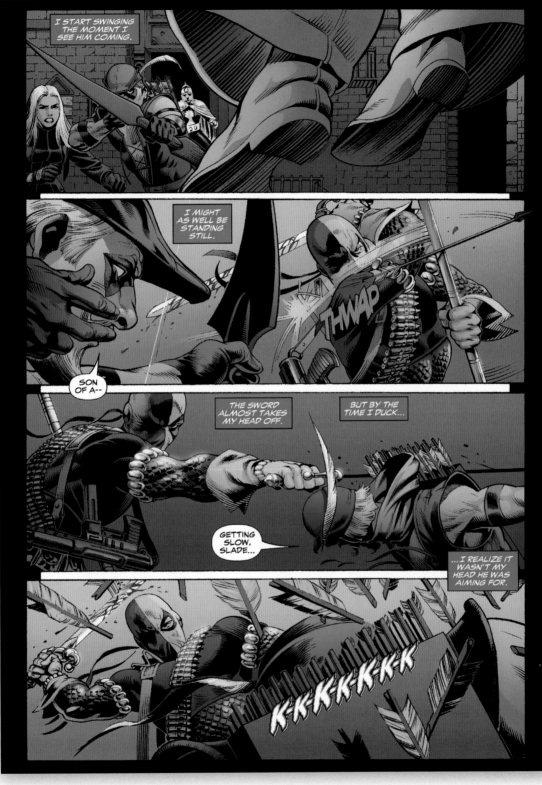

The angry JLAers were also hampered by the lingering sense of guilt each member felt for their decision to alter Light's mind. That may have also helped Deathstroke prevail against several of the mightiest heroes on Earth in *Identity Crisis* #3.

Identity Crisis #3, October 2004
Writer: Brad Meltzer *Artists:* Rags Morales & Michael Bair

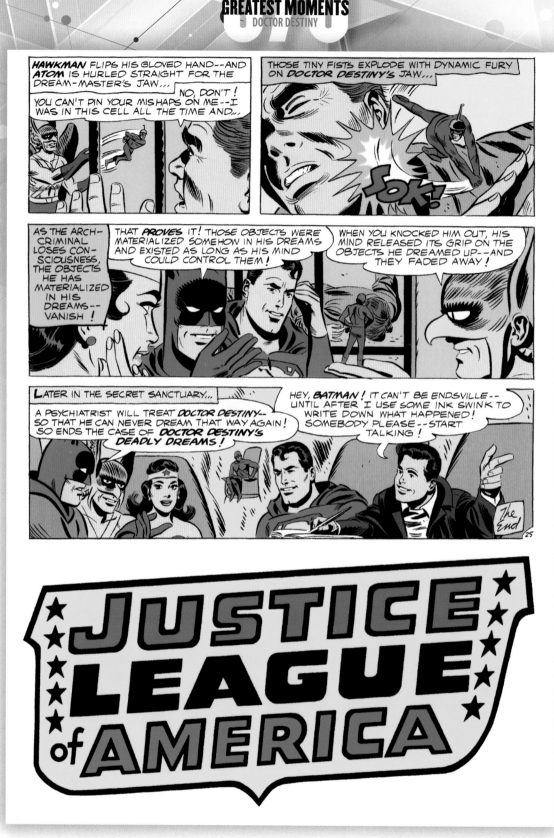

John Dee, Doctor Destiny, had a grandiose name but was reliant on a device called the Materioptikon to help him commit crimes. After being stopped by the JLA, he changed his focus to bringing down the team before taking over the world. Despite increased gadgets at his disposal, they continued to beat him as seen in this moment from *Justice League of America* #35.

Justice League of America #35, May 1965
Writer: Gardner Fox *Artists:* Mike Sekowsky & Bernard Sachs

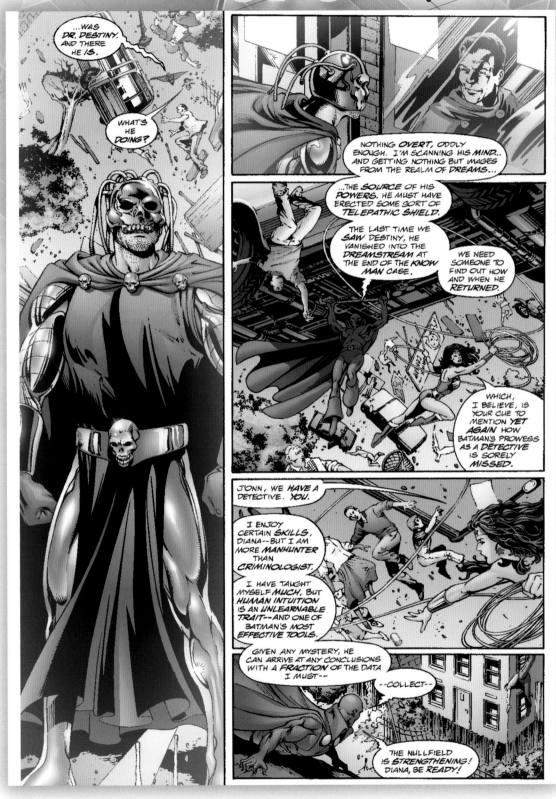

Destiny continued to grow in technological sophistication, taking to wearing this death's head helmet to augment his powers, allowing his dream-self to alter the laws of physics. These random changes perplexed the JLA until they realized Dee was behind the problem and the Martian Manhunter telepathically sent the others into that realm to stop him in *JLA* #50.

JLA #50, February 2001
Writer: Mark Waid *Artists:* Bryan Hitch & Paul Neary

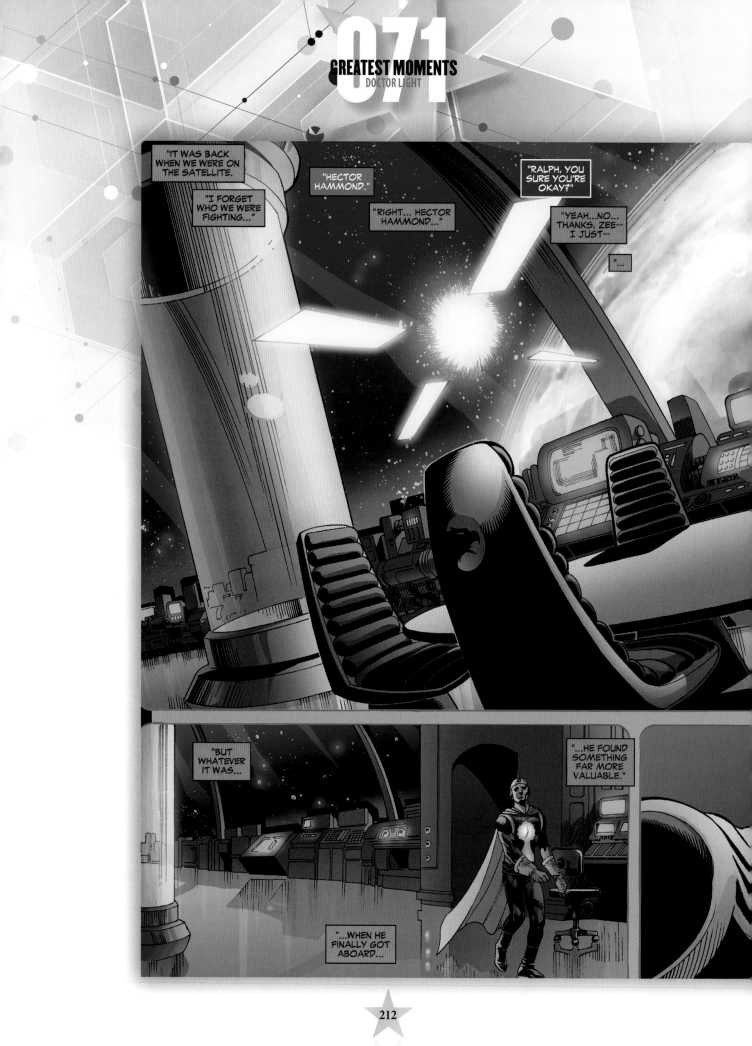

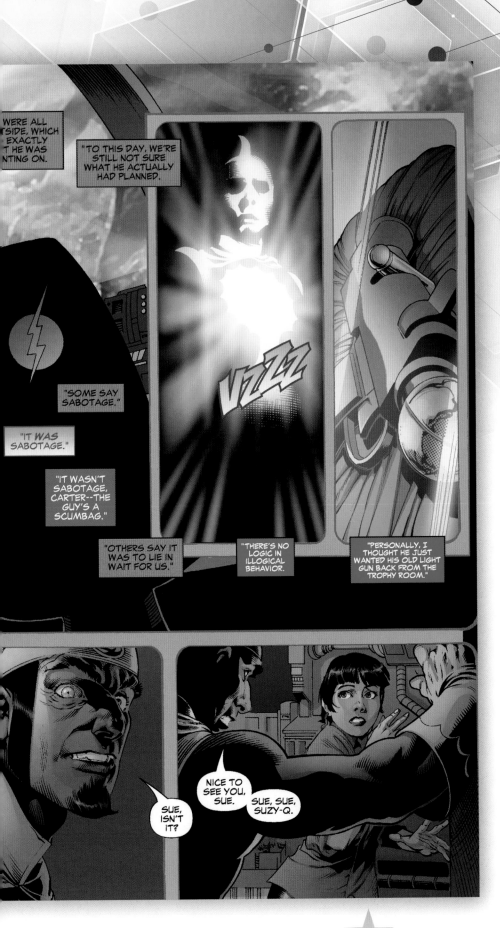

Arthur Light was a foremost scientist who understood the light spectrum better than most any other, but chose to use that knowledge for crime. With each passing defeat, he grew more and more amoral, always seeking revenge. His most brutal attack came when he accessed the JLA's satellite and raped Sue Dibny as seen in the controversial *Identity Crisis* #2. After the attack, a group of members found him and rather than imprison him or kill him, they voted to have Zatanna magically alter his mind, causing him to forget the incident. When Batman arrived just as they were acting, they also altered his mind; acts that would come back and haunt the team for years to come.

Identity Crisis #2,
September 2004
Writer: Brad Meltzer
Artists: Rags Morales
& Michael Bair

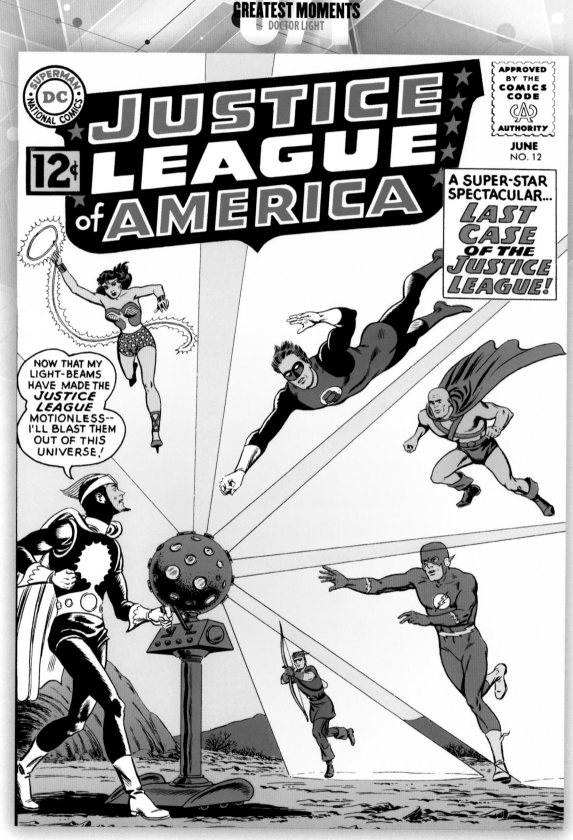

In his first appearance in *Justice League of America* #12, Doctor Light was an intelligent, clever villain with none of the members suspecting he would become one of their most mentally deranged foes, bringing heartbreak and pain to the team.

Justice League of America #12, June 1962
Artists: Mike Sekowsky & Murphy Anderson

Four aliens sought to be the absolute master of the Antares solar system and came to Earth to determine which one —Kanjar Ro of Dhor, Kromm of Mosteel, Sayyar of Llarr, or Hyathis of Alstair—would win. Hyathis would prove quite the match for Wonder Woman and Aquaman in their first encounter as recorded in *Justice League of America* #3.

Justice League of America #3, Feb./March 1961
Artists: Mike Sekowsky & Bernard Sachs

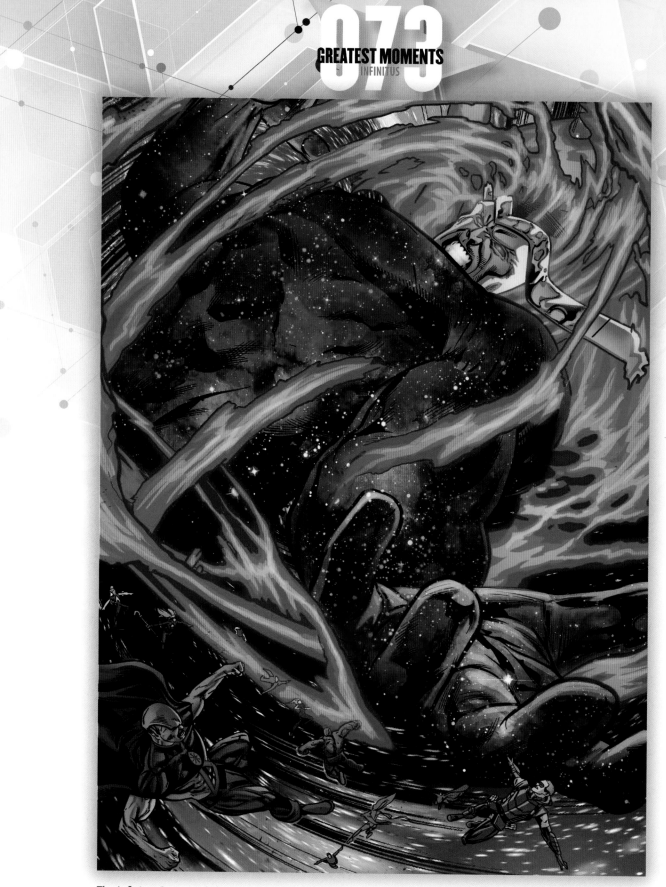

The Infinitus Saga used classic characters in shocking new ways as the shape-changing Thanagarian Byth tinkered with an alien called Ultra, who was destined to evolve into the cosmic threat called Infinitus and destroy the 31st Century, prompting the Legion of Super-Heroes to partner with contemporary heroes in *Justice League United* #10 to prevent that from happening.

Justice League United #10, May 2015
Writer: Jeff Lemire *Artists:* Neil Edwards & Jay Leisten

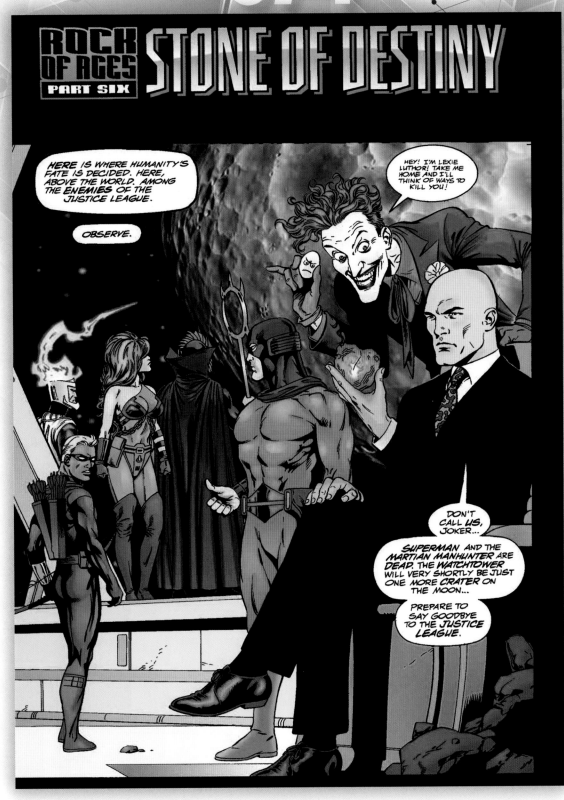

There were many times the super-villains banded together for a common cause, usually involving taking down the JLA en route to world domination. One such gathering was known as the Injustice Gang, led by Lex Luthor and the Joker as seen in this moment from *JLA* #15.

JLA #15, February 1998
Writer: Grant Morrison *Artists:* Howard Porter & John Dell

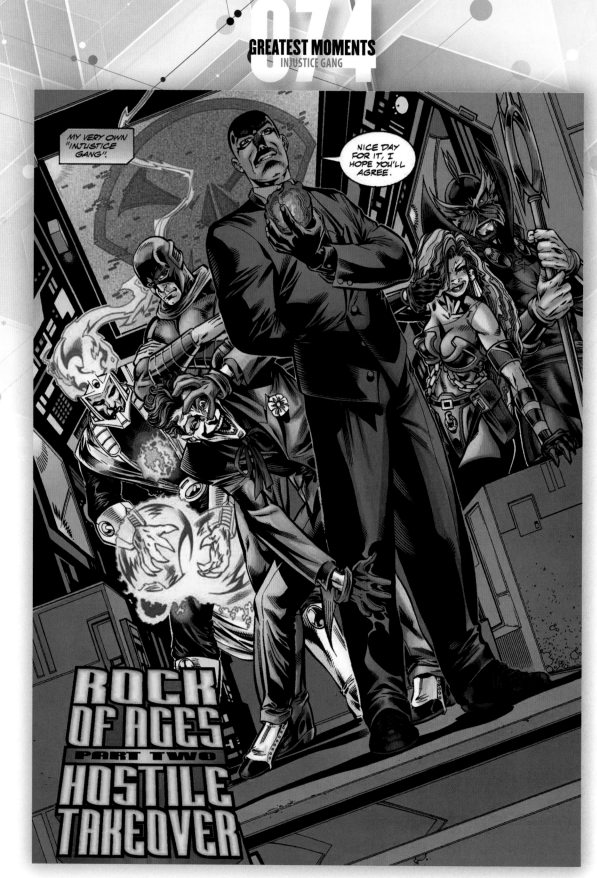

Lex Luthor assumed the Injustice Gang to destabilize the JLA, weaponizing the Joker's manic nature to create a bizarre reality that might destroy Superman and the Martian Manhunter, only to fail yet again in *JLA* #11.

JLA #11, October 1997
Writer: Grant Morrison *Artists:* Howard Porter & John Dell

Things look grim for the JLA on the cover to *Justice League of America* #14 but inside, Superman and Black Lightning lead an assault on the Injustice League's swamp headquarters, hoping to rescue a captured Wonder Woman.

Justice League of America #14, December 2007
Artists: Ian Churchill & Norm Rapmund

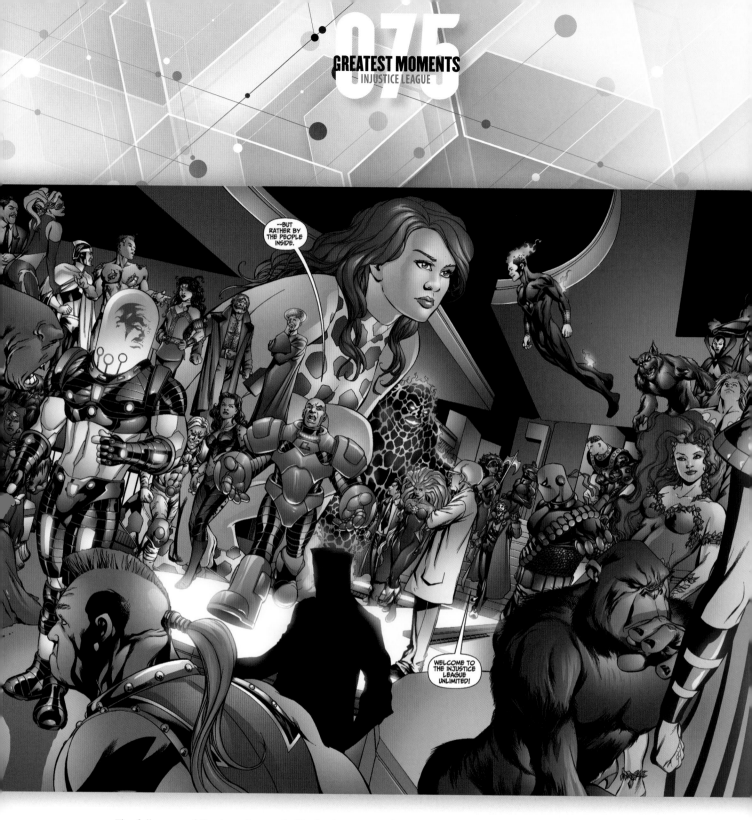

The full scope of the team is revealed in *Justice League of America Wedding Special* #1 with a sizable membership coming from the rogues' gallery of each JLA member, making for a near-unstoppable force.

Justice League of America Wedding Special #1, November 2007
Writer: Dwayne McDuffie *Artists:* Ed Benes & Sandra Hope

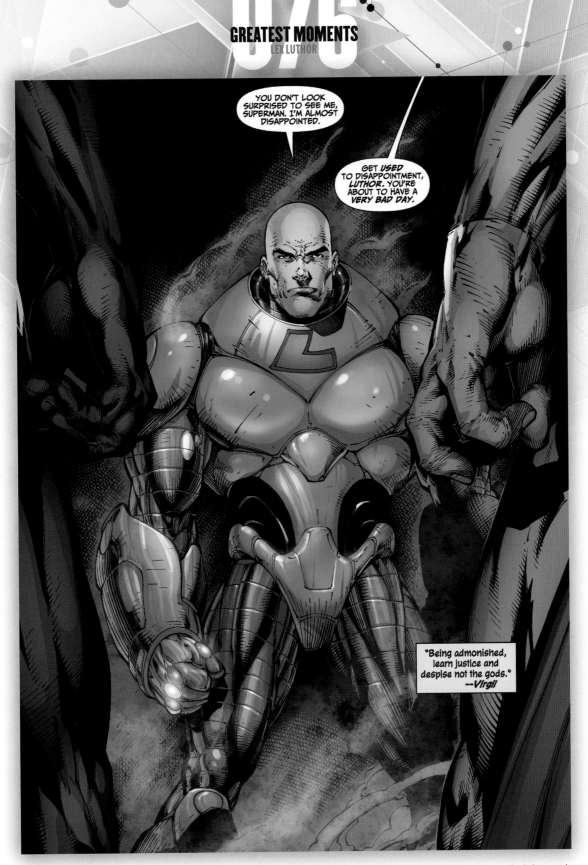

Over time, Lex Luthor has waged a one-man war against the Man of Steel and has, on occasion, expanded that with allies to take down the entire JLA as seen in this moment from *Justice League of America* #13. In more recent years, he has found himself reconsidering this position and has actually allied himself with the team, becoming a member. Can he be trusted?

Justice League of America #13, November 2007
Writer: Dwayne McDuffie *Artists:* Ed Benes & Sandra Hope

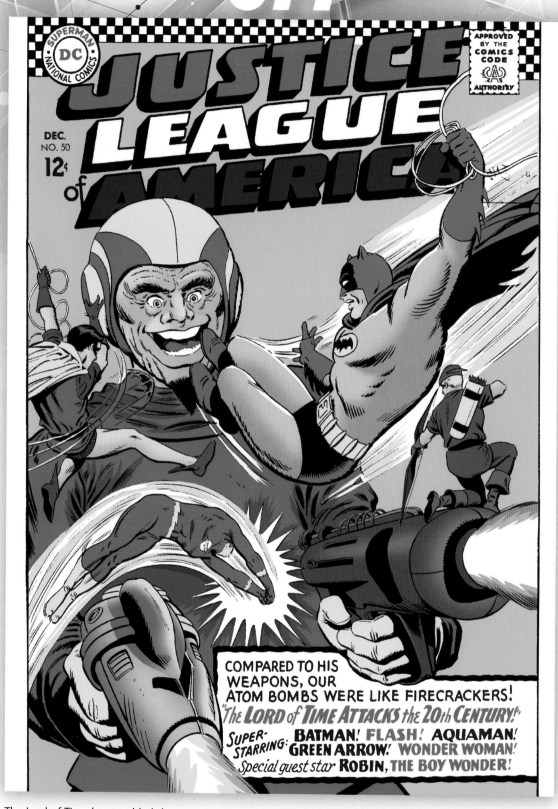

The Lord of Time has troubled the team on numerous occasions and was an apt opponent for *Justice League of America* #50, which guest-starred Robin. The Dynamic Duo is prominent on the cover due to their success on the ABC *Batman* TV series at the time.

Justice League of America #50, December 1966
Artists: Mike Sekowsky & Murphy Anderson

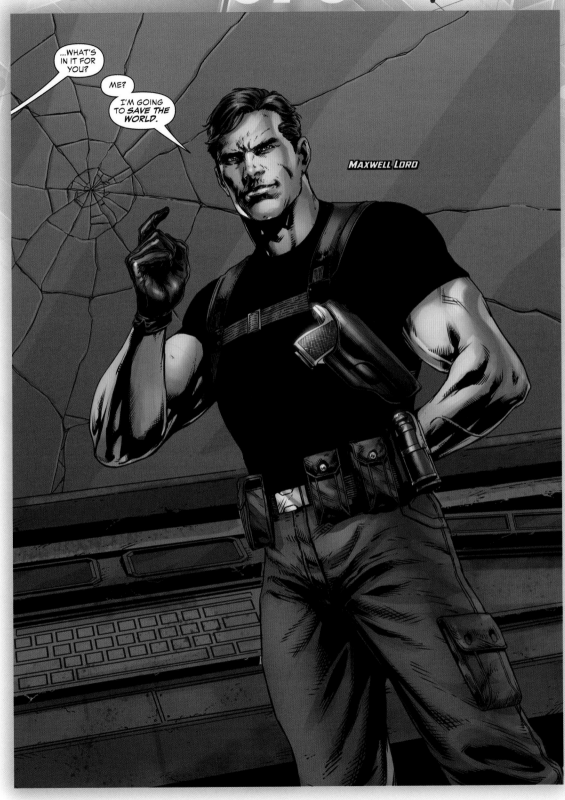

Maxwell Lord had been the JLA's benefactor in one reality but in the Rebirth universe, Lord is the twisted telepath, once leader of Checkmate and now is out to grab power for himself, using his own version of Task Force X to accomplish this, beginning in *Justice League vs. Suicide Squad* #1.

Justice League vs. Suicide Squad #1, February 2017
Writer: Joshua Williamson *Artist:* Jason Fabok

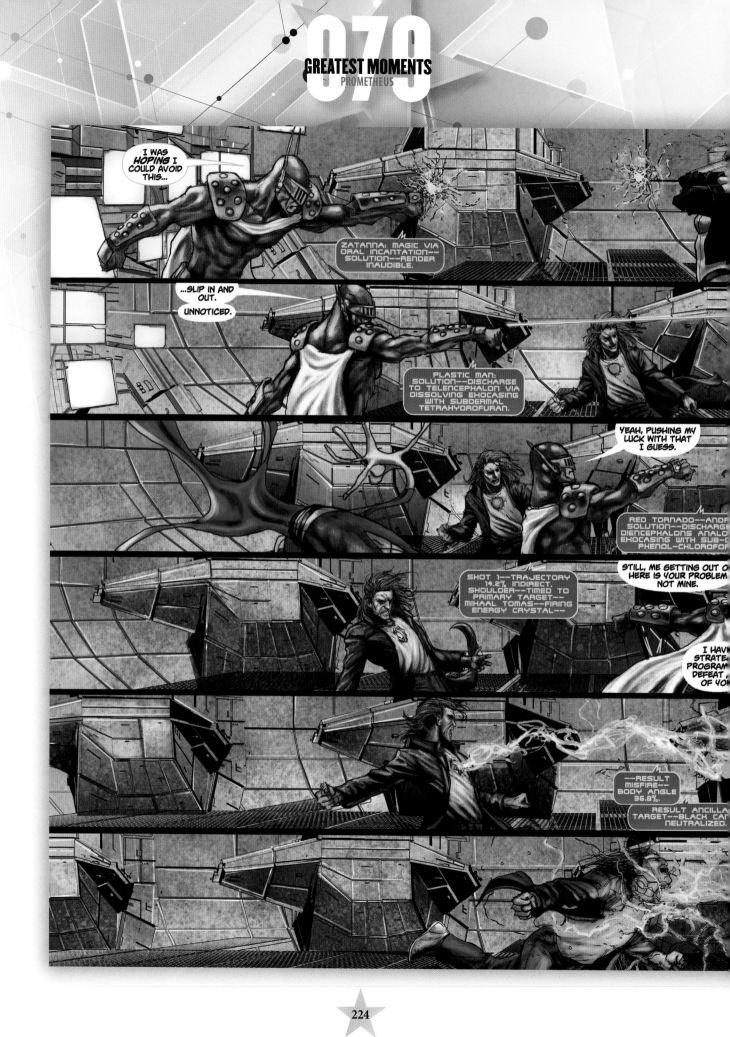

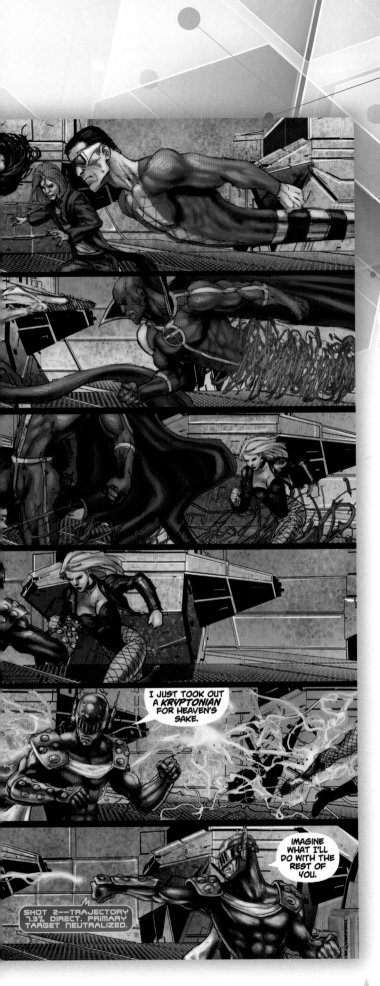

Prometheus was Grant Morrison's greatest rogue contribution to the JLA legacy, a warped human who possessed the ability to mimic anyone's abilities. As a result, he proved an incredible challenge to various incarnations of the team as seen in this fight from *Justice League: Cry for Justice* #6.

Justice League: Cry for Justice #6, March 2010
Writer: James Robinson *Artist:* Scott Clark

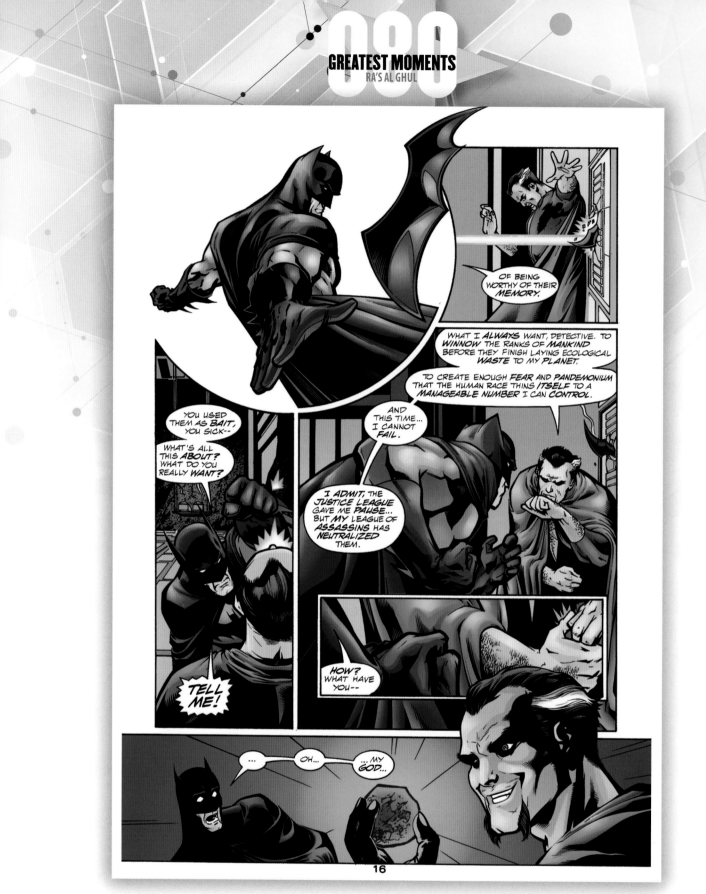

Ra's al Ghul is a near-immortal who is determined to cleanse the Earth of those who defile it—most of humanity. With his League of Assassins, he has schemed and plotted to accomplish these goals, only to be thwarted time and again by Batman. When he stole the Dark Knight's files on how to take down each member of the JLA, he opened up

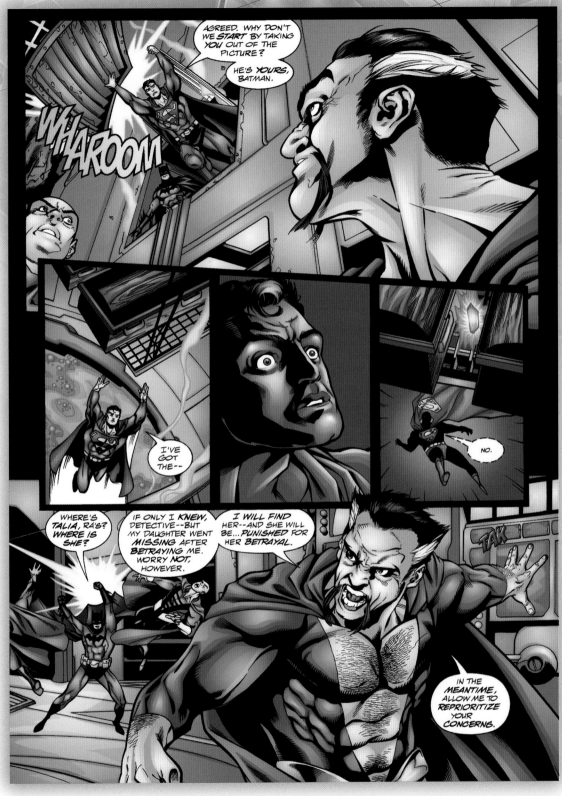

a new front in his war. Having stolen the corpses of Thomas and Martha Wayne, he drove Batman to distraction and wielded red kryptonite to incapacitate Superman in these pages from *JLA* #46.

JLA #46, October 2000
Writer: Mark Waid *Artists:* Steve Scott & Mark Propst

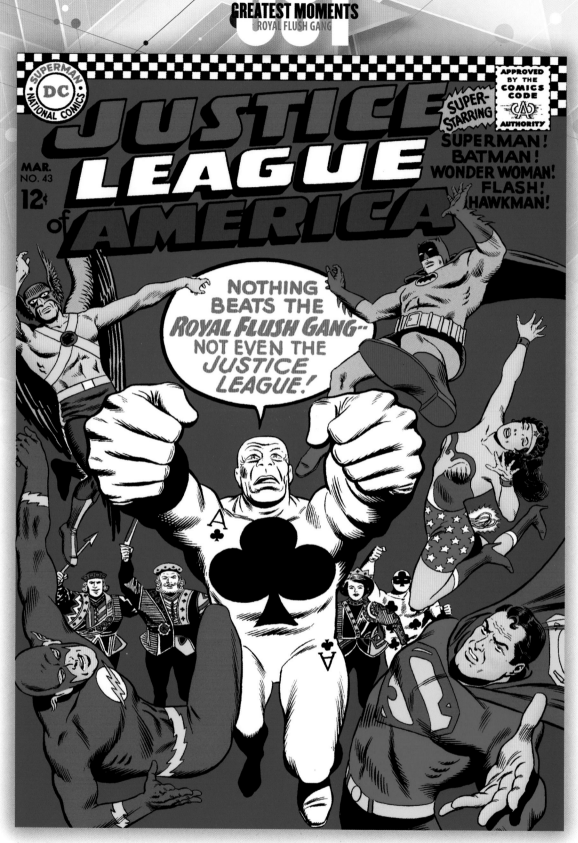

Amos Fortune repeatedly attempted to gain revenge on the JLA and nearly accomplished that when he recruited his fellow juvenile delinquents from childhood to form the Royal Flush Gang. As seen on the cover to *Justice League of America* #43, they nearly were victorious.

Justice League of America #43, March 1966
Artists: Mike Sekowsky & Murphy Anderson

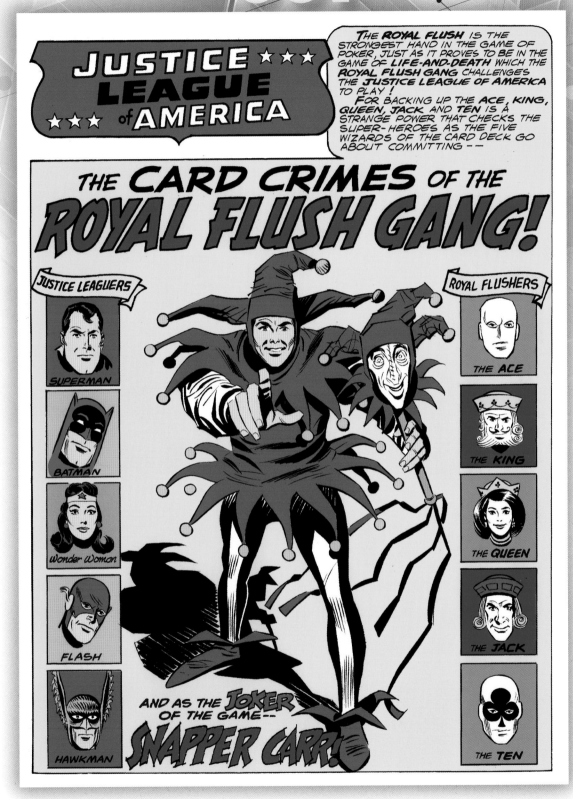

Fortune discovered "Stelleration," a special radiation that somehow compelled people to act in the astrological meaning of playing cards. With his gang, the team attacked the JLA in *Justice League of America* #43 until Snapper Carr played the wild card, using reverse psychology to aid the team in victory.

Justice League of America #43, March 1966
Writer: Gardner Fox *Artists:* Mike Sekowsky & Bernard Sachs

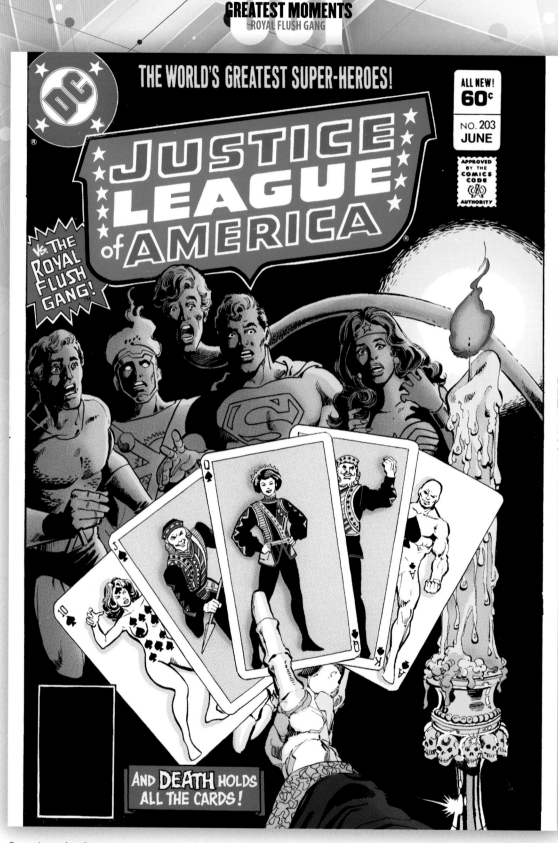

Over time, the Gang outgrew Fortune and operated independently. They continued to recruit new members and returned to plague the JLA with ever deadlier schemes. Unfortunately, internal strife prompted this incarnation, from *Justice League of America* #203, to fail.

Justice League of America #203, June 1982
Artists: George Pérez & Dick Giordano

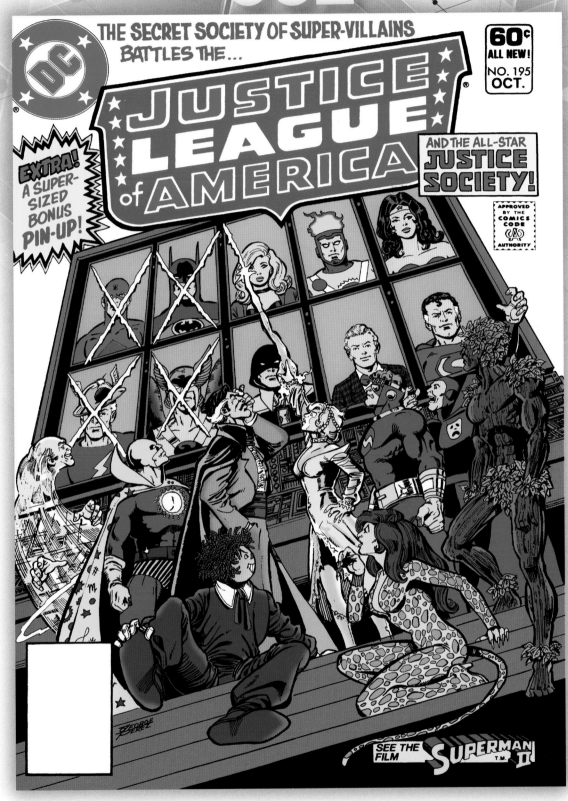

The Secret Society of Super-Villains was a constant thorn in the JLA's side, so much so, that they needed the Justice Society's aid on one occasion as noted on the cover to *Justice League of America* #195.

Justice League of America #195, October 1981
Artist: George Pérez

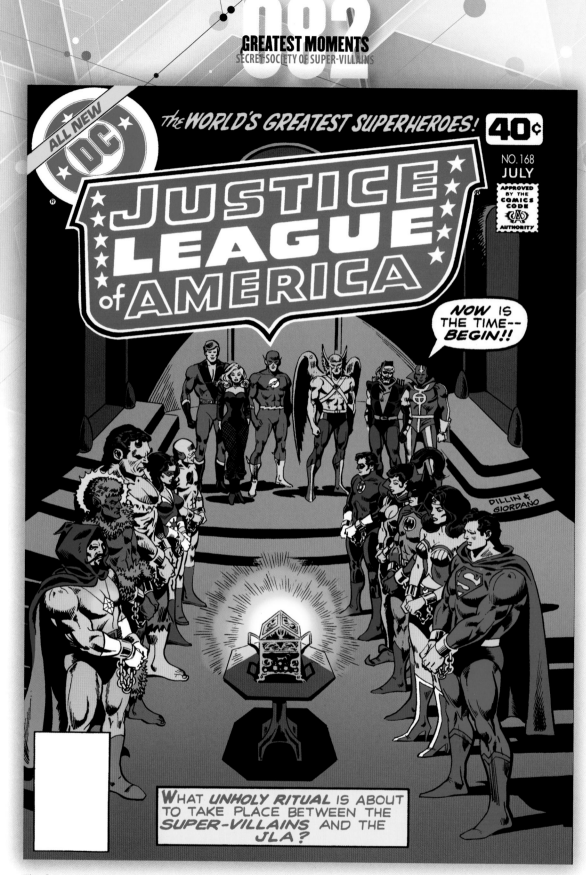

The first confrontation between the JLA and Secret Society involved a magical means of swapping their personalities, causing chaos until the unaffected members of the team could force a reversal of the process as seen on the cover to *Justice League of America* #168.

Justice League of America #168, July 1979
Artists: Dick Dillin & Dick Giordano

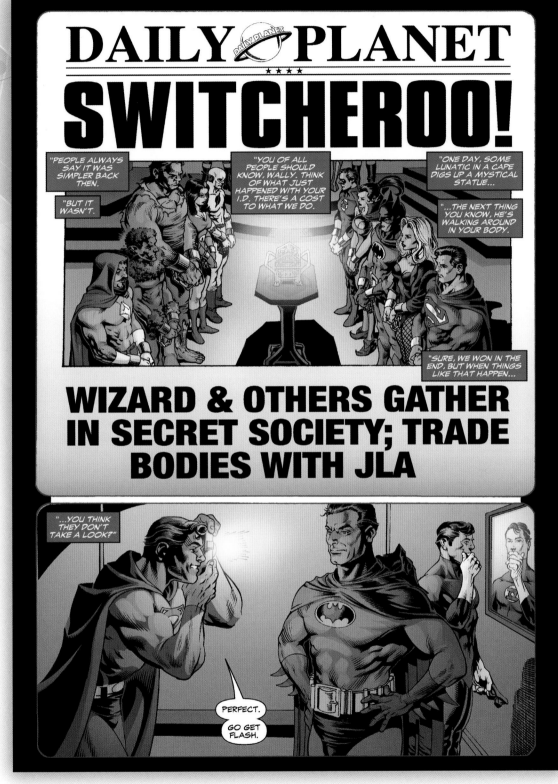

This storyline was read by young Brad Meltzer and it stuck with him, imagining what the villains would do once they possessed the heroes' bodies. He channeled that boyhood notion into the script for the acclaimed Identity Crisis event as seen in this moment from *Identity Crisis* #2.

Identity Crisis #2, September 2004
Writer: Brad Meltzer *Artists:* Rags Morales & Michael Bair

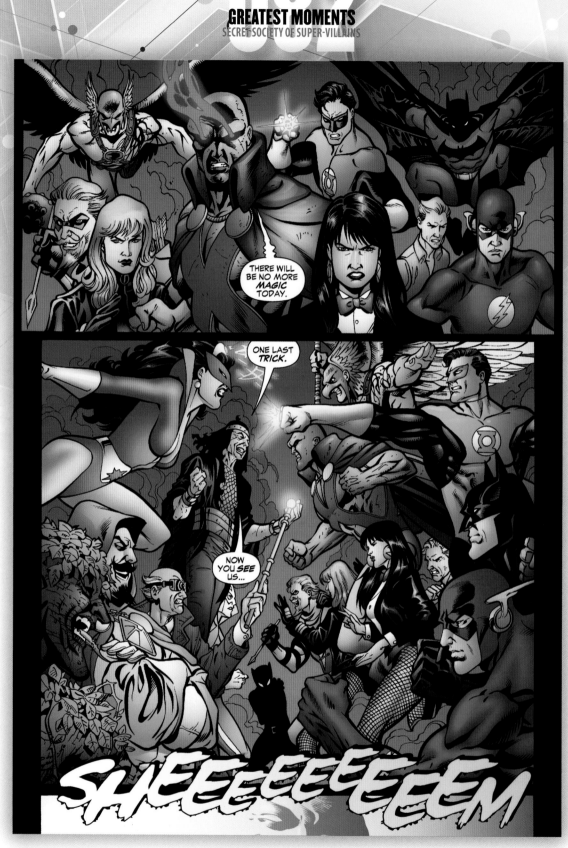

The fallout of these mind-manipulations played out for some time as both team harbored grudges setting up the Crisis of Conscience storyline including this moment from *JLA* #116, which also saw internal disputes among the Leaguers.

JLA #116, September 2005
Writers: Geoff Johns & Allan Heinberg *Artists:* Chris Batista & Mark Farmer

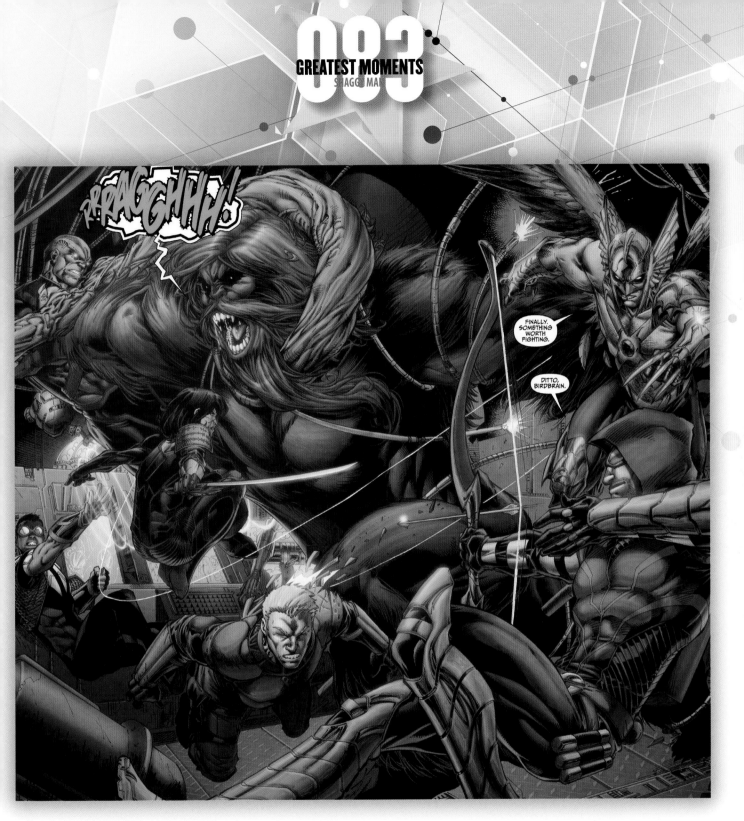

The Shaggy Man, an artificial lifeform created by Andrew Zagarian, is an unstoppable, raging creature. There have been various incarnations of the hairy monster throughout the JLA's career including this one, fighting the team in *Justice League of America* #5.

Justice League of America #5, August 2013
Writer: Geoff Johns *Artists:* Brett Booth & Norm Rapmund

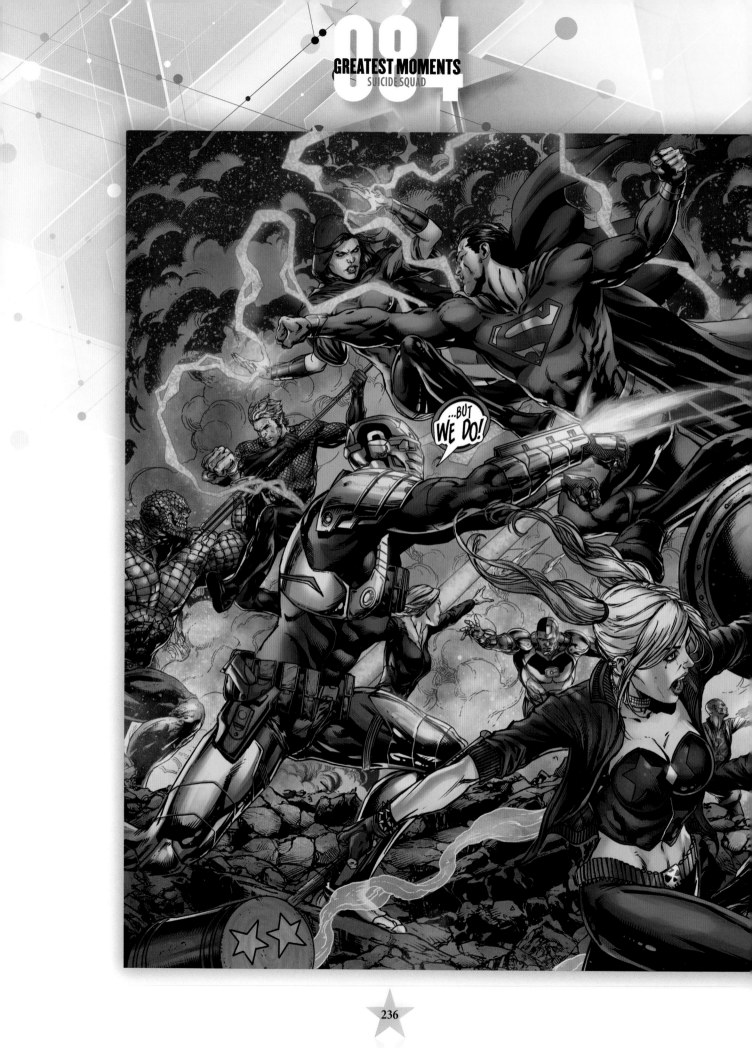

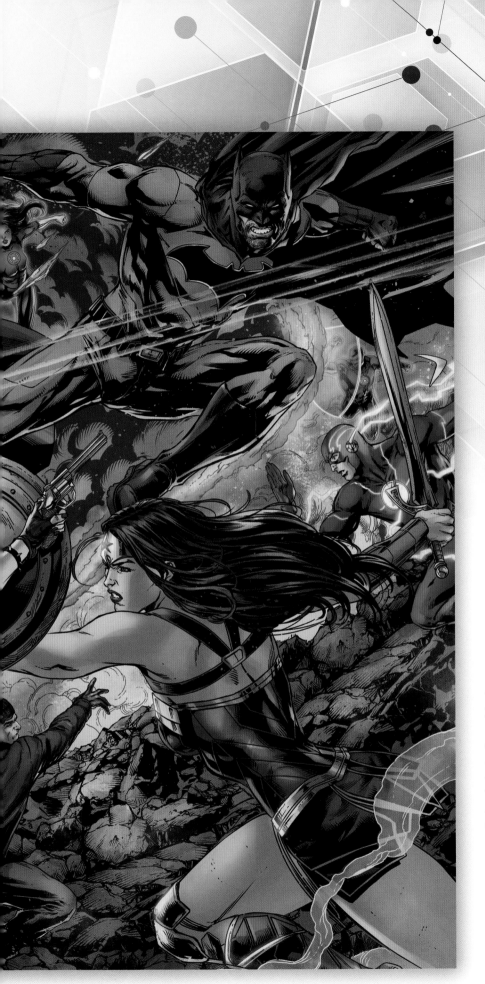

The United States government's Task Force X is better known as the Suicide Squad and Batman has continually frowned at the use of villains for America's purposes. He has attempted to take them down on his own and with the JLA. However, there comes a time when one realizes Amanda Waller has a point and the Squad has a place in a dangerous world. That said, Amanda Waller and Maxwell Lord found themselves at odds, setting up a titanic battle between the team as this clash from *Justice League vs. Suicide Squad* #1.

Justice League vs. Suicide Squad #1,
February 2017
Writer: Joshua Williamson
Artist: Jason Fabok

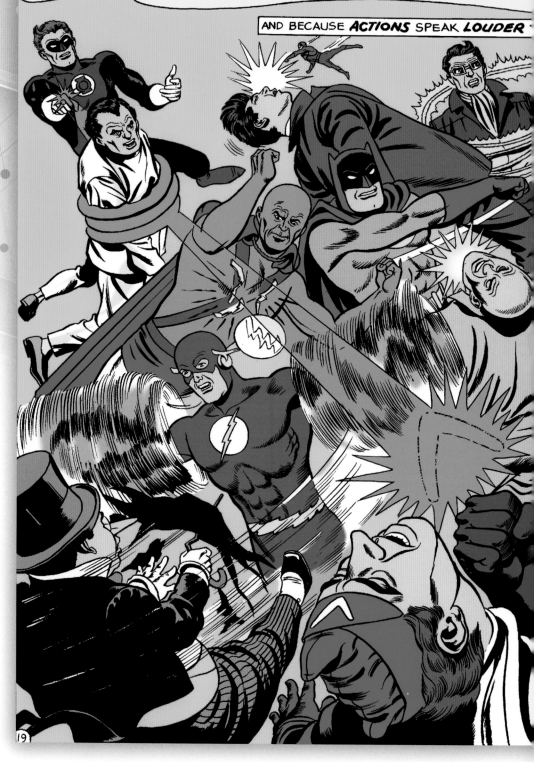

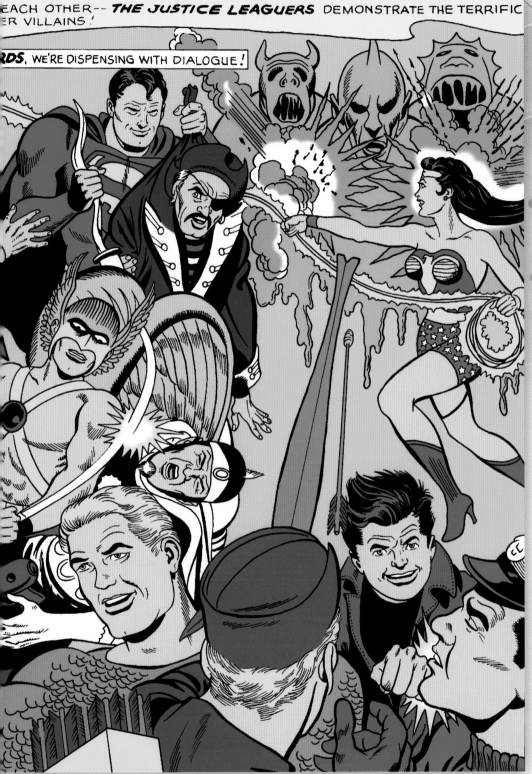

Doctor Destiny attempted to take down the JLA from within, imitating Green Arrow and quitting the team. With each member dressed as the Emerald Archer in *Justice League of America* #61, they tried to find the truth until they took down Lex Luthor, Doctor Light, the Tattooed Man, Captain Boomerang, the Penguin, I.Q., Cutlass Charlie, and the Plant Master in this titanic fight.

Justice League of America #61, March 1968
Writer: Gardner Fox *Artists:* Mike Sekowsky & Sid Greene

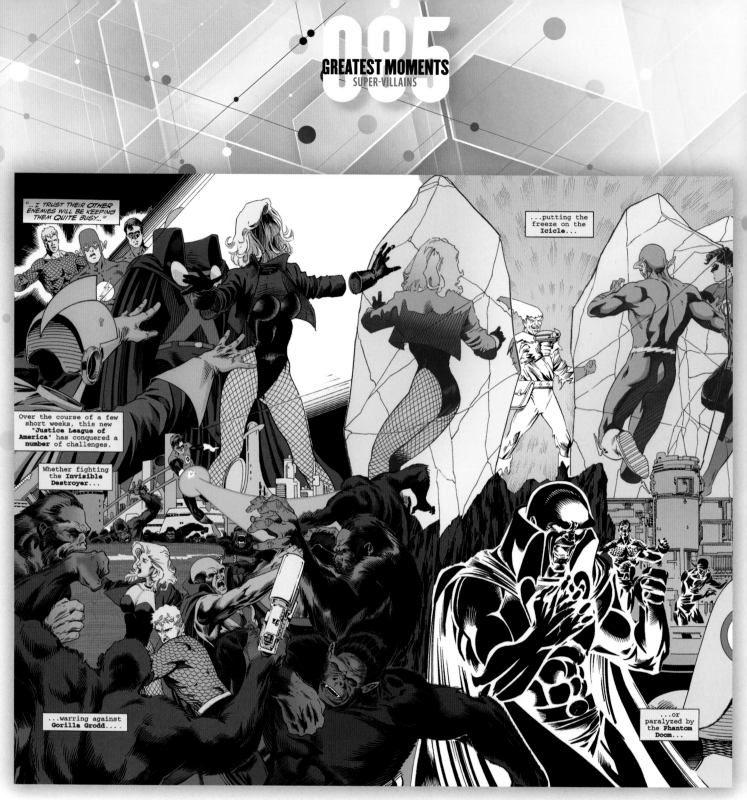

Just as circumstances brought heroes together to form the Justice League, so too did the villains gather to oppose their foes. This has been true from the very beginning as noted in this battle from *JLA: Year One* #7.

JLA: Year One #7, July 1998
Writers: Mark Waid & Brian Augustyn *Artists:* Barry Kitson & Michael Bair

Bodiless uniforms of the JLA's enemies perplexed the team until it was clear they were being enchanted by the Demons Three who were attempting to escape their confines in this moment from *Justice League of America* #35.

Justice League of America #35, May 1965
Artists: Mike Sekowsky & Murphy Anderson

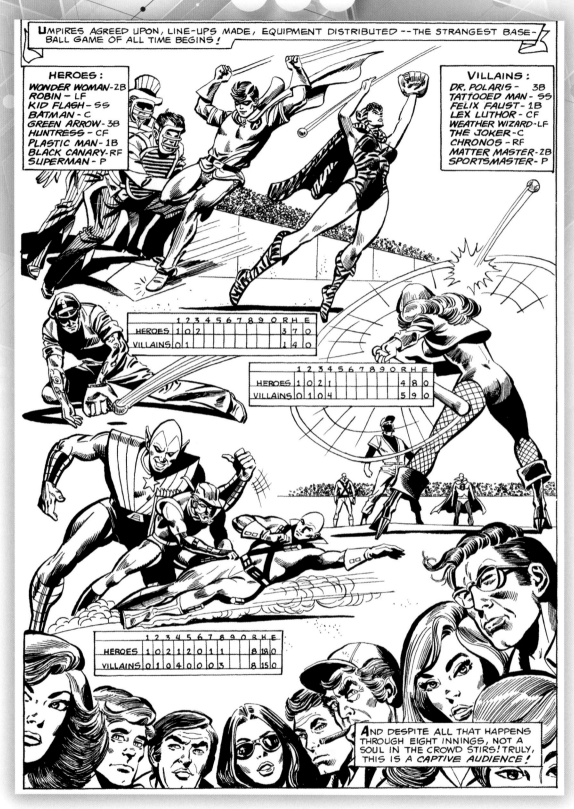

There may be no more bizarre confrontation between the JLA and their enemies than when they found themselves in a less-than-friendly game of baseball in this odd moment from *DC Super-Stars* #10.

DC Super-Stars #10, December 1976
Writer: Bob Rozakis *Artists:* Dick Dillin & Frank McLaughlin

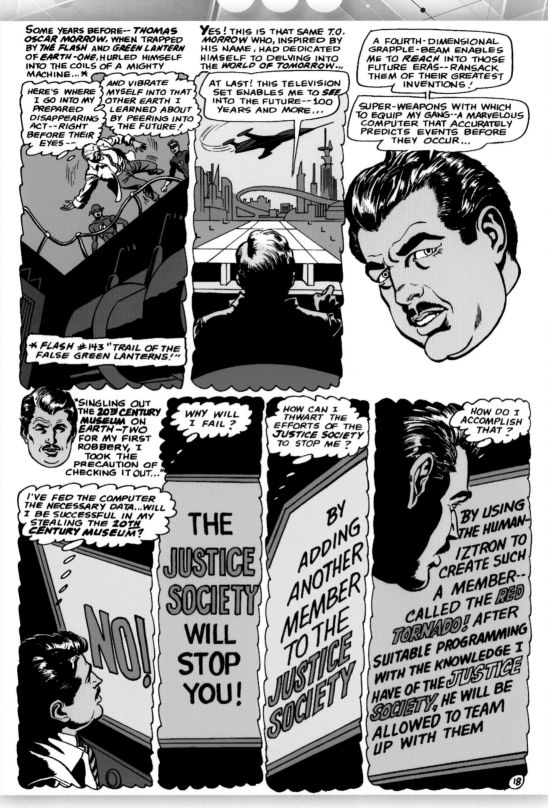

T.O. Morrow was, at first, a foe of the Flashes of two worlds but then he began going after the entire JLA and JSA. He built the Red Tornado android based on a prediction offered by his computer as seen in this moment from *Justice League of America* #64.

Justice League of America #64, August 1968
Writer: Gardner Fox *Artists:* Dick Dillin & Sid Greene

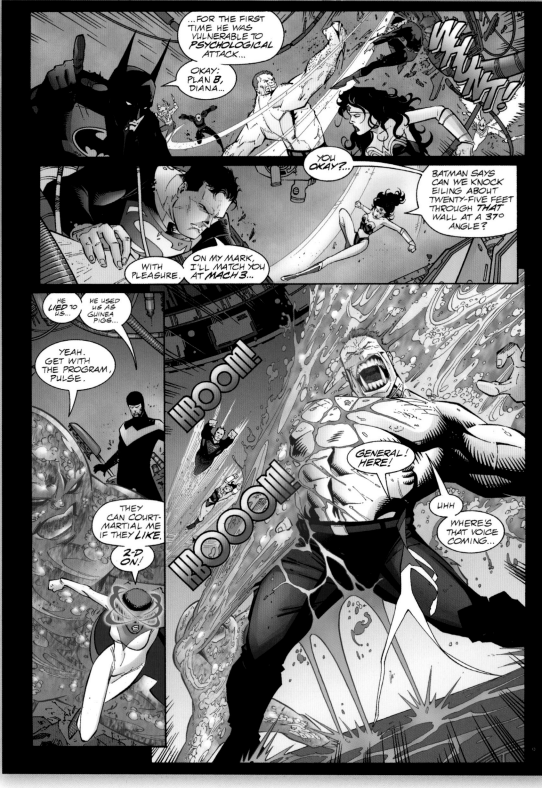

General Wade Eiling hated super heroes and did whatever it took to bring them to heel. In one instance, he coopted one of the Shaggy Man bodies and had his mind placed within. The General then attacked the team in *JLA* #26.

JLA #26, February 1999

Writer: Grant Morrison *Artists:* Mark Pajarillo & Walden Wong

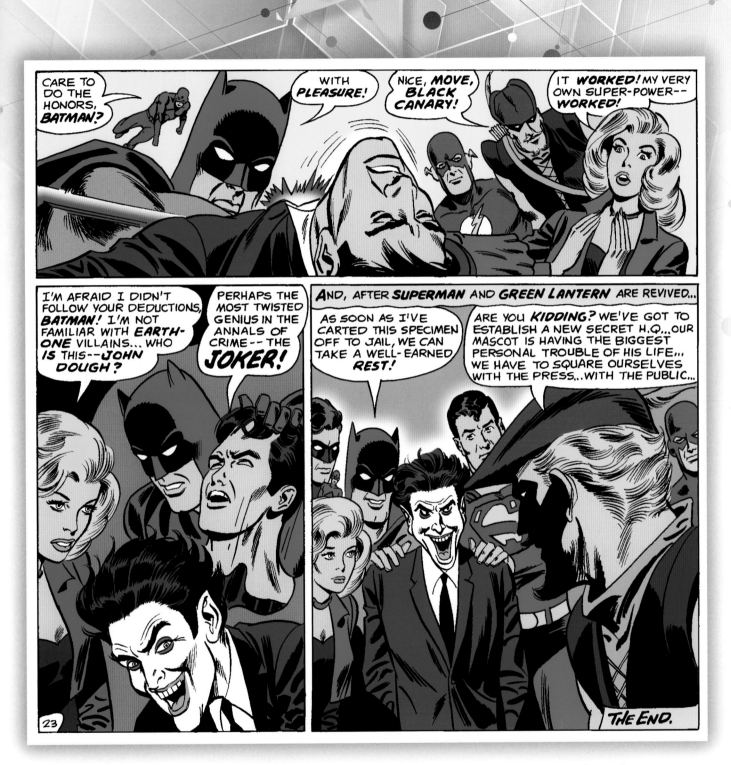

John Dough was a persuasive speaker, challenging authority, and managed to convince Snapper Carr to betray the JLA and reveal the location of the Secret Sanctuary. When Dough was apprehended in *Justice League of America* #77, he was revealed at story's end to be the Joker, the first Batman rogue to attack the team on his own.

Justice League of America #77, December 1969
Writer: Denny O'Neil *Artists:* Dick Dillin & Joe Giella

The Key evolved over the years as the "psycho-chemicals" he initially ingested continued to wreak havoc on his mind and body. The infusion was intended to activate his ten senses and he attacked the JLA in their Watchtower in *JLA* #7, hoping to increase his powers but was stopped by Green Arrow.

JLA #7, June 1997
Writer: Grant Morrison *Artists:* Howard Porter & John Dell

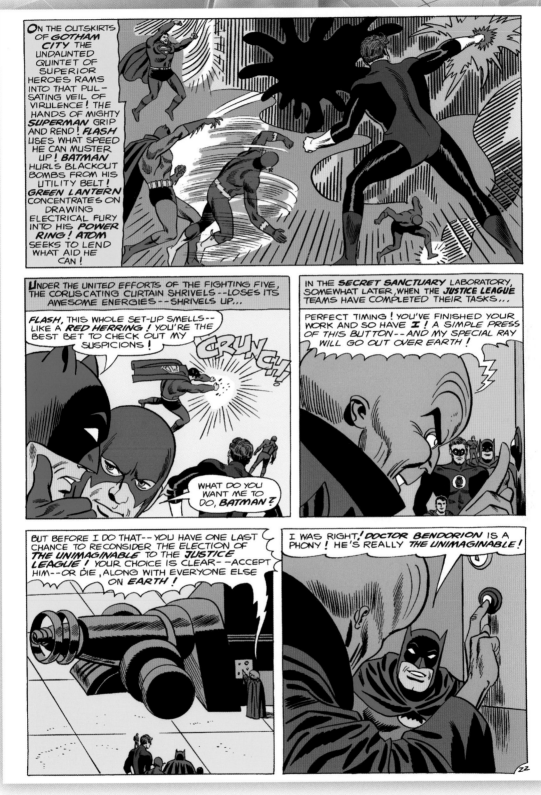

The Unimaginable was bored with existence so traveled through space, until he landed on Earth. He tried to join the JLA, which rejected him, so he used several captured aliens including Doctor Bendorion as seen in this moment from *Justice League of America* #44.

Justice League of America #44, May 1966
Writer: Gardner Fox *Artists:* Mike Sekowsky & Bernard Sachs

The United States didn't always trust the heroes and created the Ultramarines as their first line of defense. They took on the team in *JLA* #25 under the command of General Eiling but the unstable metagene manipulation proved to be their undoing.

JLA #25, January 1999
Artists: Howard Porter & John Dell

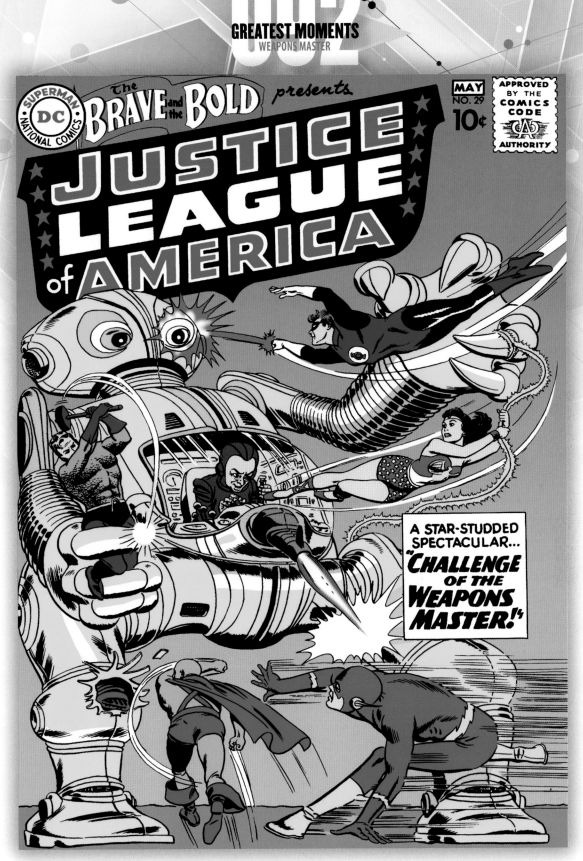

It was quickly apparent that the threats to Earth would be coming from space and time in addition to Earth-grown threats. The Weapons Master traveled all the way back from 11,960 as seen on the cover to *The Brave and the Bold* #29.

The Brave and the Bold #29, May 1960
Artists: Mike Sekowsky & Murphy Anderson

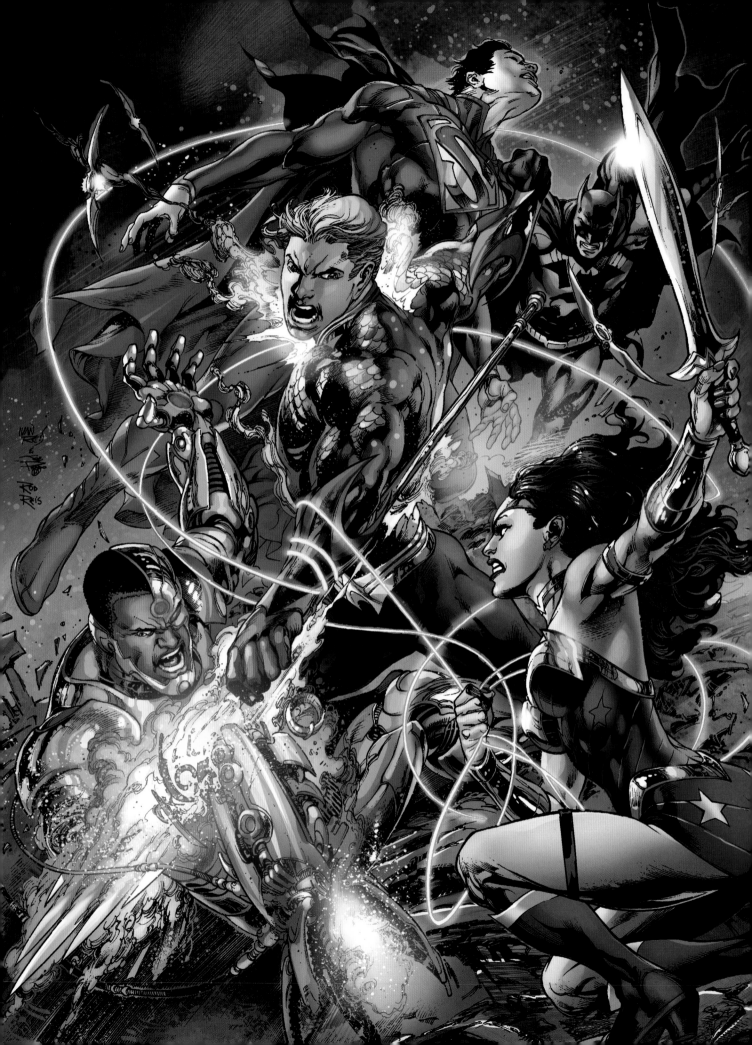

IN ITS NEARLY SIXTY-YEAR CAREER, THE JUSTICE
LEAGUE OF AMERICA HAS BATTLED ALL MANNER
OF FOE—ALIEN, OCCULT, SPIRITUAL, PERSONAL—
AND THEIR EXPLOITS HAVE BECOME THE STUFF OF
LEGEND. HOWEVER, A HANDFUL OF CONFLICTS
WHERE THE STAKES HAVE NEVER BEEN HIGHER
HAVE ENDURED IN THE MEMORIES OF FANS AND
CREATORS ALIKE. WHILE THE JLA MAY HAVE FOUGHT
SOME OF THESE FOES BEFORE AND SINCE, THESE
PARTICULAR CONFRONTATIONS HAVE BEEN CITED
TIME AND AGAIN BY BOTH CREATORS AND READERS
AS AMONG THEIR GREATEST BATTLES.

CHAPTER 7

THEIR GREATEST
BATTLES

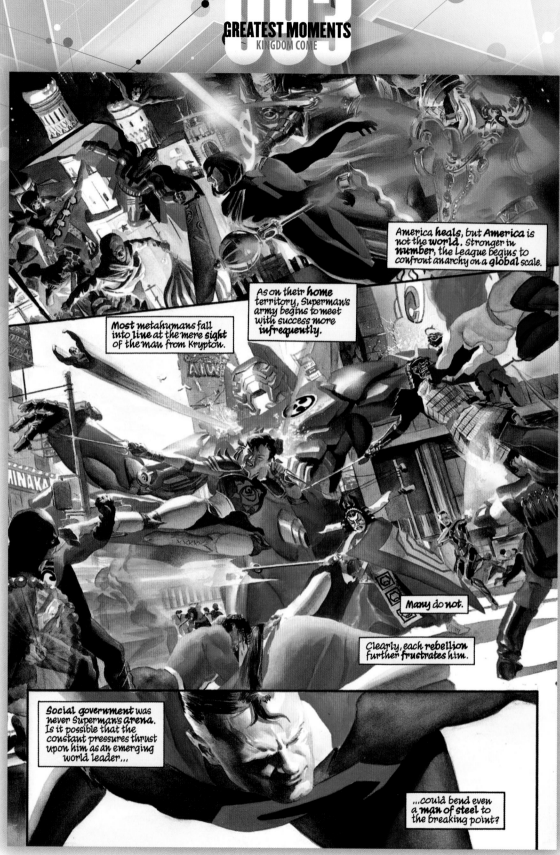

In a near future depicted in *Kingdom Come*, the super-human population has swelled so it appears there are constant battles on the streets. Even an aging Man of Steel struggles to make sense of the rampant violence.

Kingdom Come #2, June 1996
Writer: Mark Waid *Artist:* Alex Ross

KINGDOM COME

Once you accept that all comic book adventures are works of fiction, you can then begin to parse the various continuities that have evolved over time. Pre-Crisis, Post-Crisis, Zero Hour, New 52, Rebirth, and so on. But atop all of those, you have what are known as Imaginary Stories, tales that take these heroes and villains and put them into a different time or place or change one element of an event. Some of it was wish fulfillment for the writers and later the fans, providing some of the most memorable stories of DC's first fifty years.

Since then, more elaborate explorations of "what if" tales took place, and for a time they had their own Elseworlds branding to set them apart from whatever the canonical continuity was at the time.

Many featured members of the Justice League, while only a few featured the team itself. Of all these Elseworlds tales, one took on an epic scope that was so well received that elements of this potential future world began seeping into the core continuity, making that world ever more likely to happen.

The story was called *Kingdom Come*, and it came from ideas and designs from painter Alex Ross. He partnered with DC history maven and writer Mark Waid, postulating a near future where the next generation of heroes and villains had long since forgotten what they were fighting for.

The Justice League was supplanted in the hearts and minds of the citizens they were sworn to protect by a more vicious protector, Magog. He acted as judge, jury, and executioner, taking out the villains who would not repent, notably the Joker.

There were still acts of violence, including the bomb that detonated within the *Daily Planet*, taking the life of Lois Lane. Distraught, Kal-El gave up his uniform and retired from sight, working the Kent farm in isolation.

After Magog and a cadre of heroes made an error, the cost was an irradiated American Midwest that crippled the country's food supply. Wonder Woman decided enough was enough and justice had to be returned to America.

Despite serious injuries, Bruce Wayne cannot help but take delight in making a difference, leading his armored resistance in the final pages of *Kingdom Come*, a dark glimpse of a possible future.

Kingdom Come #4, August 1996
Writer: Mark Waid *Artist:* Alex Ross

She recruited Superman, who reluctantly agreed, and they set about reforming the JLA, including many younger heroes. The exception was Batman, who had yet to forgive Superman for abandoning them a decade earlier. Instead, he activated a previously established network of heroes, his Outsiders.

Luthor had his own Mankind Liberation Front, a thinly disguised regrouping of his Injustice forces. The two sides clashed and the heroes prevailed, rounding up the villains and imprisoning them in a structure known as the Gulag.

Tensions and events escalated until the overfull Gulag was breached and chaos became the order of the day. Tipping the scales in Luthor's favor was the presence of an adult Billy Batson, who had been brainwashed by the evil scientist. Saying the magic word "Shazam," he was transformed once more into Captain Marvel, who brought Superman to a standstill. Summoning the magical lightning bolts, Marvel attacked Superman, until the Man of Steel managed to catch the Captain in one bolt, returning him to Billy's form. Freeing Captain Marvel of Luthor's influence, Superman explained that Billy would decide what happened next. As Billy, he understood what mere mortals were confronted with, and as Captain Marvel he understood the super-powered stakes. The choice would be his: let the metahumans run amok and kill one another, or let Superman stop the bomb. Billy uttered the word once more, and it was Captain Marvel, flying high into the sky to stop the bomb, sacrificing his life to save the world.

In the aftermath, there was a recognized need for law, order, and justice. The JLA was back, and the elder statesmen—Superman, Batman, and Wonder Woman—were there to oversee it. Additionally, Clark Kent had stopped grieving and had begun a romance with Diana, resulting in her becoming pregnant—a symbol of hope and renewal.

After being unseen for years, Captain Marvel is revealed and takes on his rival in the climactic battle in *Kingdom Come*, a series that put armies of heroes and villains against one another with a world hanging in the balance.

Kingdom Come #4, August 1996
Writer: Mark Waid *Artist:* Alex Ross

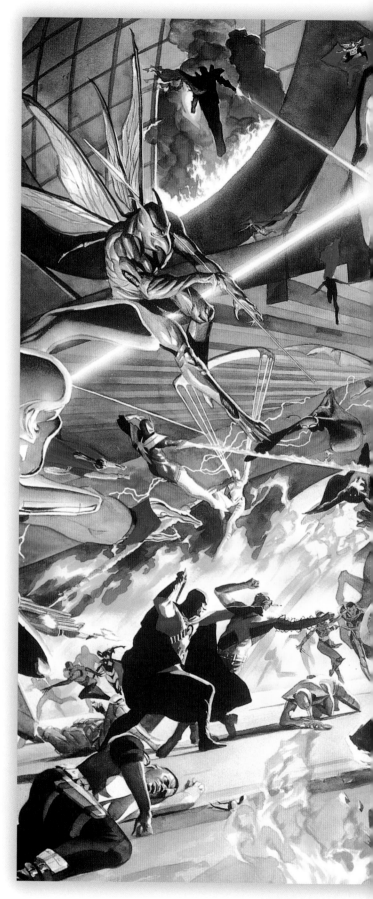

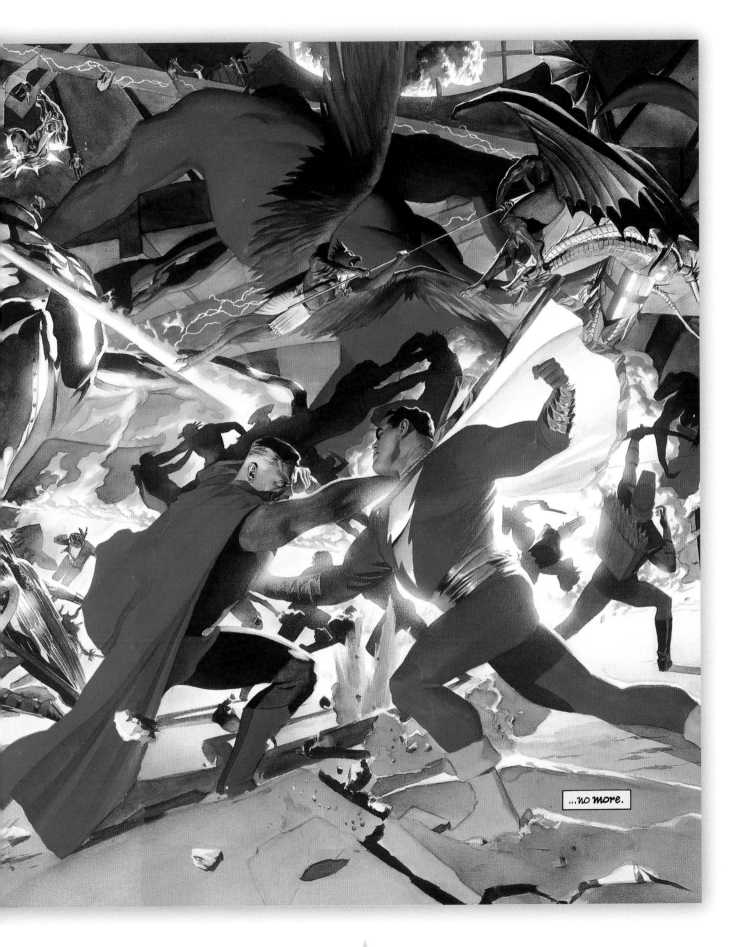

...no more.

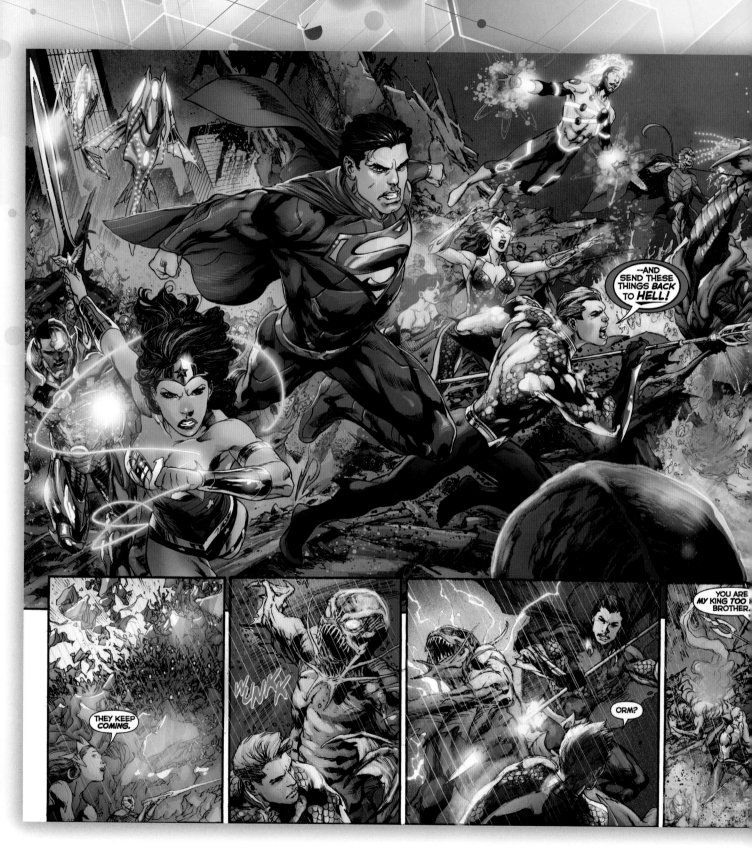

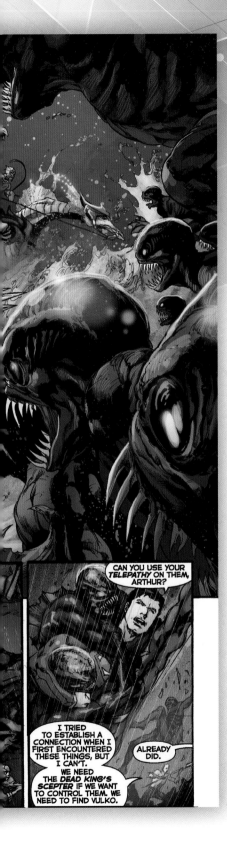

CAN YOU USE YOUR *TELEPATHY* ON THEM, ARTHUR?

I TRIED TO ESTABLISH A CONNECTION WHEN I FIRST ENCOUNTERED THESE THINGS, BUT I CAN'T.

WE NEED THE *DEAD KING'S* SCEPTER IF WE WANT TO CONTROL THEM. WE NEED TO FIND VULKO.

ALREADY DID.

THRONE OF ATLANTIS

JLA writer Geoff Johns needed new challenges and looked down instead of up, pitting the New 52 version of the Justice League against the might of the Atlantean army. A US Navy vessel's malfunctioning missile launch resulted in an accidental attack against the domed underwater nation. Aquaman's half brother, Orm the Ocean Master, sent an army in retaliation against the United States, which had little choice but to defend itself. Caught in the middle, of course, was the Sea King. During this period, every attempt he had made to bring Atlantis into the modern world was met with disdain, confusion, or outright hatred from one or both sides. There were times he seemed to be the only one who saw the value of uniting the two worlds.

Aquaman first became aware of the attack when he realized a series of tsunamis were approaching Gotham City and Metropolis. While Aquaman, his consort Mera, and Batman worked to save lives, a larger problem became clear and the JLA were summoned. As the team gathered, Aquaman recognized the attack strategy as one he and Orm had devised as a contingency plan. After all, despite aiding the JLA during Darkseid's first attack, he would have preferred to remain ruler of Atlantis, not a part-time monarch and full-time hero. When he returned to the surface world, though, Orm assumed the throne and was now using these plans to avenge the Atlantean deaths.

Circumstances have been manufactured to make it appear that Atlantis and its denizens are at war with America. The Justice League, including Aquaman, the King of the Sea, wades into the battle.

Justice League #17, April 2013
Writer: Geoff Johns *Artists:* Ivan Reis & Joe Prado

Aquaman sought a diplomatic solution, but by then it was too late, with the president of the United States declaring a state of emergency. Wonder Woman, no stranger to ruling herself, offered conflicting advice, and the League itself appeared somewhat divided. Only an impending attack on Boston got them to stop talking and act. There, the two brothers confronted each other, and when Orm wouldn't stand down, the JLA arrived, intending to force a peace. Aquaman, though, was displeased that the heroes seemingly picked sides.

Orm proved a worthy opponent, as several of the team were quickly incapacitated. Elsewhere, though, Cyborg had been fit with watertight components, allowing him to journey to Atlantis, surviving the salt water and crushing underwater depths. During the upgrade, his programming sought clues as to what may have triggered the missile accident.

Orm's intended attack on Boston was interrupted when sea creatures emerged from deep within a trench, things previously unseen and a clear threat to all life—Atlantean and surface alike. As the heroes defended against the monsters, Cyborg came to the conclusion that someone intentionally set the two powers at each other. It was Aquaman's former adviser, Vulko, using the scepter of a previous king to cause the mishap, an act of revenge for having been exiled after Aquaman stepped down from the throne.

Once the JLA defeated the trench creatures, their focus returned to Orm, but Aquaman beat his brother, regaining the Atlantean throne. Vulko was remanded to the king to stand trial for his crime, and soon after, Aquaman learned that the United States wanted Orm to stand trial for starting a war. As it was, the surface world's general public had lost faith in the Sea King, while humans had accessed abandoned Atlantean weapons. Tensions remained high, especially when the United Nations wouldn't accept Atlantis's sovereignty.

The aftermath of the story played out as Aquaman sought to find a balance between two worlds, neither of which truly trusted him. It also foreshadowed Mera's heroism and eventual induction into the JLA.

Aquaman's brother Orm, the Ocean Master, has brought Atlantis to the brink of war with the surface world; unleashing undersea creatures that challenge even the Justice League. It has been prophesied in the fabled *Atlantis Chronicles* that brother will battle brother through the ages.

Justice League #16, March 2013
Writer: Geoff Johns *Artists:* Ivan Reis & Joe Prado

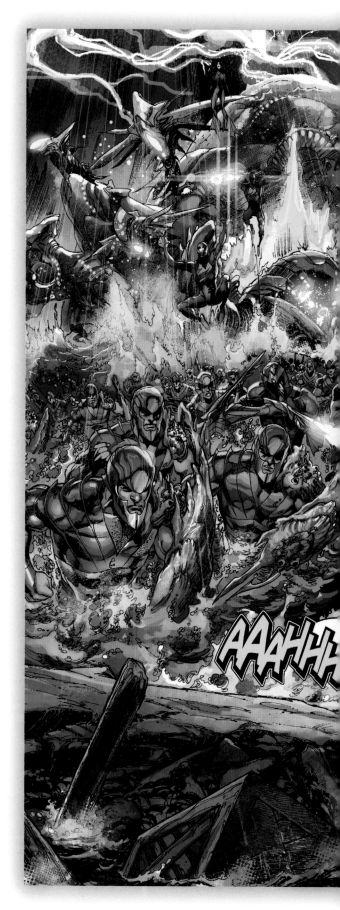

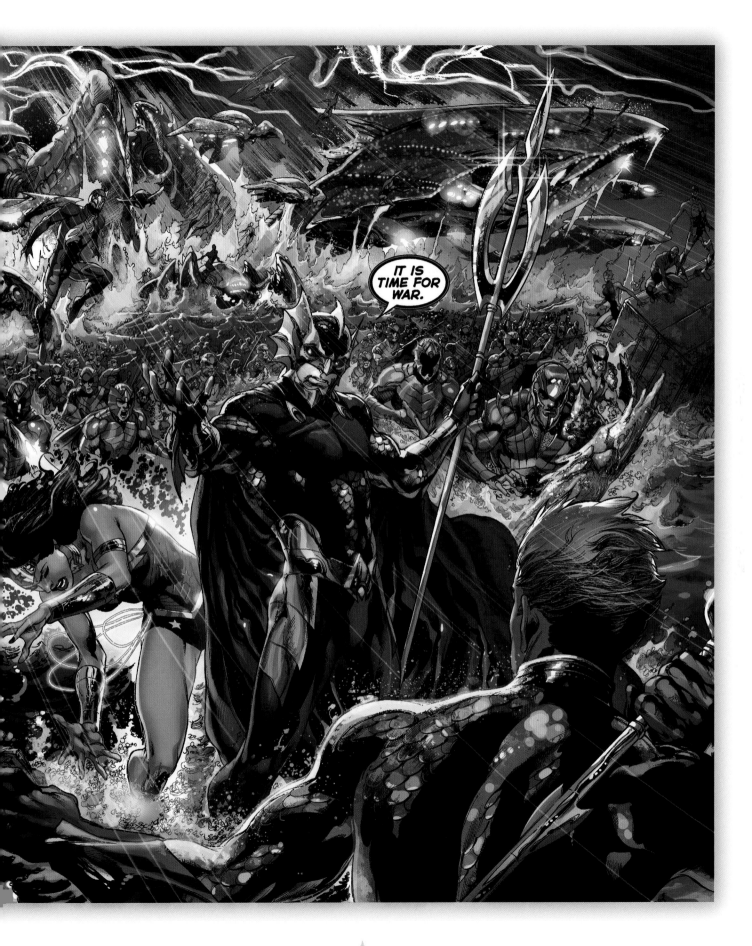

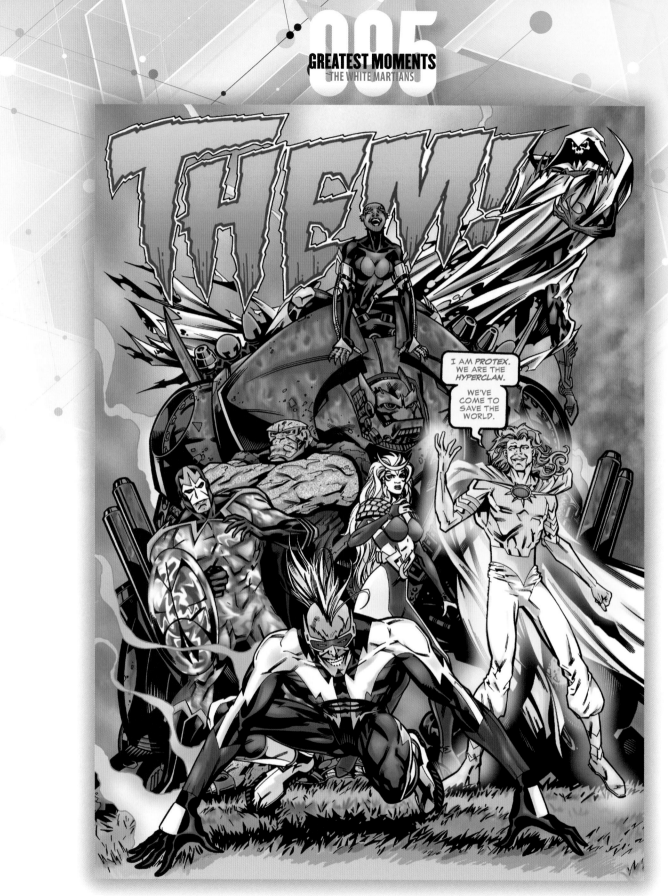

Two-skinned people. To undermine them, a quartet poses as a new super-team, the Hyperclan.

JLA #1, January 1997
Writer: Grant Morrison *Artists:* Howard Porter & John Dell

THE WHITE MARTIANS

Once, all life on Mars was unified, a race known to some as the Burning. Belligerent, they reproduced asexually and were deemed a menace to sentient life beyond the Sol solar system. Made aware of this threat, some 20,000 years ago the Guardians of the Universe intervened and split the race into two: white skinned and green skinned, no longer able to reproduce asexually. Both were given an instinctual fear of fire to inhibit either from reaching their full potential and threatening other worlds.

The white-skinned Martian race did explore other worlds, finding life on Earth and tinkering with man's genetics. While the humans were initially destined to possess amazing powers akin to the Kryptonians or Daxamites, now the metagene became recessive and only a handful of mankind would attain their original destiny. Other white explorers settled on Saturn, cloning a working class that eventually became red skinned and distinct from their progenitors.

In time, the green-skinned race became philosophical and creative, while their white-skinned brethren grew savage and warlike. Racial tensions kept the two apart for generations, with occasional skirmishes and conflicts leading to a lengthy civil war. Attrition whittled the white-skinned numbers until most were rounded

How the Martians obtained a piece of kryptonite doesn't matter but it does give them the edge over Superman as it has become clear the Hyperclan's purpose is anything but noble.

JLA #2, February 1997
Writer: Grant Morrison *Artists:* Howard Porter & John Dell

up and exiled to a dimensional space known as the Still Zone (which may be the same as the Kryptonian Phantom Zone or the space where Prometheus maintains his crooked house).

While the civil war's remnants affected Martian Manhunter throughout his time on Earth, it wasn't until a handful of White Martians targeted the world. They disguised themselves as heroes, calling themselves the Hyperclan and quickly gaining a fame that would rival the Justice League's. When they eventually attacked the JLA's satellite and killed former member Metamorpho, their intent became clear.

Protex was planning an invasion of Earth, about to unleash an armada hidden in the Still Zone, but first the League had to be annihilated. He began by trying to persuade the Manhunter to join their cause. When he refused, the battle began in earnest.

Given their powerful nature, the Hyperclan and proved a match for the League, and in short order Aquaman, the Flash, Green Lantern (John Stewart), and Wonder Woman were captured. Batman's Batplane was shot down and, deciding

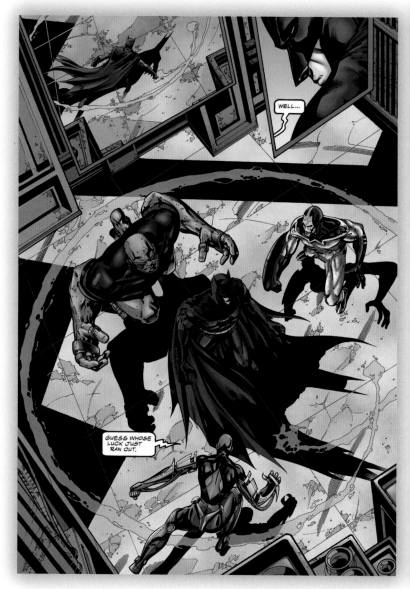

In Grant Morrison's hands, Batman was depicted as the most-prepared hero of all, and his keen deductive skills aid him in discerning the true nature of the Hyperclan. Even as they surround him, he remains unflinching.

JLA #4, April 1997
Writer: Grant Morrison *Artists:* Howard Porter & John Dell

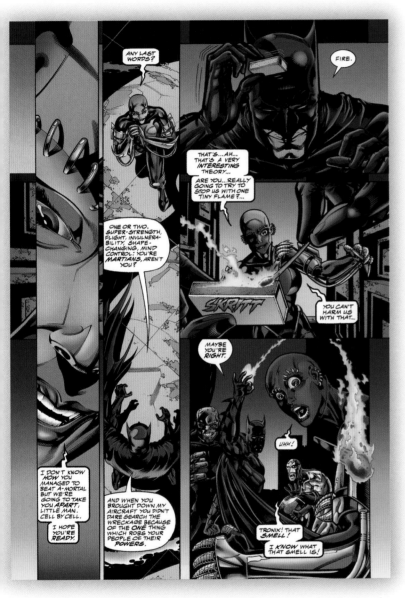

he was not worthy of investigation, he was believed dead. In turn, the World's Greatest Detective deduced the Hyperclan's true nature by noting that none came near the burning plane's wreckage. As Protex and Superman exchanged blows, the Action Ace was laid low by a piece of kryptonite. The hero was forced to watch his teammates tortured in the devious Flower of Wrath.

Much as Batman learned the truth through deduction, Superman realized Protex used his telepathic powers to convince him he was being weakened by kryptonite, but it was a phantasm. Freeing himself, the two fought afresh, with the Man of Steel prevailing. He then revealed the Hyperclan's true nature to the world while the JLA defeated the Martians. Martian Manhunter and Aquaman combined their powerful minds to convince the white-skinned invaders that they were actually humans. They were inserted among humanity and quietly observed by the League.

Although the white-skinned Martians would return for more battles, this confrontation, from writer Grant Morrison and artist Howard Porter, proved the most memorable.

Having seen them shun fire earlier, Batman is ready to expose the Martians for the villains they truly are, setting up the climactic battle in Grant Morrison's first storyline, remaking the JLA as the World's Greatest Super Heroes.

JLA #4, April 1997
Writer: Grant Morrison Artists: Howard Porter & John Dell

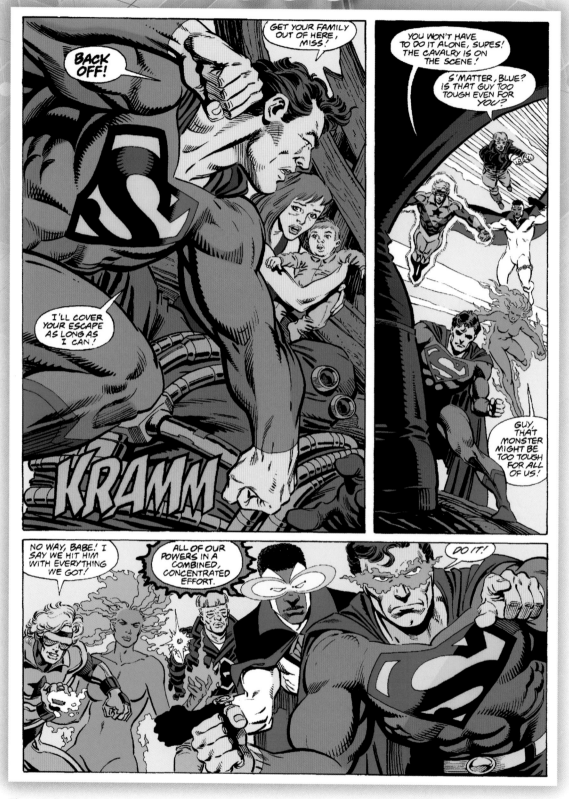

The epic battle between Superman and Doomsday detours into the JLA's title, demonstrating just how devastatingly powerful the Kryptonian creature truly is. The team at the time doesn't realize that Bloodwynd, in white, is a disguised Martian Manhunter.

Justice League America #69, December 1992
Writer/Penciller: Dan Jurgens *Inker:* Rick Burchett

DOOMSDAY

A Kryptonian experiment gone awry, the artificial life-form known to man as Doomsday was a killing machine designed to wipe out Kryptonian life, adapting its form to whatever dangers it encountered. Deemed too dangerous to keep near Kryptonians, Doomsday was bound up and buried deep within Earth's surface.

Through the millennia, Doomsday pounded away at his prison until it finally broke free. Sensing a Kryptonian also on the surface, it began a destructive swath across North America, bringing in the JLA. The somewhat underpowered team, consisting of Green Lantern Guy Gardner, Blue Beetle, Booster Gold, Maxima, Fire, Ice, and Bloodwynd (a disguised Martian Manhunter), arrived in Bucyrus, Ohio. The hulking creature quickly proved the team was of little challenge. Booster Gold was punched so hard he became airborne, saved by Superman. Maxima, warrior queen from another world, also was unable to slow the behemoth. Despite their best efforts, the team was badly bruised and injured, while Doomsday continued toward Metropolis.

Eventually, Superman and Doomsday had a knock-down, drag-out battle the likes of which no one had ever seen before. The two charged each other and delivered killing blows, stopping a threat to all life on Earth and depriving the world of the greatest super hero who ever lived.

It is clearly evident that the Justice League is no match for Doomsday despite their myriad powers. The Midwest is wrecked in the battle as the monster heads for Metropolis.

Justice League America #69, December 1992
Writer/Penciller: Dan Jurgens Inker: Rick Burchett

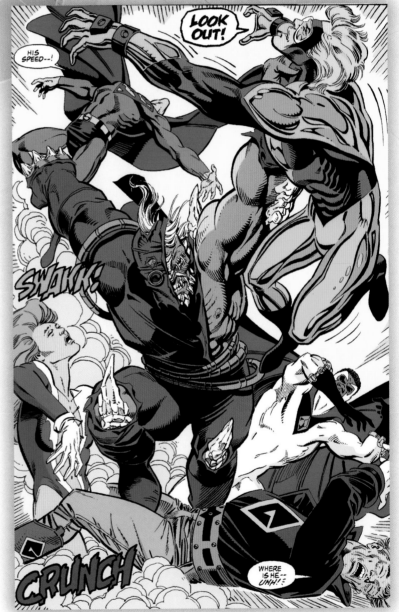

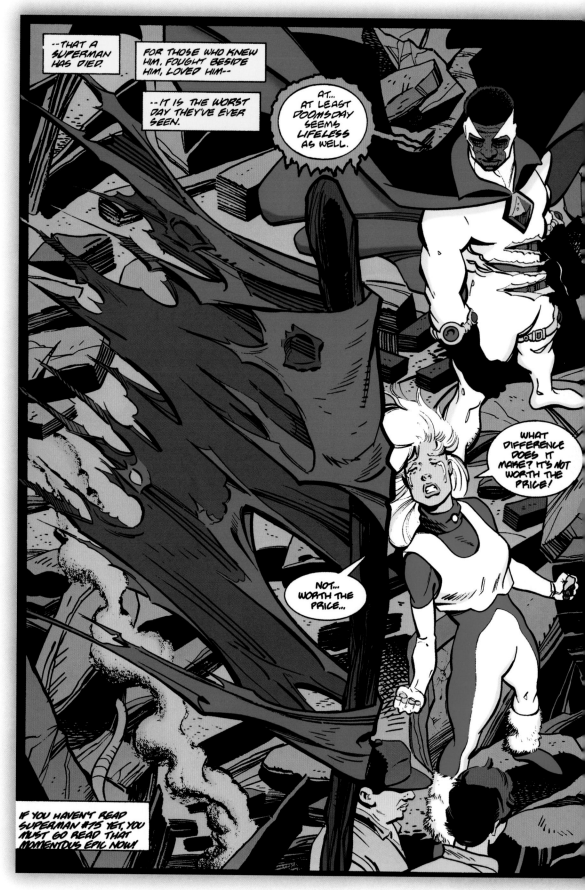

--THAT A SUPERMAN HAS DIED.

FOR THOSE WHO KNEW HIM, FOUGHT BESIDE HIM, LOVED HIM--

--IT IS THE WORST DAY THEY'VE EVER SEEN.

AT... AT LEAST DOOMSDAY SEEMS LIFELESS AS WELL.

WHAT DIFFERENCE DOES IT MAKE? IT'S NOT WORTH THE PRICE!

NOT... WORTH THE PRICE...

IF YOU HAVEN'T READ SUPERMAN #75 YET, YOU MUST GO READ THAT MOMENTOUS EPIC NOW!

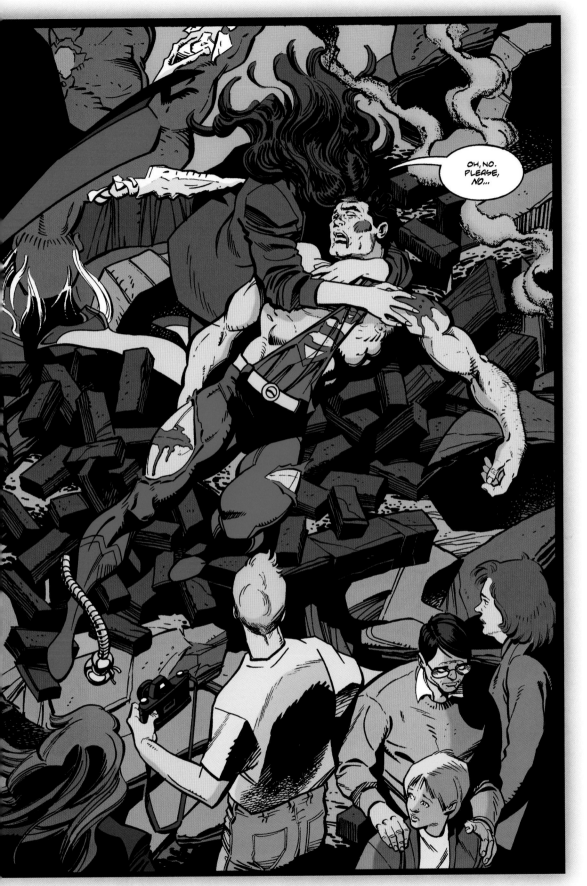

Moments after Superman's tragic demise in *Superman* #75, the story picks up here as the JLA arrives too late to help. While Doomsday was also killed, the cost was deemed too high and they ponder a World Without a Superman.

Justice League America #70, January 1993
Writer/Penciller: Dan Jurgens *Inker:* Rick Burchett

A possessed Superman announces the unstoppable arrival of the cosmic entity Mageddon, something fellow JLAer Aztek had been preparing for his entire life. Even so, the imminent battle gives him pause.

JLA #41, May 2000
Writer: Grant Morrison Artists: Howard Porter & Drew Geraci

MAGEDDON

At the edge of known space, there is something known as the Source Wall. Many have dared to go beyond it, but none have succeeded. Those who dared pass it have become one with the wall, a frozen tapestry representing countless races across the eons. Also at the edge of space/time is Mageddon, the war machine that survived the fall of the Third World gods and was trapped in an "immense sinkhole" of gravity. To prepare

for the eventuality that Mageddon would free itself, Wonderworld was created and populated with super-powered beings, led by Adam One, who remained alert for a change in the cosmic status quo.

Also preparing were the Controllers, an offshoot of the Guardians of the Universe, who believed in a more proactive approach to maintaining peace and order. A

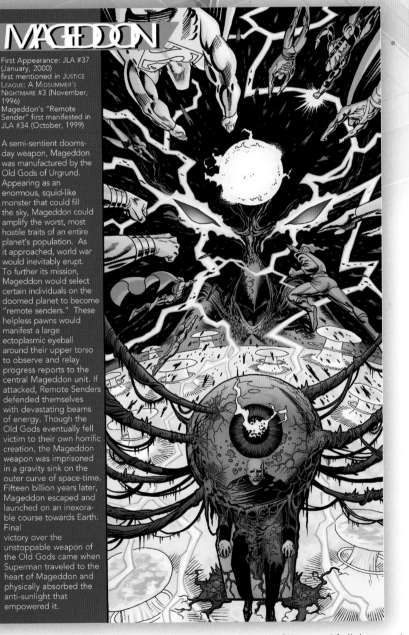

MAGEDDON

First Appearance: JLA #37 (January, 2000)
first mentioned in JUSTICE LEAGUE: A MIDSUMMER'S NIGHTMARE #3 (November, 1996)
Mageddon's "Remote Sender" first manifested in JLA #34 (October, 1999)

A semi-sentient dooms-day weapon, Mageddon was manufactured by the Old Gods of Urgrund. Appearing as an enormous, squid-like monster that could fill the sky, Mageddon could amplify the worst, most hostile traits of an entire planet's population. As it approached, world war would inevitably erupt. To further its mission, Mageddon would select certain individuals on the doomed planet to become "remote senders." These helpless pawns would manifest a large ectoplasmic eyeball around their upper torso to observe and relay progress reports to the central Mageddon unit. If attacked, Remote Senders defended themselves with devastating beams of energy. Though the Old Gods eventually fell victim to their own horrific creation, the Mageddon weapon was imprisoned in a gravity sink on the outer curve of space-time. Fifteen billion years later, Mageddon escaped and launched on an inexora-ble course towards Earth. Final victory over the unstoppable weapon of the Old Gods came when Superman traveled to the heart of Mageddon and physically absorbed the anti-sunlight that empowered it.

The sheer scope of Mageddon's might is glimpsed here in this profile page. Of all the cosmic entities trying to conquer or destroy Earth, he was one of the few to come close.

JLA Secret Files and Origins #3, December 2000
Writer: Scott Beatty *Artist*: Norm Breyfogle

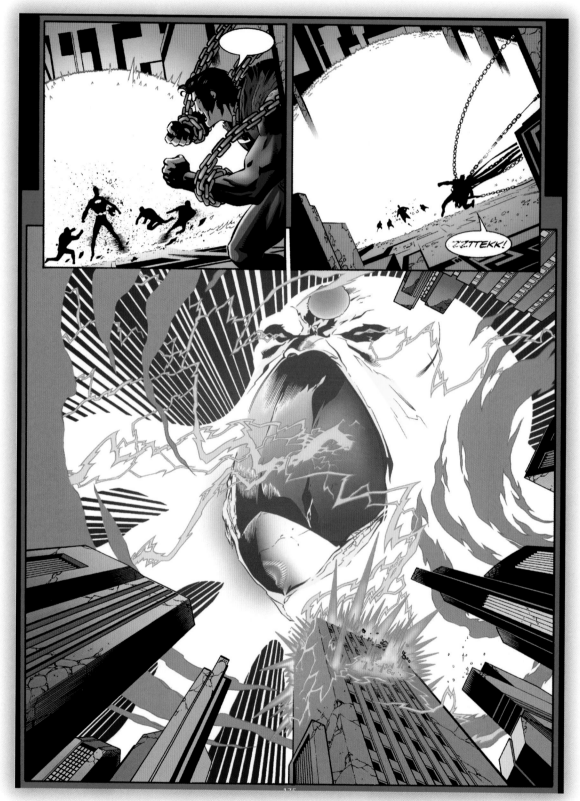

No one on Earth could possibly be prepared to comprehend the frightening image of the cosmic entity Mageddon as he fills the skies over Earth.

JLA #41, May 2000
Writer: Grant Morrison *Artists*: Howard Porter & Drew Geraci

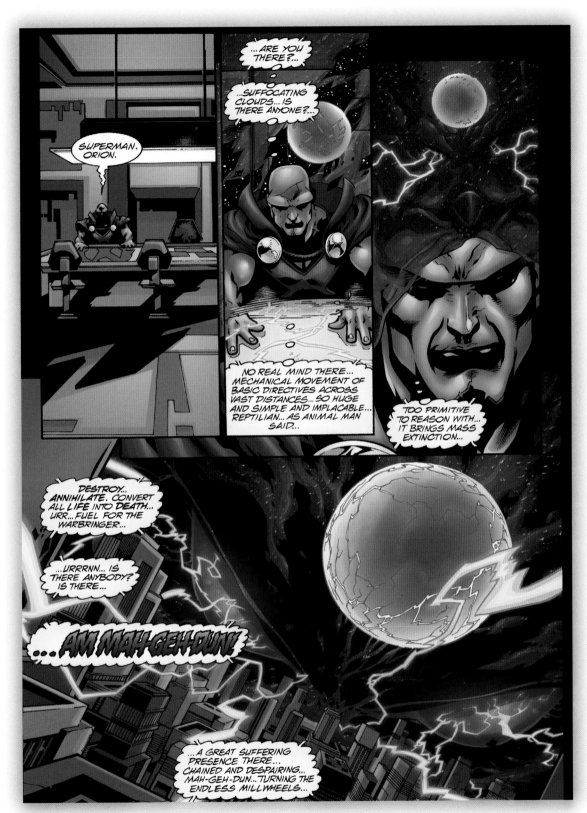

Mageddon's coming had been anticipated for millennia by only a handful of humans but as it drew closer, the mightiest telepaths, including the Martian Manhunter, were affected by the powerful mind.

JLA #40, April 2000

Writer: Grant Morrison *Artists:* Howard Porter & Drew Geraci

Controller assigned to the sector of space where Earth resided arrived during man's early days and selected one to receive intelligence and immortality, preparing him should Mageddon ever find the world. This "Know Man" was waiting and utilized Doctor Destiny to give mankind super-powers, to equip the planet to battle Mageddon; but this also resulted in the existing heroes, including several former JLA members, losing their memories. When the seven core adventurers were restored to normal, a defeated Know Man warned them of the impending threat and placed the responsibility for its defeat in their hands. Consequently, a new iteration of the Justice League was formed.

Word of the entity's threat had spread to many cultures, who all wished to be prepared. One, Quetzalcoatl, the feathered serpent, left his essence in a helmet, believing that his rival Tezcatlipoca would return to destroy Earth for Mageddon. The helmet was handed down, generation to generation, by the Brotherhood of Quetzalcoatl, as they trained their chosen champion. The last of the line was named Uno, who become the Justice Leaguer known as Aztek. After the Brotherhood's recent benefactor Lex Luthor struck at the team with the Injustice Gang, Aztek quit in the belief that his own trustworthiness had been compromised.

Shortly thereafter, Takion, leader of the New Gods, asked Orion and Big Barda to join the JLA, suspecting that Mageddon was free and headed for Earth. Neither New God, nor the angel Zauriel, told their teammates of the impending doom.

As expected, events allowed Mageddon to slip its bonds, and it headed straight for Earth, destroying Wonderworld in the process. It was able to extend its immense power and begin systematically invading and then controlling the minds of humans, including the powerful telepathic villain Hector Hammond. Luthor's dismissal of the entity's threat was to be proven incorrect by Luthor becoming one of the first people touched by Mageddon's power, and he reformed the Injustice Gang to execute the machine's plans.

The story was entitled *World War Three*, but the battle against Mageddon was one of cosmic import. Only some-one battle-tested like the Last Son of Krypton could possibly break free from its thrall.

JLA #40, April 2000
Writer: Grant Morrison *Artists:* Howard Porter & Drew Geraci

Aztek also realized that he had been truly trained for a reason and sought to stop the machine, but was blinded, while Superman was captured and Orion left lifeless in the void. The Watchtower was soon after destroyed, claiming Zauriel's life, although it allowed him to return to Heaven. There, he lobbied the Heavenly Host to come to Earth and quell the many wars breaking out across the continents.

It fell to Wonder Woman and Black Lightning to turn Animal Man's idea into reality, transforming Themyscira's Purple Healing Ray into something that could be channeled through Animal Man's morphogenic field, which accessed all animal life. It was powered by Glimmer, the sole survivor of Wonderworld, who had come to warn Earth and was earlier rescued by the Flash. Altogether, the plan worked much as Know Man had first envisioned it: granting all humans super-powers. With over 7 billion super-humans fighting Mageddon, it faced probable defeat, triggering its fail-safe programming: an "anti-sun" in its core would go supernova, destroying half the galaxy.

Before that could be executed, Aztek arrived, having first rescued Orion and activating his own self-destruct mechanism within his helmet, unleashing the four-dimensional energies that could damage the machine. Despite radiating waves of despair to slow the JLA, Batman (aided by Martian Manhunter's telepathic link) managed to convince the Man of Steel to absorb the nova blast, letting him permanently shut down Mageddon.

Once free, Superman takes charge, bringing the battle to Mageddon before it could devastate Earth. This battle was one for the ages and easily earns its place among the team's greatest.

JLA #41, May 2000
Writer: Grant Morrison *Artists:* Howard Porter & Drew Geraci

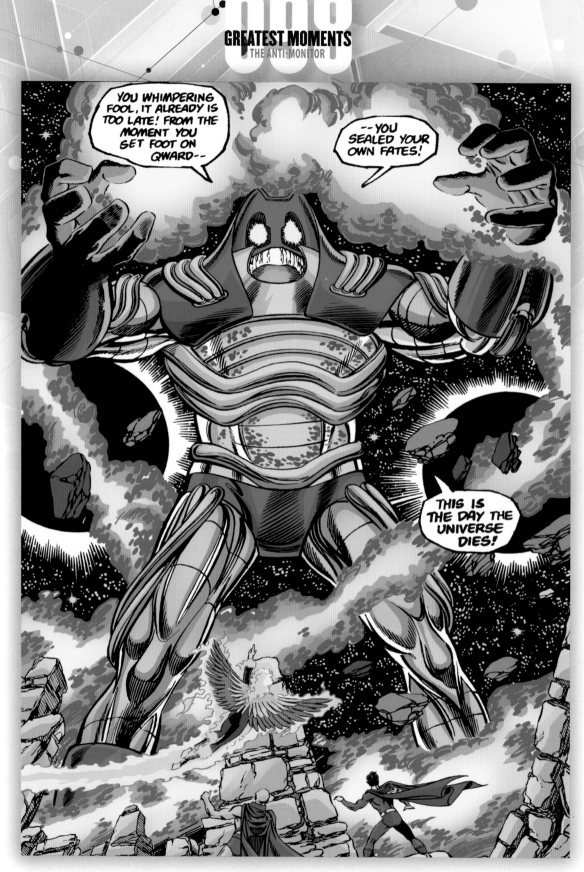

Despite thinking the Anti-Monitor had been defeated and a single positive-matter universe remained, the creature's return threatened all life across the universe. Standing in his way: the Justice League.

Crisis on Infinite Earths #12, March 1986
Writer: Marv Wolfman *Artists:* George Pérez & Jerry Ordway

THE ANTI-MONITOR

Once, there were two universes, one positive matter and the other anti-matter. In the former, life developed on many planets, but none greater than Maltus, which colonized other worlds, notably Oa, considered the center of the universe. In time, one of their scientists, Krona, decided to study the beginning of time, which was forbidden by Oan law. As he saw the stars shaped like a hand with a whirling vortex in its palm, there was a tremendous explosion. In time, it was learned that this caused the universe to shatter into countless parallel universes.

The Oans argued over the best course of action in the wake of this event, with one faction leaving to settle in the anti-matter universe of Qward. On parallel moons, there rose two beings, exactly opposite in nature. The Qwardian-born being harnessed the inchoate energies

and attempted to conquer his universe. When he became aware of his positive-matter twin, he changed plans and sought to defeat this being. The two "brothers" fought for a million years before one clash that left both in a state of unconsciousness for the next 9 billion years.

Finally came the day a scientist in his own universe sought to study the same thing Krona did, and this time, his actions led the two slumbering entities to awaken. One, the Monitor, knew his twin would once again attempt to consume the universes in a quest for ultimate power, and dedicated his life to making certain that life would remain free. The other, the Anti-Monitor, began doing as expected, and unleashed waves of anti-matter to destroy those positive universes and absorb their powers.

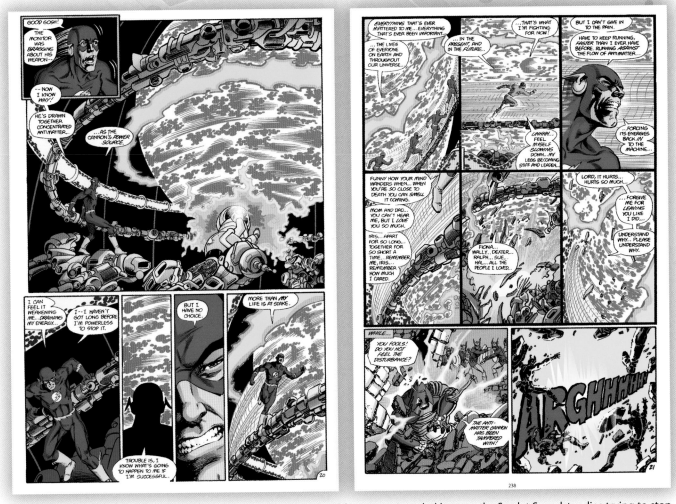

The Silver Age of DC Comics began with the arrival of the Flash and fans argue it ended here, as the Scarlet Speedster dies trying to stop the Anti-Monitor from destroying all of reality.

Crisis on Infinite Earths #8, November 1985
Writer: Marv Wolfman *Artists*: George Pérez & Jerry Ordway

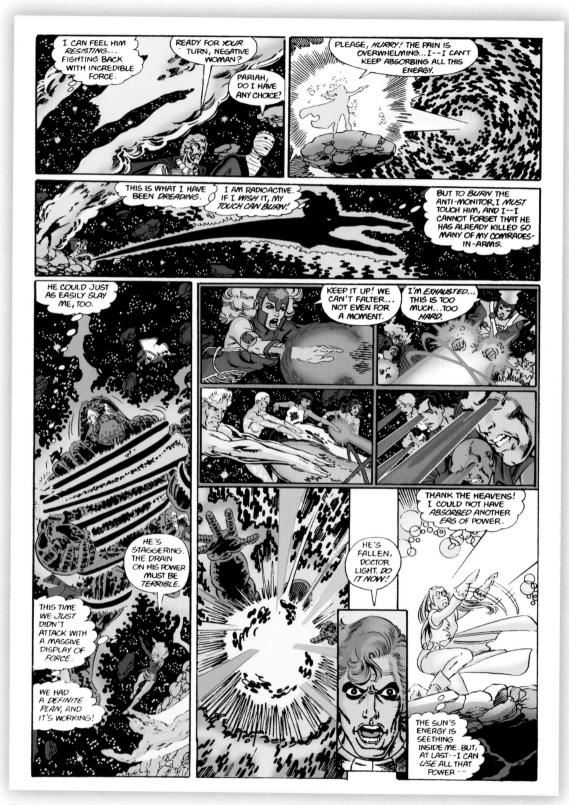

The Doom Patrol's Negative Woman bound the Anti-Monitor, allowing the energies of Firestorm, Martian Man-hunter, Power Girl, and two Supermen to bombard him. The new Doctor Light delivers the coup de grace: the energy of a sun.

Crisis on Infinite Earths #12, March 1986
Writer: Marv Wolfman *Artists:* George Pérez & Jerry Ordway

276

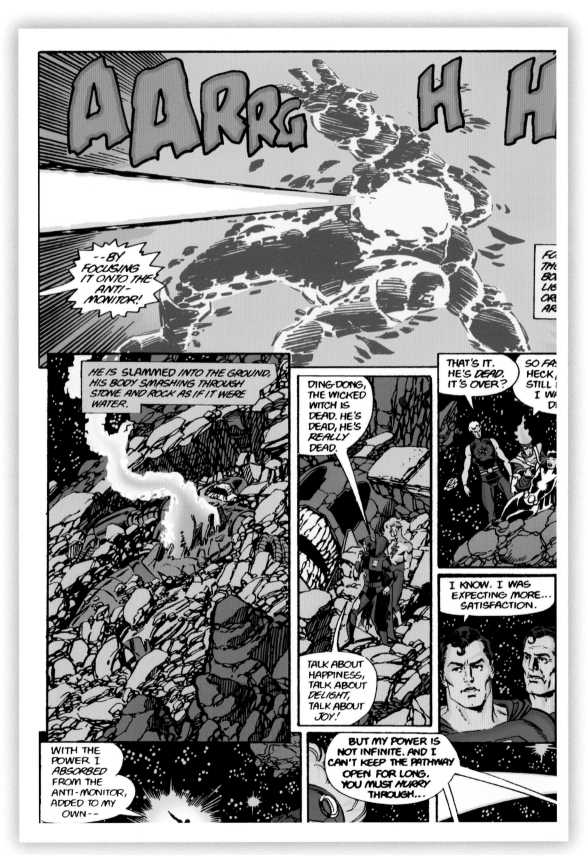

The solar energy does the trick, it seems, ending the Anti-Monitor's threat, allowing the heroes to return home. If only it were that easy. . .

Crisis on Infinite Earths #12, March 1986
Writer: Marv Wolfman *Artists:* George Pérez & Jerry Ordway

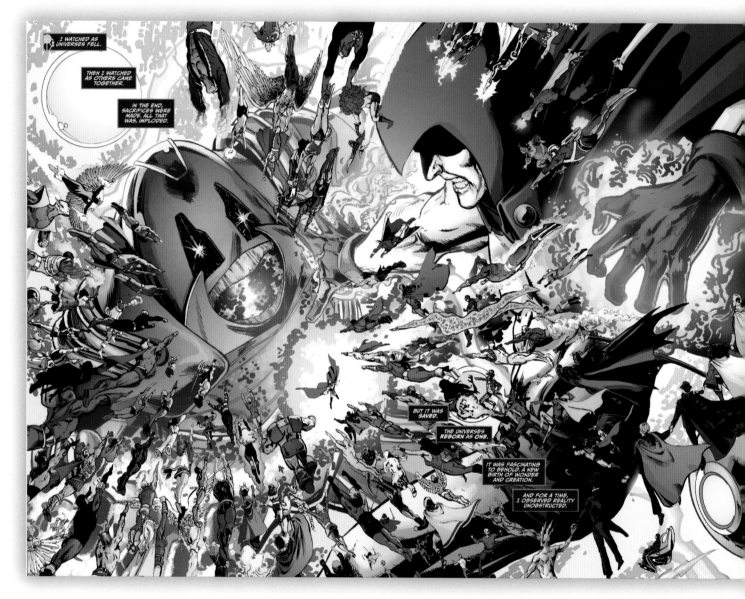

The battle with the Anti-Monitor became one for the ages and no matter how often reality is reordered, this titanic struggle remains an indelible moment in time. Never have so many risked so much for the fate of the entire universe.

DC Sneak Peek: Justice League, 2015
Writer: Geoff Johns *Artist:* Jason Fabok

When there were just five positive universes left, the Monitor was ready. And so began the most cosmic battle of all time.

And of course the Justice League was in the center of the action. While the team itself was scattered across time and space, then-inactive members Superman, Batman, and Wonder Woman each led factions and saw to it that others would be free to fight. The Flash was captured by the Anti-Monitor, while other heroes suffered or died. In time, the Monitor himself was killed, betrayed by his ward Lyla—the Harbinger—while she was controlled by his anti-matter counterpart. Regaining control, the heroine continued her mentor's plans to save reality. A coalition of heroes, led by the Supermen from two worlds, Supergirl, Captain Atom, and other powerful heroes, took the battle to the Anti-Monitor. He was beaten but not defeated, and not before he unleashed a powerful energy that took Supergirl's life.

The Scarlet Speedster was the next to fall, as his speed was used to counteract the Anti-Monitor's next gambit, an anti-matter cannon designed to destroy those five remaining universes.

Even the all-powerful Spectre seemed incapable of defeating the Anti-Monitor and his limitless resources.

It turned out that the hand Krona had witnessed was the Anti-Monitor's, and the Spectre wrestled with it, unleashing a new wave of energy that reordered reality.

With just a positive-matter and negative-matter universe, the heroes saw that their histories and relationships, even their powers, seemed altered in subtle ways. The Anti-Monitor still remained a threat, so his shadow creatures were contained by the universe's most powerful sorcerers, while a handful of heroes, led by the twin Supermen, confronted the Anti-Monitor anew. When it seemed he was defeated, the heroes focused on their new lives. Yet, while his body was destroyed, the Anti-Monitor's spirit remained, and as pure energy he once more imperiled the positive-matter universe. Here, Superman, the sole surviving hero of Earth-2, shattered the force, scattering its molecules and ending the threat. With the Anti-Monitor defeated once and for all (or so it seemed), the Alexander Luthor of Earth-3 opened a portal to a place beyond time and space, letting Superman-2, his wife Lois Lane, and Superboy from Earth-Prime join him.

The JLA and their readers consider this the ultimate Justice League story, given how everyone who ever fought as a member or beside the team stood ready to protect life and sacrifice their own, should duty demand it.

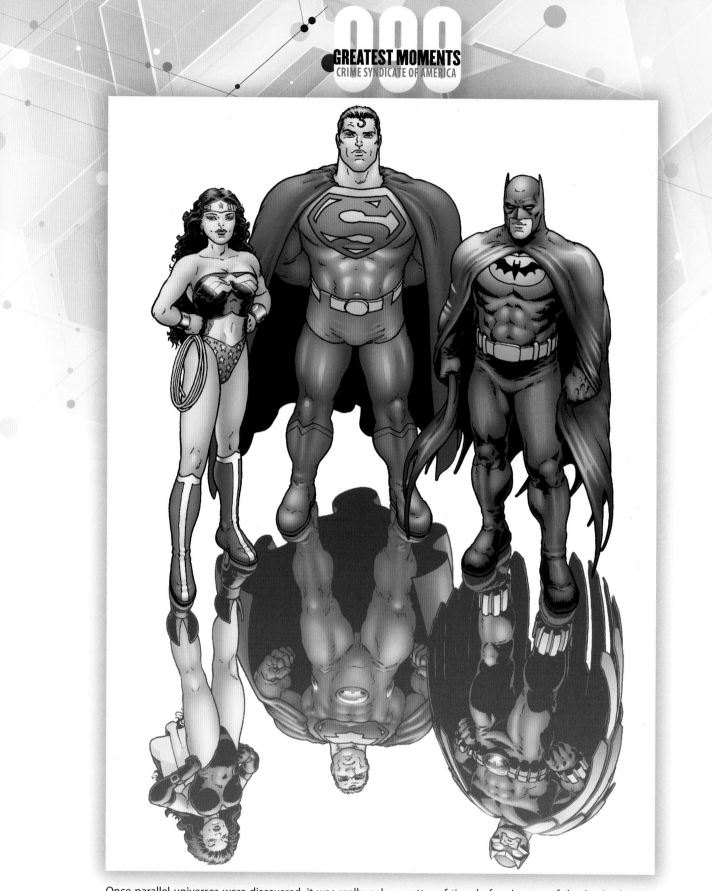

Once parallel universes were discovered, it was really only a matter of time before images of the Justice League would emerge. No one could have anticipated, though, how often they would clash.

JLA: Earth 2, 2000
Artist: Frank Quitely

CRIME SYNDICATE OF AMERICA

There may be more powerful foes, or cosmic entities that could snuff out universes, but there is nothing quite like looking at a funhouse mirror version of yourself. You cannot be anything but horrified by how a life may have turned out had things gone a different way. Perhaps the team's most persistent foes in any reality, their reflections have plagued the heroes since the Crime Syndicate of America's 1964 introduction in *Justice League of America* #29. The team was limited to the core members, with Ultraman, who gained a new power each time he was exposed to kryptonite; Superwoman, an Amazonian; Owlman, the smartest man on Earth; Johnny Quick, a speedster using the

name of a Golden Age hero; and Power Ring, whose emerald weapon was magical in nature. To demonstrate how deadly these opponents could be, the quintet managed to menace both the Justice League and the Justice Society. Had deeper characterization been the norm at the time, writer Gardner Fox could have had his characters reflect on how their lives might have been. The team was ultimately defeated and trapped in a power ring–generated cube with warning signs.

They returned several times, including in Crisis on Earth-Prime, the 1982 summer crossover that also featured time travel, involving the World War II–era

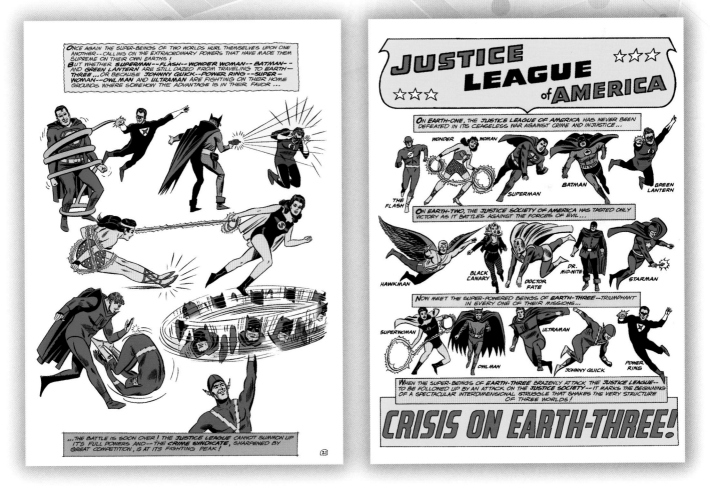

In their first meeting, the Crime Syndicate seemed to easily best the JLA, requiring the assistance of the Justice Society of America to put an end to the danger to the multiverse.

Justice League of America #29, August 1964
Writer: Gardner Fox *Artists:* Mike Sekowsky & Bernard Sachs

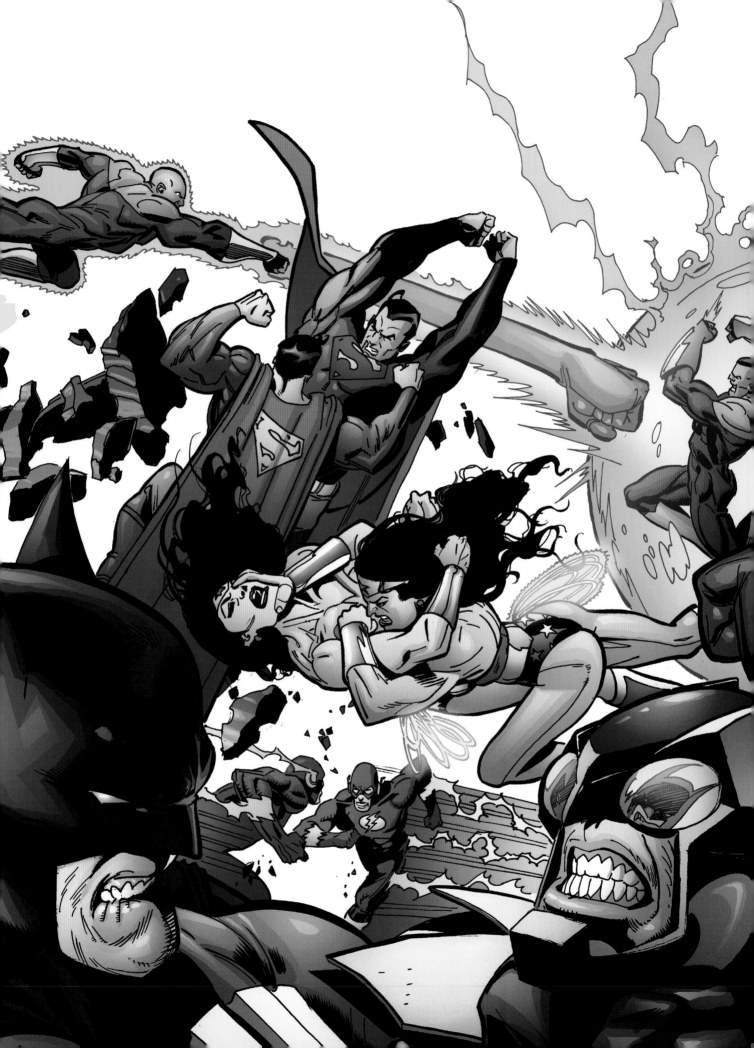

All-Star Squadron. Here, writers Gerry Conway and Roy Thomas, along with artists Don Heck and Adrian Gonzales, saw the villain Per Degaton free the CSA, who threatened Earth-Prime, then considered the world the readers lived in.

Interestingly, the next time they were seen was in *Crisis on Infinite Earths* #1, the company's fiftieth-anniversary project. The issue opened with a wave of anti-matter annihilating one parallel universe after another, and as the wave threatened Earth-3, the CSA charged toward the wave to protect their world.

The revamped reality after Crisis on Infinite Earths meant there were two parallel universes: the positive-matter universe, where the JLA operated, and the anti-matter universe of Qward, where that Earth housed the CSA, bored overlords of a corrupt world. They arrived with appropriate pomp and circumstance courtesy of Grant Morrison and Frank Quitely in the 2000 hardcover graphic novel *JLA: Earth 2*, considered by many to be one of the best stories of the 21st Century.

Alexander Luthor, the lone hero from the anti-matter universe, breaks the barrier between Earths 1 and 2, seeking the JLA's help as he imprisons and takes the place of his evil positive-matter counterpart. Meanwhile, the JLA investigate a plane crash where all the dead passengers have hearts on the right sides of their bodies, and money bearing the slogan "In Mammon We Trust" and the face of Benedict Arnold. This leads them to Alexander Luthor, who informs them of the other Earth and asks for forty-eight hours of their time to help the oppressed world. The JLA, except for Aquaman and Martian Manhunter, follow Luthor to the alternate Earth.

In this reality, the CSA learns of Earth and decides to cross the dimensional barrier and conquer the positive-matter universe. Here, Superwoman is Lois Lane, engaged in an affair with Owlman; Johnny Quick is a drug addict hooked on the formula that grants him speed, while Power Ring is controlled by his ring. The initial confrontation goes in the League's favor, but Owlman has correctly calculated that physics demands a balance, and the JLA, along with Lex Luthor, find themselves transported to Earth-2. There, the JLA tries to undo the CSA's evil, although they are stunned at the changes they see, such as Gotham's police commissioner being Thomas Wayne, who survived the burglary gone wrong in Crime Alley, which left his wife, Martha, and son, Bruce, dead. In his grief, Bruce's brother, Thomas Wayne Jr., vowed vengeance and became Owlman. The natural order of that world proved difficult to overcome, frustrating the moral heroes.

Back on Earth, the CSA runs free, destroying the White House and much of the country's capital before being stopped by Aquaman and Martian Manhunter. The heroes determine that the moral compass in the positive-matter universe means that even just two JLAers would prevail.

However, Lex Luthor has had his mind hijacked by the mirror universe's Brainiac, and the two universes are preparing to collide, canceling each other out and turning the evil alien into an Nth Level Intelligence, effectively becoming God. While his world's Brainiac is a cybernetic organism, the other Brainiac is organic, preventing Superman from killing him. So the Flash sends everyone to their respective worlds, and there, Ultraman lobotomizes Brainiac, preserving life on both sides of the barrier.

In the wake of this titanic clash, the CSA is sent home but thirsts for revenge and makes repeated forays onto Earth-1. The first such battle, Syndicate Rules, saw CSA's own reality warped so that Power Ring no longer mirrored Hal Jordan, but instead John Stewart. With all of Earth at stake, the JLA had to stop them once again in this story from Kurt Busiek and Ron Garney.

As seen here, you could change who wields the power ring, the Earth-3 villains would come up with a counterpart. Their battles have grown more vicious with each meeting as seen in *Syndicate Rules*. Bored with conquering their world, they come to Earth-1 in search of new conquests.

JLA #111, February 2005
Artist: Ron Garney

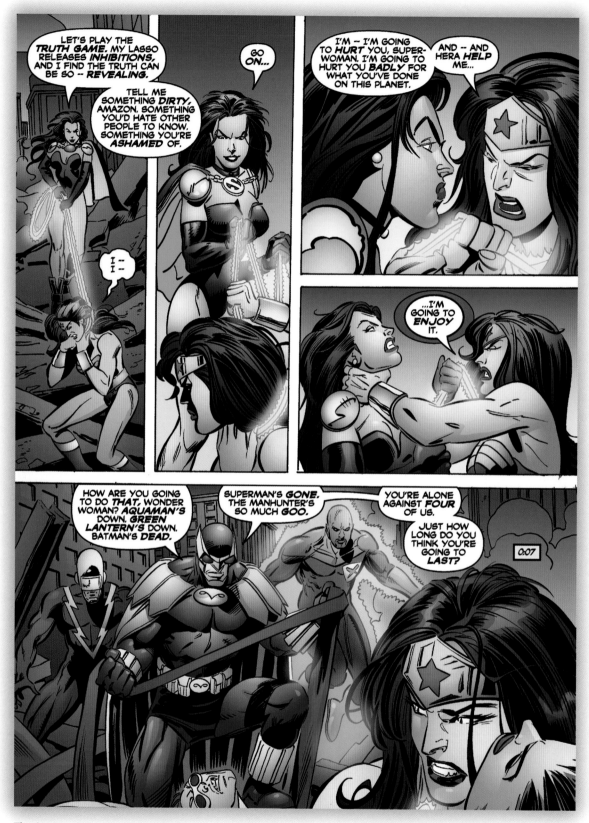

The Amazon Princess is truly tested when she has to take on four members of the Crime Syndicate. Here, the lasso of truth forces her to admit she will enjoy the coming battle.

JLA #111, February 2005

Writer: Kurt Busiek *Artists:* Ron Garney & Dan Green

After reality was twisted and revamped several more times, the parallel universes were restored, limited to fifty-two iterations, including the CSA's Earth-3. The new team had additional members including Deathstorm, a doppelganger for Firestorm, and Sea King, a version of Aquaman. It was at this time that Atomica, the female Atom, was revealed to be an Earth-3 mole within the JLA, setting up, from writer Geoff Johns and artist David Finch, an event known as Forever Evil. With the help of a sentient computer virus named Grid, the CSA managed to attack various JLAs and claimed Earth-0, now the prime home of the familiar JLA, as their own. The CSA recruited and manipulated that world's villains to aid their scheme as part of a new version of the Secret Society of Super-Villains, which included amping up Ultraman's powers to unheard-of levels and revealing Nightwing's identity

to the world, crippling his career. The team was seriously outnumbered and early on appeared beaten, as the Watchtower was destroyed and Aquaman's trident, Wonder Woman's lasso, and Superman's cape were delivered as evidence that the League had fallen.

As one would imagine, the CSA saw Earth-0's villains as mere pawns and easily turned on them, pitting them against a new evil force. While distracted with their global struggles, Batman and Catwoman, having been freed from their prison within the atomic matrix comprising Firestorm, managed to access his files about the JLA, hoping his contingency plans for taking each one down might be adapted against their evil counterparts. Their first opponent was Power Ring, who wound up with his arm severed, freeing him from the

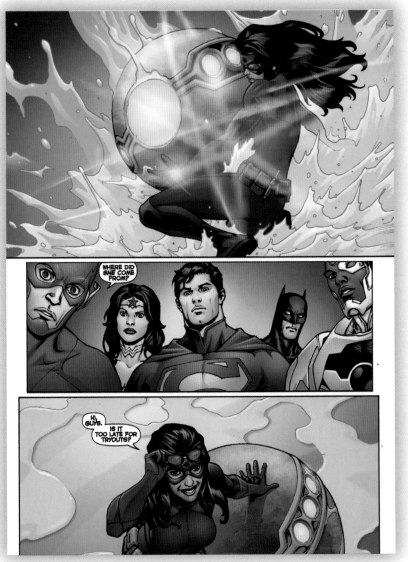

A new Atom joins the JLA and it is some time before she is revealed as a plant from Amanda Waller and A.R.G.U.S., gaining their trust and passing on useful intelligence.

Justice League #18, May 2013
Writer: Geoff Johns Artist: Jesus Saiz

ring's diabolical control, and he died, relieved. The ring sought out a new host, winding up with Jessica Cruz, who would eventually join the JLA as a Green Lantern.

Just as it appeared that the JLA would prevail, Alexander Luthor said "Mazahs!" and turned into Earth-3's twisted Captain Marvel. With his arrival, Superwoman revealed her own betrayal of Owlman, with whom she was

having an affair, and Ultraman, her husband. Pregnant with Mazahs's child, she took his side in the internal conflict. Lex Luthor, though, said the magic word, summoning the black lightning and destroying his mirror self, upending all the scheming.

The JLA managed to come out as victors, but not without the aid of Luthor, who worked his way onto the roster.

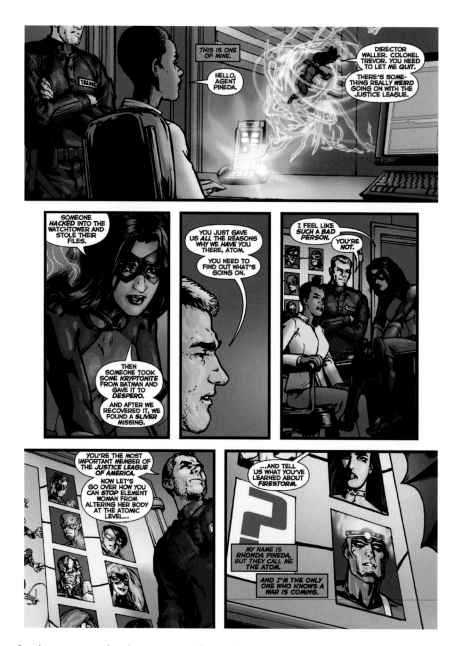

Readers are treated to the new Atom's betrayal fairly early but the dramatic irony doesn't get revealed to the team until much later. Meantime, the League's secrets are revealed.

Justice League #20, July 2013
Writer: Geoff Johns *Artist:* Jesus Saiz

Twist upon twist is revealed here as the new Atom is actually Atomica, spying on all of Earth on behalf of her colleagues in the Crime Syndicate of America.

Justice League #23, October 2013
Writer: Geoff Johns *Artists:* Ivan Reis, Joe Prado, Oclair Albert, & Eber Ferreira

Thought defeated and long gone, the Crime Syndicate returns to New Earth, sowing seeds that don't see fruition until the Darkseid War storyline two years later. Note new member Deathstorm in the background.

Justice League #23, October 2013
Writer: Geoff Johns *Artists:* Ivan Reis,
Joe Prado, Oclair Albert, & Eber Ferreira

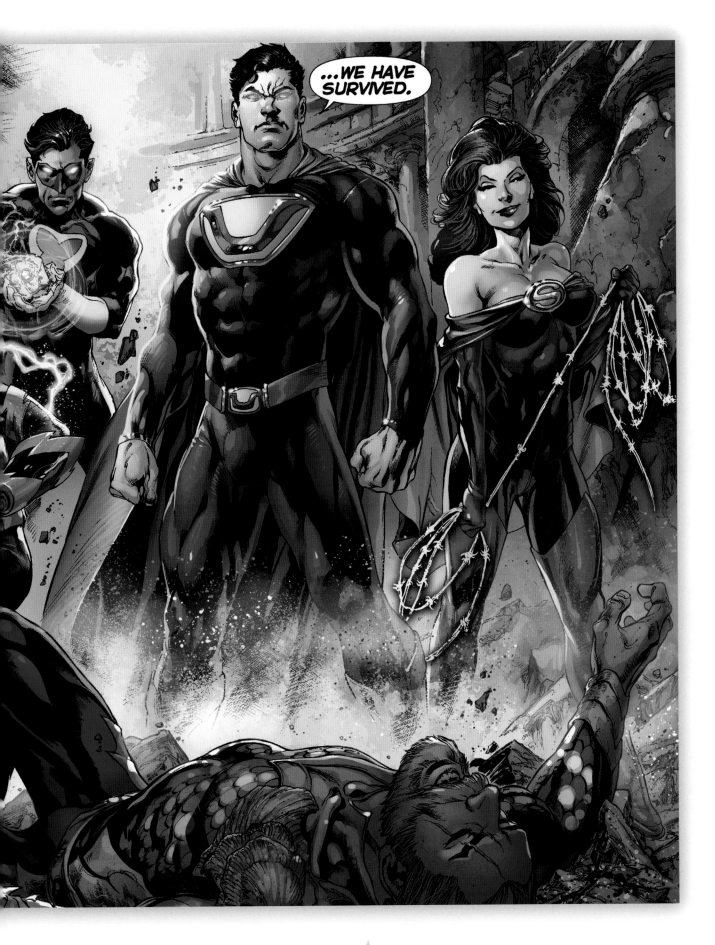

Grant Morrison saw the Justice League as modern-day analogues of the ancient Greek gods so it made perfect sense to pit them against the most dangerous of the New Gods, Darkseid. Regardless of era or reality, writers can't resist pitting the team against the destroyer.

JLA #14, January 1998
Writer: Grant Morrison *Artists:* Howard Porter & John Dell

DARKSEID

The New God known as Darkseid has come to rule Apokolips, the fiery, dark world that is the opposite of New Genesis, although both worlds represent the home of the gods of the Fourth World. Darkseid has sought the Anti-Life Equation in an attempt to control all sentient life in the universe. Repeatedly he has come to Earth in search of the equation and has been thwarted by his son Orion or Earth's champions, usually the Justice League of America. In one memorable incident, the legendary JSA traveled from Earth-2 to lend their support.

In the post-Flashpoint reality, Darkseid arrived on Earth in search of his daughter, Grail. His stomping around Earth led to the League's formation, and thanks to Cyborg using Boom Tube technology, Darkseid was sent home, but no one believed he'd stay there.

The Darkseid War, as it was known, has become one of the team's greatest clashes. The team at the time consisted of Batman, Superman, Wonder Woman, Cyborg, Shazam, the Flash, Aquaman, and Lex Luthor, who joined in the wake of his helping the team stop the Crime Syndicate.

As Darkseid schemed for revenge, Metron had been observing the myriad timelines and various realities, hoping the current one would solidify before Darkseid became aware of its soft shape. However, he was told of it by Kaiyo the Trickster and became fascinated by the Last Son of Krypton.

Darkseid came to Earth, sensing the Amazons were a key to his victory, so he seduced Myrina, impregnating her, and she gave birth the same night as Queen Hippolyta gave birth to Diana. Menalippe predicted Myrina's daughter, Grail, would have a very dark future,

Darkseid bet the Phantom Stranger he could destroy humankind's belief in heroes and sent his acolytes, including DeSaad, to make that a reality; instead the competition set the stage for a new era of heroism.

Legends #1, November 1986
Writers: John Ostrander & Len Wein *Artists:* John Byrne & Karl Kesel

As the Darkseid War unfolded, change was in the air. Superwoman was about to give birth, Volthoom possessed Jessica Cruz, and here, Lex Luthor finds himself transformed from human to New God.

Justice League #45, December 2015
Writer: Geoff Johns *Artist:* Francis Manapul

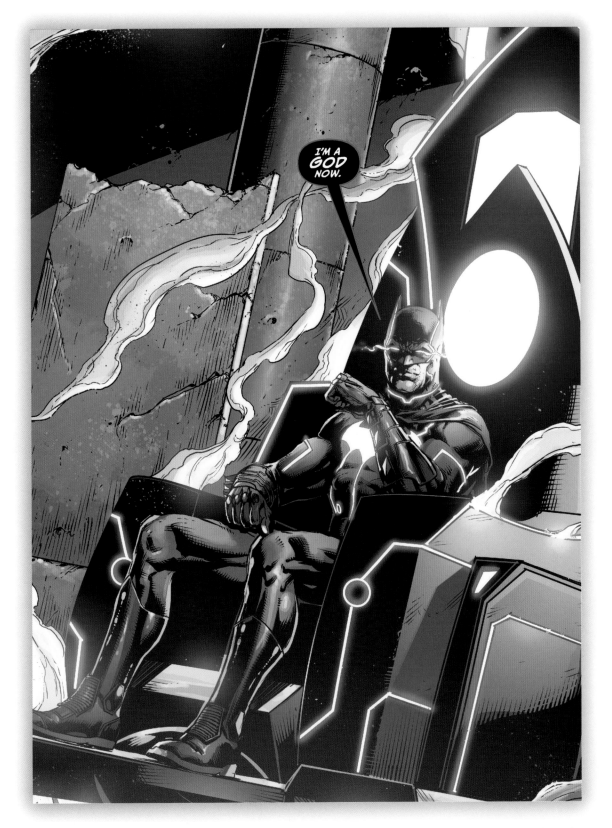

Perhaps the only thing scarier than Lex Luthor as a god was the notion that Batman possessed the Mobius Chair giving him access to time and space, enhancing the World's Greatest Detective's base of knowledge. That's not necessarily a good thing.

Justice League #42, September 2015
Writer: Geoff Johns *Artist*: Jason Fabok

causing the two to leave the Amazons. Myrina, once the Amazons' assassin, considered herself mankind's savior, having systematically killed those who would send the world into war. When the Amazons left man's world for Themyscira, she remained behind, sensing Darkseid would one day come back to Earth, and someone had to be prepared to stand against him. She raised Grail to stand ready to kill her father.

On Earth-3, Metron's doppelganger, Mobius (alias that reality's Anti-Monitor), willingly destroyed that reality to harness the energy in order to defeat Darkseid. He failed, and it became clear to Metron that Earth-0, home to the Justice League, was endangered and the heroes had to be ready for the attack. Darkseid also determined that the time had come to find his one-time lover, dispatching Kanto and Lashina to America in the hopes of killing her.

The Justice League began investigating the deaths of women sharing the name Myrina Black, initially unaware that there was one being sought by Darkseid. Scott Free, Mister Miracle, failed to stop Darkseid on Apokolips and fled to Earth, finding the proper Myrina first. But she defeated him, bringing him to her temple, where she planned to pit Mobius against Darkseid.

The liberal use of Boom Tube technology by Darkseid's operatives alerted Cyborg, who warned his teammates that something was brewing. Grail soon after arrived and made quick work of Batman, the Flash, Cyborg, and Shazam, although Wonder Woman managed to contact Superman. The Man of Steel and Luthor were already investigating a related incident when they were attacked by Lex's sister Lena, who had been seduced into working for the Dark God. She transported the pair to Apokolips, while Grail used Jessica Cruz's power ring to bring Mobius across the dimensions to Earth-0.

With the Last Son of Krypton now on his turf, Darkseid ordered his Blood Shepherd to release his slaves, offering freedom to the one who would bring him Superman's body. Darkseid then realized Mobius was now within reach and ordered Steppenwolf to lead an assault on Earth to obtain him and his power. The depraved DeSaad, insectoid Mantis, the Female Furies, and Darkseid's firstborn son Kalibak went to war.

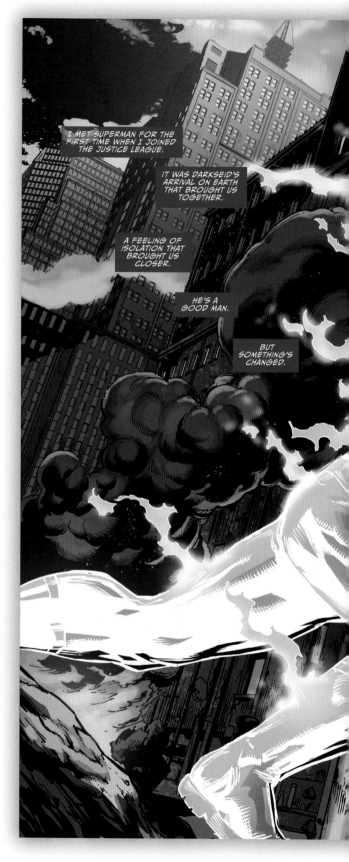

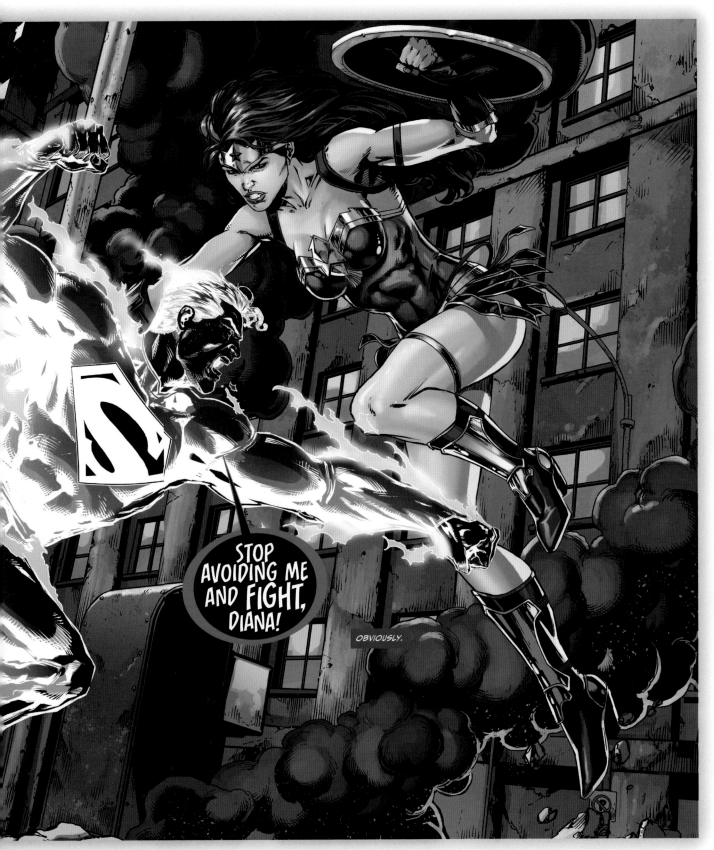

A possessed Superman ravages the city and perhaps the only one to stand in his way is the Amazon Princess. At the time of this story, the pair had been enjoying a passionate romance but this adventure threatened that relationship, along with all life on Earth.

Justice League #41, August 2015
Writer: Geoff Johns *Artist:* Jason Fabok

Meanwhile, Metron rescued the beleaguered heroes, transporting them to the Rock of Eternity. In a confrontation, Green Lantern declared his distrust of Metron, so Wonder Woman removed him from the powerful chair, which was then used by Batman, transforming him into a New God but also trapping him in the chair. He and Green Lantern left to seek answers, while Mister Miracle arrived to support the JLA in their forthcoming fight. His timing was excellent, as Darkseid arrived with a Parademon Army.

On Apokolips, Luthor dropped his partner into the fire pits, recharging the Kryptonian's waning powers. What he didn't count on was the negative energy twisting Superman into his very antithesis, with the hero now destroying the Parademons and turning his cruel intentions on Luthor. Abandoning the brilliant scientist on the fiery world, Superman returned to Earth, and Luthor wound up being found by the Forgotten People. Their leader, Ardora, was quickly charmed by Luthor.

The all-out war proved several things, including just how deadly Grail was; she was even more powerful than Wonder Woman. With everyone preoccupied, Jessica Cruz used her magical power ring to separate Darkseid and Mobius, with the latter using the opportunity to wield the Anti-Life Equation. The collector of souls, the Black Racer, had been summoned by Darkseid, but before he could do his duty, the Racer was bonded to the Flash thanks to Mobius's effort. Mobius then used the combined entity to kill Darkseid.

With the Omega Sanction leaving Darkseid's body, the JLA made quick work of the remaining Apokoliptian forces, and the war appeared over. Batman sensed this and warned Green Lantern that the Parademon Army was leaving Earth for Oa, home to the GL Corps. The raw energy returned to Apokolips, where Ardora ensnared it and placed it now within Luthor, transforming him into a New God.

The death of Darkseid rippled across reality, which had unforeseen effects on Shazam, as his patron, the Wizard, was forced to make a new bargain with the various gods that provided Billy Batson with the magical abilities, making him the world's mightiest mortal. During this process, Billy learned many hard truths, the most mind-boggling being that one of those deities, Zonuz, was also known as Yuga Khan, Darkseid's father.

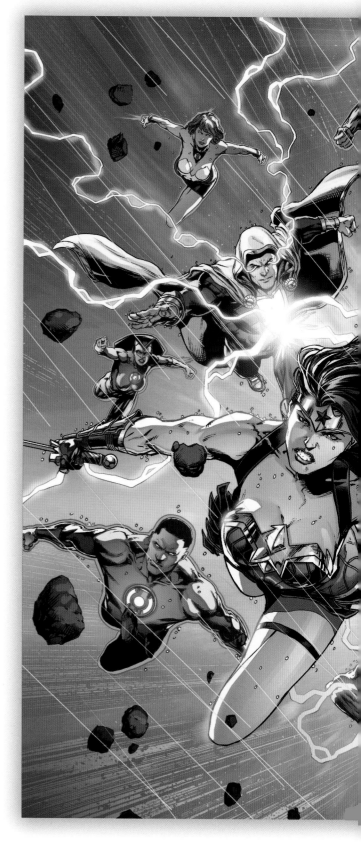

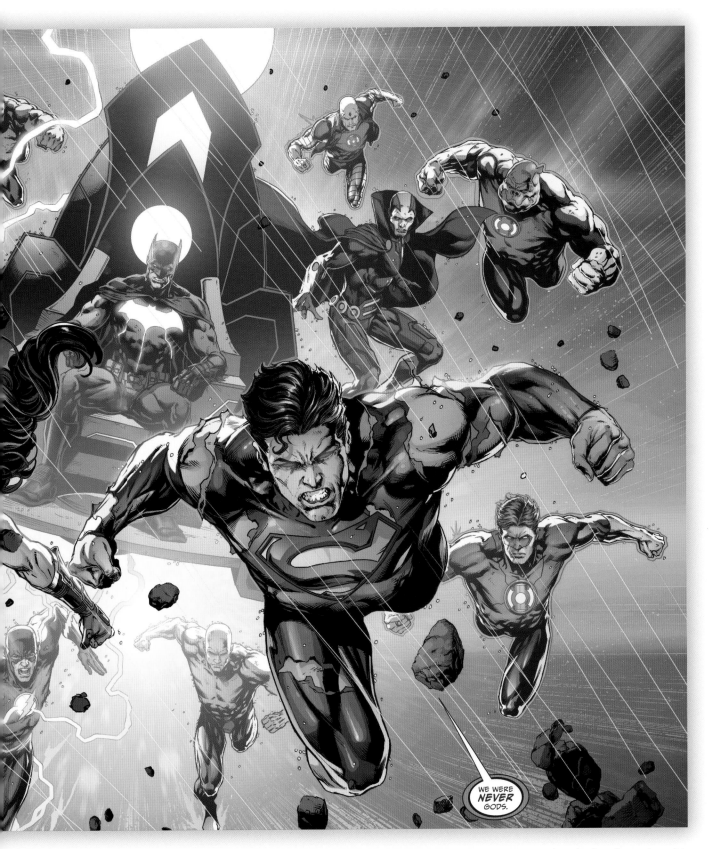

Tested repeatedly, the Justice League, aided here by members of the legendary Green Lantern Corps, arrive for a final confrontation with the forces of Apokolips and the Crime Syndicate, all in the hopes of preventing a return for Darkseid.

Justice League #50 July 2016
Writer: Geoff Johns *Artist:* Jason Fabok

Other Leaguers were challenged as well, with the Flash literally trying to outrace death as he sought to sever his bond with the Black Racer, especially before he was forced to kill his lover, Iris West. Superman's return to Metropolis was complicated by the negative energy still within him, threatening the entire city. In nearby Gotham City, Batman was capturing people before they could commit a crime thanks to the Mobius Chair, sending some to isolation in Antarctica and some men to Themyscira for Amazonian judgment. He then sought Joe Chill, the man who shot his parents, and mentally tortured him.

Across the galaxy, the Parademons infested the Central Power Battery on Oa and defeated the Corps. A defeated John Stewart sent an SOS to his friend Hal Jordan, already en route.

While things looked grim for those members, the other members of the team had their hands full with Steppenwolf, Kanto, Lashina, and Kalibak. Wonder Woman proved a match for Kalibak, but Volthoom began weakening Jessica Cruz's control of the power ring, letting Lashina gain the upper hand. Kanto beat Mister Miracle, but the New God was saved by the timely arrival of his wife, Big Barda. Once the villains were defeated, Steve Trevor suggested that the imprisoned members of the Crime Syndicate might hold some answers to the cross-dimensional calamity. Before they could act, Superman arrived and attacked Trevor, seeing him as a threat to his then-girlfriend, Wonder Woman. Batman arrived and realized that not only was the negative energy twisting Superman's moral compass into a pretzel, but it was also killing him.

Mister Miracle, Big Barda, Cyborg, and Jessica Cruz split off from the team, heading for Belle Reve, the super-prison where the CSA, including a very pregnant Superwoman, were housed. The meeting did not go well, with the Crime Syndicate quickly overpowering the heroes and Volthoom once more betraying Cruz, trapping her consciousness within the ring along with Cyborg's, and restoring the artificial intelligence Grid to the world. Things looked bleak, before the brilliant Owlman realized the stakes and insisted the villains and heroes would have to work side by side to save reality.

He carefully outlined Earth-3's history and the threat posed to them by Mobius. In an act of trust, Superman presented Ultraman with a piece of kryptonite, which imbued him with one more super-power. Now united with the JLA, Grid quickly located Mobius in Gotham City.

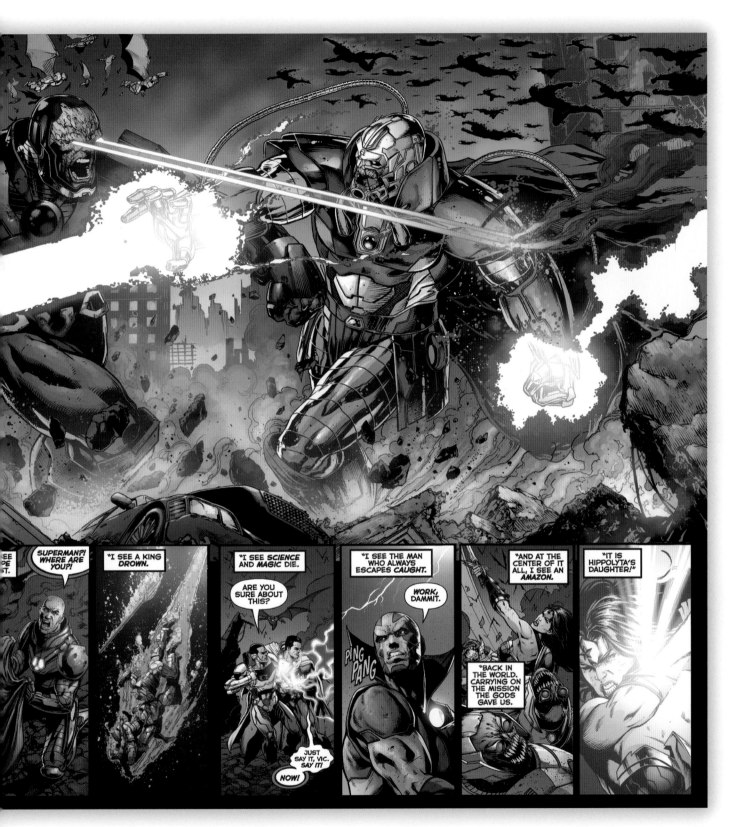

On Earth-3, home to the Crime Syndicate, the Anti-Monitor and Darkseid fought a titanic struggle that laid waste to the world. A threat awaits Prime Earth if the combined might of the Justice League, Green Lantern Corps, and New Gods does not prevail.

DC Sneak Peek: Justice League, 2015
Writer: Geoff Johns *Artist:* Jason Fabok

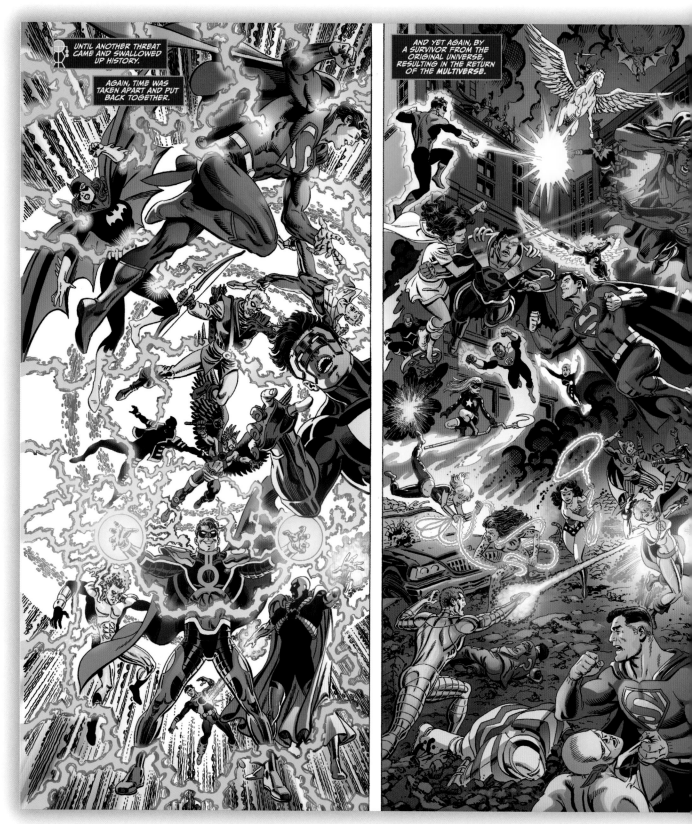

Battles across time and space, reality after reality, informed the events of the Darkseid War as seen here in moments from Zero Hour (as Green Lantern becomes Parallax the destroyer), Final Crisis (with Superman fighting the Earth-Prime Superboy), and Flashpoint which seemed to end one reality and provide a new start to the multiverse, the New 52 as it were.

DC Sneak Peek: Justice League, 2015
Writer: Geoff Johns *Artist:* Jason Fabok

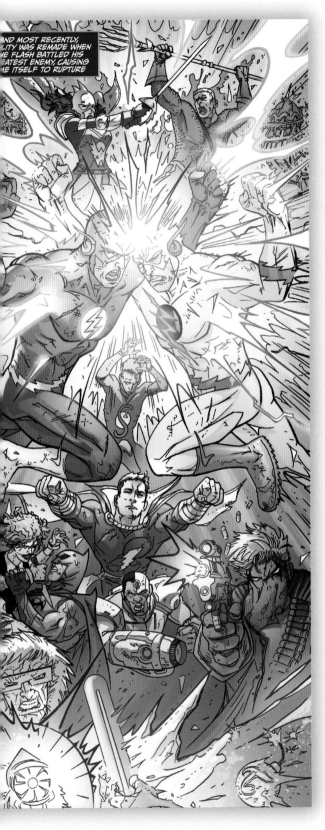

Grail and Myrina confronted Mobius in Gotham, pointing out that the recent events and trans-dimensional travel meant the Earth-3 New God was no longer in possession of the Anti-Life Equation; Grail had taken it from him. Still, he was supremely powerful and ready for the onslaught in the form of the united JLA and CSA. Mobius wanted his chair back from Batman, who of course refused, allowing Green Lantern to summon the Corps for support. Even the alien power ring–armed army started to fall before Mobius. Ultraman wanted a crack at the Anti-God, and he was murdered for his effort.

Just as things looked bleak for mankind, Luthor, now a God himself, arrived with the Parademon Army. As they fought Mobius, Jessica Cruz and Cyborg partnered within Volthoom's power ring to free themselves and take him out of the battle.

In a temple, Myrina and Grail prayed to the Old Gods and then used the captured Steve Trevor as the new vessel for the Anti-Life Equation, turning him into a weapon for use against Mobius. He was being unleashed at almost the same moment Superwoman was deep into labor, ready to give birth.

Aware of the dangers on Apokolips, with chaos rampant in the wake of Darkseid's death, Big Barda chose to return there to lend support, while her husband, Mister Miracle, chose to remain with the JLA. Superman then expelled the negative energy in a super-flare, saving his life and using the unleashed power to hurt Mobius. Luthor pressed his advantage, but his own arrogance, amplified by his new power, let Mobius strike back.

Batman realized the newborn would be the actual weapon to defeat Mobius, but not before Trevor was used to seemingly kill Mobius. At Grail's behest, Trevor then turned his power on Wonder Woman, his former lover. She was clearly the next threat to be contained, but with her cosmic axe, she proved so powerful that not even the extant GL Corps could contain her. The corrupted Luthor, trying to kill Trevor, was stopped by Superman, and in retaliation he unleashed the Omega Sanction. Quickly, Owlman commanded Superwoman to use her newborn to absorb the energy.

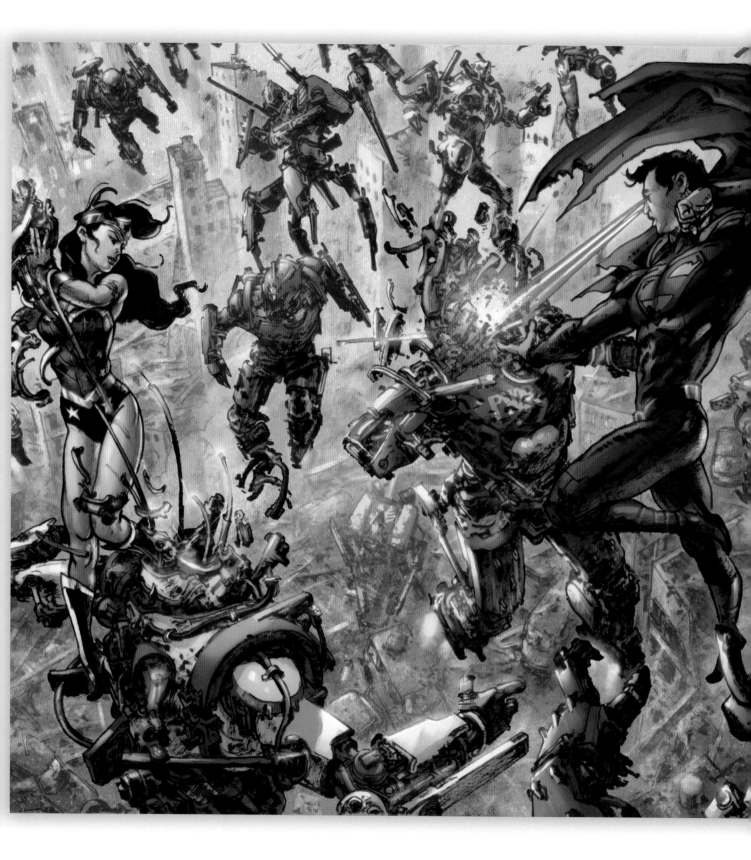

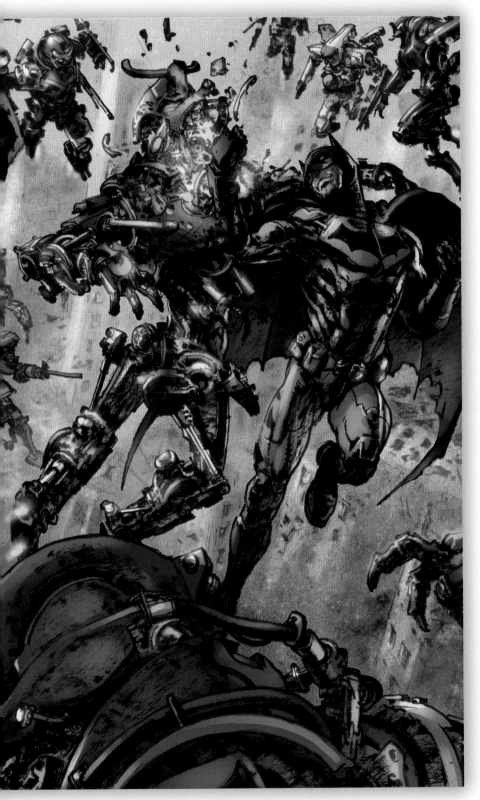

The conflict between the creatures of Apokolips and Earth's trinity of heroes—Wonder Woman, Superman, and Batman—is captured here in a panoramic image. Rarely have the three been forced to fight so relentlessly against ever-increasing threats, uncertain what has become of their allies, their friends, and their loved ones.

Wonder Woman #49, Superman/Wonder Woman #26,
Justice League: Darkseid War Special #1, June 2016
Triptych Artist: Kim Jung Gi

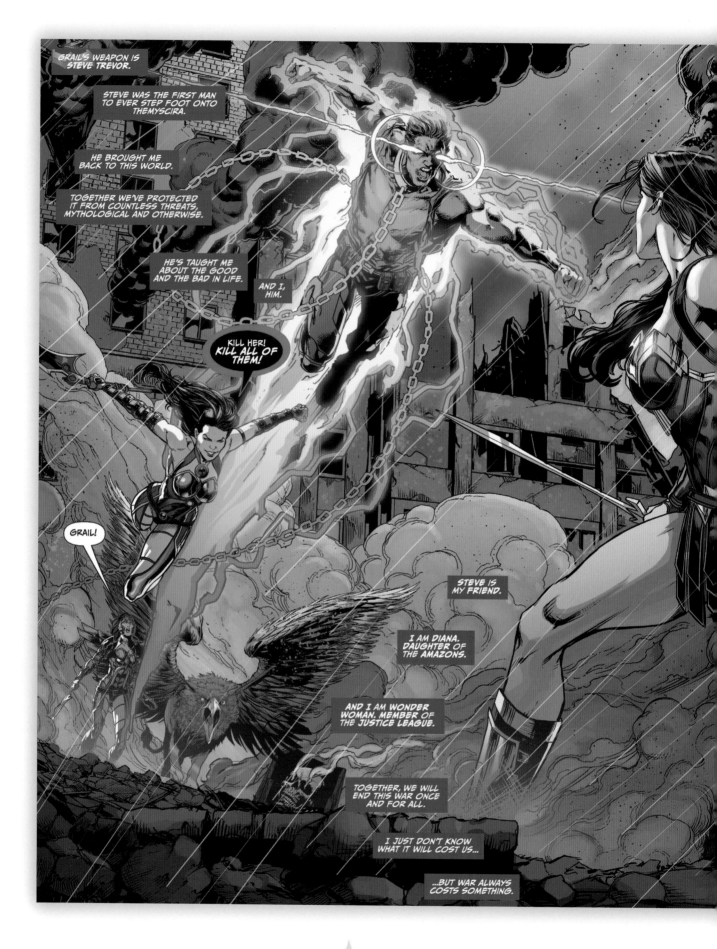

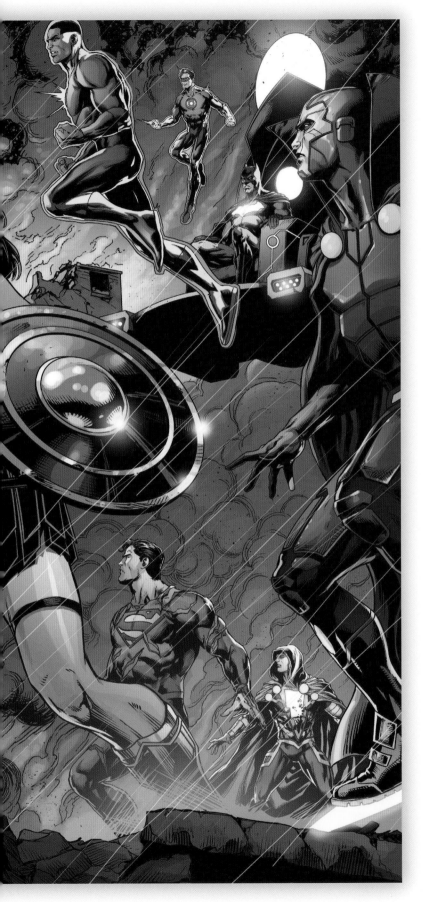

One of the most heart-wrenching moments of the Darkseid War sees Wonder Woman having to fend off a possessed Steve Trevor, her friend and former lover. She can't kill him, but she cannot let the evil energy win.

Justice League #50, July 2016
Writer: Geoff Johns *Artist:* Jason Fabok

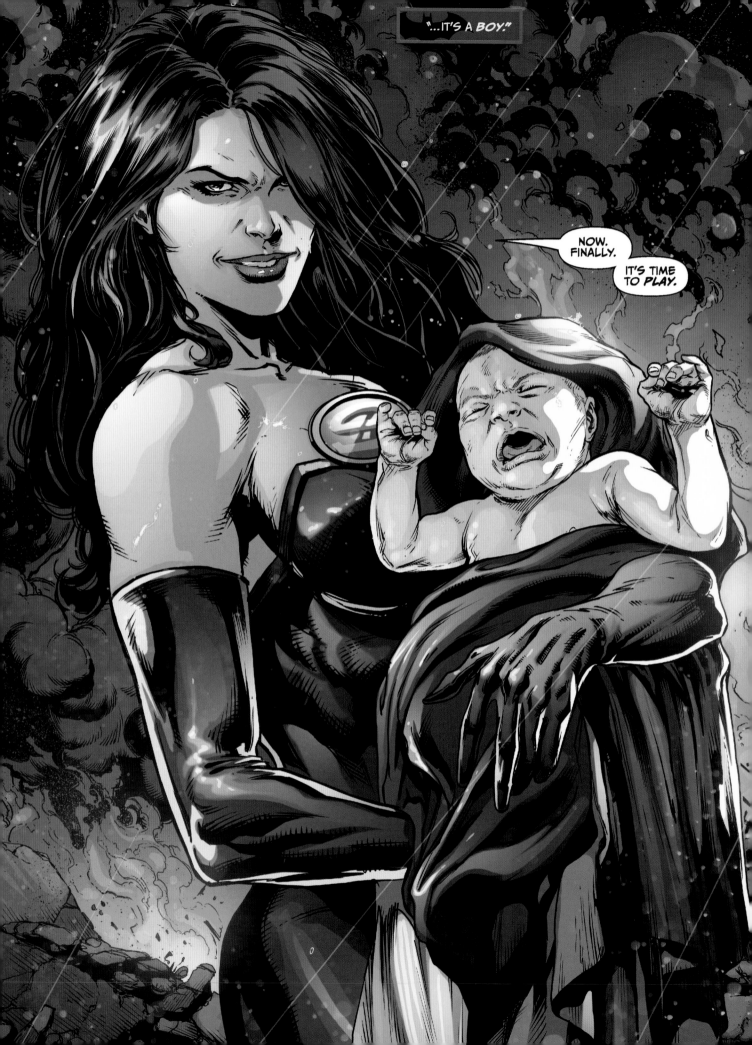

The baby safely internalized the power, but Grail moved swiftly, disintegrating Superwoman and snatching the child for her own use. Her first act was to separate Black Racer and the Flash; then she sent the speedster running from death. He was saved from certain doom by Jessica Cruz, who had briefly regained control of her body and the power ring. Instead of claiming Barry Allen's life, the Black Racer settled for the last remnants of Volthoom's life, still within her power ring, and departed. Grail was busily attacking Shazam and missed this change of fortune. Instead, she had removed the Anti-Life Equation from Steve Trevor, restoring him, and placed it within the baby.

The baby was now transformed into a new incarnation of Darkseid.

Grail turned her father into a weapon and aimed him at Batman. Green Lantern loaned the Dark Knight his own power ring, giving him the extra energy he needed to finally free himself from the Mobius Chair, just before he was destroyed by the Fourth World technology. Owlman quickly took possession of the chair and downloaded Grid's sentient programming into it and then freed Cyborg from Jessica Cruz's power ring.

Before Grail could renew the attack, a Boom Tube brought Big Barda back to Earth, at the forefront of forces determined to kill Grail. Myrina tried to stop her mad daughter but failed. It took Wonder Woman's lasso of truth to calm Grail's mind enough to end the battle once and for all, but not before Grail killed her mother and seemingly destroyed Superwoman's son, the reborn Darkseid.

This epic battle spanned a year or so of publishing and resolved old threads while opening up many new ones that continue to be felt in the Rebirth line of DC Comics. For example, Owlman was taught how to properly use the Mobius Chair by Metron, and they both learned of a brand-new threat to the cosmos, only to be obliterated by Dr. Manhattan, the first step in the massive 2017–2018 Doomsday Clock event.

Another aspect of the event was the return of Wally West from some limbo realm, the first messenger to Earth's heroes that someone or something (later revealed to be Dr. Manhattan) had reordered reality, stealing five years from them all. West's return triggered suppressed memories within the Flash and, with Batman's help, he began to piece together the clues as to who was behind this cosmic alteration. Meantime, West was working to restore things to the way they were, starting with bringing the Justice Society back to reality. He then realized the future had also been tampered with, as members of the 31st Century Legion of Super-Heroes were located on 21st Century Earth.

Luthor had returned to Apokolips to aid Ardora in a revolution and was rewarded with a Mother Box–powered suit of armor that also bore the seal of the Kryptonian House of El, turning him into a bona fide champion of justice.

Jessica Cruz's bravery earned her a true power ring, and she began learning how to conquer her crippling anxiety and be a better hero through her actions.

On New Genesis, Mister Miracle and Big Barda ended their marriage after her perceived betrayal of her husband and the League. She actually was retrieving reinforcements, but the damage to their relationship was done.

Darkseid was destroyed, yes, but Grail protected her father by stealing the coruscating powers from the heroes and infusing them in the baby Superwoman bore, Alexander Luthor Jr. He has since been growing up, regaining his strength, fueled by Grail's hunting down of Zeus's offspring, killing them, and rechanneling the energy into the youth. The first to die was Hercules, Wonder Woman's half brother.

Despite all their efforts, Superwoman gives birth and the soul of Darkseid finds its way into the infant who rapidly grows, feasting on the energy of slain old gods, returning to rule Apokolips and target Earth as Darkseid.

Justice League #49, June 2016
Writer: Geoff Johns *Artist:* Jason Fabok

TEAM ROSTERS

CHARACTER	ALTER EGO	JOINED IN
JUSTICE LEAGUE OF AMERICA		
Superman	Kal-El / Clark Kent	*The Brave and the Bold #28*
Batman	Bruce Wayne	
Wonder Woman	Princess Diana / Diana Prince	
The Flash	Barry Allen	
Green Lantern	Hal Jordan	
Aquaman	Orin / Arthur Curry	
Martian Manhunter	J'onn J'onzz / John Jones	
Green Arrow	Oliver "Ollie" Queen	*Justice League of America #4*
The Atom	Ray Palmer	*Justice League of America #14*
Hawkman	Katar Hol / Carter Hall	*Justice League of America #31*
Black Canary	Dinah Laurel Lance	*Justice League of America #74*
Phantom Stranger	Unknown	*Justice League of America #103*
The Elongated Man	Ralph Dibny	*Justice League of America #105*
Red Tornado	Ulthoon / John Smith	*Justice League of America #106*
Hawkgirl	Shayera Hol / Shiera Hall	*Justice League of America #146*
Zatanna	Zatanna Zatara	*Justice League of America #161*
Firestorm	Ronnie Raymond and Martin Stein	*Justice League of America #179*
Steel	Hank Heywood III	*Justice League of America Annual #2*
Vixen	Mari Jiwe McCabe	
Vibe	Paco Ramone	
Gypsy	Cindy Reynolds	*Justice League of America #236*
JUSTICE LEAGUE INTERNATIONAL		
Blue Beetle	Ted Kord	*Legends #6*
Captain Marvel	Billy Batson	
Doctor Fate	Kent Nelson	
Green Lantern	Guy Gardner	
Mister Miracle	Scott Free	*Justice League #1*
Doctor Light	Kimiyo Hoshi	
Booster Gold	Michael Carter	*Justice League #4*
Captain Atom	Nathaniel Adam	*Justice League International #7*
Rocket Red #7	Vladimir Mikoyan	
Rocket Red #4	Dimitri Pushkin	*Justice League International #11*
Fire	Beatriz da Costa	*Justice League International #14*

CHARACTER	ALTER EGO	JOINED IN
Ice	Tora Olafsdotter	
Hawkman	Fel Andar	*Justice League International #19*
Hawkwoman	Sharon Parker	
Huntress	Helena Bertinelli	*Justice League America #30*
Doctor Fate	Linda Strauss	*Justice League America #31*
Lightray	Sollis	*Justice League America #42*
Orion	Orion of Apokolips	
General Glory	Joseph Jones	*Justice League America #50*
Tasmanian Devil	Hugh Dawkins	*Justice League America #56*
Maxima	Maxima of Almerac	*Justice League America #63*
Ray	Ray Terrill	*Justice League America #71*
Black Condor	Ryan Kendall	
Agent Liberty	Benjamin Lockwood	
Bloodwynd	–	*Justice League America #78*
Flash	Jay Garrick	
JUSTICE LEAGUE EUROPE		
Animal Man	Buddy Baker	*Justice League International #24*
Flash	Wally West	
Metamorpho	Rex Mason	
Power Girl	Kara Zor-L / Karen Starr	
Crimson Fox	Vivian and Constance d'Aramis	*Justice League Europe #13*
Blue Jay	Jay Abrams	*Justice League Europe #20*
Silver Sorceress	Laura Neilsen	
Maya	Chandi Gupta	*Justice League Europe #50*
JUSTICE LEAGUE ANTARCTICA		
Major Disaster	Paul Booker	*Justice League Annual #4*
G'nort	Gnort Esplanade G'neeshmacher	
Multi-Man	Duncan Pramble	
Big Sir	Dufus P. Ratchett	
Cluemaster	Arthur Brown	
Clock King	William Tockman	
The Mighty Bruce	Bruce	
Scarlet Skier	Dren Keeg	
POST-ZERO HOUR		
Triumph	William MacIntyre	*Justice League International #67*
Hawkman	(Modern Age) Katar Hol	*Justice League America #0*

CHARACTER	ALTER EGO	JOINED IN
Nuklon	Albert Rothstein	
Obsidian	Todd Rice	
Amazing Man	Will Everett III	
Blue Devil	Daniel Cassidy	*Justice League America #98*
Icemaiden	Sigrid Nansen	
L-Ron/Despero	L-Ron / Despero of Kalanor	*Justice League Task Force #12*
Mystek	Jennifer Barclay	*Justice League Task Force #26*
Zan and Jayna	Zan and Jayna of Exor	*Extreme Justice #16*
JLA		
Green Lantern	Kyle Rayner	*Justice League: A Midsummer's Nightmare #3*
Tomorrow Woman	Clara Kendall	*JLA #5*
Aztek	Curt Falconer	*Aztek #10*
Green Arrow	Connor Hawke	*JLA #9*
Oracle	Barbara Gordon	*JLA #16*
Plastic Man	Patrick O'Brien	
Steel	John Henry Irons	
Zauriel	–	
Wonder Woman	Hippolyta of Themyscira	
Big Barda	Barda Free	*JLA #17*
Hourman	Matthew Tyler	*JLA #26*
Jade	Jennie-Lynn Hayden	*Made reserve in JLA #27*
Antaeus	Mark Antaeus	*JLA: Superpower*
Jesse Quick	Jesse Chambers	*The Flash Vol. 2 #140*
Dark Flash	Walter West	*JLA #33*
Moon Maiden	Laura Klein	*JLA Giant Size Special #3*
Nightwing / Batman	Dick Grayson	*JLA #69*
Faith		
Hawkgirl	Kendra Saunders	
Jason Blood (Etrigan)	–	
Green Lantern	John Stewart	*JLA #76*
Manitou Raven	–	*JLA #78*
JUSTICE LEAGUE ELITE		
Sister Superior	Vera Lynn Black	*JLA #100*
Menagerie	Sonja (last name unrevealed)	
Coldcast	Nathan Jones	
Naif al-Sheikh	–	*Justice League Elite #1*
Kasumi	Cassandra Cain	
Manitou Dawn	–	
POST-INFINITE CRISIS DURING 52		
Firestorm	Jason Rusch (and other hosts)	*52 #24*
Firehawk	Lorraine Reily	
Super-Chief	Jon Standing Bear	
Bulleteer	Alix Harrower	
Ambush Bug	Irwin Schwab	
ONE YEAR LATER RECRUITS		
Black Lightning	Jefferson Pierce	*Justice League of America Vol. 2 #7. Originally offered membership and declined.*
Red Arrow	Roy Harper	
Geo-Force	Prince Brion Markov	
Supergirl	Kara Zor-El / Linda Lang	*Justice League: Cry for Justice #3*
Starman	Mikaal Tomas	*Justice League: Cry for Justice #5*
Congorilla	William "Congo Bill" Glenmorgan	
Guardian	Jim Harper	*Justice League of America Vol. 2 #41*
Mon-El	Lar Gand	
Donna Troy	–	
Cyborg	Victor Stone	
Starfire	Koriand'r	
Blue Beetle	Jaime Reyes	*Justice League: Generation Lost #3*
Rocket Red #7	Gavril Ivanovich	*Justice League: Generation Lost #4*
THE NEW 52/DC REBIRTH		
Batman	Bruce Wayne	*Justice League Vol. 2 #6*
Superman	Clark Kent / Kal-El	
The Flash	Barry Allen	
Wonder Woman	Princess Diana of Themyscira	
Aquaman	Orin / Arthur Curry	
Cyborg	Victor Stone	
Green Lantern	Hal Jordan	
Martian Manhunter	J'onn J'onzz / John Jones	*Between Justice League Vol. 2 #6 and #7*
The Atom	Rhonda Pineda	*Justice League Vol. 2 #18*
Element Woman	Emily Sung	
Firestorm	Ronnie Raymond and Jason Rusch	
Shazam	Billy Batson	*Justice League Vol. 2 #31*
Lex Luthor	–	*Justice League Vol. 2 #33*
Captain Cold	Leonard Snart	
Power Ring/ Green Lantern	Jessica Cruz	*Justice League Vol. 2 #35 (Power Ring)*
Green Lantern	Simon Baz	*Justice League Vol. 3 #1*
Mera	Mera of Xebel	*Justice League Vol. 3 #24*
Green Arrow	Oliver "Ollie" Queen	*Green Arrow Vol. 6 #31*
Hawkgirl	Kendra Sanders	*Dark Knight: Metal #6*

CHARACTER	ALTER EGO	JOINED IN
NEW 52 JUSTICE LEAGUE DARK		
Madame Xanadu	Nimue Inwudu	*Justice League Dark #1*
Constantine	John Constantine	
Deadman	Boston Brand	
Zatanna	Zatanna Zatara	
Shade, the Changing Man	Rac Shade	
Mind Warp	Jay Young	*Justice League Dark #3*
Andrew Bennett	–	*Justice League Dark #9*
Black Orchid	Alba Garcia	
Doctor Mist	Nommo Balewa	
Timothy Hunter	–	*Justice League Dark #11*
Frankenstein	–	*Justice League Dark Annual #1*
Amethyst	Amaya	
Swamp Thing	Alec Holland	*Justice League Dark #25*
Nightmare Nurse	Asa	*Justice League Dark #24*
Pandora	–	*Trinity of Sin: Phantom Stranger #14*
The Phantom Stranger	Judas Iscariot	
Zauriel	–	*Constantine #10*
NEW 52 JUSTICE LEAGUE INTERNATIONAL		
Booster Gold	Michael Jon Carter	*Justice League International Vol. 3 #1*
August General in Iron	Fang Zhifu	
Fire	Beatriz da Costa	
Godiva	Dorcas Leigh	
Green Lantern	Guy Gardner	
Ice	Tora Olafsdotter	
Rocket Red	Gavril Ivanovich	
Vixen	Mari Jiwe McCabe	
Batman	Bruce Wayne	
Batwing	David Zavimbe	*Justice League International Vol. 3 #8*
O.M.A.C.	Kevin Kho	*Justice League International Vol. 3 #9*
Blue Beetle	Jaime Reyes	*Justice League International Vol. 3 Annual #1*
Olympian	Aristides Demetrios	
NEW 52 JUSTICE LEAGUE OF AMERICA		
Col. Steve Trevor	Steve Trevor	*Justice League of America Vol. 3 #2*
Hawkman	Katar Hol	

CHARACTER	ALTER EGO	JOINED IN
Martian Manhunter	J'onn J'onzz / John Jones	
Katana	Tatsu Yamashiro	
Vibe	Francisco "Cisco" Ramon	
Stargirl	Courtney Whitmore	
Catwoman	Selina Kyle	
Green Arrow	Oliver "Ollie" Queen	*Justice League of America Vol. 3 #4*
Green Lantern	Simon Baz	*Justice League of America Vol. 3 #5*
Doctor Light	Arthur Light	*Justice League Vol. 2 #22*
NEW 52 JUSTICE LEAGUE UNITED		
Stargirl	Courtney Whitmore	*Joined the JLA in Justice League of America Vol. 3 #1*
Martian Manhunter	J'onn J'onzz / John Jones	
Green Arrow	Oliver "Ollie" Queen	
Animal Man	Bernhard "Buddy" Baker	*Justice League United #1*
Adam Strange	Adam Strange	
Supergirl	Kara Zor-El	*Justice League United #2*
Equinox	Miiyabin Marten	*Justice League United #5*
Hawkman	Katar Hol	*Justice League United #3*
REBIRTH JUSTICE LEAGUE OF AMERICA		
Batman	Bruce Wayne	*Justice League of America Vol. 4 #1*
Black Canary	Dinah Laurel Lance	
Vixen	Mari Jiwe McCabe	
Ray	Ray Terrill	
The Atom	Ryan Choi	
Lobo	Unpronounceable	
Killer Frost	Caitlin Snow	
REBIRTH JUSTICE LEAGUE OF CHINA		
Super-Man	Kong Kenan	*New Super-Man #2*
Wonder-Woman	Peng Deilan	
Bat-Man	Wang Baixi	
The Flash	Ho Avery	*New Super-Man #9*

CHARACTER	REAL NAME	NON-FULL MEMBERSHIP IN
OTHER HEROES		
Snapper Carr	Lucas "Snapper" Carr	Made honorary member and team mascot in *The Brave and the Bold #28*
Sargon the Sorcerer	John Sargent	Made honorary in *Justice League of America #99*
Golden Eagle	Charley Parker	Made honorary in *Justice League of America #116*
Captain Comet	Adam Blake	Made honorary in *DC Special #27*
Deadman	Boston Brand	Made honorary in *Justice League of America #274*

CHARACTER	ALTER EGO	NON-FULL MEMBERSHIP IN
Sandman	Garrett Sanford	Made honorary in *Justice League of America Annual* #1
Sue Dibny	–	Made honorary in *Justice League International* #24
Adam Strange	–	Made honorary in *JLA: Secret Files* #1
Tempest	Garth	Made honorary in *Justice League of America* Vol. 2
Batgirl	Barbara Gordon	Made honorary after her death in Zero Hour #0
Creeper	Jack Ryder	Made honorary in *Justice League International»* #24
Retro	Unrevealed	Made honorary in *New Year's Evil: Prometheus*
Resurrection Man	Mitch Shelley	Granted probationary in *Resurrection Man* #21
Toyman	Hiro Okamura	Made honorary in *Superman/Batman* #49
Tattooed Man	Mark Richards	Made honorary in *Final Crisis* #6
Bulleteer	Alix Harrower	Made reserve member in *Justice League of America* Vol. 2 #56

STAFF

CHARACTER	ALTER EGO	NON-FULL MEMBERSHIP IN
Simon Carr	–	*JLA: Year One* #1
Dale Gunn	–	*Justice League of America Annual* #2
Maxwell Lord	–	*Justice League* #1
Oberon	–	
Catherine Cobert	–	*Justice League International* #8
Kilowog	Kilowog of Bolovax Vik	*Justice League America* #33
L-Ron	–	*Justice League America* #42
Hannibal Martin	–	*Justice League Task Force* #1
Yazz	–	*Justice League America* #95

ALTERNATE LEAGUES

NEW 52 JUSTICE LEAGUE 3000
A 31ST CENTURY JUSTICE LEAGUE OF RESURRECTED HEROES

CHARACTER	ALTER EGO	JOINED IN
Batman	Bruce Wayne	*Justice League 3000* #1
The Flash	Barry Allen	
Green Lantern	Hal Jordan	
Superman	Clark Kent / Kal-El	
Wonder Woman	Princess Diana	
Firestorm	Ronnie Raymond and Jason Rusch	*Justice League 3000* #4
The Flash	Teri	*Justice League 3000* #9
Green Lantern	Guy Gardner	*Justice League 3001* #1

NEW 52 SUPER BUDDIES 3000
A 31ST CENTURY RECREATION OF THE SUPER BUDDIES/JUSTICE LEAGUE INTERNATIONAL

CHARACTER	ALTER EGO	JOINED IN
Blue Beetle	Ted Kord	Sometime prior to *Justice League 3001* #3
Booster Gold	Michael Jon Carter	
Fire	Beatriz Bonilla da Costa	
Ice	Tora Olafsdotter	
The Flash	Barry Allen	
Green Lantern	Hal Jordan	

FUTURES END JUSTICE LEAGUE BEYOND
THE ACTIVE JUSTICE LEAGUE FROM THIRTY-FIVE YEARS IN THE FUTURE

CHARACTER	ALTER EGO	JOINED IN
Superman	Kal-El	*Batman Beyond Vol. 5* #9
Green Lantern	Kai-Ro	
Big Barda	Barda Free	
Aquagirl	Mareena Curry	
Warhawk	Rex Stewart	
Micron	Unknown name	

JUSTICE LEAGUE 1,000,000

CHARACTER	ALTER EGO	JOINED IN
Aquaman	N/A	*JLA* #23
Batman	Unknown name	
Starman	Farris Knight	
Superman	Kal Kent	
Wonder Woman	N/A	
Flash	Jonathan Fox	*Flash Special* #1
Hourman	Matthew Tyler	*JLA* #12

THE WORLD NEEDS
HEROES

Since DC Comics began publishing more than eighty years ago, it has become apparent that their world, like ours, needs heroes. The call to action rings out and people with extraordinary abilities answer, risking their lives to protect others.